INDIANA UNIVERSITY
CINEMA
THE NEW MODEL

INDIANA UNIVERSITY
CINEMA
THE NEW MODEL

BRITTANY D. FRIESNER *and* JON VICKERS

This book is a publication of

Indiana University Press
Office of Scholarly Publishing
Herman B Wells Library 350
1320 East 10th Street
Bloomington, Indiana 47405 USA

iupress.org

Manufactured in Canada

Cataloging information is available from the
Library of Congress.

ISBN 978-0-253-05808-9 (hardback)
ISBN 978-0-253-05809-6 (ebook)

First printing 2021

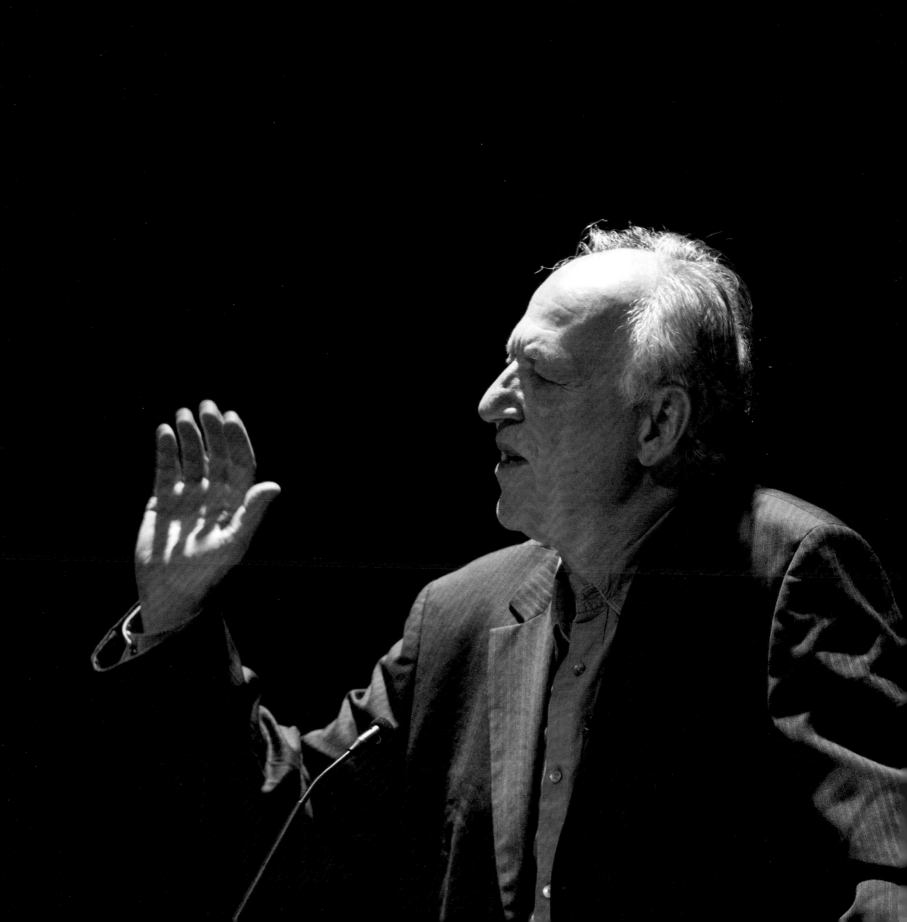

CONTENTS

ACKNOWLEDGMENTS

It is our pleasure to acknowledge those responsible for the overwhelming success IU Cinema has enjoyed in its first decade. Our achievements to date are the product of many individual contributions of time, financial gifts, hard work, and intellectual and creative thought. This includes our talented and dedicated full-time, part-time, student, and volunteer staff; our academic, student, and community partners; and generous donors, alumni, students, audience members, and industry colleagues. Many of these good people—perhaps yourself included—are mentioned inside these covers. If we missed you, please know it does not mean you were not on our minds when writing these chapters. Along with support from individuals, it is important to note the unparalleled commitment to the arts and humanities by Indiana University's administration and faculty. The leadership of President Michael A. McRobbie, Provost and Executive Vice President Lauren Robel, Deputy Chief of Staff and Bicentennial Director Kelly Kish, and former Provost and Executive Vice President Karen Hanson was critical to the inception and development of IU Cinema in its first decade. Of course, we all built on the long-standing traditions and priorities of University leadership who preceded us, especially IU's beloved eleventh president, Herman B Wells.

This book would not exist without the dedication, drive, organization, and editing of our Publications Editor Michaela Owens; incredible layout and design by our Design and Marketing Manager Kyle Calvert, with guidance from Jennifer Witzke of IU Press; the expertise and wisdom of Gary Dunham and Stephen Williams at IU Press; and the generosity of IU Cinema champions Jane and Jay Jorgensen. We are deeply grateful to all IU Cinema staff for their contributions, including Carla Cowden, Elena Grassia, Seth Mutchler, and Jessica Davis Tagg; we are indebted to Alyssa Brooks and Payton Frawley for their work in transcribing many of the filmmaker interviews inside. Special thanks to Photograph Curator Bradley Cook with the University Archives for directing us to great historical images and University Historian James Capshew for always having the backstory. Although each figure in this publication has a caption and acknowledgments, this book would not have its aesthetic beauty without contributions from the talented photographers of IU Studios over the years, coupled with the brilliant design of IU Cinema promotional materials from Kyle Calvert, volunteer Jennifer Vickers, and many other contributors. Thank you all!

BRITTANY D. FRIESNER

Countless engaged and passionate individuals have helped make IU Cinema a reality and contributed to its first decade of amazing and transformative programming. I am deeply grateful to Indiana University—my alma mater twice over—for its vision in establishing IU Cinema, and I am immensely thankful for all the coworkers, colleagues, collaborators, and artists I have been fortunate to work with over the years—you have been integral in helping make the magic of this place possible. Moreover, I feel a profound sense of gratitude to my loved ones who have supported me and my work—you help make the challenging days less difficult and the good days even greater. And a very special thank you goes to Francis "Frankie" Josephine Friesner, who has inspired more than one good programming idea.

JON VICKERS

When Brittany first suggested this book, it seemed like a novel idea, albeit bold after only ten years. This book would not exist without her foresight and confidence. Now that it has taken shape, I reflect on the last decade with an enormous amount of pride for what we have collectively built. I am humbled and honored to be part of IU Cinema's history and thank Indiana University for this opportunity, which I never took for granted. I also need to thank Jennifer, Max, Frankie, and Ava for uprooting and making the move to Bloomington to continue the journey of this accidental career in community building disguised as film exhibition. For the love of film!

FOREWORD

Timing is everything. If I hadn't attended the inauguration of Indiana University's newest president, Michael A. McRobbie, on October 18, 2007, I wouldn't have heard the speech outlining his goals for his presidency. One of those goals was to create a state-of-the-art cinema inside the vacant University Theatre. At the first mention of the words "state-of-the-art cinema," my curiosity was piqued, and I could not wait to hear more details about this plan! Since I was a child, I have always loved movies—going to them, watching home movies, or pretending to make movies. This love of cinema remains a large part of who I am to this day, thanks to the influence of my parents and my brother, David Anspaugh, who pursued a successful career in feature films.

A hard-hat tour was arranged in the venue the next day, and, as the saying goes, the rest is history. It was obvious a great deal of thought and planning had already been set in motion, and I was ready to do whatever was needed to help move this project forward. I knew there was something very special about this space and what the future might hold. It was a unique opportunity to be on the ground floor of such an inspired project, and I wasted no time getting involved.

It is important to understand the University Theatre had not been used for several years. However, seeing its condition for the first time did not dampen my enthusiasm—in fact, I was energized by the potential and eager to be a part of its transformation. Tackling the physical renovations was only the beginning.

We would need to conduct a search for an experienced founding director to develop a vision for the new cinema (and to make it happen). This person needed to assemble a highly qualified team of professionals who shared the vision and had the passion, drive, and patience to build a stellar program that could attract the best filmmakers to our university. Fortunately, we found the leadership in Jon Vickers as founding director and Brittany D. Friesner as founding associate director. Their leadership, vision, and determination are responsible for the Cinema's success.

When my husband, Jay, and I were approached about endowing a guest filmmaker series, we wholeheartedly embraced the idea, and the Jorgensen Guest Filmmaker Series was created. Little did we realize how transformative our gift would be! Under Jon and Brittany's leadership, the Cinema has presented thousands of programs, partnering with hundreds of University departments. The Jorgensen Guest Filmmaker Series has allowed IU Cinema to host more than two hundred filmmakers to date, including renowned international directors, American indie-film icons, and A-list actors, as you will see in this book.

This book is meaningful to both the University and our family. I have been able to be involved in almost every step of the Cinema's development since its inception—the groundbreaking, hard-hat tours, renovation updates, and the formal dedication ceremony a decade ago. This book takes you through the amazing journey, from a university president's goal to the opening and launch of a new program to the strategic planning, innovative programming, quality branding, and professional execution that have made it the highly respected and successful venue and program it is today—the Indiana University Cinema. It has been an honor to be passionately involved with the Cinema and watch it grow more impressively each and every year.

Jane Jorgensen

INDIANA UNIVERSITY
CINEMA
THE NEW MODEL

01
SETTING
THE
STAGE

t is a warm October night, and hundreds of people flow into the Teatro Verdi from the streets of Pordenone, Italy—a small city dating back to the Middle Ages, situated about eighty kilometers north of Venice. People make their way to their seats and get comfortable for the European premiere of the 1916 western *The Return of Draw Egan*. The film stars William S. Hart, who also directed the film and is one of Hollywood's top leading men. Coincidentally, the film was made one year after students from a university in the Midwest began presenting this new artform— film in their student union, but we'll get to that later.

The audience settles into their seats, the orchestra adjusts and applies final tuning to their instruments to accompany the silent film, the auditorium begins to dim, and the magic of light flickers and bursts onto the screen with Tri-Stone Pictures Inc. presents William S. Hart In The Return Of Draw Egan.

The rising rumble of percussion leads to strings and woodwinds, and the rhythm of an opening theme materializes, with the sensation of it jumping off the screen. After about an hour, the picture ends with a roar of applause, which leads to a standing ovation. In 1916, this was a common reaction to films presented with a live orchestra in moderate-size cities around the world. The silent movies were never silent, and these early days of cinema elicited strong audience reactions.

But this is not 1916—it's October 11, 2019, and the film score played by the orchestra was commissioned by Indiana University (IU) Cinema and composed by Indiana University Jacobs School of Music (JSoM) alumnus Ari Barack Fisher. Fisher was present for this presentation as a guest of the renowned Le Giornate del Cinema Muto, which selected the film, along with Fisher's music, to be showcased in its 2019 festival. The world premiere of this new, original score was presented in IU Cinema three years earlier—one hundred years following the release of the film.

The opening of a state-of-the-art movie theater (which we will refer to as *cinema* throughout this book) does not just happen overnight on a large state university campus. These types of facilities are generally built into master plans and discussed for decades before they come to fruition. In the case of IU Cinema, it was a combination of building on IU traditions and the will of a dynamic new leader who launched a bold, new, ambitious venture to support and celebrate film, the seventh art. This chapter pays tribute to the leadership and contributions of countless individuals who have helped make possible the opening and extraordinary growth of IU Cinema in its first decade.

Right, top: Still title frame from the 1916 film *The Return of Draw Egan*. Library of Congress

Right, bottom: Ari Barack Fisher in IU Cinema's lobby after the world premiere of his orchestral score for *The Return of Draw Egan* on February 20, 2016. Chaz Mottinger/IU Studios

Next page: Ari Barack Fisher's score being performed at the Le Giornate del Cinema Muto film festival in Pordenone, Italy, on October 11, 2019. Valerio Greco

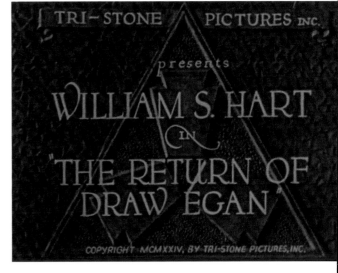

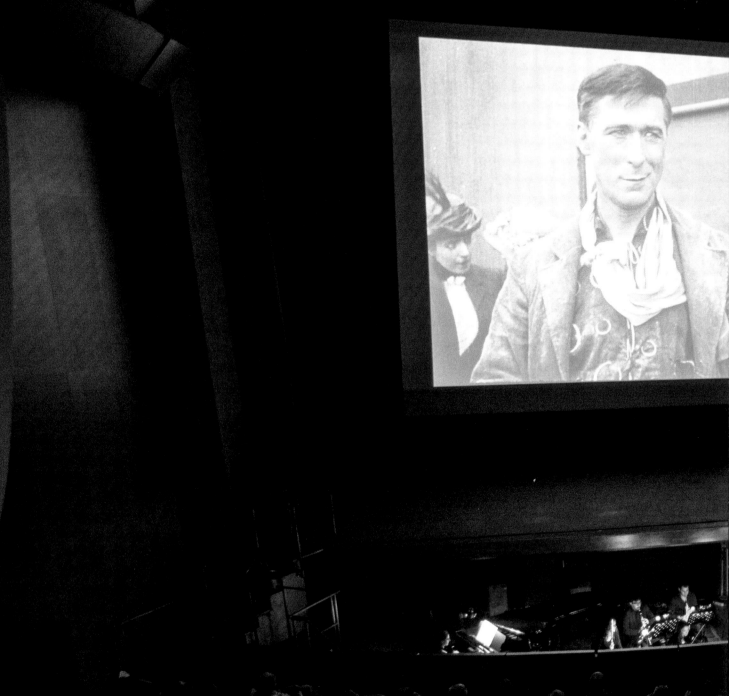

IN THE BEGINNING

The first moving picture show on the IU Bloomington campus was screened December 2, 1914, on 35mm in the auditorium of the Student Building, initiating a Union movies program. In order to present films in the Student Building, a hole was cut in the wall of the building's auditorium, and the newly created projector booth was "lined inside and outside with asbestos so as to make it absolutely fireproof," as the *Indiana Daily Student* (*IDS*) reported. The Simplex 35mm projector was installed the day prior, and on that night, four short films— *The Mill of Life*, *The Telltale Knife*, *Wally Van*, and *Thanks for the Lobster*—screened for a standing-room-only audience of "first-nighters." There was music to accompany the films throughout the evening.

The *IDS* wrote, "Motion picture producers have shown an exceptional interest in the Indiana Union movies." By the spring of 1915, movies were screened every week on Wednesdays and Fridays, making this program at Indiana University the first in the US on a college campus. Union Board Films remains the oldest student-operated film program in the United States.

This is the first inspiration for IU Cinema. Film screenings and movies have been part of the student experience here at the University for more than half of its life. Based on this alone, it would not seem too far of a stretch to build a facility dedicated to the artform nearly one hundred years later.

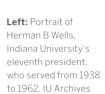

Left: Portrait of Herman B Wells, Indiana University's eleventh president, who served from 1938 to 1962. IU Archives

Right: Column from the Thursday, December 3, 1914, issue of the *Indiana Daily Student*. IU Archives

Facing: Conceptual drawing of IU Auditorium and proposed arts plaza at Indiana University from New York architectural firm Eggers & Higgins. IU Archives

STANDING ROOM ONLY AT THE UNION MOVIE SHOW

Well Balanced Program of Comedy and Drama Pleases Large Crowd of "First Nighters."

WILL GET A STRONGER LENS

With students standing in rows three deep around the walls and all the seats occupied, the Union movies made their first appearance last night in the Student building. An excellent four-reel show was presented which apparently pleased the large crowd of spectators.

Comedy and tragedy had equal place in the show. "The Mill of Life" was a powerful Biograph drama with Maurice Costello in the lead. The other films were "The Tell-tale Knife," "Wally Van" and "Thanks for the Lobster." A feature film on the city of Gary was shown, entitled "An American in the Making."

The lens did not prove entirely satisfactory last night, and a more powerful one will be procured at once. A new operator will also be secured, as Earl Moore, an assistant in Psychology, who operated the machine last night, will be unable to continue the work. It is the plan of the Union board to employ students as far as possible.

Only three more shows will be given this term, but shows will be given every Wednesday and Friday night of next term.

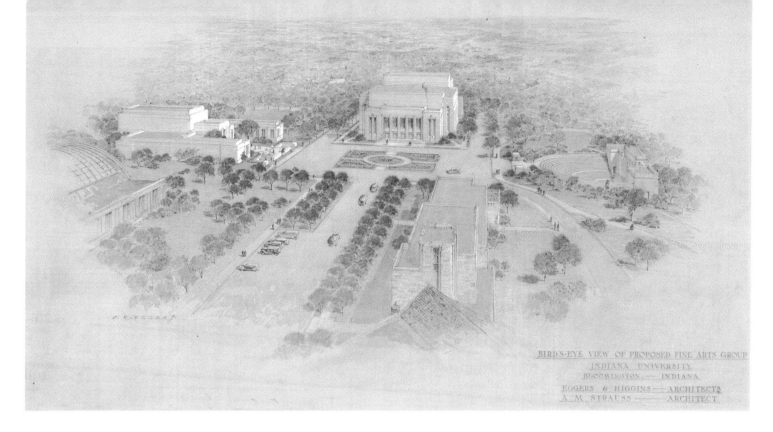

BIRD'S-EYE VIEW OF PROPOSED FINE ARTS GROUP
INDIANA UNIVERSITY
BLOOMINGTON —— INDIANA
EGGERS & HIGGINS —— ARCHITECTS
A. M. STRAUSS —————— ARCHITECT

AN AUDITORIUM

In 1938, Herman B Wells was named Indiana University's eleventh president. At the age of thirty-five, he was the country's youngest state university president. Wells was an educational visionary who helped transform IU into an internationally recognized center of research and scholarship. Under the Wells presidency, IU experienced its greatest growth and widened its scope to encompass the globe. To many people, Wells is, was, and remains an icon for Indiana University.

He served as president for a quarter century and continued to be a vital contributor as IU chancellor for another thirty-seven years. His association with the institution spanned eight decades, dating from when he was a student until his death.

Among his many accomplishments at the University, he is known for his commitment to using arts and culture to "bring the world to Indiana." In the March 1939 issue of *Reader's Digest*, Karl Detzer wrote a condensed article titled "This College Campus Is the Whole State," in which he praised the young president "for the spread of culture across the state via these unusual methods he is employing or planning to employ. . . . Through forums, music, drama, movies, radio, he is pushing the university influence to the farthest corners of the state."

In *Herman B Wells: The Promise of the American University* (IU Press, 2012), University historian and professor James Capshew wrote, "Wells clearly saw his role as a leader in the cultivation of cultural heritage, reframing and incorporating it into the liberal arts context, and thus making it available for the education of all citizens of the commonwealth."

Wells' single greatest commitment to arts and culture would be the construction of the Indiana University Hall of Music—now called the IU Auditorium—which would connect to the University Theatre, the space that would eventually become IU Cinema. Herman B Wells and Ward Biddle began planning the IU Auditorium in 1938 and envisioned it to be unlike any other performance space on a state university campus.

On March 22, 1941, the Auditorium of Indiana University and the attached University Theatre (immediately referred to as the Little Theatre) were formally dedicated. This event was attended by state of Indiana dignitaries; presidents of surrounding universities; and musicians, composers, performers, and artists, including Thomas Hart Benton. Even President Franklin D. Roosevelt sent a letter to be read at the ceremony: "The building which you are at this time dedicating is a source of pride to your national government as well as the state of Indiana. It stands as a fitting monument to the capacity of the American form of government to promote the welfare and happiness of its citizens in a period of great stress. Now, when democracy faces an even greater crisis, it is reassuring to know that it can preserve and promote the arts of peace as well as defend civilization against assault from any source. Very sincerely yours, Franklin D. Roosevelt."

FIRST FLOOR PLAN
SCALE: 1/8"=1'-0".

ELEVATION OF THEATRE ENTRANCE
SCALE 3/4"=1'-0"

The letter from Roosevelt was an appropriate honor for Indiana University. In President Wells' speech that day, he stated that 45 percent of the funding for the cost of the building came from the Public Works Administration (WPA) of the federal government. The WPA's national director, John Carmody, intended to be in Bloomington for the dedication but sent his regrets in a telegram stating the WPA's goal was to create "institutions that will live for generations" and "influence the lives of young men and women who avail themselves to these magnificent facilities."

The joyous ceremony was expertly led by Wells at the podium, who celebrated the wonderful structure and the men and women responsible for its realization, saying, "Here . . . original musical scores composed by students and faculty will be heard, and student artists will be stimulated by the exterior and the interior beauty and facilities of the structure."

He also stated the Auditorium "will serve as a gathering place for students of all divisions, undergraduate and graduate, and for members of the staff, academic and non-academic."

Wells offered special recognition to Ross Teckemeyer, who was responsible for saving the Thomas Hart Benton murals—which today grace the walls of IU Cinema, IU Auditorium, and Woodburn Hall—sharing how the murals could have easily met their demise: "Had it not been for his conscientious and intelligent care, the murals undoubtedly would have deteriorated in the eight years

Left: Architectural drawing of the University Theatre seating layout, 1938. IU Archives

Right: Architectural drawing of the University Theatre building name inscription, formalized thirteen years after the opening of IU Auditorium in 1941. IU Archives

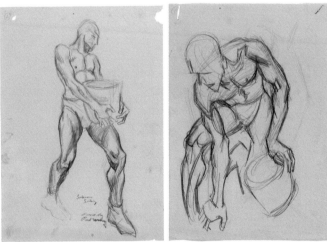

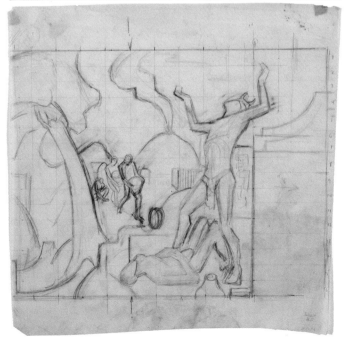

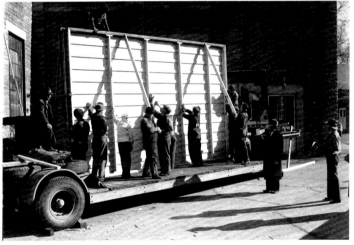

Left, top: Image from the March 22, 1941, IU Auditorium dedication. Pictured are Thomas Hart Benton (third from left) and President Herman B Wells (shaking hands with an unidentified woman). IU Archives

Left, bottom: Preparatory drawings by artist Thomas Hart Benton for Cultural Panel 1 of his Indiana Murals. Four mural panels were later designed and incorporated into the University Theatre's design. Graphite on paper. Sidney and Lois Eskenazi Museum of Art

Right, top: Program from the March 22, 1941, IU Auditorium dedication. IU Archives

Right, bottom: Thomas Hart Benton murals being delivered during construction to IU Auditorium for mounting in the Auditorium's Hall of Murals and the University Theatre. IU Archives

TIMELINE FOR FILM COLLECTIONS AND STUDIES AND THE UNIVERSITY THEATRE

Between 1941 and 2007, there were significant events and commitments to the arts and humanities on the IU Bloomington campus. Many of these had an impact on cinema and media programs, collections, and academic units, ultimately building the base for things to come. These included:

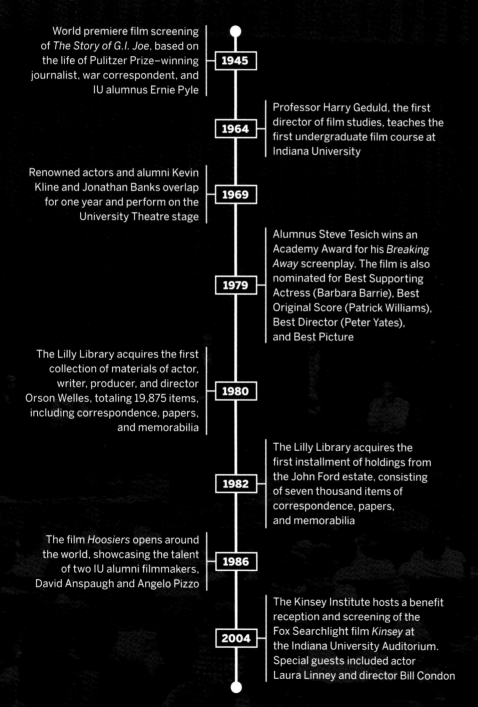

1945 — World premiere film screening of *The Story of G.I. Joe*, based on the life of Pulitzer Prize–winning journalist, war correspondent, and IU alumnus Ernie Pyle

1964 — Professor Harry Geduld, the first director of film studies, teaches the first undergraduate film course at Indiana University

1969 — Renowned actors and alumni Kevin Kline and Jonathan Banks overlap for one year and perform on the University Theatre stage

1979 — Alumnus Steve Tesich wins an Academy Award for his *Breaking Away* screenplay. The film is also nominated for Best Supporting Actress (Barbara Barrie), Best Original Score (Patrick Williams), Best Director (Peter Yates), and Best Picture

1980 — The Lilly Library acquires the first collection of materials of actor, writer, producer, and director Orson Welles, totaling 19,875 items, including correspondence, papers, and memorabilia

1982 — The Lilly Library acquires the first installment of holdings from the John Ford estate, consisting of seven thousand items of correspondence, papers, and memorabilia

1986 — The film *Hoosiers* opens around the world, showcasing the talent of two IU alumni filmmakers, David Anspaugh and Angelo Pizzo

2004 — The Kinsey Institute hosts a benefit reception and screening of the Fox Searchlight film *Kinsey* at the Indiana University Auditorium. Special guests included actor Laura Linney and director Bill Condon

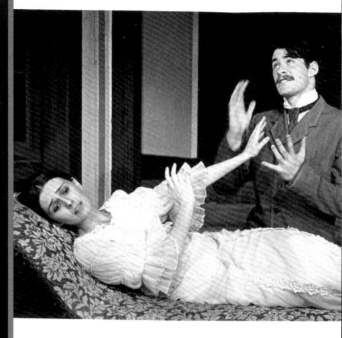

Kevin Kline on the University Theatre stage in 1969 with Victoria Thatcher in *Waltz of the Toreadors*. IU Archives

that lapsed between their showing in Chicago at the 1933 A Century of Progress International Exposition World's Fair and their unveiling here tonight. When brought to Indiana University, they were in just as good of condition as they were the day they were taken from the walls in Chicago."

The opening performances that week in the University Theatre were of a new play titled *Jordan River Review*. The opening week of activity in the IU Auditorium included student musical productions, a religious service, a Broadway theatrical production, a recital by Metropolitan Opera stars, and a symphony concert.

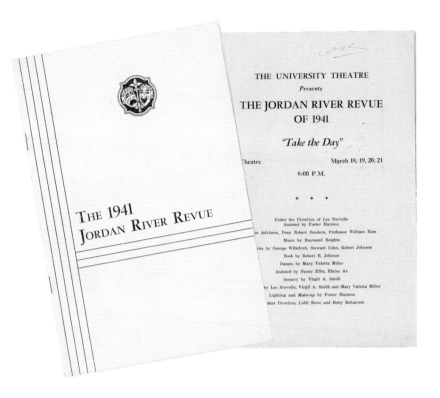

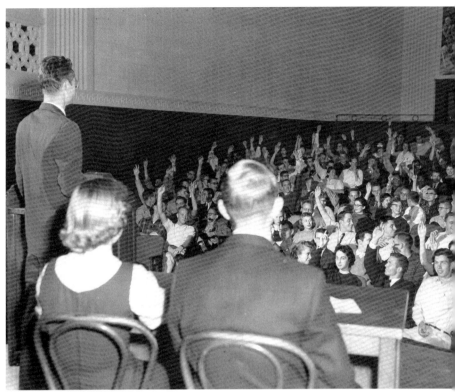

Left, top: Playbill for the *Jordan River Review*, the first stage production produced in the University Theatre in 1941. IU Archives

Right, top: University Theatre being used for a public forum in 1965, demonstrating one of the many uses of the space between 1941 and 2001. IU Archives

Right, bottom: Reverse image of the University Theatre being used for a public forum in 1965. IU Archives

Next page: Exterior of the University Theatre as patrons enter for a student production of the play *The Circle* in 1963. IU Archives

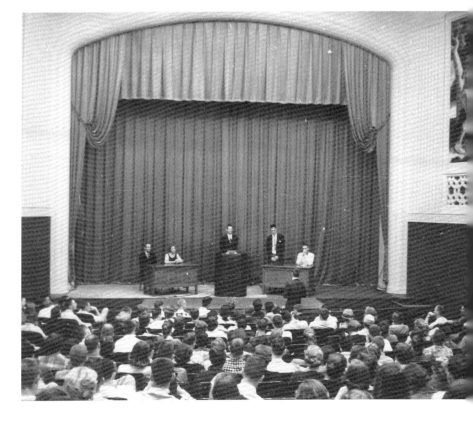

THE UNIVERSITY THEATRE GETS A REST

In November 2001, the University Theatre presented its final performance with Samuel Beckett's play *Waiting for Godot*. Access to the University Theatre was then closed to the public after sixty years of offering itself to the creation of memories, careers, and community. On January 18, 2002, the new Indiana University Theatre and Drama Center was formally dedicated and hailed as "a perfect mix of state-of-the-art performance and public spaces, studios, laboratories, workshops, and high-tech classrooms," according to Leon Brauner, chair of the IU Department of Theatre, Drama, and Contemporary Dance.

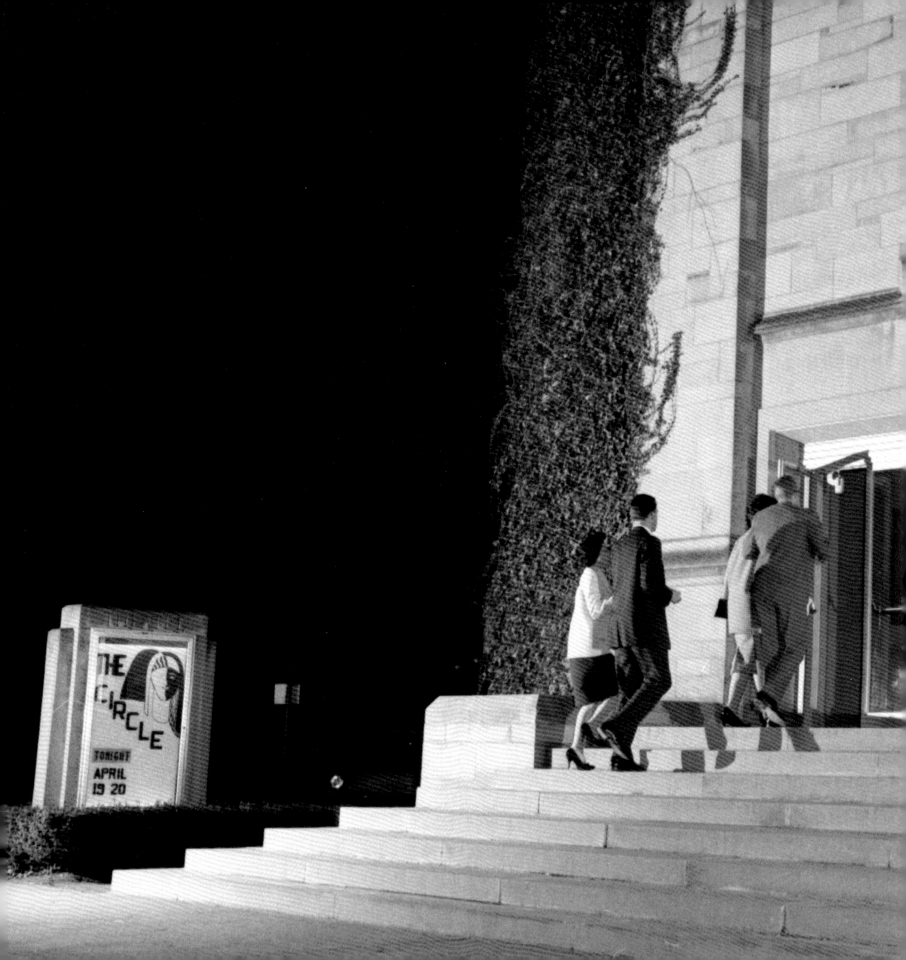

THE EDUCATION OF
MICHAEL A. McROBBIE

On July 1, 2007, Michael A. McRobbie became the eighteenth president of Indiana University, one of the largest universities in the United States, with nine campuses, which in the University's bicentennial had twenty thousand faculty and staff, more than one hundred thousand students, and approximately seven hundred thousand living alumni. He joined IU in 1997 as the university's first vice president for information technology and chief information officer. He was appointed vice president for research in 2003, and, in 2006, was named interim provost and vice president for academic affairs for IU's Bloomington campus.

A native of Australia, McRobbie received a PhD from the Australian National University in 1979. He started at the University of Queensland as an undergraduate in 1968. There was no on-campus cinema until 1970, but approximately one mile off campus was an art deco arthouse cinema called the Avalon, and there were several more cinemas located within five miles of campus. McRobbie spent many hours watching films during his undergraduate years.

The first film McRobbie recalled having a major impact on him was Michelangelo Antonioni's *Blow-Up* (1966). This was his first exposure to an international art film, and it was a revelation—opening him up to a brand-new cinematic world. The film remains a favorite of his, as fresh, vibrant, and enigmatic as ever.

However, the big movie event of his first year in Queensland was the release of *2001: A Space Odyssey* (1968). He saw it with friends, who were all amazed and stunned by the film, so much so they stayed up all night discussing and debating, then went to see it again the next evening. According to McRobbie, the film "remains an ageless masterpiece" and is "one of the most magnificent examples of the cinematic arts ever. No science-fiction movie since has come close to surpassing it."

These vivid recollections of how the world opened up for him through international cinema as an undergraduate helped illuminate the need to create similar opportunities at Indiana University. Films enriched his university experience, informing and influencing the debates and discussions he had as an undergraduate. McRobbie takes great joy in knowing IU Cinema exists so IU students have this same opportunity as part of their Indiana University education.

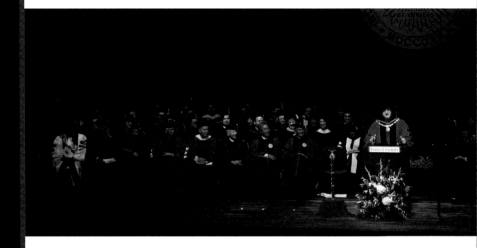

Top: Michael A. McRobbie at his inauguration as the eighteenth president of Indiana University. IU Archives

Facing: Interior of the University Theatre during a hard-hat tour while being considered as a potential space for the University's new cinema. Halkin Mason Photography

The new $26 million, 117,000-square-foot facility included the Marcellus Neal and Frances Marshall Black Culture Center; two performance venues, the Wells-Metz Theatre and the Ruth N. Halls Theatre; studios specifically designed for acting, directing, design, lighting, and technology; a scenic workshop; a costume design workshop; modern, high-tech classrooms; and all the support spaces necessary for operating a significant theater program.

Philadelphia-based architectural firm MGA Partners designed the Theatre and Drama Center to incorporate extensive use of Indiana limestone in both the interior and exterior design to blend with other campus buildings. "From the conception of the project there was but one goal: to create a beautiful and functional home for the education of tomorrow's theater scholars and artists," Brauner said.

The first public performances in the new complex were Shakespeare's *Much Ado about Nothing* and Arthur Miller's *Death of a Salesman*, both opening in February 2002.

A DECLARATION OF NEED

Michael A. McRobbie delivered his inaugural address as Indiana University's eighteenth president on October 17, 2007. The speech, titled "Endurance, Excellence, and the Energy of Change at Indiana University," addressed ten strategic initiatives for his presidency.

One of those initiatives, subtitled "Extending Our Glorious Tradition in the Arts and Humanities," would seal the fate of the University Theatre and give it new life, bringing beauty and relevance back to the once-elegant venue.

In his address, President McRobbie stated, "The renewed energy we will bring to our statewide engagement will be matched by the energy that animates our glorious tradition in the arts and humanities. That tradition is based first and foremost on the eminence of our outstanding scholars. From language and literature, to the fine and performing arts, they have established IU's programs as among the finest in the world. They have also contributed immeasurably to providing a true liberal education to generations of IU students.

It is our intention to build on this remarkable legacy and to expand even further our ability to pursue research and education in international affairs and foreign languages and cultures in the humanities and social sciences. . . . IU's reputation in the arts and humanities is also based on the superb facilities, championed by successive IU presidents.

"But there is one art where IU has, for decades, had a superb scholarly reputation but where it has no facilities. This is film. To address this need, we will immediately begin the conversion of the old University Theatre, just yards away from us, into a state-of-the-art facility that will fully support the scholarly study of film in its traditional and modern forms. It will also provide a vital tool for the education of generations of IU students as a venue for the

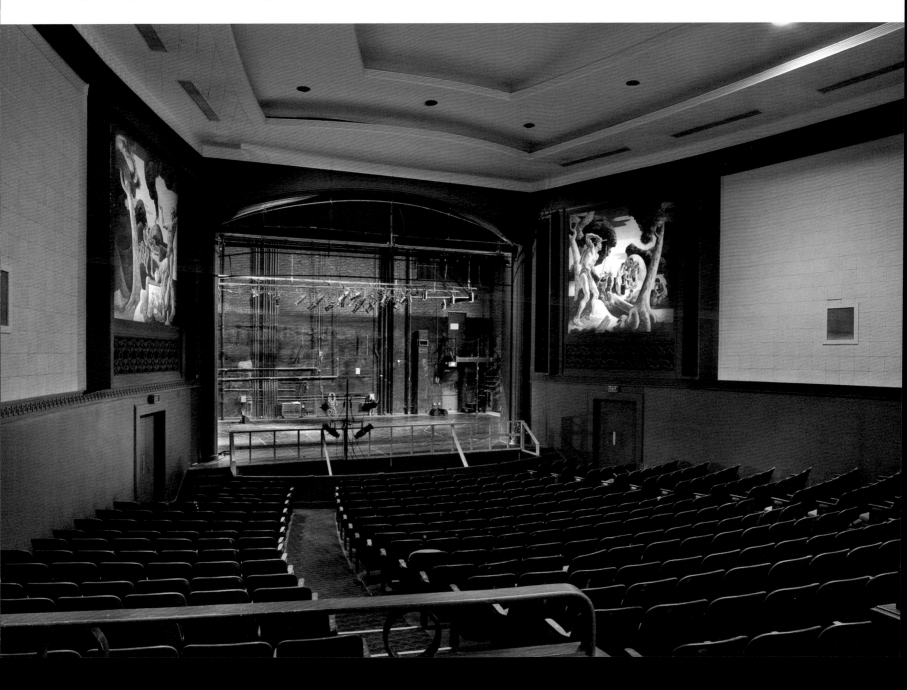

The Bloomington campus of Indiana University features facilities to support nearly every form of artistic performance or exhibition. The Musical Arts Center hosts countless concerts and operas; the IU Art Museum features artists from around the world; the Lilly Library houses manuscripts from centuries past; and venues in the Lee Norvelle Theatre and Drama Center stage fine dramatic productions just as the IU Auditorium offers professional musical and theatrical events.

But what IU lacks is a facility dedicated to the cinema. At its finest, cinema is an art form comparable to the greatest paintings, music, and theatre. Like photography, cinema was treated with suspicion in its infancy, but it has long since gained respect and found its own singular voice and aesthetic sensibility. Indeed, since the first motion pictures appeared in the 1890s, cinema has become truly international.

Indiana University already has a long and distinguished history in film studies. With film courses in at least seven different departments and a Film and Media Studies Program offered through the Department of Communication and Culture, IU faculty members have pioneered the development of film curriculum since the 1960s.

IU is home to the Black Film Center Archive, which houses over 1000 historic and contemporary films produced by or related to the African American community. The Lilly Library has acquired the papers of Orson Welles, John Ford, Clifford Odets, Peter Bogdanovich, original Federico Fellini scripts, and the working scripts of Twentieth-Century Fox producer Darryl F. Zanuck. The IU Library media collection contains over sixty thousand films, DVDs, and video and tens of thousands of scholarly books on film. These incomparable resources provide in-depth research opportunities to film scholars and students alike.

Bloomington benefits from the creative energy generated by such scholars and students and by local film series such as the Ryder, City Lights, and Underground. The city is home to the PRIDE Film Festival and has hosted the Iris Film and Video Festival as well as the Hometown Cinema Film Festival. These efforts demonstrate the keen

A University Cinema
New life for University Theatre

The cinema is not an art which films life: the cinema is something between art and life. Unlike painting and literature, the cinema both gives to life and takes from it.

—Jean-Luc Godard, French filmmaker and author

exploration of the humanities, world cultures, and social sciences through the lens of film. This exploration will draw upon our remarkable cinematic collections including our Black Film Center/Archive, the David Bradley Film Collection, and our general library collection, which together contain tens of thousands of items."

In the audience for this inauguration speech that day was IU alumna and donor Jane Jorgensen, who would become integral to IU Cinema's success.

Left: Early fundraising brochure used prior to publicly declaring the commitment to convert the University Theatre into a state-of-the-art cinema. IU Archives

Facing: Image from the preconstruction tour with MGA Partners, taken from the University Theatre stage, looking into the theater and IU Auditorium, which shared a common backstage. Halkin Mason Photography

FILM COLLECTIONS AT IU

There is certainly more than meets the eye when looking at the role film plays on the Bloomington campus of Indiana University. The libraries and centers are home to more than 120,000 items in 8mm, 16mm, or 35mm film prints and hundreds of thousands of film-related press materials, posters, memorabilia, and correspondence. Here is a sample of what you will find in IU's collections:

+ Within the Orson Welles Collection at the Lilly Library, there are storyboards for his most famous film, *Citizen Kane* (1941), the most studied film in history. This collection also contains scripts, research, and production material related to two important unfinished films, *Heart of Darkness* (1940) and *It's All True* (1943).

+ The most researched collection of materials within the Lilly Library is the John Ford Collection, which includes memorabilia, correspondence, and production materials for some of his greatest films. It may also be no surprise that the most popular items for visitors are Ford's Oscars for *How Green Was My Valley* (1941) and *The Grapes of Wrath* (1940).

+ At the height of the Great Depression, Russian filmmaker Sergei Eisenstein shot *¡Que viva México!*, funded by author Upton Sinclair and others. With most of the work completed, Josef Stalin insisted on Eisenstein's return to the Soviet Union, and the Soviet Film Industry prohibited the completion of the project. The Lilly Library holds the extensive records of this famous uncompleted film of the 1930s.

+ As well as being a repository of more than eight thousand films, the Black Film Center/Archive holds rare film ephemera, including a 1937 British flyer for the film *King Solomon's Mines* starring Paul Robeson; a poster for the 1939 film *Paradise in Harlem*; a 1934 UK press book for Josephine Baker's first talking film, *Zou Zou*; and posters from the Richard Norman Collection of films with all-Black casts from the 1920s.

+ David Bradley, a former movie director, was one of the most significant collectors of 16mm films in the United States. Though the David S. Bradley Collection, held by the Lilly Library, is not intended for outside use, prints have been loaned to the Musée du Louvre, Museum of Modern Art, and Cinémathèque Québécoise. Some of

the rare and unique holdings within the collection include *White Tiger* (1923), an unusual, plot-twisted melodrama from Tod Browning that follows a brother-sister team of thieves and a mechanical chess machine, and *Mantrap* (1926), Victor Fleming's story of a cynical divorce lawyer who meets a beautiful, coquettish, irresistible—but married—woman, played by Clara Bow at her temptress best.

+ Kenneth Anger, the most influential avant-garde filmmaker, was a friend of Alfred Kinsey's. The Kinsey Institute is now the home of Anger's earliest film, *Fireworks* (1947), as well as his other film productions, publications, artifacts, and extensive print materials he collected over the past fifty years.

+ The two newest collections of filmmaker materials in the Lilly Library's collections are the papers, manuscripts, and ephemera of Ousmane Sembène, considered the "Father of African Cinema," as well as British filmmaker John Boorman, known for such films as *Hope and Glory* (1987), *Deliverance* (1972), *Excalibur* (1981), and *Point Blank* (1967).

A NEW LIFE FOR
THE UNIVERSITY THEATRE

Like any good leader, President McRobbie had been strategically working behind the scenes to fully understand the commitment he was making for the University in his inaugural address. Several months earlier, he had assembled a committee charged with investigating whether the University Theatre could be a feasible site for a university cinema.

The committee was led by esteemed Chancellor's Professor Emeritus James O. Naremore and included additional IU faculty and staff: Daniel Karlov, Kelly Kish, Barbara Klinger, Robert Meadows, Doug Pearson, and Gregory Waller. They were to complete an inspection of the facility, visit other benchmark cinemas in the Midwest, research and compile a manifest of local resources that a campus cinema could draw on, and answer several questions:

- How would the campus cinema be used?
- What sort of technologies will be needed?
- What renovations will be needed?
- What would be the estimated budget and staffing needs?

Prior to publicly announcing his plans in his inaugural address, President McRobbie had begun a "quiet stage" of fundraising for the project. He clearly understood what he was looking for in a university cinema and how it could serve the campus—its departments, collections, students, faculty, and staff. He also understood that, if done well, it could set itself apart as a leading venue and program.

Much of this plan was introduced to potential donors in a fundraising brochure printed in May 2007, appropriately titled "A University Cinema: New Life for University Theatre." The spirit of that brochure has continued to drive IU Cinema in support of President

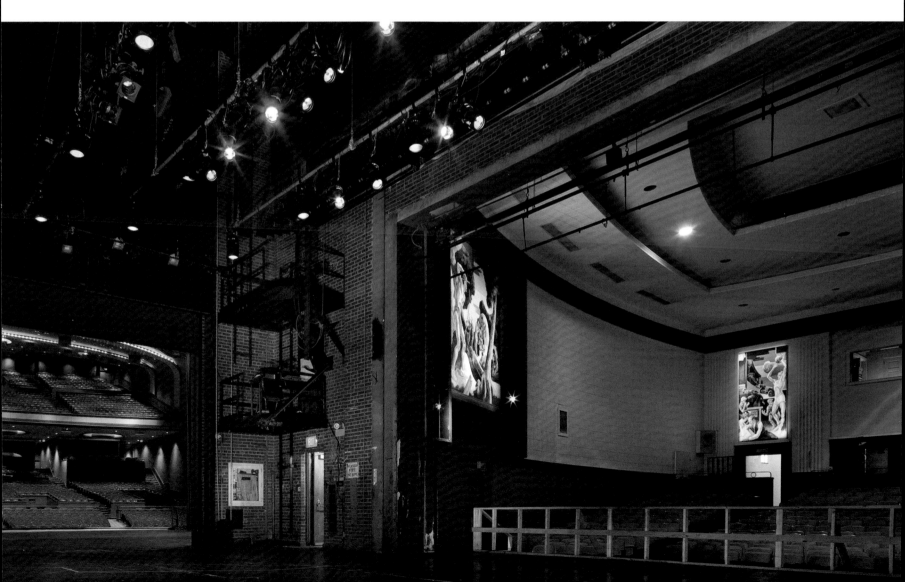

McRobbie's vision. The brochure also neatly and succinctly summarized IU's outstanding film and paper collections as well as the University's commitment to the scholarly study of the artform.

With research, initial fundraising efforts, some planning in place, and the commitment publicly made, there was no turning back.

BREAKING GROUND

October 18, 2009, was the day Indiana University ceremonially broke ground to launch the Theatre and Drama Cinema Renovation project, which would divide and convert the University Theatre into separate venues and work spaces for both the Department of Theatre, Drama, and Contemporary Dance and a new unit and venue on campus, the Indiana University Cinema.

Several stakeholders participated in the groundbreaking, with speeches from Provost Karen Hanson and President McRobbie. McRobbie declared, "The University Theatre is a most symbolic location for the new University Cinema. Completed in 1941 as part of the Auditorium complex, the theater embodies IU's glorious history of artistic accomplishment, combining great traditions of performance and visual art. [The year] 1941 also marked one of the pinnacles in the age of American cinema. That year, films directed by John Huston, William Wyler, Howard Hawks, Alfred Hitchcock, and Orson Welles were nominated for Academy Awards. It is astounding to think that films by these six remarkable directors were nominated in the same year. And the 1940s also saw the dawn of the great age of

international film. Ingmar Bergman, Federico Fellini, Michelangelo Antonioni, and Akira Kurosawa all began their cinematic careers around that time.

"These—and others—are the cinematic luminaries whose work will again quicken this space. Steeped in such rich artistic tradition, this theater space will return to life, offering scholars, students, and the broader community an accessible dedicated facility that is vitally necessary to the cinematic experience. Once again they will be able to see the masterpieces of cinema as they were meant to be seen.

"The very best cinema and the very best theater bring people from varied backgrounds together to explore other worlds, to visit other times, and to suspend their own lives for that moment in the theater."

RESTORATION

In 2008, the Indiana University Board of Trustees approved the financing and design of the Theatre and Drama Cinema Renovation project, which met approval in June 2009 by the Indiana Commission for Higher Education and in July 2009 by the State Budget Committee. MGA Partners, the Philadelphia architectural firm hired to lead the 2001 Theatre and Drama Center project, was again contracted to coordinate the design, with a total project budget of $15 million, with $5 million funded by private gifts and $10 million from university funds.

The project included creative repurposing of the backstage and fly-loft areas at University Theatre to add a small black-box theater;

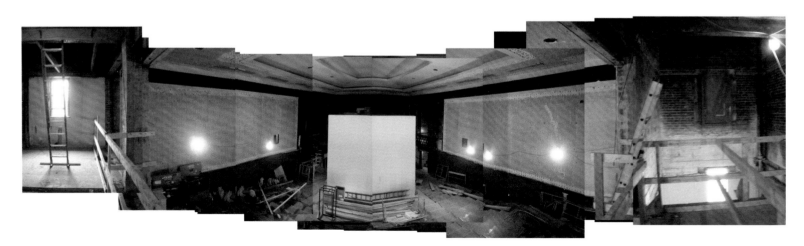

Compiled panoramic image of construction of IU Cinema with climate-controlled mural restoration room situated in the center of the construction. MGA Partners Architects

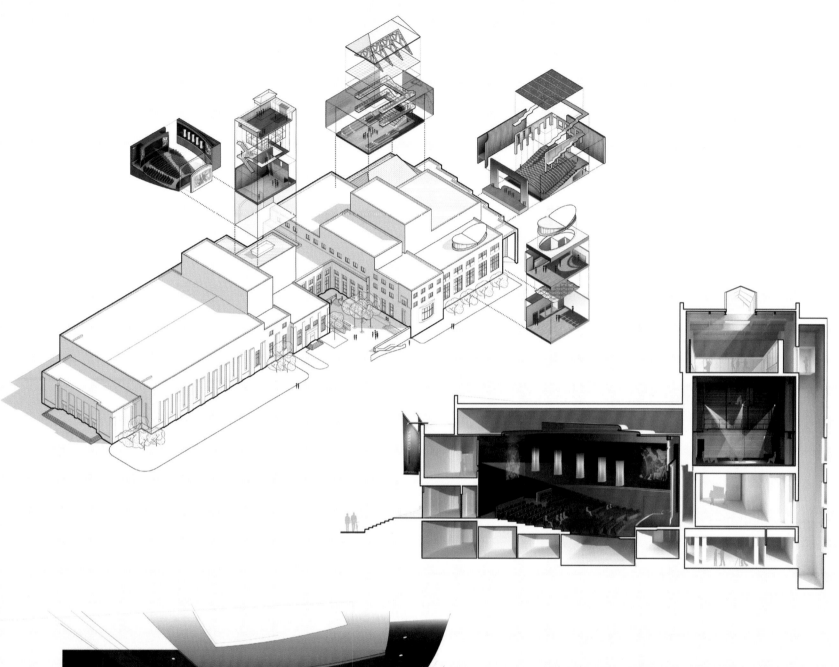

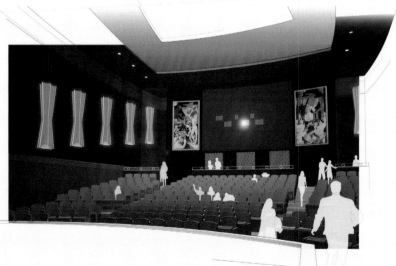

Left, top: Architectural rendering of Indiana University Cinema and three new levels of the Lee Norvelle Theatre and Drama Center spaces utilizing the stage and fly-loft space of the University Theatre in relationship to the existing IU Auditorium and Theatre and Drama buildings. MGA Partners Architects

Right, center: Architectural rendering and cross-section of Indiana University Cinema and the new Lee Norvelle Theatre and Drama Center spaces. MGA Partners Architects

Left, bottom: Architectural rendering of the interior of Indiana University Cinema. MGA Partners Architects

a naturally lit third-level movement studio; classrooms; offices; and spaces for voice work, rehearsal, and scene preparation. In the renovation, roughly everything behind the proscenium would become part of the Lee Norvelle Theatre and Drama Center, while everything in front of the proscenium would be transformed into IU Cinema. This did not come without complications. For example, an entire wall needed to be constructed in the entrance of the auditorium to create a light and sound block from the main lobby while also providing support to double the size of the existing lighting booth into a world-class projection booth.

MGA Partners delivered a design nothing short of breathtaking. Using the information provided, they envisioned an aesthetically stunning and technological benchmark of a motion-picture screening room.

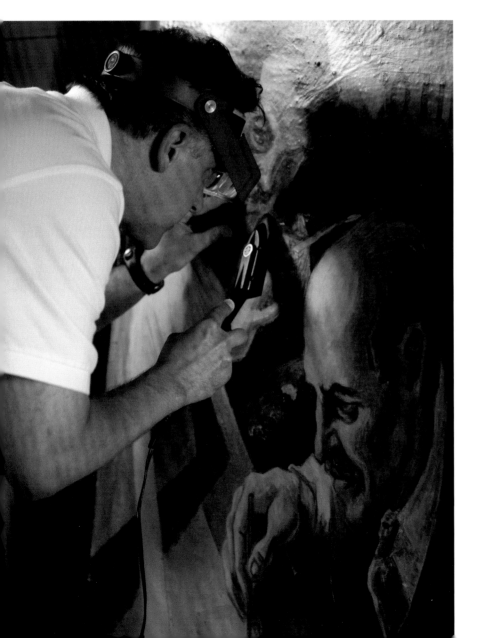

They honored existing architectural elements from the building's original construction, working them into new design features. They intentionally hid the technology in the room—with the grand Austrian drape and custom fixtures hiding the surround sound speakers—so on first entering the space, it feels as though you could be standing in a stage theater from the 1930s. They chose a deep, rich color scheme for the interior, which was informed by prominent colors in the palette of the four Thomas Hart Benton murals that line the walls. They widened the aisles and the seating to create a comfortable viewing experience in memory-foam seats, personally approved by President McRobbie. And they created welcoming, accessible, and well-designed support spaces to accommodate envisioned staff and large audiences.

Regarding technology, the University planned for film exhibition in its past and modern forms to be a part of IU Cinema's programming. Designed into the building were acoustical isolation walls between IU Auditorium and the Theatre and Drama Center to keep unwanted sound from bleeding into and out of each of the adjoining venues. There was also the addition of an orchestra pit (on an electromechanical lift) designed to allow IU Cinema to present silent films with orchestras of up to fifteen musicians. The motion-picture package installed in the auditorium and booth rivaled that of any other public venue in the US. Motion picture technologies included 35mm, 16mm, variable speed for silent-film projection framerates, 2K resolution DCI-compliant DCP projection, 4K resolution video projection, Dolby 7.1 sound, and all the lens and masking capabilities to screen every SMPTE standard aspect ratio. When THX certified the installation, they declared IU Cinema "the best equipped university cinema in the U.S."

In addition to creating a great space for public film exhibitions, the Cinema would open as a well-equipped classroom, and it has hosted film and media classes since opening.

Prior to construction, a climate-controlled room was built in the middle of the auditorium, where seating had been removed. This room became the home of the Benton murals for the entirety of the construction. In the middle of this dust-filled, hard-hat construction area, the Benton murals were given new life, as conservators cleaned and repaired the almost eighty-year-old paintings. Inside this whitewashed room in the middle of the construction site was a reminder of the beauty of the building's past and inspiration for its apparent future.

Left and facing: Thomas Hart Benton murals being cleaned and restored by IU conservators, led by Margaret Contompasis. Sidney and Lois Eskenazi Museum of Art

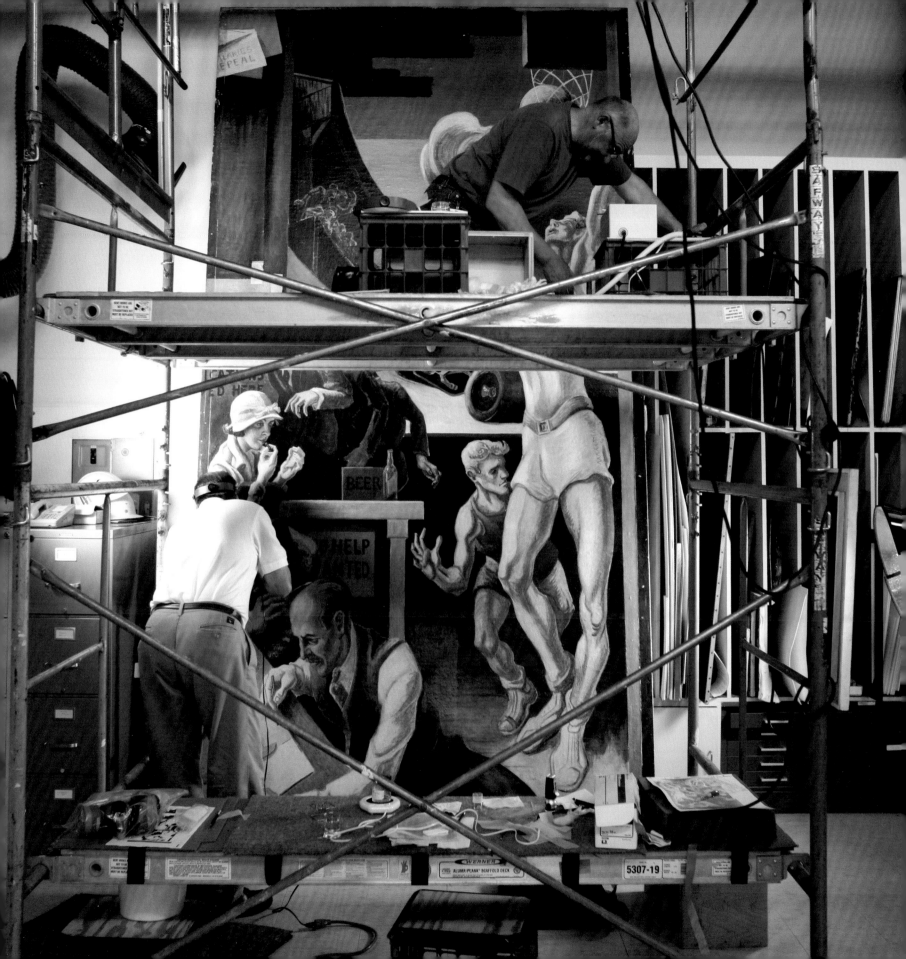

FOUNDING DIRECTOR

With the construction of the building underway, Indiana University needed to find someone to bring the venue to life. The founding IU Cinema director would be responsible for setting the Cinema's mission, planning and administration, programming and education, developing stakeholders and audiences, fundraising and finance, and creating standards and practices.

A search committee was formed—led by Provost Professor Gregory Waller, chair of the Department of Communication and Culture—and filled with faculty and staff stakeholders. In November 2009, four final candidates for the director position each visited the Bloomington campus for a day of interviews. Waller commented in a press release, "The search committee was very pleased with the high quality of the applicant pool, drawn by the unique opportunity this position offers and by the university's extraordinary commitment to film studies and to the experience of cinema. We look forward to introducing the campus community to the four finalists."

Jon Vickers was chosen as the inaugural director of IU Cinema and began his role on March 22, 2010. In the press release announcing the appointment, Provost Hanson stated, "The wealth of operational experience that Jon Vickers brings to this position will help to ensure that this new enterprise thrives. . . . He has very successfully opened and managed two cinemas, one of which is the only THX Certified Cinema in Indiana. He also possesses a strong knowledge of film history and an eagerness to work with all campus units that are interested in engaging with film. I am delighted to welcome him to Bloomington."

In that same release, Vickers returned with, "I look forward to the honor of becoming the first director of the Indiana University Cinema. I am impressed by the commitment to the project and program, from all levels of the university. Restoring the original beauty of the 1930s University Theatre into a state-of-the-art, THX Certified Cinema, along with the creation of this position to build a program, demonstrates that dedication. The enthusiasm for the project is also apparent in every student, faculty, and staff member that I have met. I am equally enthused and can't wait to begin building campus relationships while planning for our inaugural year."

Vickers' path to film exhibition was not direct. He earned a bachelor's degree in civil engineering at Michigan State University and went into his family's manufacturing business, Vickers Engineering,

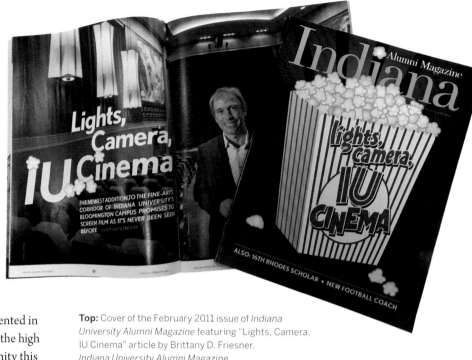

Top: Cover of the February 2011 issue of *Indiana University Alumni Magazine* featuring "Lights, Camera, IU Cinema" article by Brittany D. Friesner. *Indiana University Alumni Magazine*

Facing: Promotional materials for a November 2010 press event to introduce Indiana University Cinema to local, regional, and national press outlets. IU Studios

with his father and brothers in 1987. While that business was fast-growing, Vickers and his wife, Jennifer, purchased the long-closed movie theater in the small Michigan town of Three Oaks in 1993. After renovating the building, they opened a boutique, 126-seat art cinema, the Vickers Theatre. What began as a hobby business on weekends soon became a sustainable venture, open to the public five or six days each week. In addition to Vickers Theatre, the Vickers family was embedded in the local arts community, having started a nonprofit arts organization responsible for developing music festivals, free summer music programming, the building of an all-volunteer community radio station, an opera program, a silent film festival, and more.

In 2002, Vickers left manufacturing and, in 2004, was invited to open the Browning Cinema at the University of Notre Dame—housed within the DeBartolo Performing Arts Center—all while maintaining the small family business of the Vickers Theatre. Vickers continued managing and programming the Browning Cinema while, in 2008, taking on the role of managing director of the Performing Arts Center. It is at Notre Dame where Vickers developed a strong dedication to collaborative programming within the academy.

In a February 2011 article written by IU alumna Brittany D. Friesner—who would be named as IU Cinema's founding associate director two years later—for the *Indiana University Alumni Magazine*, Vickers stated, "The faculty I met upon my first visit to campus were very passionate about this project and passionate about what they do. It seemed like this would be a really wonderful place to collaborate."

When asked why he left Notre Dame, Vickers responded, "People thought we were leaving paradise and the perfect job, but the commitment and enthusiasm at Indiana University to build one of the best screening rooms in the country was nearly irresistible."

MISSION AND VISION

The majority of 2010 was devoted to building relationships, infrastructure, staffing, and programs in parallel with the construction of the venue and support spaces. A key element and guiding set of principles to all this would be the Cinema's mission statement, which focused intently on world-class standards of cinema exhibition and curation, advancing the University's commitment to the arts, and a dedication to collaboration across the academy.

The mission helped guide IU Cinema's 2010 programming and collaboration guidelines, marketing and communications plan, development plan, peer benchmarks, metrics, and guest services philosophy. All this was developed while the venue was becoming what MGA Partners had rendered almost two years prior.

The mission defined what IU Cinema would strive to become.

> "Indiana University Cinema is a world-class venue and curatorial program dedicated to the highest standards of presentation of film in both traditional and modern forms. By providing unique and enriching cinematic experiences, the Cinema advances Indiana University's long-standing commitment to excellence, scholarship, and engagement in the arts across campus and community."
>
> —IU Cinema mission statement

PREPARING TO UNVEIL

One component of IU Cinema's marketing plan was to engage press and industry stakeholders in a preopening press launch event, boldly introducing the campus and community to the venue, leadership, program, and promise of what was to come. The event would include a university premiere of Sony's new 4K restoration of the 1957 David Lean film *The Bridge on the River Kwai*, with Grover Crisp, executive vice president of asset management, film restoration, and digital mastering for Sony Pictures, in attendance.

The festive event included guided tours of the Cinema, a reception, and speaking programs, and was attended by regional and national press as well as campus and community stakeholders.

Event materials noted, "The majestic building that once housed the University Theatre will re-open in January 2011 as the new Indiana University Cinema, a world-class space for the scholarly study of film and the highest standards of exhibition of film in its traditional and modern forms."

02

UNVEILING
A NEW
MODEL

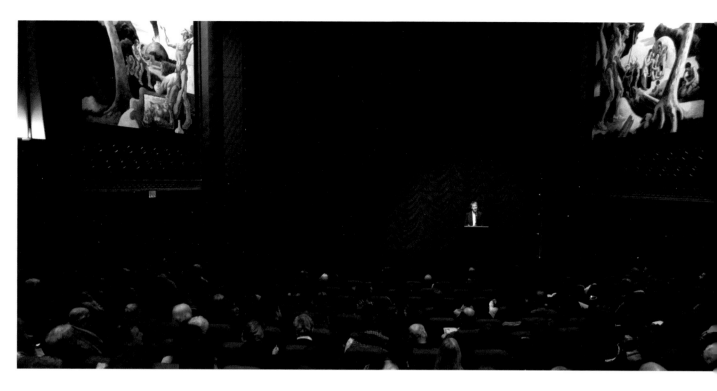

U Cinema opened its doors to a public audience for the first time on January 13, 2011, with a screening of David Lean's epic masterpiece *Lawrence of Arabia* (1962), part of a series called the Lean Years, which featured several of his films. In addition to this series, IU Cinema welcomed multiple Academy Award–winning production designer Terrence Marsh, who collaborated with Lean on several films. The Cinema's opening season program was introduced with unique series, events, and visiting filmmakers in addition to Marsh, including Stanley Nelson, Albert Maysles, Jill Godmilow, Kenneth Anger, and Paul Schrader.

The night was the inaugural opportunity for IU Cinema to embrace its audience. From the podium, Jon Vickers addressed the sold-out crowd:

> Welcome to the Indiana University Cinema. It feels really good to say those words. Before we begin, it is important to acknowledge the foresight and determination of the University administration for making this project a reality. Not only President McRobbie for making the bold commitment in July 2007 that film, as an artform, needed a home on this campus, but also Provost Hanson for providing her leadership and academic vision for the program, and all of the others involved in making it happen—from fundraising to project management. It was a masterful plan to turn the beautiful but unused University Theatre into new rehearsal, technical, performance, and classroom spaces for the Department of Theatre and Drama and our state-of-the-art IU Cinema.
>
> It would be reckless to try to list all of those responsible for the opening of the Indiana University Cinema, as there would surely be someone of significant importance left out. This opening is a culmination of many people's contributions of time,

financial gifts, hard work, intellectual and creative thought, and volunteer hours. Everyone involved shared a common vision.

I would, however, like to recognize a few of our major financial contributors, including Jane and Jay Jorgensen, who have funded the Jorgensen Guest Filmmaker Lecture Series and the Cinema's lobby. We also have David R. Franklin, John and Amy Applegate, Steve and Alicia Trawick, Bruce and Robin Miller, and Wachovia Wells Fargo. We appreciate their leadership support.

I would also like to thank IU Cinema staff members Matthew Kerchner and Manny Knowles, who have worked tirelessly in getting ready for today, as well as one volunteer who devoted hundreds of hours of his time, Andy Hunsucker.

In our strategies to become the top arthouse, or cinematheque, in the Midwest, we will be screening the best in new and classic international film; a very robust repertory program featuring new restorations; silent film with piano, organ, and orchestral accompaniment; documentary and experimental film; and even curated programs of service and educational films from IU's own vast collections.

We will introduce new, repeating series like CINEkids, showcasing international films for children and families; Made in Indiana, featuring commercial and noncommercial films made here; From the Archives Series, pulling from IU's seventy thousand items in their film holdings; and other unique and exciting series. We will also bring dozens of filmmakers to campus each year to introduce and speak about their work as well as offer lectures and class visits.

In addition to all of this is our academic programming. IU Cinema is dedicating up to 40 percent of its program to be curated in partnership with academic units across campus. You can see many examples of this programming in our spring lineup, which includes the screenings of *Metropolis* with a Jacobs School of Music orchestra, the Kenneth Anger visit in partnership with the Kinsey Institute, and many others.

The Cinema boasts the best in 16mm and 35mm film projection equipment (the Kinoton FP38Es) with variable speed control and running reel-to-reel with changeover. This, along with our booth practices, gives us access to film

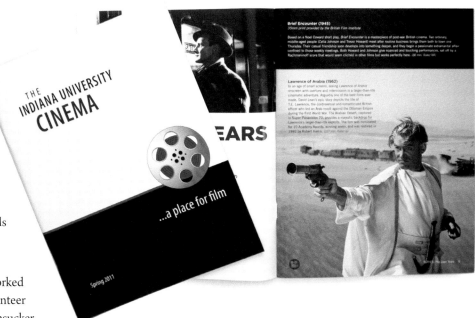

Cover and pages from IU Cinema's first printed program book featuring a David Lean series, including the opening night film, *Lawrence of Arabia*, spring 2011. IU Studios

prints from any archive in the world. This spring, you can see film prints from the Deutsches Film Institut, the British Film Institute, Library of Congress, UCLA, and others. Our Barco 2K projector and Sony 4K projector provide access to digital presentations of any format, including 3D. Because of these capabilities, we should have access to the best formats available for almost any film in circulation.

Lastly, IU Cinema will not reach its goals if we are not clearly focused on the exhibition part of our mission. Meeting the highest standards of exhibition requires attention to the details. We want to change your moviegoing expectations. We want you to expect nothing but the best from us—the best film prints, the best projection, the best service, and the best architectural setting. It is our commitment to get to know you as patrons and make your experience personal. We plan to be part of creating your favorite filmgoing experiences.

Tonight's presentation [of *Lawrence of Arabia*] will include the overture and a brief intermission, as was intended upon its release. We hope you enjoy your first IU Cinema experience. We thank you again for being with us!

Now, on to Aqaba!

FORMAL DEDICATION

IU Cinema was formally dedicated on January 27, 2011, during a robed ceremony with all the pomp, circumstance, and weight these types of formal events carry. In addition to the reception and dinner, the significant difference from the opening night event was the presence of a short film titled *Precious Images* and the conferring of an honorary degree—doctorate of humane letters—for filmmaker Peter Bogdanovich.

Bogdanovich first visited Indiana University as a guest of Union Board Films in 1976 and had returned several times since. The papers of two of his close mentors, Orson Welles and John Ford, are housed in the Lilly Library's collections, so it came as no surprise his papers and ephemera would become part of the library's growing filmmaker collections as well. In 1994, more than one hundred thousand of his personal items became the Bogdanovich MSS, 1885–1994 collection, consisting of the papers, scripts, correspondence, business records, production materials, and films of the director, actor, screenwriter, producer, critic, and author. It was thus fitting that Bogdanovich would be honored at the opening of IU Cinema, becoming the first filmmaker to receive Indiana University's highest honor, an honorary doctorate degree.

Filmmaker Chuck Workman won an Oscar in 1986 for his short live-action film *Precious Images*. Vickers asked Workman if the Cinema could screen the film during the formal dedication ceremony, stating, "There is no better love letter to the artform than Workman's film." Workman agreed and secured permission from the Directors Guild of America, which originally commissioned the film.

The evening was filled with good cheer and speeches, including President McRobbie delivering his remarks titled "Building on a Glorious IU Tradition: Breaking New Ground in the Arts and Humanities," emphasizing how essential excellent facilities are to the arts and humanities: "They are for the humanist and the artist the equivalent of the laboratories or the supercomputers of the life scientist or the computer scientist. What we have lacked is a facility dedicated to cinema. This project will change all that."

> ## "I don't know if I have ever seen my film [*The Last Picture Show*] look this good."
> —Peter Bogdanovich, director of *Targets* and *Paper Moon*

Top: Peter Bogdanovich at a reception in IU Auditorium following IU Cinema's formal dedication on January 27, 2011. Aaron Bernstein/IU Studios

Bottom: IU alumna Jane Jorgensen and IU Foundation President Curt Simic at a reception in IU Auditorium following IU Cinema's formal dedication on January 27, 2011. Aaron Bernstein/IU Studios

President McRobbie's speech was filled with quotes from master filmmakers, including Ingmar Bergman, who said, "Film is a language that literally is spoken from soul to soul in expressions that, almost sensuously, escape the restrictive control of the intellect."

The president also thanked supporters of the project, stating,

> Specialized facilities like this often require champions, who dedicate countless hours as advocates for various aspects of the project. I would like to recognize a number of this project's strongest advocates.
>
> Doug Booher, Jonathan Michaelsen, and James Naremore each helped lead the planning committee for this project and brought together the interests of the Auditorium, Theatre and Drama, and the Cinema, respectively. Jim Naremore, one of the world's leading film scholars, deserves special recognition since he actually retired in 2004. I would also like to recognize Terry Clapacs and Tom Morrison, whose service overseeing the construction of IU facilities has seen the start and finish of this project.
>
> Finally, I would be remiss if I failed to mention the unceasing hard work and careful attention that Kelly Kish from my office has dedicated to every stage of this project.

Provost Karen Hanson delivered her own speech that evening, entitled "Stage and Screen: The Future of Theatre and Film Studies at Indiana University." "Since its opening in 1941, the original Theatre and Drama building has drawn many distinguished visitors from the world of cinema," she observed. "Film legends who have come to perform or lecture in the adjacent IU Auditorium have eagerly shared their expertise with IU theater students. Hal Holbrook, who often brought his one-man show *Mark Twain Tonight!* to the Auditorium, had a wonderful rapport with Indiana students and loved talking with them, as did the late screen legend Vincent Price, another frequent visitor to campus."

In a 1984 interview with Keith Michael, the chair of the Department of Theatre and Drama, Price praised Indiana University's strengths in the arts, stating, "Indiana has a head start. . . . Its fame is incredible. . . . Its opera school is . . . the best in America. Its art museum [has] enormous collections. Its library is one of the best in the country. Its art school and drama program are great strengths."

Provost Hanson ended her remarks with, "These renovations also add the Indiana University Cinema to Vincent Price's list of great artistic strengths on this campus."

Top: IU Cinema promotional materials with the slogan "A place for film." Jon Vickers

Bottom: Notice of registration for Indiana University's trademark of the slogan "A place for film" for exclusive use by IU Cinema, July 2011. United States Patent and Trademark Office

Facing: IU Cinema's formal dedication at which President Michael A. McRobbie conferred filmmaker Peter Bogdanovich with an honorary doctorate degree, January 27, 2011. Aaron Bernstein/IU Studios

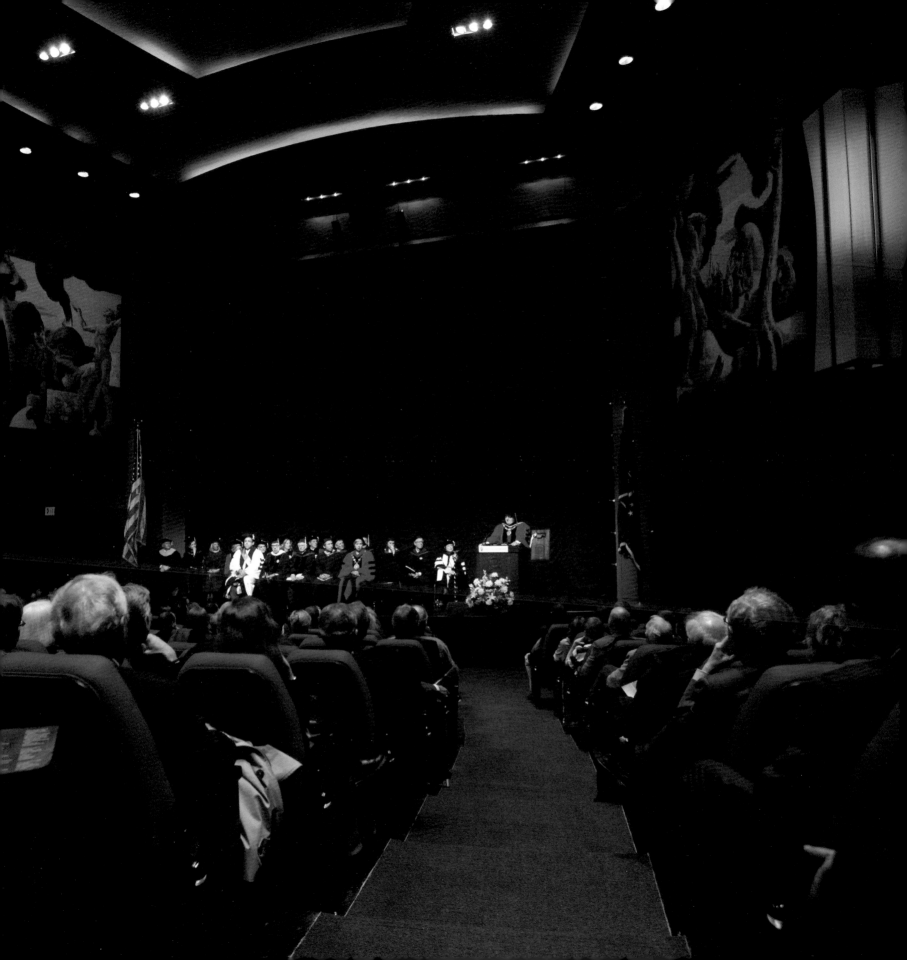

PUTTING THE MAGIC
OF CINEMA IN MOTION

Indiana University did indeed build a wonderful temple for the exhibition of film with great capabilities carefully designed into the seventy-year-old venue. With the founding of IU Cinema, the University added an invaluable venue to the arts and humanities tapestry of the Bloomington campus and community, along with the Cinema's small team, which was charged with bringing the program to life and setting it on a sustainable path to its future.

The charge from President McRobbie included

- becoming Bloomington's dedicated arthouse cinema;
- supporting the film work of students and alumni;
- being accessible in venue, programs, and pricing;
- connecting with and being relevant to the academy;
- developing infrastructure to become sustainable; and
- building a reputation for film and media at IU as one of the best programs in the US.

Much of this chapter and book will be dedicated to the programming in the Cinema's first decade. To support the programming of any public arts or humanities program, the organization needs well-defined systems; dedicated and impassioned staff; long- and short-term

> "If the ancient Greeks had invented cinema, they'd have a temple like this."
> —Peter Weir, director of *Dead Poets Society* and *The Truman Show*

funding streams; vision and talent to create and promote a brand; and strategic plans to harness, steer, and steward these resources to meet the institution's goals.

IU Cinema opened with three full-time staff members: a director, a technical manager, and an administrative coordinator. The team was expanded by utilizing graduate-student assistant projectionists, undergraduate part-time hourly house managers, student and community volunteers, and occasional interns.

Before the end of the first decade, IU Cinema expanded to seven full-time staff: director, associate director, technical director, business manager, events and operations director, design and marketing manager, and technical coordinator. In addition to student staff and community volunteers, IU Cinema has a robust array of formal internships as well as graduate assistantships supported through work-study, providing valuable experience in working closely with professionals and leadership at a nationally recognized public arts organization.

IU CINEMA COMMITMENTS

Throughout 2017 and 2018, IU Cinema devoted a significant amount of staff time to advance its 2020 Strategic Plan, refine its mission, develop its long-term vision, and commit to best practices of working together as an engaged, dynamic staff. Part of this process was the development of its internal and external commitments, which are employed as guiding principles and regularly reevaluated and adapted with input from all staff:

1. Our purpose is to provide world-class service to everyone who engages with us.

2. We will create unique and amazing cinematic experiences accessible for all.

3. We will assume good intent, communicate, and listen honestly, openly, directly, and with transparency.

4. We will respect our time, resources, and work/life balance.

5. We will ask for what we need in a timely and respectful manner.

6. We will be collaborative, inclusive, and flexible with all Cinema stakeholders, respecting defined boundaries.

7. Through trust, we will demonstrate and cultivate honesty, awareness, reliability, compassion, and support.

8. We will take ownership of our defined expectations and authority.

9. We will proactively share good ideas and be open to opportunities to improve.

10. We will recognize and celebrate good and have fun.

Looking beyond IU Cinema's first decade, additional staffing will be essential as the organization continues to develop and support the needs of the University and the community as well as fulfill its own goals. This will require funding outside of the University's generous academic allocation, which supports current staffing and a portion of operating costs.

In addition to serving as a public-facing arts organization, IU Cinema is also a nondegree-granting independent academic unit. The Cinema reports directly to the Office of the Provost and Executive Vice President, allowing it to serve academic units across the entire University and not be beholden to a single school. In return for its annual budget allocation from the academy, IU Cinema remains academically relevant by hosting classes, distinguished faculty and guest lectures, master classes, and other functions. It also dedicates a significant percentage of its program to collaborative programming, considering itself one of the most collaborative units at Indiana University—a model for the Bloomington campus. The balance of the Cinema's budget is a combination of earned income in the form of ticket sales, partnership support, grant funding, annual giving, and endowment drawn from generously supported endowed programs.

IU Cinema's first program endowment was the Jorgensen Guest Filmmaker Series Fund, created from gifts from the Ove W Jorgensen Foundation, specifically Jane and Jay Jorgensen. The endowment

Top: Recognition signage in IU Cinema's lobby acknowledging donors and additional individuals who have supported IU Cinema since its inception. Jon Vickers

Bottom: The Honorable P. A. Mack Jr., a former Indiana University trustee and dedicated supporter of Indiana University, who endowed the Jon Vickers Film Scoring Award for IU Cinema. Eric Rudd/IU Studios

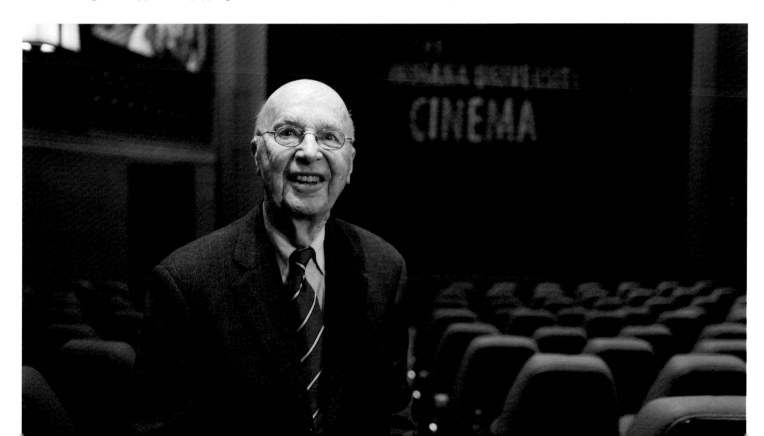

was established in 2010 and has supported visiting filmmakers every semester since the Cinema opened. This leadership gift helped inspire additional programming and general funds and endowments in the Cinema's first decade, many of which had their impact doubled by matching funds made available during the multiyear For All: The Indiana University Bicentennial Campaign. The program funds and endowments established in the Cinema's first ten years were as follows:

- John S. and Amy G. Applegate IU Cinema Fund, John S. and Amy G. Applegate
- Art and a Movie Film Series, Harold A. Dumes and Marsha R. Bradford
- CINEkids International Children's Film Series, Gregory Waller and Brenda R. Weber
- Filmmaker to Filmmaker Program Fund, S. James Sherman and Roberta T. Sherman
- Tina M. Jernigan IU Cinema Fund, Tina M. Jernigan
- Tina M. Jernigan IU Cinema Student Scholarship, Tina M. Jernigan
- Jorgensen Guest Filmmaker Series, Ove W Jorgensen Foundation, Jane M. and Jay O. Jorgensen
- Michael A. McRobbie President's Choice Film Series, multiple donors
- Kaili and Ed Myerson Cinema Equipment Fund, Kaili Peng

- Dr. Gregg A. Richardson International Arthouse Series Fund, Gregg A. Richardson
- Dr. Gregg A. Richardson Travel Scholarship for Film and Media Students, Gregg A. Richardson
- Paula W. Sunderman International Film Fund, Paula W. Sunderman
- Michael W. Trosset Archival Print and Restoration Exhibition Fund, Michael W. Trosset
- Grafton Trout Programming Fund, Laura C. Trout
- Jon Vickers Film Scoring Award, P. A. Mack Jr.
- Jon Vickers IU Cinema Director's Discretionary Fund, John F. and Kathleen J. Fiederlein
- Jon Vickers Pics Fund, Darlene J. Sadlier and James O. Naremore

IU Cinema continues to pursue principal gifts to fulfill its funding goals and strategic plan for the next several decades. Throughout its first decade, IU Cinema and its programming have received support from local, regional, and national grant-funding entities, including the National Endowment for the Arts; Academy of Motion Picture Arts and Sciences; Cultural Services of the French Embassy; the Andrew W. Mellon Foundation; and Science on Screen, a national grant initiative funded by the Alfred P. Sloan Foundation and administered by the Coolidge Corner Theatre. The Cinema has also received internal research funding from the University in support of several initiatives.

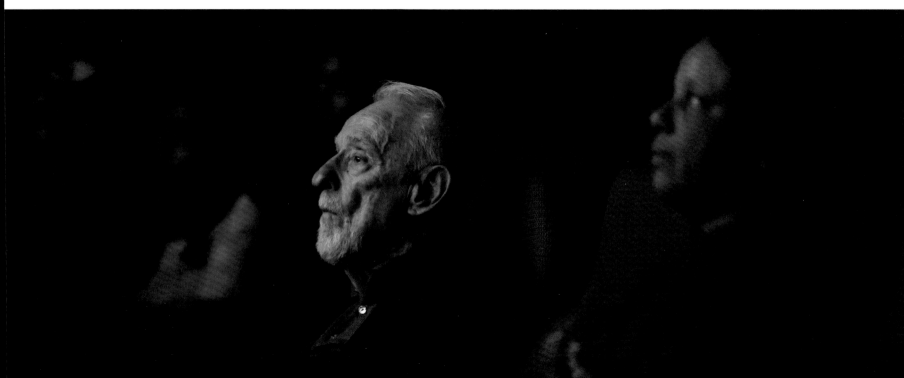

Finally, no organization can consider itself sustainable without proven, documented, and trained systems in place to ensure consistency and reliability in its programming, technical and logistical operations, communications, maintenance, service, and stewardship. Because the Cinema is a young organization, assessment and a commitment by staff toward continuous improvement have been key to its success.

ENGAGING STUDENTS

Indiana University students play an integral role in several areas of IU Cinema's operations, including event management, projection, communications, marketing, and programming. Undergraduate and graduate students across the Bloomington campus are regularly offered opportunities to curate film series, screen original films, publish film-criticism essays, volunteer in cinema operations, introduce films, interact with and have work critiqued by filmmakers, and be employed as projectionists and house managers.

Each academic year, IU Cinema provides part-time employment, graduate assistantships, practicum and research projects, internships, and volunteer opportunities to an average of fifty undergraduate and graduate students. IU Cinema also maintains one seat on its Program Advisory Board for an undergraduate student representative. All students working at IU Cinema receive world-class training and acquire professional experience, which serve them well when they leave the University. Many of these students have stated how important their time at IU Cinema was to their overall college experience and education.

"IU Cinema is more than just a place for film. It is a place for friends; a place for learning; a place for exposure to new cultures, new people, and new ideas. It's a place for art, a place for music, a place where you can have your beliefs challenged in ninety minutes. It is a place for community, both local and global. The IU Cinema is a place unlike any other . . . and my favorite place in Bloomington."

—Olivia Seyerle, IU Cinema volunteer and house manager and IU alumna

Facing: Audience members during an IU Cinema screening, including the late Grafton D. Trout, in whose honor Laura C. Trout endowed a programming fund. James Brosher/IU Studios

Top: IU students participate in a Q&A with Bollywood actor Anil Kapoor following a screening of *Mr. India* (1987) at IU Cinema, October 7, 2014. Eric Rudd/IU Studios

Next page: IU students gather outside IU Cinema before a screening of *Breaking Away* in September 2015. Chaz Mottinger/IU Studios

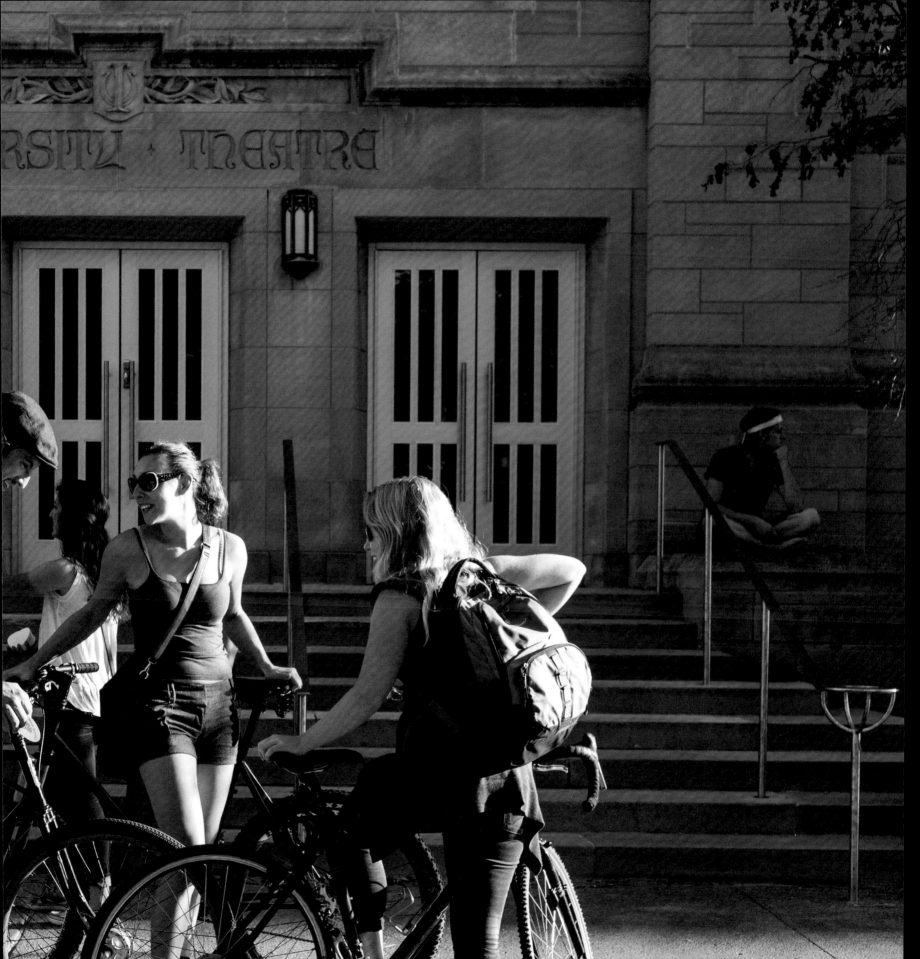

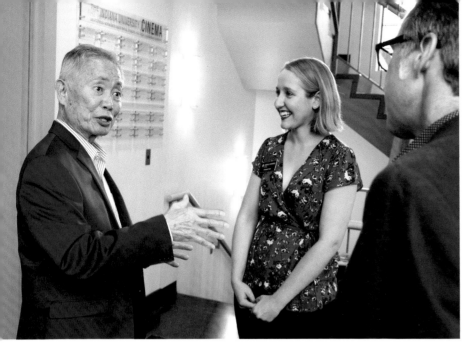

Projectionists

As projectionists, graduate students gain rare experience operating some of the world's finest projection equipment and handling a variety of film and video formats, including archival 35mm and 16mm films from moving-image archives across the globe. Projectionists are trained by the Cinema's full-time technical staff to prepare and operate cinema systems for more than 250 public screenings and lectures each year, including inspection and reel-to-reel changeover projection of 35mm and 16mm film, preparation and processing of digital cinema programs, and setup and operation of the Cinema's teaching lectern for cinema and media studies courses taught on site.

Students from across all disciplines are eligible to apply and become trained as projectionists, with those pursuing academic studies in film history, theory, criticism, and production comprising the majority of applicants. Projectionist opportunities are available to IU graduate students as ten-month student academic appointments and hourly part-time employment. Attention to detail, ability to work well under pressure, and willingness to learn are the foremost requirements for success as an IU Cinema projectionist.

House Managers

House managers serve an essential role as the public face of IU Cinema and are trained by the Cinema's full-time events management and guest services staff to manage logistics for all public events. IU Cinema depends on its house managers—mostly undergraduate students— to be courteous and helpful to each and every patron who walks through IU Cinema's doors while also possessing a deep knowledge about the organization's history, operations, and programs.

Through coordinating pre-event preparations with projectionists, greeting and attending to the needs of patrons, providing visitor tours,

Top: Actor and activist George Takei speaks with IU Cinema Lead House Manager Elizabeth Roell and Founding Director Jon Vickers in the Cinema's lobby prior to a screening of *To Be Takei* (2014), September 19, 2007. James Brosher/IU Studios

Bottom: Volunteer ushers welcome patrons to IU Cinema's *Star Wars* trilogy screening marathon, August 24, 2019. Chaz Mottinger/IU Studios

Facing, top: Filmmaker Andrew Ahn poses with IU Cinema student staff Jacob Weisenfluh and Robert Iannuzzo and volunteer usher Jessica Chipley after a screening of *Spa Night* (2016) at IU Cinema, April 3, 2017. Chris Meyer/IU Studios

Facing, bottom: IU Cinema house manager and volunteer training manuals. Kyle Calvert

> "My real education was at the Cinema—in the auditorium watching movies, in master classes with visiting filmmakers, in the lobby talking with patrons, and having the opportunity to learn from staff what it truly means to be a professional."
>
> —Chelsea Connors, IU Cinema house manager and IU alumna

introducing films, and supervising volunteer ushers, IU Cinema house managers act as a bridge between the community and the University, helping the arts thrive on the Bloomington campus and beyond. House-management positions are open to undergraduate and graduate students as well as recent graduates, with the most successful candidates demonstrating excellent communication skills, agency and independence in problem solving, and a strong commitment to providing world-class customer service.

Volunteers

IU Cinema's Volunteer Ambassadors program offers undergraduate and graduate students, along with community members, the opportunity to contribute to Cinema operations through the Usher Corps and the Promotional Team. Usher Corps members regularly greet patrons with a smile and answer questions; they possess a depth of knowledge and passion for IU Cinema. Promotional Team volunteers help spread the word about IU Cinema programs by distributing promotional posters and representing the Cinema at outreach events, including the IU Student Involvement Fair, Bloomington PRIDE's Pridefest, IU Arts and Humanities Granfalloon, and the Bloomington Volunteer Network's Community Volunteer Fair.

Volunteer ambassadors come from across the Bloomington campus and community, with the majority being IU undergraduate students. In academic year 2018–19, fifty-five IU Cinema volunteer ambassadors donated 1,927 volunteer hours valued at a rate of $24.69 per hour for an approximate in-kind contribution of $47,578 (calculated based on figures at www.independentsector.org).

"One of my biggest joys these last few years is talking to younger students who come up to me after a screening and ask if they can volunteer and how they can be a part of this all, and then seeing them a few weeks later as an usher at their very first shift. Once strangers or sometimes acquaintances before, the Cinema and a combined love of film ties all of us ushers and volunteers together."

—Noni Ford, IU Cinema volunteer usher and IU alumna

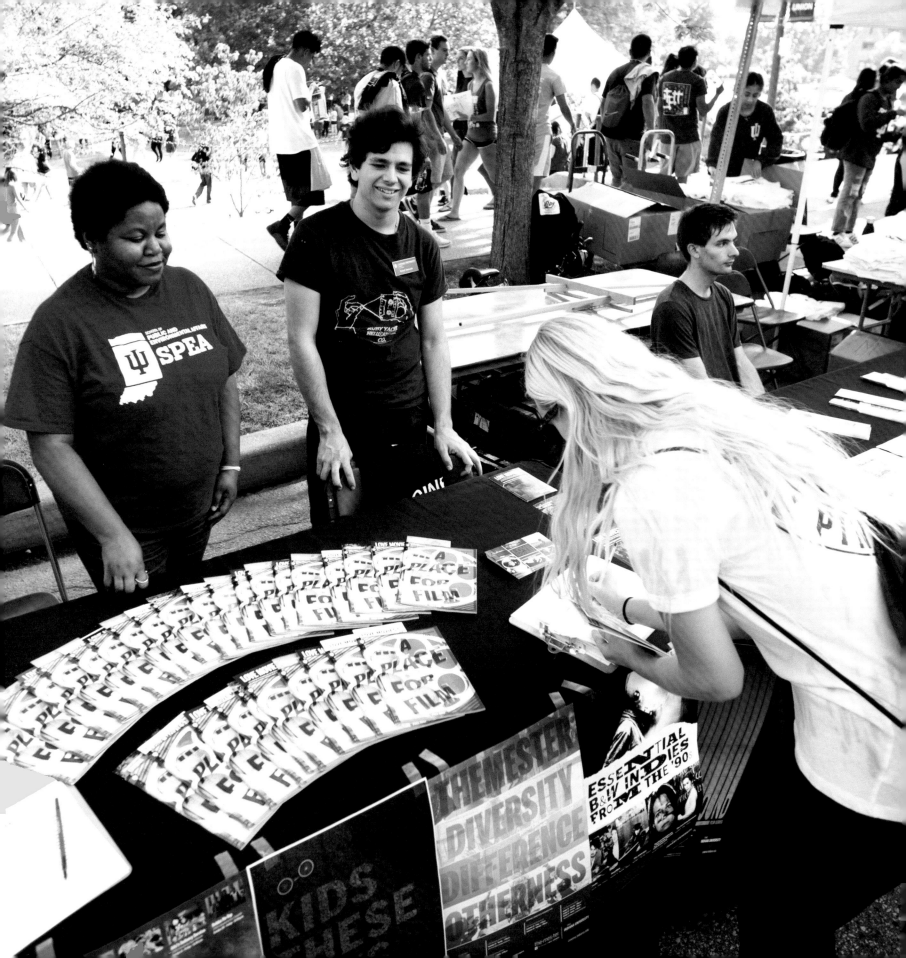

Programming and Guest Hosting

IU Cinema also provides students opportunities to curate film series and programs, including the long-standing City Lights Film Series and Underground Film Series, programmed each semester by graduate students. Both of these series predate IU Cinema and were previously limited to 16mm and DVD presentations in classrooms. The Cinema has embraced these programs and the revolving committee of student programmers, screening these curated series using the best film print materials available. Students have also curated various film festivals presented in IU Cinema, such as the semiregular Iris Film Festival and the Crimson Film Festival.

In the Cinema's first decade, students have been able to lead onstage conversations and present the work of dozens of filmmakers, including Roger Corman, Josephine Decker, Kenneth Anger, and Joshua Oppenheimer. Many visiting filmmakers led master classes with undergraduate and graduate students, providing feedback on students' work while also offering advice on their own creative processes; Meryl Streep led the first master class of her career when she visited. Other notable and engaging classes have been led by Julie Dash, Robert Greene, Frederick Wiseman, Deborah Riley Draper, David Holbrooke, Numa Perrier, Popo Fan, Nia DaCosta, Kevin Kline, Ash Mayfair, and Kogonada. Students are also regularly invited to participate in informal lunch discussions and formal receptions with visiting filmmakers. In addition, each academic year, one undergraduate student is appointed by IU Cinema to sit on its Program Advisory Board.

"[IU Cinema] is an incredible resource. The fact that students have such access to both amazing films and filmmakers is something I envy."

—Eliza Hittman, IU alumna and director of *Never Rarely Sometimes Always* and *It Felt Like Love*

Facing: IU Cinema student staff Phillisha Wathen and Robert Iannuzzo engage with students at the IU Student Involvement Fair, August 28, 2017. Chaz Mottinger/IU Studios

Bottom: IU student Jesse Pasternack participates in a master class with visiting filmmaker Kogonada and Founding Director Jon Vickers, September 15, 2017. Chris Meyer/IU Studios

Student Work

Student creative work is regularly showcased through film festivals and special programming at IU Cinema. One of the flagship live-music programs established in the Cinema's first year of operation is Double Exposure, which pairs music composition students from the Jacobs School of Music (JSoM) with film-production students in the Media School to collaboratively produce an original short film with accompanying score and sound mix. Completed projects are premiered each spring at IU Cinema with a live orchestra, conductor, and sound engineer to a sold-out crowd.

First piloted in 2012, the Jon Vickers Film Scoring Award is an annual award endowed in 2015 by former IU trustee the Honorable P. A. Mack Jr. Through a juried competition, a commission is awarded each year to a student from the JSoM Composition Department. The students who receive the award write an original orchestral film score for a silent-era feature film selected by IU Cinema programmers. Composers are given more than a year to complete their scores with an instrumentation supported by twelve to fifteen student musicians. The cycle completes itself with the world-premiere presentation of

"In the film industry, perhaps more so than most industries, the disparity between learning in a classroom and doing actual work in the real world is vast. Having the opportunity to work on *Dr. Jekyll and Mr. Hyde*—a genuine project with real deadlines and people who are counting on you—has brought that real-world experience a lot closer to home. I had never experienced this as a composer, and acclimating myself to a genuinely collaborative environment has been deeply valuable to me."

—Ryn Jorgensen, 2020 Jon Vickers Film Scoring Award recipient and IU alumni

Left: Documentarian Frederick Wiseman leads a master class with IU students at the Media School as part of IU Cinema's Filmmaker to Filmmaker program, April 2017. Jon Vickers

Right: Student-film showcase programs. Kyle Calvert

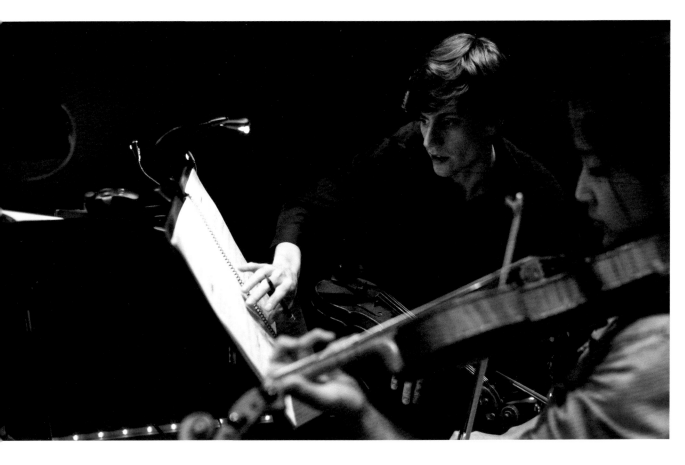

the new score at IU Cinema, with live orchestra accompaniment. These truly student-centric events include IU students in the roles of composer, conductor, musicians, audio technicians, projectionist, house managers, and ushers. The student composers walk away with a portfolio piece that includes hundreds of pages of original music they were paid to write, a live recording of the score, and the experience of a world-premiere performance.

Motivated in part by IU Cinema's dedication to showcasing student creative work through film scoring, in 2017 JSoM created a new minor in film scoring through its Music Scoring for Visual Media program. Emmy-winning composer Larry Groupé was hired to inaugurate the program, teaching composing-to-picture courses concentrated on analyzing story arc and character with intentional musical choices implemented to serve the narrative. In January 2019, JSoM announced that the program, housed in the school's Composition Department, would grow to include a master's degree, two certificate degrees, and undergraduate and doctoral minors. Several additional courses were added to support the program in the areas of synthestration, screen orchestration, and licensing.

Mentorship

As a nondegree-granting academic unit, IU Cinema provides mentorship to students across the IU Bloomington campus through the aforementioned opportunities as well as through various internships, graduate assistantships, and practicum projects created in collaboration with academic units and individual students. The most formal of these opportunities are offered through the Cinema's partnership with the Paul H. O'Neill School of Public and Environmental Affairs, which involves placement of two Service Corps Fellows from the school's arts administration graduate program. Graduate students are employed part-time throughout each academic year and gain experience in event management, marketing, programming, and development.

During the Cinema's first decade, IU Cinema staff have worked with students from across the University to develop individualized internships and practicums in various operational areas, including data management, filmmaker-interview transcription, video editing, and event photography.

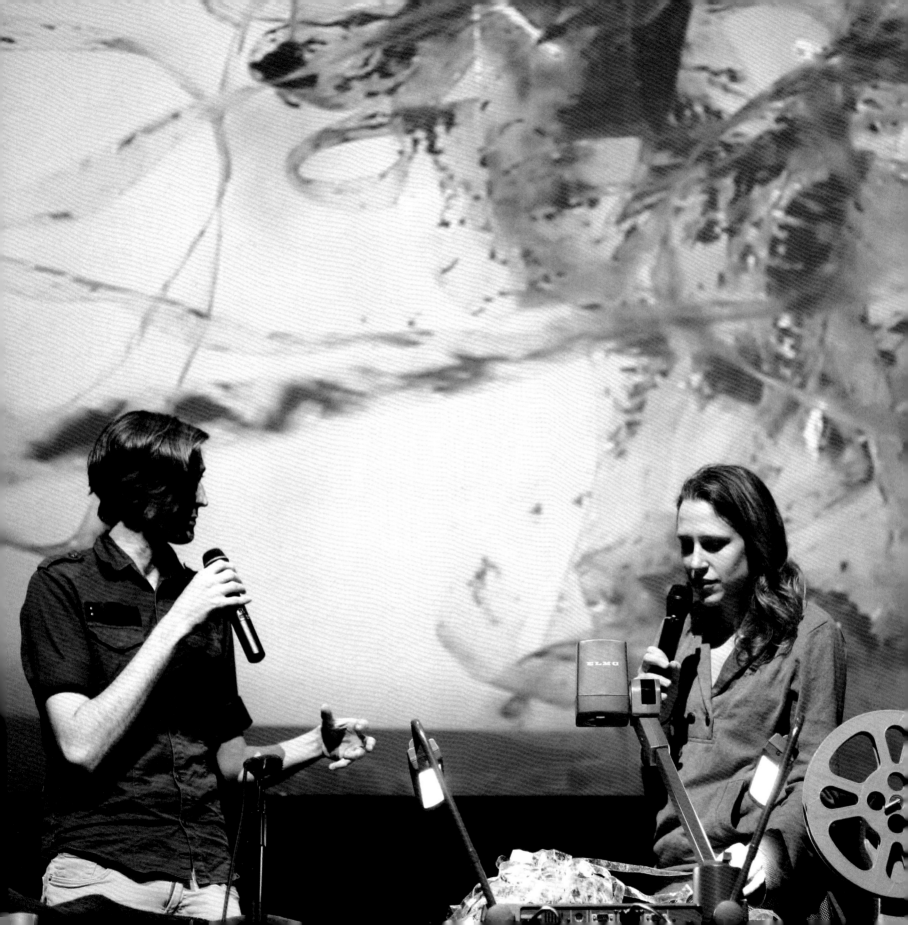

AUDIENCE EXPERIENCE

"Light passes through the celluloid, the glass, the air, then collides with the screen. . . . Memories are forged." This is a line from a short poem Jon Vickers wrote while sitting in the projection booth of the Vickers Theatre in 1998, gazing over the top of an audience watching Martin Scorsese's biopic on the Dalai Lama, *Kundun* (1997).

Memories of moviegoing experiences can last a lifetime. We all have them. It is highly unlikely that the experience of watching any movie on a smart device, your computer, or even the grandest of home-theater screens will be one of those lifelong memories. IU Cinema opened with the philosophy that memorable filmgoing experiences can be curated and often rely on several elements beyond a good film: the people with whom you interact; the comfort, cleanliness, and even uniqueness of the space or setting; and the quality of the presentation. Movies can transfix and transform an audience along with the individuals therein.

A world-class moviegoing experience begins before audience members arrive at the venue. Along with a carefully curated program, the promotional materials audience members see are equally curated and thoughtfully branded to reflect the nature of the event and ethos

"I can confidently say that the Cinema was the highlight in my college career. It changed my life as a student and as a person, filling me with interest in and knowledge of films and filmmakers of whom I'd never even heard."

—Hannah Garvey, IU Cinema house manager and IU alumna

of an IU Cinema experience. Materials include beautifully produced and printed program booklets, which are both striking and useful; custom-designed posters for curated series; print and screen advertisements; social media content; and IU Cinema's award-winning website, launched in 2011 and redesigned in 2018. These materials reflect the intention and curation behind the Cinema's program as well as the quality and consistency of thoughtful brand development.

IU Cinema's printed program booklets serve additional functions beyond developing the campus and community audiences. Program booklets are distributed by Cinema staff at film festivals and conferences as an introduction of IU Cinema to industry peers, scholars, archivists, and filmmakers. These booklets have proven

Facing: Filmmaker and IU graduate student Russell Schaeffer collaborates with director Josephine Decker on an experimental film project, "The Unburied Experience: Visceral Filmmaking," as part of a Jorgensen Guest Filmmaker event, October 3, 2014. Eric Rudd/IU Studios

Right: Audience members watch student films during the annual Double Exposure live-music event, March 6, 2016. James Brosher/IU Studioss

Next page: IU Cinema graduate-student projectionist Payton Frawley introduces Hayao Miyazaki's *Howl's Moving Castle* to a sold-out audience at IU Cinema during Welcome Week, August 22, 2019. Alex Kumar/IU Studios

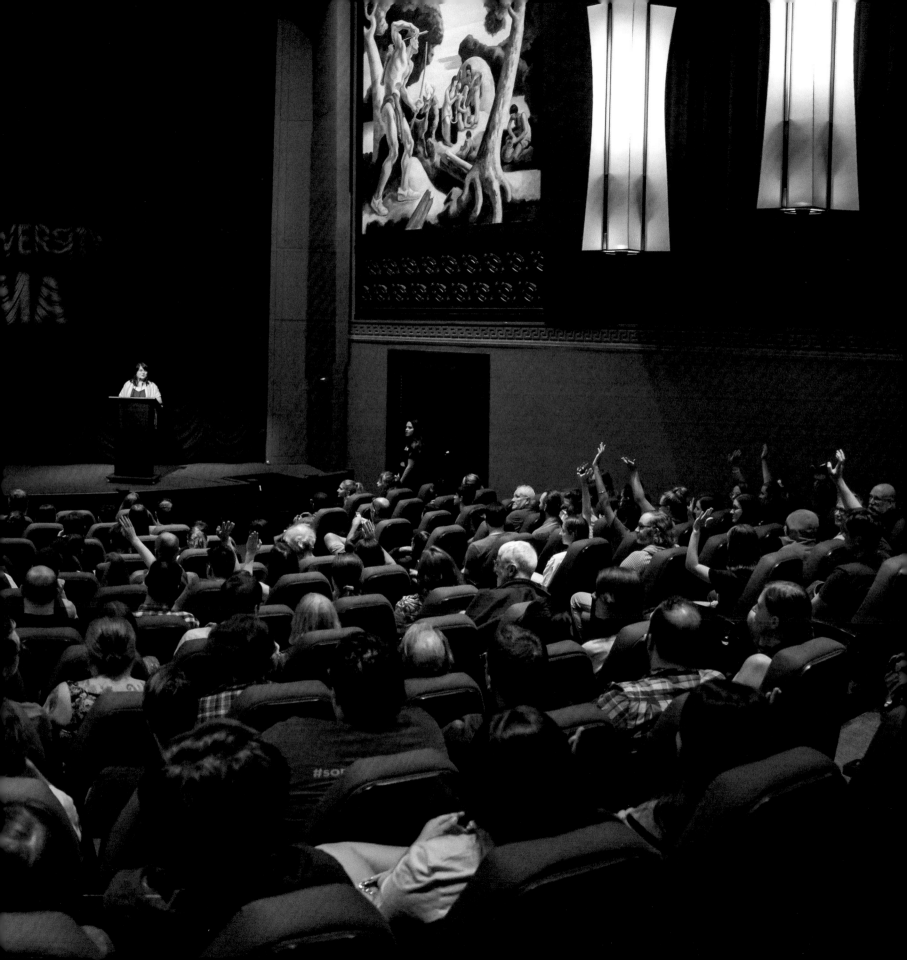

A PLACE FOR FILM BLOG

In October 2016, IU Cinema launched the *A Place for Film* blog to further engage with audiences through high-quality, relevant, interesting, and sometimes provocative writing about subjects linked to its programming. Contributions to the blog are primarily written by a stable of regular contributors—many of whom have worked or volunteered in some capacity for the Cinema—and submissions are also provided by the Cinema's programming partners, along with IU students and alumni.

Blog posts are published multiple times each week and run the gamut from original video essays, reviews, and sneak previews to exclusive filmmaker and scholar interviews. The most popular posts in the blog's first five years include the following:

- "What Is Photogénie?" video essay by Laura Ivins

- "Dreams, Remembering, and Anti-Symbolism in Ingmar Bergman's *Wild Strawberries*" by Nathaniel Sexton

- "*In the Mood for Love*: Nostalgia and Memory" by David Carter

- "Myrna Loy: More Than Just 'The Perfect Wife'" by Michaela Owens

- "The Weight of 143 lbs.: 'I Love You' as Mister Rogers' Universal Constant" by Caleb Allison

- "Jacques Demy in La La Land" by Jesse Pasternack

to be an effective tool for spreading the reputation of IU Cinema's program across the US and abroad and even in recruiting faculty, staff, and students.

In addition, these program booklets archive the history of IU Cinema's curatorial program; there is no better way to learn about the Cinema's program than to sit with the printed program booklets showcasing the first decade of programming. It is no small feat to produce this seventy-two-page, full-color professional publication twice each year, but the multitude of benefits keep driving the decision to continue.

IU Cinema also engages with its audiences via social media. Since 2011, the Cinema has been active on social media, starting with Facebook. In the latter half of this first decade, the majority of the Cinema's social media engagement has taken place on Twitter, Instagram, and Facebook. Each platform allows an open

dialogue between IU Cinema and patrons while also connecting its local audience and the industry at large with IU Cinema and its programming.

Social media proved invaluable as the Cinema worked diligently to engage and communicate with audiences during the isolating and devastating COVID-19 pandemic. Social media became much more than a tool for marketing and promotions; it became one of the critical ways IU Cinema remained connected with its audiences.

World-class service is what every guest receives when they arrive in IU Cinema's lobby. The experience begins even before audience members enter the theater, when the door is opened by a staff member greeting patrons with a smile and a congenial "Welcome to IU Cinema!" House staff and volunteers are thoroughly and professionally trained to give top-notch, personal service, which is not commonplace in most movie theaters. During the Cinema's first ten years,

several full-time staff brought decades of events and customer-service management, volunteer recruitment, and retention expertise to the organization, including Vickers and Friesner. Most notably, IU Cinema benefitted from Events and Operations Director Jessica Davis Tagg's leadership experience with Interlochen Center for the Arts, Tanglewood Festival, and—most recent prior to joining the IU Cinema—as executive director for the Tuscaloosa Symphony.

Friendly, casual relationships develop between staff and returning patrons, often resulting in conversations about films and various cultural activities. This relationship development is key to building a community around the artform and can lead to loyalty to the IU Cinema filmgoing experience that reaches beyond the individual film titles or even the venue.

What IU Cinema has also determined in its first decade is that information is king. The Cinema's guest services team strives to provide guests with as much useful information as possible before entering the lobby and trains event staff with all they need to know about the film or event at hand. Additional information is provided on lobby signage

> **"The IU Cinema is one of the finest projection houses I have ever seen. . . . I was honored to be invited to screen films here."**
>
> —Meryl Streep, actor, *Sophie's Choice* and *The Deer Hunter*

and in onstage introductions when determined useful and important. Patrons continue to show their gratitude for this thoughtful work.

Another critical element of the audience experience is the quality of the presentation. Part of IU Cinema's mission states it is "dedicated to the highest standards of presentation of film in both traditional and modern forms." The Cinema opened as the best-equipped university cinema in the US, and countless filmmakers have stated they have never seen or heard their work presented as well as in IU Cinema.

A reputation for stellar presentation goes far beyond a room full of state-of-the-art equipment. It requires experienced, professional staff and well-defined archival and leading-edge booth practices to set and document standards; train projectionist staff; evaluate and test materials to be screened; and maintain existing, as well as plan for future, technologies. In its first decade, IU Cinema's two full-time technical leads each brought a wealth of experience to the organization. Founding technical lead Manny Knowles helped design and build projection booths in the Bahamas before studying film production and projecting film at University of Southern California.

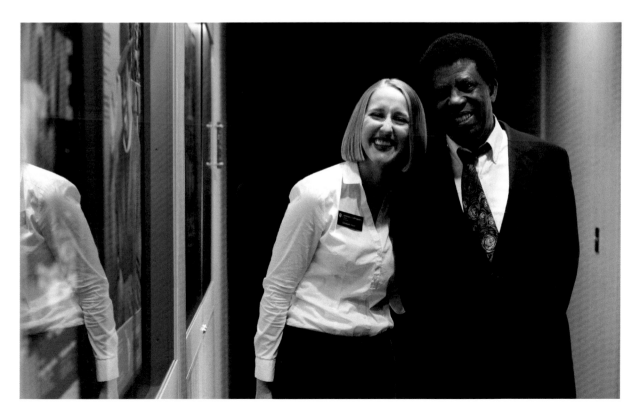

Facing: Select entries from IU Cinema's *A Place for Film* blog. IU Cinema

Left: Lead House Manager Elizabeth Roell welcomes author Dany Laferrière to IU Cinema for his February 2017 visit. Chaz Mottinger/ IU Studios

Hired in 2017 following Knowles' departure, technical lead Elena Grassia projected and served as technical leadership for several renowned film festivals, including Telluride, Turner Classic Movies, Sundance, and Traverse City.

Each year, new students are professionally trained as archival projectionists on 35mm and 16mm as well as DCI-compliant digital cinema. Full-time technical staff train and supervise the student projectionists while also ensuring all booth and material inspection practices meet the standards set by the International Federation of Film Archives (FIAF). IU Cinema and IU Libraries Moving Image Archive (IULMIA) represent Indiana University as full members of FIAF, alongside fewer than a dozen US institutions. This recognition reflects the level of attention IU Cinema places on its exhibition standards. Every single program the Cinema presents to a public audience has been thoroughly tested on screen before the first patron enters the doors.

To remain mindful of the ever-changing landscape of public arts presentation, IU Cinema solicits feedback from its patron base each year through an audience survey and has implemented numerous operational changes as a result. Patron feedback directly affected the addition of online ticketing, the establishment of additional recurring series focused on repertory film programming, an increase in the number of ticketing sale clerks for popular screenings, and refinements to the Cinema's printed program, including the reorganization of the events calendar and the addition of a program index.

Programming is the final element to a memorable cinematic experience. It is worth noting that IU Cinema's programming reflects on President Herman B Wells' notion of going out into the world and bringing it back to Indiana to share with its students, faculty, and staff. Cinema is the newest of the major artforms and perhaps the most accessible. Movies also have the uncanny ability to build empathy. They can transcend borders, cultures, languages, class divides, and even generations. They help us find universal truths and feel connected as citizens of a shared planet. IU Cinema's programming embodies this same spirit of discovery, curation, and sharing—which often leads to further exploration and exchange with others, feeding what Roger Ebert called the "empathy machine." Aiding in this empathic exploration, each program presented in IU Cinema is accompanied

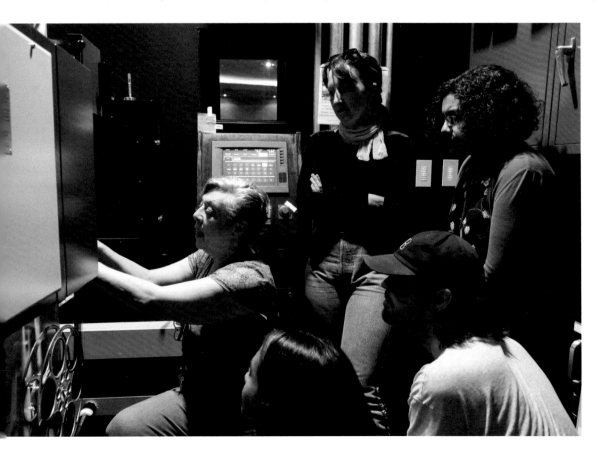

Left: IU Cinema Technical Director Elena Grassia leads a projection workshop during the Biennial Audio-Visual Archival Summer School at Indiana University, May 2019. Brenden Michael Spangler/ IU Libraries Moving Image Archive

Facing: Actor Glenn Close waits with Distinguished Professor Bernice A. Pescosolido in IU Cinema's lobby before heading onstage for a Jorgensen Guest Filmmaker event, April 27, 2015. Eric Rudd/IU Studios

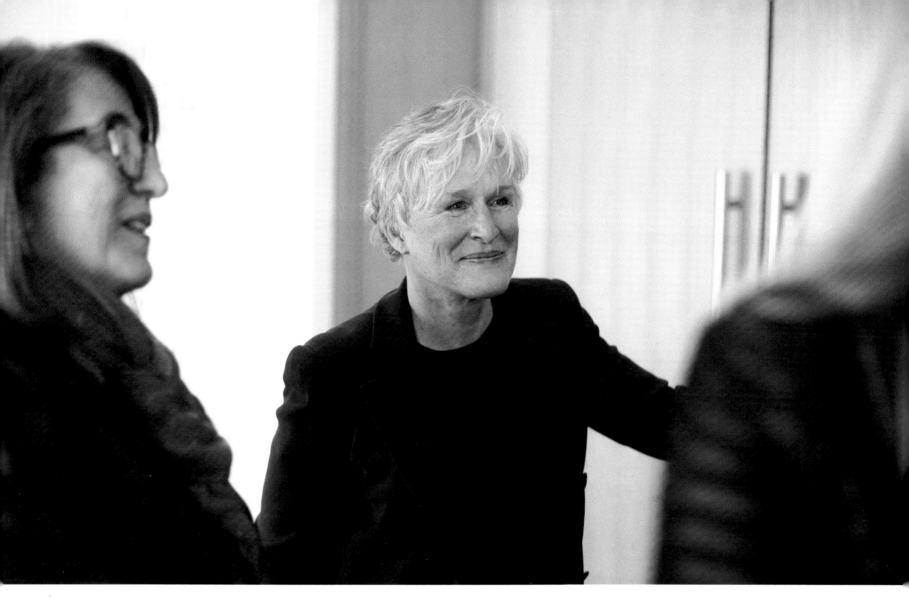

by an introduction, providing greater context for audiences. These introductions are often made by film and media scholars—both from Indiana University and beyond—visiting filmmakers introducing their own work or work they have chosen to present, and IU Cinema staff.

If all the elements align, movies can create magical experiences. IU Cinema is committed to aligning these elements, multiple times each week, and to developing and stewarding audiences who trust they will have a wonderful experience every time they enter the Cinema's doors.

> **"The programming really rivals those of the best cinematheques in the world."**
> —Walter Salles, director of *On the Road* and *The Motorcycle Diaries*

BUILDING THE PROGRAM

With the mandate of establishing IU Cinema as one of the premiere university cinemas in the world, Founding Director Jon Vickers developed the Cinema's programming model to be dedicated in equal parts to collaborative programming envisioned in partnership with the Bloomington campus and community, innovative curation by IU Cinema programmers of signature series highlighting a broad spectrum of repertory and contemporary cinema, and inviting and welcoming to IU a diverse array of filmmakers and film scholars from around the globe.

IU Cinema's vision is to provide transformative cinematic experiences accessible for all—a dedication to ensuring a curatorial program that allows everyone to find cinema that represents them, that challenges them, and that inspires them.

Collaborative Programming

In support of Indiana University's long-standing commitment to excellence, research, and public engagement in the arts, IU Cinema's collaborative programming provides a platform for making IU's intellectual and cultural assets accessible and visible through campus- and community-wide thematic film programming—creating a space for making the arts and humanities at IU Bloomington robustly public facing through strong outreach throughout the Bloomington campus and community.

With nearly half of its curation dedicated to collaborative programs with Indiana University academic units, IU Cinema is among the most academically relevant cinema programs on a university campus. In its first decade of programming, the Cinema has partnered with more than 250 campus and community collaborators on over twelve hundred film-related events.

The majority of the Cinema's collaborative programming is generated through its formal Creative Collaborations program, through which it welcomes proposals twice each year from any IU Bloomington academic unit, nonacademic unit, or student group, as well as community organizations. Regular collaborations with the Black Film Center/Archive (BFC/A), the Media School, the Jacobs School of Music, the IU Libraries Moving Image Archive, Eskenazi Museum of Art, and the Center for Documentary Research and Practice, among many others, has afforded IU Cinema the opportunity to engage students, faculty, staff, and Bloomington community members in hundreds of unique film programs and to welcome visionary filmmakers and scholars from across the globe.

To ensure diverse and inclusive partnerships, IU Cinema appointed a broad-based, eleven-member inaugural Program Advisory Board to review and approve programming proposals for each spring and fall semester program. By IU's bicentennial year, the board had expanded to twenty-one, consisting of members from across the Bloomington campus in addition to an undergraduate student representative and a community representative.

> "I cannot say enough good things about the chance to work with you on this project. . . .
> I hope you know what a profound impact the work you do has on this campus. I'm so very glad for the chance to collaborate with you."
>
> —Doug Bauder, founding director, LGBTQ+ Culture Center

Posters from a sampling of past
IU Cinema Creative Collaborations series.
Kyle Calvert

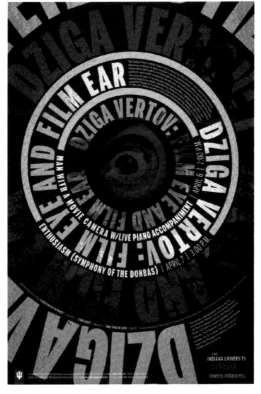

With an abundance of arts and humanities units and programs on the IU Bloomington campus, the College Arts and Humanities Institute (CAHI) within the College of Arts and Sciences as well as the IU Arts and Humanities Council (A&H Council) were founded as bridging units for advancing and highlighting campus arts and humanities research and activity.

CAHI's primary mission objectives are supporting new research and creative work in the arts and humanities in the college and serving as public advocate for the arts and humanities, work that it accomplishes through public programming, granting of research awards to faculty and graduate students, and providing workshops and additional professional development opportunities.

Established in 2015 to address the arts and humanities–related aspects of IU's Bicentennial Strategic Plan for IU Bloomington, the A&H Council is committed to building on the rich legacy of the arts and humanities on the Bloomington campus by increasing student engagement with campus cultural and arts institutions. At the heart of the council's work is presenting public programs and supporting collaborative, interdisciplinary research projects.

IU Cinema frequently partners with both CAHI and the A&H Council to curate programs satisfying the mission and objectives of all parties while maximizing pooled resources. These partnerships have afforded IU Cinema the resources to host major filmmakers and initiatives like Mira Nair, Carlos Reygadas, John Waters, and Rising Tide: The Crossroads Project. Founded in 2018, the Center for Rural Engagement (CRE) is another bridging unit on the IU Bloomington

campus and was established with the mission to reimagine the connective and mutually beneficial relationship between universities and rural communities. By focusing on the research, service, expertise, and teaching of IU Bloomington faculty, staff, and students, the CRE addresses various challenges Indiana communities face and enhances opportunities in collaboration with communities. Its focus areas include health, arts and culture, education, housing, environment and resilience, business and innovation, and leadership and development.

Through the CRE, and in collaboration with Bloomington non-profit film organization Cicada Cinema, IU Cinema has curated and coordinated film screenings and filmmaker workshops in the rural Indiana communities of Salem, Nashville, and Huntingburg.

One area in which IU Cinema has developed a rich and distinguished international reputation is in its commissioning and presentation of silent films with live music. Events with newly commissioned silent-film orchestral scores written and performed by students are regularly premiered at IU Cinema. Many of these events have been US or world premieres of new scores, restorations, and films.

Some of the prominent premieres of the first decade were the US premiere of the reduced orchestral score for a complete version of *Metropolis*, newly restored in 2011 after footage was found in South America; the world-premiere event for which the band SQÜRL—featuring filmmakers Jim Jarmusch and Carter Logan—performed new scores for two 1950s experimental films by Ohio filmmaker Ed Feil, which also premiered the films' restoration led by IULMIA; the world premiere of Alloy Orchestra's very first

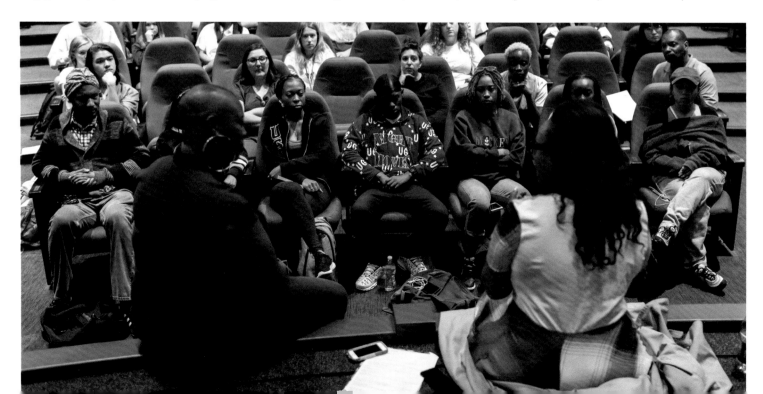

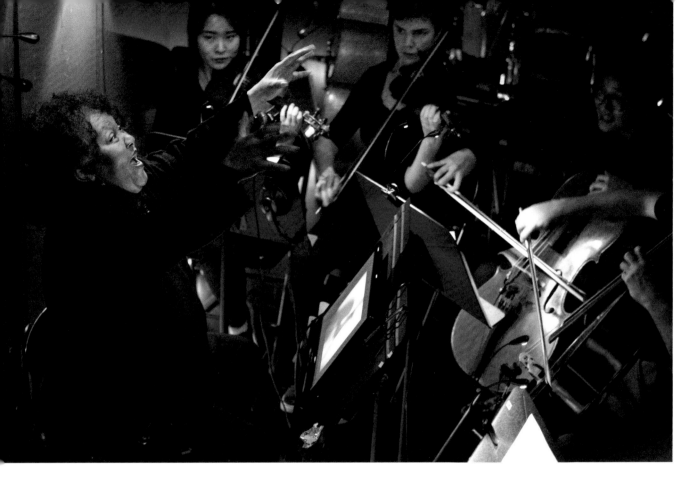

commission in the group's thirty-year history, which was a score for the 1924 French film *La galerie des monstres*, commissioned for Indiana University's bicentennial celebration; US premieres on two occasions of new orchestral scores from UK composer Neil Brand for silent films by Alfred Hitchcock; and world premieres of new films by filmmaker Bill Morrison in 2013 and 2018.

In addition to the selection of live events mentioned, there have been dozens of additional films presented in IU Cinema's program with music from local or touring musicians and bands, solo pianists and guitarists, and even Benshi and Foley artists. IU Cinema has also presented multiday events with live music in partnership with internationally known programs Slapsticon (2013), Orphans Midwest (2013), and Le Giornate del Cinema Muto in Indiana (2019). The earlier events screened 35mm and 16mm prints of rare and unseen work, and each of these programs were presented in partnership with IULMIA, among other partners.

The work commissioned by Indiana University has traveled throughout the US and abroad, carrying IU Cinema's name in the presentation acknowledgments. These creative outputs have continued to build on IU's reputation for innovative research, while the drive to establish and curate these commissions and premieres demonstrates IU Cinema's commitment to providing opportunities to working artists and the importance of creating new work. These events also offer Cinema audiences unique cinematic experiences typically limited to arts presenters in major metropolitan areas.

The robust programming of live-music events and strong partnership with JSoM have made this portion of IU Cinema's program a benchmark and perhaps unlike any other university cinema program in the country, leading renowned composer Neil Brand to state that IU Cinema's program is internationally "recognized as a tastemaker."

IU Cinema takes seriously its role in the support of research. In addition to organizing regular series and programs, Cinema programmers frequently collaborate with numerous University and community partners to support various symposia and film conferences with guests from around the world. In the Cinema's first decade, this has included an annual symposium titled New Trends in Modern and Contemporary Italian Cinema presented by the Department of French and Italian, the semiannual Latinx Film Festival and Conference led by the Latino Studies program, the semiannual Sherlock Holmes–related conference in collaboration with Wessex Press and Lilly Library, and the Biennial Audio-Visual Archival Summer School led by IULMIA in partnership with FIAF. In 2017 and 2018, IU Cinema supported

the work of the Center for Documentary Research and Practice (CDRP), helping host a series of three Sawyer Seminars designed to bring filmmakers, historians, film and media scholars, anthropologists, cognitive scientists, journalists, and documentary filmmakers together with lectures, panels, and film screenings.

The Cinema has also taken a leadership role in developing unique and timely conferences and symposia in partnership with academic units and faculty at Indiana University and beyond. These have included the following:

- Visible Evidence XXV (2018), an international documentary conference copresented with the CDRP, IULMIA, and the Media School, was comprised of paper presentations from scholars from across the globe; film screenings; and onstage conversations with filmmakers including Deborah Stratman, Sergei Loznitsa, and Bill Morrison—the latter who presented a world premiere of a new work titled *Buried and Breaking Away*

- Wounded Galaxies 1968: Paris, Prague, and Chicago (2018), a fiftieth-anniversary examination of the social, cultural, and political impact of the volatile and revolutionary year

- From Cinematic Past to Fast Forward Present: D. W. Griffith's *The Birth of a Nation*—A Centennial Symposium (2015), a two-day symposium presented by the BFC/A in partnership with IU Cinema and the Media School that assessed *The Birth of a Nation*'s racist legacy and continued relevance to transnational, political, and cultural affairs, such as contemporary issues in race relations, immigration policy, and Hollywood representations of race and patriarchy, resulting in a monograph titled *The Birth of a Nation: The Cinematic Past in the Present* (IU Press, 2019)

- Orson Welles: A Centennial Celebration and Symposium (2015), a centenary celebration that incorporated a major exhibition of Welles' papers in IU's Lilly Library and gathered Welles scholars, archivists, and filmmakers to discuss the filmmaker and his legacy, resulting in an anthology monograph, *Orson Welles in Focus: Texts and Contexts* (IU Press, 2018)

- The Burroughs Century (2014), a symposium and film series that included an exhibition of author and artist William S. Burroughs' paintings and unpublished works from his estate, culminating in a monograph titled *William S. Burroughs: Cutting Up the Century* (IU Press, 2019)

- Orphans Midwest: Materiality and the Moving Image (2013), a symposium produced in partnership with New York University

- Regeneration in Digital Contexts: Early Black Film Conference (2013), presented in partnership with the BFC/A and the College of Arts and Sciences with a major grant from National Endowment for the Humanities' Office of Digital Humanities

Almost all of these symposia resulted in published anthologies which expanded upon the content presented at these conferences.

Printed symposia programs for Wounded Galaxies 1968: Paris, Prague, and Chicago and Orson Welles: A Centennial Celebration, Symposium, and Exhibition. Jennifer Vickers

IU CINEMA NUMBERS AT A GLANCE THROUGH THE BICENTENNIAL YEAR

113
COUNTRIES REPRESENTED
(OF THE 195 COUNTRIES RECOGNIZED BY
THE UNITED NATIONS IN JUNE 2020)

52%
FREE PROGRAMMING

49%
PROGRAMMING WITH
PARTNERSHIPS

312,627
TICKETS ISSUED

2,277
UNIQUE FILM
TITLES SCREENED

2,925
PUBLIC EVENTS
PRESENTED

341
VISITING FILMMAKERS AND SCHOLARS

$1,646,509
MARKET VALUE OF FREE TICKETS ISSUED

Signature Series

Every season, IU Cinema presents recurring series spotlighting the best in contemporary and repertory cinema while highlighting innovative thematic curation, introducing patrons to influential filmmakers who have had an indelible influence on cinema, and also allowing Cinema programmers to have fun with creative special-event programming.

The flagship of these recurring programs is the International Arthouse Series—the most popular series in the Cinema's program—cosponsored by the community-based Ryder Film Series (which celebrated its fortieth anniversary in 2019). The series features contemporary film releases from around the globe, some of which have not been released theatrically in the US, enabling IU Cinema to host dozens of sneak previews as well as world,

US, and Midwest premieres of arthouse titles. Many films programmed in the International Arthouse Series have gone on to win awards and screen at prestigious film festivals around the world after screening at IU Cinema, including *Parasite* (2019), *Portrait of a Lady on Fire* (2019), *Spotlight* (2015), *Little Woods* (2018), *Sorry to Bother You* (2018), and *Ex Machina* (2014).

The most popular recurring repertory series in the Cinema's program are Sunday Matinee Classics, offering a brief introduction to classic cinema curated with a unique theme each semester; the 5X Series, providing a peek into the canon of the celluloid legends who may not be able to visit IU Cinema in person but whose influence is felt every time its screen lights up; and the Not-Quite Midnights film series—which began as the Midnight Movies series—featuring cult films, undiscovered cinematic gems, and classic late-night movies.

ARCHIVES

Indiana University is one of an esteemed group of American institutions granted full International Federation of Film Archives (FIAF) membership, alongside the Museum of Modern Art, UCLA Film and Television Archive, Academy Film Archive, Library of Congress, George Eastman Museum, Harvard Film Archive, and University of California Berkley Art Museum and Pacific Film Archive. Throughout its first decade, IU Cinema has borrowed and projected prints from the following archives:

- Academy Film Archive
- American Genre Film Archive
- Anthology Film Archives
- Austrian Film Museum
- Black Film Center/Archive
- British Film Institute and BFI National Archive
- China Film Archive
- Cineteca di Bologna Film Archive
- Deutsches Filminstitut
- EYE Filmmuseum
- The Film Foundation
- Filmoteca Española

- George Eastman Museum
- Goethe-Institut
- Harvard Film Archive
- Hong Kong Film Archive
- Institut Français
- Instituto Luce Cinecittà
- IU Libraries Moving Image Archive
- Jerusalem Cinematheque and Israel Film Archive
- The Kinsey Institute
- KOBE Planet Archive in Japan
- La Cinémathèque française
- La Filmoteca de la UNAM

- Library of Congress
- Munich Film Archive
- Museum of Modern Art
- National Archive in Australia
- National Film and Sound Archive of Australia
- Polish Film Institute
- Reserve Film and Video Collection of the New York Public Library for the Performing Arts
- Taiwan Film Institute
- UCLA Film and Television Archive
- Wisconsin Center for Film and Theater Research

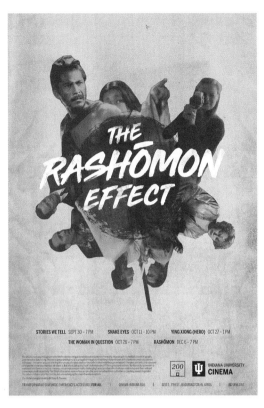

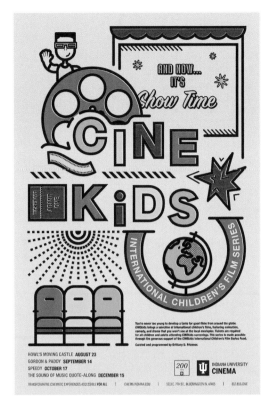

Posters from a sampling of IU Cinema–curated signature series. Kyle Calvert

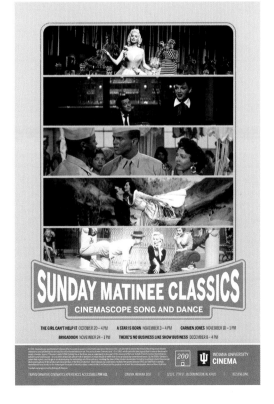

JORGENSEN GUEST FILMMAKER SERIES

The Jorgensen Guest Filmmaker Series, one of IU Cinema's flagship programs, offers patrons unparalleled access to some of the most influential artists in filmmaking. Since opening in 2011, the Cinema has hosted more than three hundred visionary filmmakers, scholars, and acting luminaries—the majority of these made possible through the Jorgensen Guest Filmmaker Series. The series was established with the generous support of the Ove W Jorgensen Foundation, with great appreciation to Jane and Jay Jorgensen. In addition to the Jorgensen Series guests noted below, many additional filmmakers and scholars have also presented work in IU Cinema and are mentioned throughout this book.

Through Indiana University's bicentennial year, Jorgensen guests have included **Vadim Abdrashitov**, James Acheson, **Haifaa al-Mansour**, Barry Allen, **Alloy Orchestra**, Natalia Almada, **Rick Alverson**, Ana Lily Amirpour, **Kenneth Anger**, David Anspaugh, **Anthony Arnove**, Angus Aynsley, **Beth B**, Jonathan Banks, **Jacob Bender**, Robby Benson, **Joseph Bernard**, Prashant Bhargava, **Olivia Block**, Peter Bogdanovich, **John Boorman**, Neil Brand, **Irene Taylor Brodsky**, Richard Brody, **Tony Buba**, Charles Burnett, **Philip Carli**, George Chakiris, **Glenn Close**, Roger Corman, **Pedro Costa**, Donald Crafton, **Nia DaCosta**, David Darg, **Julie Dash**, Bridgett M. Davis, **Peter Davis**, Josephine Decker, **Claire Denis**, Danfung Dennis, **Joseph Dorman**, Dennis Doros, **Nathaniel Dorsky**, Sara Driver, **Cheryl Dunye**, Ava DuVernay, **Tamer El Said**, Mike and Chris Farah, **Xie Fei**, Hannah Fidell, **Ari Folman**, Ja'Tovia Gary, **David Gatten**, Lucian Georgescu, **Sandra Gibson**, Jill Godmilow, **Bobcat Goldthwait**, Bette Gordon, **Megan Griffiths**, Larry Groupé, **Werner Herzog**, Jerome Hiler, **Eliza Hittman**, J. Hoberman, **Dennis James**, Steve James, **Jim Jarmusch**, Jeremy Kagan, **Ichiro Kataoka**, Abbas Kiarostami, **Bora Kim**, KyungMook Kim, **Alison Klayman**, Kevin Kline, **Dany Laferrière**, Alain LeTourneau, **Rod Lurie**, William Lustig, **Guy Maddin**, Terence Marsh, **Ash Mayfair**, Albert Maysles, **Paul D. Miller (DJ Spooky)**, Pam Minty, **Bryn Mooser**, Bill Morrison, **Mira Nair**, Stanley Nelson, **Avi Nesher**, Edward James Olmos, **Ron Osgood**, Nisha Pahuja, **Darcy Paquet**, Richard Peña, **Numa Perrier**, Alex Ross Perry, **Alexandre O. Philippe**, Angelo Pizzo, **Luis Recoder**, Nicolas Winding Refn, **Kelly Reichardt**, Kris Rey, **Carlos Reygadas**, Boots Riley, **Deborah Riley Draper**, Bruce Joel Rubin, **Stefani Saintonge**, Mireia Sallarès, **Walter Salles**, Nelson Pereira Dos Santos, **John Sayles**, Christel Schmidt, **Paul Schrader**, Michael Schultz, **Jonathan Sehring**, Amy Seimetz, **MM Serra**, Parvez Sharma, **Abderrahmane Sissako**, Todd Solondz, **Penelope Spheeris**, Whit Stillman, **Meryl Streep**, Joe Swanberg, **Monika Treut**, Michael Uslan, **Christine Vachon**, Amy Villarejo, **Todd Wagner**, Patrick Wang, **John Waters**, Peter Weir, **Ti West**, Kevin Willmott, **Chuck Workman**, Adel Yaraghi, **Hoyt Yeatman**, A. B. Yehoshua, and **Krzysztof Zanussi**.

Part of IU Cinema's mission is to be recognized as a leading university cinema both by its exemplary exhibition standards and its world-class program curation, including a commitment to serve as a link between the film exhibition industry and the archival world. IU Cinema programmers regularly curate thematic series presenting archival prints and new restorations of classic films. Through its repertory programming and membership in FIAF, IU Cinema has been afforded the opportunity to borrow materials from many of the world's leading archives.

IU Cinema's curation of repertory programming to build awareness and highlight the work of archivists and archives has led to the establishment of an endowment—the Michael W. Trosset Archival Print and Restoration Exhibition Fund—to ensure archival print presentations are a regular part of the Cinema's program. In fact, many of the Cinema's recurring repertory series have been endowed through the generosity and vision of forward-thinking donors dedicated to ensuring classic film will always be represented on IU Cinema's screen. In September 2017, more than thirty Indiana University faculty and staff members presented gifts to endow the Michael A. McRobbie President's Choice Film Series Fund, making the recurring series part of IU Cinema's program in perpetuity and honoring President McRobbie's leadership in founding IU Cinema and his affinity for cinematic art.

Visiting Filmmakers

Each year, Cinema patrons regularly engage with groundbreaking and iconic filmmakers. These filmmaker visits have become an integral part of the Cinema's ability to offer unique and transformative cinematic experiences. Year after year, patrons participating in the Cinema's annual audience survey note that filmmaker visits are some of the most memorable experiences they have enjoyed at IU Cinema. Guest filmmakers introduce their work, have engaging discussions with audiences, present public lectures, lead master classes, and dine with students. Intimate conversations occur on a regular basis between patrons and some of the most prominent artists in the global film industry and subject-matter experts in myriad and diverse academic fields.

The majority of IU Cinema's guests have visited through its flagship Jorgensen Guest Filmmaker Series as well as through partnerships with university units. More than three hundred award-winning US and international filmmakers and scholars have presented their work at IU Cinema, including John Boorman, Glenn Close, Kenneth Anger, Claire Denis, Carlos Reygadas, Cheryl Dunye, Krzysztof Zannussi, Haifaa al-Mansour, Jim Jarmusch, Abderrahmane Sissako, Albert Maysles, Xie Fei, Richard Brody, Kelly Reichardt, Abbas Kiarostami, Julie Dash, John Waters, Nelson Periera dos Santos, Ava DuVernay, and IU alumnae Hannah Fidell and Eliza Hittman.

In partnership with other academic units and offices, IU Cinema has also nominated and supported filmmakers for esteemed lectureships and honorary degrees, which has brought to campus acting and filmmaking luminaries like Meryl Streep, Peter Bogdonavich, Viola Davis, and IU alumni Kevin Kline and Jonathan Banks.

"Bringing filmmakers into the university setting and having them spend time with the community and with students, that's a real gift."

—Steve James, director of *Hoop Dreams* and *Life Itself*

Writer/director Ash Mayfair poses outside IU Cinema prior to a Q&A following a screening of her film *The Third Wife* (2018), September 19, 2019. Alex Kumar/IU Studios

03

TRANSFORMATIVE CINEMA IN ACTION

C inema is experienced in the moment. The effects can build over time, imprinting a film experience, emotion, or some transformative universal truth onto our very being. These changes can last a lifetime, but the catalyst was the moment. Much of this book has been dedicated to the creation of those moments and the vision, planning, attention, and, sometimes, luck behind them.

This chapter will present a collection of outputs associated with the hundreds, even thousands of such moments in IU Cinema's first decade. Like any good institution, the Cinema strives to document much of what is curated and produced, even if what is presented is intended to be primarily impactful for the audiences attending in person. Inside are highlights from some of these outputs in the form of transcribed interviews and lectures, IU Cinema-designed posters and artwork, stellar photography from IU Studios and guest photographers, samples of newly commissioned musical scores, and a variety of additional works.

This chapter is divided into two sections: Filmmakers and Creative Works. The Filmmakers section is heavy on the written word, highlighting seventeen short and extended filmmaker interviews. The Creative Works section is a collection of images, design work, musical scores, and additional creative outputs.

> "It's the best place in the entire Midwest . . . maybe one of the best in the country."
>
> —Werner Herzog, director of *Grizzly Man* and *Fitzcarraldo*

FILMMAKERS

Each year, dozens of filmmakers visit IU Cinema by invitation, either directly from Founding Director Jon Vickers, founding Associate Director Brittany D. Friesner, faculty, or community partners through our Creative Collaborations, or via various campus units. Occasionally, filmmakers are also invited by conference or symposia hosts in connection with IU Cinema screenings.

There are many factors that contribute to the quality of programs and engagement when hosting visiting filmmakers. Negotiating these details is always crucial, as it is important every visiting film-maker walks away from their experience as a new ambassador for IU Cinema. This mindset has helped spread the Cinema's world-class reputation across the industry.

While reading and reviewing the materials in this section is no adequate substitute for participating directly in these experiences, the insights visiting filmmakers have generously shared over the years remain inspiring and illuminating. The interviews have been edited and excerpted for length and are presented courtesy of the filmmakers.

> "Indiana University Cinema is just incredible. . . .
> There's nothing like it anywhere else.
> This is, for a film junkie, this is nirvana."
> —Joseph Bernard, visual artist and director of
> *Night Mix* and *Intrigues* (Part I–VII)

Creative Collaborations

Through IU Cinema's unique and robust Creative Collaborations program, the Cinema has hosted hundreds of filmmakers since its opening. Regular partners for these filmmaker visits have included the Black Film Center/Archive (BFC/A), the Media School, IU Libraries Moving Image Archive (IULMIA), and the Center for Documentary Research and Practice. In addition to the filmmakers featured on the following pages, these partnerships have helped bring to campus renowned filmmakers Pedro Costa, Pema Tseden, Jesse Maple, Esai Morales, Rosine Mbakam, Joshua Oppenheimer, Madeline Anderson, Alison Klayman, Stanley Nelson, Kleber Mendonça Filho, Mike Henderson, James Balog, and Philippe Falardeau.

In addition to filmmakers, additional guests have visited IU Cinema as part of collaborative programs to present films, including civil rights leader Julian Bond with *Eyes on the Prize* (1987); chef, author, and food activist Alice Waters with *The Baker's Wife* (1938); Olympic swimmer Greg Louganis with *Back on Board* (2014); and Broadway producer Harriet Newman Leve with *An American in Paris* (1951), among many others.

Visits are often led by faculty doing personal research on the work of these guests or are incorporated into coursework and frequently include class visits and additional student and academic engagement. Several of the visiting filmmakers through Creative Collaborations had substantial retrospectives curated and presented at IU Cinema. Many of the visits led to published articles or interviews initiated during their time at Indiana University.

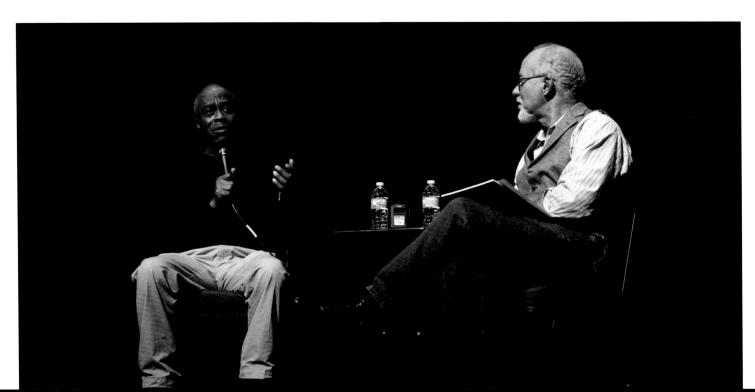

NATALIA ALMADA

From the transnational dimensions of *narco-corridos* to the material expression of symbolic power in the form of extravagant mausoleums, Natalia Almada's films offer unique and intimate portrayals of cultural phenomena stemming from the Mexican drug trade. Departing from the experience of common people, these films shed light on the complex interrelations between violence, immigration, the economy, and cultural production.

Almada's visit to Indiana University was arranged by Associate Professor Jonathan Risner in partnership with IU's Department of Spanish and Portuguese and IU Cinema. Additional partners were College Arts and Humanities Institute, Latino Studies Program, Department of Communication and Culture, Department of American Studies, Center for Latin American and Caribbean Studies, and Film and Media Studies. The curated program, Porous Borders: The Documentary Films of Natalia Almada, included screenings and conversations on several of her films, a Jorgensen Guest Filmmaker program, and meetings with students.

The recipient of the 2009 Sundance Documentary Directing Award for her film *El General*, Almada earned a master of fine arts degree in photography at the Rhode Island School of Design. Almada's *El velador* (2001) premiered at New Directors/New Films and Cannes' Directors' Fortnight. Her credits include *All Water Has a Perfect Memory* (2001), an experimental short film that received international recognition, and *Al otro lado* (2005), her award-winning debut feature documentary about immigration, drug trafficking, and corrido music. In 2017, Almada released her first fictional narrative film, *Everything Else* (2016). Her work is poignant and poetic with a distinct style and pace.

Almada's films have been screened at the Sundance Film Festival, the Museum of Modern Art, the Guggenheim Museum, and the Whitney Biennial. All of her documentary features have been broadcast on the award-winning PBS series *POV*, and, in 2012, she was awarded a prestigious MacArthur Fellowship, often referred to as the "genius grant."

While at IU Cinema, Natalia Almada sat for an interview with founding Associate Director Brittany D. Friesner, "Natalia Almada: An IU Cinema Exclusive."

Facing: Filmmaker Charles Burnett interviewed by Professor Michael T. Martin at IU Cinema on November 3, 2011, during a Jorgensen Guest Filmmaker event. Stan Gerbig/ IU Studios

Top: Natalia Almada in the lobby of IU Cinema prior to a Jorgensen Guest Filmmaker event in October 2014. Chaz Mottinger/ IU Studios

Brittany D. Friesner: Why is film such a powerful artform?

Natalia Almada: I feel like, as a filmmaker, what I really love is being able to look at something in many different ways and think about it in different ways, then represent it visually and sonically. I feel like, as a viewer of film, there's something very immersive, especially about the cinema experience, as opposed to watching at home or on your computer. There is something about the collectivity, the way the dark room envelops you, and how you really fall into a film that is incredibly powerful.

BF: Do you have a film experience that changed your life?

NA: I always think about when I was shooting *Al otro lado*, which was my first feature documentary. I was shooting about thirty miles north of the border with the Civil Homeland Defense Group and following Chris Simcox, who is the head of that group. I was starting to think, "I'm wasting my time, this is really crazy, why am I doing this," you know. It felt pointless in a way. And then, I was looking through the camera, following his figure walking, and all of a sudden I saw eyes looking back at me from a ditch on the ground. It was a moment that really, I think, changed me, because I understood how powerful the camera is and how much I had to be very responsible and ethical with my use of it. It was also a moment of conflict, because I didn't really know if I did the right thing, or what I should do—if I should continue filming and be the filmmaker, knowing my camera was definitely intimidating and humiliating these people who were already being humiliated. It was making their reality worse. Yet, it also seemed to provide the opportunity to give them a voice, which seemed important. So, it just really brought up for me in a moment I was filming the understanding of the real power and the conflict that having a camera means. The privilege and responsibility that entails. I always think of that as the moment that really marked me as a filmmaker.

BF: What or who are some of your artistic influences?

NA: It's always different, depending what I'm working on. For example, working on *El velador*, I thought a lot about improvised jazz. There's this kind of tension and release when you listen to the music that can make the chaos you can feel when listening to improvised music sometimes frustrating almost. But then, if a melody or something recognizable comes in, you feel this kind of "ahh," this kind of release, because something made sense or was understandable. It moves in a way that works with your emotions. I am not a musician, so this may be my way of experiencing the music, but that's what I thought about making *El velador*. I think with each film,

Top: IU Cinema poster for Porous Borders: The Documentary Films of Natalia Almada, October 2014. Jennifer Vickers

Facing: Almada and Associate Professor Jonathan Risner onstage at IU Cinema during a Jorgensen Guest Filmmaker event in October 2014. Chaz Mottinger/IU Studios

"I don't know why I make films. I love doing it. I love when I'm making a film. I love when I'm shooting. I love editing. For me, that's when I really feel okay in the world."

there's kind of a medium, or a certain artist, writer, or someone who is particularly important to me at that time. But I find being around different kinds of artists to be really important, and not just filmmakers, but to be in dialogue with writers, and musicians, and artists.

BF: Why do you make films?

NA: I don't know why I make films. I love doing it. I love when I'm making a film. I love when I'm shooting. I love editing. For me, that's when I really feel okay in the world, and the kind of noise and anxiety of life subsides in those moments. I stop questioning—it just is, and it is fine.

BF: Do you make your films for a particular audience?

NA: I hate the question of audience, and I think it's often because it comes up when you make film work that's not of the mainstream. I understand that's not why you're asking me now, but that's often why I get asked. "Who is this film for?" is usually a question from somebody who feels the film isn't for them, either because it is in Spanish, and it's subtitled, or it's about Mexico, and they're not from Mexico, so why should they care. I think that one of the most enriching things about my experience has been showing films to completely different audiences all over the world. Showing them at home, showing them abroad, to young people, to older people, to different education and class levels, showing them on public television and in museums and in festivals. All of those audiences bring something different, and, in their responses, I have learned how something I have seen and portrayed is perceived by different kinds of people. That is the dialogue that really interests me, much more so than saying my films are to convince these people about a certain issue or to touch these people. When I look at art, I know it wasn't made for me, and that's the art I love. So, I think that's the idea.

BF: When did you know that you wanted to become a filmmaker?

NA: I don't think I ever decided that I wanted to be a filmmaker. I studied photography, and I had an incredible teacher who really inspired me. I made a short film. I think I also work as a photographer, meaning my way of thinking really comes out of my background in photography, in terms of framing, what the frame means, what the image means, how we read an image. I think filmmaking just sort of happened, more than anything, and I often attribute it to a kind of response to being bicultural and bilingual, where language becomes unreliable in a way. You are always thinking in two languages and two cultures. They contradict each other, or they don't make sense together, or you may feel like, "I express myself in English, and therefore there's something I wish I could say in

Spanish, but I can't." Language becomes this fragile, unreliable method of communication, which makes the image much more concrete. I can say, "Here's my image," and it is what it is. People can interpret and read it differently, but the image is there. I think that was maybe how I started to get interested in images.

BF: How important is a good university cinema program for the students?

NA: I think it's really important to have a good cinema program. What I'm saying by that is, a theater like this with good sound, good image quality, good programming, and people who are writing about cinema—I think that's really important. I did not study film, and I don't really believe that school is the place to learn craft. Technology is changing so fast, so quickly, we might be teaching students a lot of archaic methods. But I think it's important to learn how to look at images, to learn how to talk about images, to learn how to critique work, to learn how to listen to critique, and to learn how to articulate your thoughts about an image. I'm using image as shorthand for a film, or a photograph, understanding what image does with sound and story. I think it's incredibly important in that way. I think the mistake is when it becomes too much about the industry or craft. If those students instead are taught conceptually how to edit and given the confidence that they can figure things out, then it doesn't matter if technology changes, because they can adapt. I always think of some of the great editors like Walter Murch, who is someone who began editing on a flatbed and is still editing films today with huge effects, completely digital, like this whole new world. He is an editor; he's not someone who knows a system. That's what we want to teach—how to think—much more so than the craft.

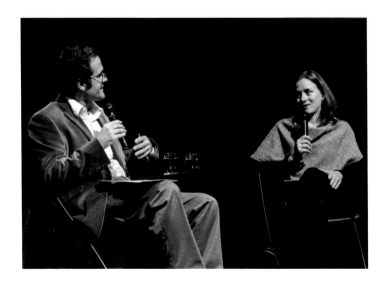

AVA DUVERNAY

Ava DuVernay visited IU Cinema and the BFC/A in September 2013, not long before she started filming her breakout film, *Selma* (2014), which was nominated for an Oscar for Best Picture and Golden Globes for Best Director, Best Picture, and Best Original Song, the latter two of which it won. DuVernay's visit was sponsored by the BFC/A, Department of African American and African Diaspora Studies, Department of American Studies, Department of Communication and Culture, Film and Media Studies program, Women's Philanthropy at IU, and IU Cinema, and it was led by BFC/A Associate Director Brian Graney. Events included screenings of all her feature films to date, a Jorgensen Guest Filmmaker program, meetings with students, and an interview for the scholarly film journal *Black Camera*.

Winner of Best Director honors at the Sundance Film Festival, Emmy Awards, British Academy of Film and Television Arts (BAFTA) Awards, and Peabody Awards, Academy Award nominee Ava DuVernay is a trailblazer in the independent film and television world as a writer, director, producer, and film distributor. Her feature film and television work includes *When They See Us* (2019), *A Wrinkle in Time* (2018), *13th* (2016), *Queen Sugar* (2016–present), *Selma*, *Scandal* (2013), *Nine for IX: Venus Vs.* (2013), *Middle of Nowhere* (2012), *I Will Follow* (2010), *My Mic Sounds Nice: A Truth about Women and Hip Hop* (2010), and *This Is the Life* (2008).

In addition to writing, directing, and producing her own films, DuVernay launched a groundbreaking film distribution venture in 2010, the African American Film Festival Releasing Movement—reborn in 2015 as ARRAY. Through a strategic alliance with African American and African diasporic film festivals, ARRAY acquires and distributes a consciously curated roster of independent films made by people of color and women filmmakers globally, including *Lingua Franca* (Isabel Sandoval, 2020), *The Body Remembers When the World Broke Open* (Elle-Máijá Tailfeathers and Kathleen Hepburn, 2019), *Out of My Hand* (Takeshi Fukunaga, 2015), *The Burial of Kojo* (Samuel "Blitz" Bazawule, 2018), *Vaya* (Akin Omotoso, 2016), *Jezebel* (Numa Perrier, 2019), and V*anishing Pearls* (Nailah Jefferson, 2014). The company was named one of *Fast Company*'s Most Innovative Companies.

DuVernay sits on the advisory board of the Academy of Television Arts and Sciences as well as the board of governors for the directors branch of the Academy of Motion Picture Arts and Sciences and has become a champion for women and Black filmmakers around the globe.

Facing: DuVernay being filmed in IU Cinema for the documentary *Life Itself* in September 2014. Dana Kupper/Kartemquin Films

Top: IU Cinema poster for Ava DuVernay and AFFRM: A Call to Action from September 2014. Jennifer Vickers

"I would say I make films for myself. . . . And, by making them for myself, I'm making them for Black people; by making them for myself, I'm making them for women; by making them for myself, I'm making them for human beings who are connected to the kinds of stories I'm telling."

In addition to the public events listed, DuVernay was interviewed in IU Cinema by filmmaker Steve James for his documentary on the late film critic Roger Ebert, *Life Itself*. She also sat for this interview with Founding Director Jon Vickers, titled "Ava DuVernay: An IU Cinema Exclusive."

Jon Vickers: What is the most powerful aspect of cinema as an artform?

Ava DuVernay: I really grasped its power when I began to travel abroad, travel to places where folks don't have everyday interaction with people of color, and understanding that their whole idea about who "the other" is comes from film, comes from these images. It's a little distressing when you think about what they're watching and how what they're watching impacts who they think I am. So, the power of film in that way is really affecting the way that we are seen, as whoever we are. But also, more personally, it affects the way that I see myself, as I've watched images of Black people, Black women, and women in general, in film over the years, how it's really changed my self-view. So, the power of film is the way that we are seen and the way that we see ourselves, and those make up the foundations of who we are.

JV: Who or what are some of your artistic influences?

AD: I'm heavily influenced by the filmmakers known as the L.A. Rebellion filmmakers: Haile Gerima, Charles Burnett, Julie Dash, and others. So much art is inspiring, but those filmmakers, because they were working in the place where I'm from and because they were making films that were contemporary representations of Black life at that time, just really speak directly to the work that I'm most interested in. Whenever I'm feeling drained, I'll put on *Ashes and Embers* [1982] or *Daughters of the Dust* [1991] or *Killer of Sheep* [1978]—just three among many films from the filmmakers from that generation.

JV: When did you know you wanted to become a filmmaker?

AD: I started to have thoughts about being a filmmaker in my early thirties. I read articles about [Steven] Spielberg, knowing that he was making films on his little Super-16 when he was five or something. I didn't have any thought about how a film was made or that one could actually make a film as a normal person. Coming from where I came from, I had no context for actually making the films; I just knew that I loved films. So, it wasn't until I became a publicist and was working on sets, getting to know filmmakers, that I was like, these people are just like me. I have some stories to tell; let me give it a try. So, I started to write a script. *Middle of Nowhere* was the first script I wrote, not the film I made but the first script I wrote. I was like thirty-one or thirty-two when I started working on that. So, a little late!

JV: Why do you make films, and who are they for?

AD: I would say I make films for myself. I feel that if I can satisfy myself with these films, then eventually they'll reach other people who may also be satisfied by them. And, by making them for myself, I'm making them for Black people; by making them for myself, I'm making them for women; by making them for myself, I'm making them for human beings who are connected to the kinds of stories I'm telling, whether a story of loss, grief, or separation. But it starts by satisfying me, as opposed to being in the editing room, or being at my desk typing a script, or being on set trying to think about what other people would like. Because I think that's the death knell.

JV: What advice would you give to a young filmmaker?

AD: I have an idea. I have the passion. I have friends. I have this little bit of money. I have this location. I have access to this camera. Okay, I can make something with those things I have instead of focusing on all the things that I did not have, all the things that I wanted. My needs started to change, and my posture became much more active, and I was moving forward as opposed to standing still. And it all started from a place of desperation. If you channel your desperation toward the things that you have, it becomes passion. If you channel your desperation toward the things that you don't have, it becomes depression and stagnation. So, let that desperation drive you to a good place, and you'll be making a film.

> "If you channel your desperation toward the things that you have, it becomes passion. If you channel your desperation toward the things that you don't have, it becomes depression and stagnation. So, let that desperation drive you to a good place, and you'll be making a film."

JV: What is the importance of a place like the Black Film Center/Archive?

AD: A space, a program, and the intention behind the Black Film Center/Archive is so vital, not just to Black people. It's vital to film lovers. It's vital to people who are interested in the world outside of themselves, who may not be Black. I was watching a film earlier today at the Black Film Center/Archive from a Black couple who made commercial films in their living room in 1929 from Indiana. And by watching that film, I saw the way they walked, the way they laughed, what was appropriate in touch at that time, the spatial relationship to each other, the way the furniture was in the room. By watching, I'm learning, and a whole world opens up. For me as a Black woman, to be connected to my ancestors, to our legacy, to see those images which have been kept from us on television and film, was really moving. It's something I saw, and I said, "God, I wish everyone could see it." But everyone's not going to see it if there's no place for these films to live and be protected. So, to know there are places like this, and this particular place exists, so well run, so passionately run, it is moving. As a filmmaker as well, to know there are people and places like this helps me believe that my own work might live on when I'm not here.

JV: How do you value a good university cinema?

AD: I get jealous of people who have access to not only the pristine quality of the picture and the sound of this particular place but just access to a university cinema in general. The world is waiting for you. I mean, it's the whole world. You don't have to be a film geek, you don't have to know about films, you don't have to know the masters; it's just a window. And to have a cinema that's so passionately curated and bringing in these jewels from all over the place. Like I said, I get jealous that I didn't have it [*laughs*], but you think of the campuses that do have spaces like this, and the opportunity that is sitting right in these chairs, to actually transform the way we think about ourselves and about other people, internalized when we leave a space like this. It's really vital. It should be something that's everywhere. You think of music programs, and all kinds of arts programs that we should have more of. Certainly, campuses which have a space like this are the lucky ones.

DuVernay speaking during her "An IU Cinema Exclusive" interview at IU Cinema prior to her Jorgensen Guest Filmmaker event in September 2014. Toth Media, LLC

JULIE DASH

Julie Dash's rich filmography explores the spectrum of Black women's experience across wide swaths of geography and time. The year 2016 marked the twenty-fifth anniversary of her film *Daughters of the Dust*; the BFC/A and IU Cinema thought it would be the perfect time to screen the newly released digital restoration of the film. Dash previously visited Indiana University and the BFC/A multiple times and returned to IU in December 2016 to present her groundbreaking film along with a selection of short films from her time as part of the L.A. Rebellion, the Black cinema revolution of the late 1960s to late 1980s based at University of California, Los Angeles (UCLA). She also participated in a Jorgensen Guest Filmmaker event in the form of a public interview led by IU Media School Associate Professor Terri Francis, who was named director of the BFC/A in 2017.

Though she began studying film production in Harlem at City College of New York, Dash's film work was refined at UCLA, where she earned her master of fine arts degree in film and television production and then served as a Producing and Writing Conservatory Fellow at the American Film Institute. UCLA is where she made a short film based on an Alice Walker story, *Diary of an African Nun* (1977), which won an award at the Directors Guild of America for student work. She followed this with another short film, *Illusions* (1982), which was also critically acclaimed. It was her Sundance award–winning feature film *Daughters of the Dust* that broke beyond racial and gender boundaries and made history by becoming the first feature film made by an African American woman to have a wide theatrical release in the United States. The film was deemed culturally and historically significant by the Library of Congress as it was named to the National Film Registry in 2004.

Her television work includes writing and directing for CBS, BET, Starz Encore, Showtime, MTV Movies, and HBO. Her direction of *The Rosa Parks Story* in 2002 earned her a nomination for Best Director from the Directors Guild of

Dash in IU Cinema's lobby before a Jorgensen Guest Filmmaker event in December 2016. Chaz Mottinger/ IU Studios

America as well as two National Association for the Advancement of Colored People Image Awards and an Emmy nomination for actor Angela Bassett.

Dash's work also includes documentaries, public-service announcements, music videos, industrial films, and commercial spots for Fortune 500 brands like Coca-Cola and GMC. She has been a Distinguished Professor of Cinema, Television, and Emerging Media at Morehouse College and has taught at many leading universities, including Stanford University, Princeton, Harvard, and Yale.

During her visit to Indiana University, Julie Dash sat for this interview with Founding Director Jon Vickers, "Julie Dash: An IU Cinema Exclusive."

Jon Vickers: Why is film such a powerful artform?

Julie Dash: Being in a darkened room, watching something projected to you, is hypnotic. It's a very powerful mechanism for supporting ideas, introducing new ideas. Traumatizing you, even, as well as hopefully healing and enlightening you as a viewer.

JV: Why do you make films, and who are they for?

JD: I make films for myself, I make films for my community, I make films to reimagine who I am, and who I am as an African American woman in a diasporic larger community, and I make films to explore ideas.

JV: Who or what are your artistic influences?

JD: The fine arts, the paintings of Kerry James Marshall . . . Michael Kelly Williams' sculptures and crafts, the photography of James Van Der Zee. There's so many. It's hard to pin them down, you know.

JV: What drives you to take on the subjects you do in your films?

JD: With every film I create, I always want to bite off more than I can chew. I like switching up genres, you know, from a dance film to a biography to a documentary. I haven't done a western yet, so that's still on the list, but I have done, like, a cheesy thriller. I always just want to try different things, I want to tell different stories, and I want to be able to visualize myself and my community in those different stories that are told in ways that are meaningful and that are exciting, and films that do not portray us as victims.

JV: What would you hope your legacy might be as an artist?

JD: I hope people remember that Julie Dash was a great mother; I think some of that mothering, the nurturing, that natural, organic need to nurture as a mother, comes through in my films as well. I'm not trying to pretend that I'm some hardcore, action-packed

Top: IU Cinema poster for the Julie Dash: Daughters of the Dust Twenty-Fifth Anniversary film series, December 2016. Kyle Calvert

Facing: Dash and BFC/A Director and Associate Professor Terri Francis onstage at IU Cinema during a Jorgensen Guest Filmmaker event in December 2016. Chaz Mottinger/IU Studios

"Being in a darkened room, watching something projected to you, is hypnotic. It's a very powerful mechanism for supporting ideas, introducing new ideas."

film director and writer. I want to do films that uplift, that take us a few steps further toward being enlightened, perhaps, or into something that's healing, something that makes you think or want to do more research about the subject matter yourself. But mainly, films that make you want to take action in some kind of way that's very positive, that feels good—feel-good films.

JV: What advice would you pass on to a young or emerging filmmaker?

JD: To follow your heart, follow your passion, follow your intentions—your original intentions—and do not be dissuaded by people who will say, "Well, I don't fully understand what you're trying to say or do, your voice is one that's unfamiliar, so therefore, do it my way, don't do it your way, do it my way so you can get it sold, so you can get a production deal, so you could move further along in your career." I think it's important to speak with your own voice and to stand in truth whatever, wherever you are.

> **"I want to do films that uplift, that take us a few steps further toward being enlightened, perhaps, or into something that's healing."**

JV: How was your experience visiting the Indiana University Black Film Center/Archive?

JD: The Black Film Center/Archive has always been very important to me. I've been here three times before: two times with the late Phyllis Klotman and one time with Michael Martin prior to this visit. I am always on [their] website, the Black Film Center/Archive, the blog, the website, and the Black cinema review [*Black Camera*],

the magazine that comes out. It's very important to me as a filmmaker to be able to reach out and double check, also as a . . . visiting professor, I have to be able to have at hand's reach the resources that allow me to teach things properly and factually and to continually feed me new information. Every time the blog comes through, like, "We found a stash of films here and there," it's just like, "Really?!" and it's like, "Well, can I see them?!" It's like, yes! It's right here. So, thank you. It's a wonderful thing.

JV: What is the importance of a good cinema on a university campus?

JD: Well, I think it's critical. I applaud all the colleges and universities that are teaching film through the English department, but they're really not approaching film studies in the way that they could, and they should, and they ought to. You must be able to project films or show the films in the medium in which they were made. So, if it's HD film, show it in HD. If it's 35- or 16mm celluloid, show it that way. The sound has to be great, just as great as the producers of the film made the sound. You have to respect the art of the whole filmmaking process, the craft, and the technology as well as the artist making the film. And to do that, you need facilities like this, like you have at Indiana University. You also need the research facility side, like you have at the various archives. Because we are nothing as filmmakers unless we can not only talk about films but research film, study film, read screenplays, and to look at the films that were made long before we were on this planet.

MICHAEL SCHULTZ

In early November 2018, the BFC/A and IU Cinema celebrated the fifty-year career of filmmaker Michael Schultz with the series Young, Gifted, and Black: Michael Schultz Celebrates Fifty Years in Stage and Screen.

Among the very first African American directors to work within the Hollywood studio system, Schultz thrived with a number of popular, broadly appealing films that bore his trademarks of positivity in representation and integrity in production. At a Directors Guild of America tribute to Schultz in 2011, filmmaker Taylor Hackford praised Schultz, saying, "Michael has done as much to open doors to directors of color as anyone in this industry."

The visit and series marked a reunion as well, taking place thirty years after Schultz's previous visit to Indiana University with his wife and creative partner, Gloria Schultz. During their 1987 visit, Schultz told the BFC/A in an interview, "I want to see exist in this country a Black film industry. . . . There are now enough people trained in all the disciplines and all the business areas of the industry to really make that happen."

IU Cinema and IULMIA presented a selection of the award-winning director's most exuberant films from the dawning years of the hip-hop age as well as a Jorgensen Guest Filmmaker program, which took the form of an extended onstage interview with curator and writer Sergio Mims. The visit even included birthday cake and a toast!

This multidisciplinary partnership was supported through IU Cinema's Creative Collaborations program and sponsored by the BFC/A; IU Office of the Bicentennial; Archives of African American Music and Culture; the Media School; Office of the Vice President for Diversity, Equity, and Multicultural Affairs; and IU Cinema.

While on campus, Schultz agreed to take part in an interview with Founding Director Jon Vickers titled "Michael Schultz: An IU Cinema Exclusive."

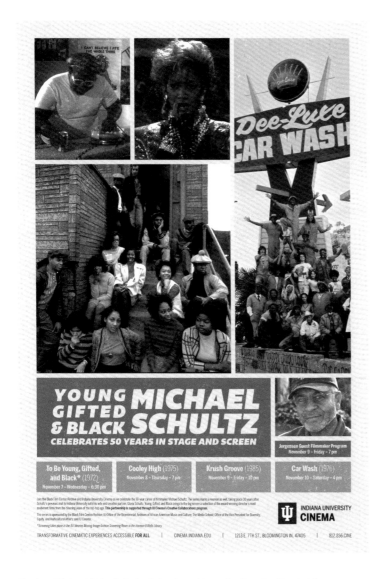

Facing: Michael Schultz being interviewed by writer/curator Sergio Mims in IU Cinema on November 10, 2018, as a Jorgensen Guest Filmmaker event. Chaz Mottinger/IU Studios

Top: IU Cinema poster for Young, Gifted, and Black: Michael Schultz Celebrates Fifty Years in Stage and Screen, November 2018. Kyle Calvert

> "What I hope people take away from my films is a sense of joy, of optimism, about the world that we live in and where we're going as a people."

Jon Vickers: Why is film such a powerful artform?

Michael Schultz: The breadth of experience that can be delivered to an audience through film is almost limitless. They can take you into worlds that you could never step into. We can create whatever worlds we want to, to transport the audience into lands and realms where they've never been.

JV: Do you have a film experience that changed your life or direction as a filmmaker?

MS: What inspired me to become a director, a storyteller, and a filmmaker was that I saw the absolute need to build bridges of understanding between cultures—our culture as African Americans, the dominant White culture in America, the world at large—and really tell stories that I felt other people needed to hear to have a better understanding of who we were. And that was the driving force in my wanting to do what I luckily wound up being able to do.

When I did Car Wash [1976], I was invited to the Moscow Film Festival. This was before the Iron Curtain came down, mid-'80s, maybe early '80s. So, they invited my wife and me to the festival, and Moscow was really this huge, gray, cavernous city, that we still had keepers that would follow us around, you know, or be afraid to take us into certain places, like some of the Coptic churches that we wanted to go see. They were deathly afraid that they'd be excommunicated from the Communist party if they were seen near a church. But the thing that was mind-blowing to us was that the Russian people were avid filmgoers.

They showed Car Wash in a theater that sat twenty-five hundred people, on this enormous screen, and they had the interpreter on a microphone interpreting all the characters' dialogue as the film was going on. But it was the largest film festival that I had ever seen, with films from Vietnam, from Japan, from Cambodia, from all of these countries that never got exposure in the States. And seeing the lines of Russians standing outside the theater, just hungering for exposure to other cultures and stories, was really inspiring. And I saw the power of cinema in a place where you'd never expect it.

JV: Why do you make films, and who are they for?

MS: Each film that I do or that I have done deals with a different theme or subject matter. And I try to choose material that kind of enlightens people about a situation or about a group of individuals that touches them, that makes them laugh, that kind of loosen them up and [makes them] realize that those people they're seeing on-screen are just like themselves. And what I hope people take away

from my films is a sense of joy, of optimism, about the world that we live in and where we're going as a people, and inspiration.

JV: What advice would you give to a young or emerging filmmaker?

MS: Always strive to tell the truth. Because in telling your truth, that is the most direct way to connect other people to who you are and what your story is. And more than all the make-believe in the world, the truth that emerges from your story is what touches people.

JV: What is the importance of moving image archives like we have here on campus?

MS: I am so thankful and grateful that the president of this university has the foresight and the vision to really put an emphasis on archiving, restoring films from the past, and saving those incredible artistic creations for future generations. The one thing—I mean, I'm a theater person by heart, and I love the theater—but when the theater is done, it's gone; it's ephemeral. The great thing about film—and I guess the

> "The arts are so critically important to the development of a well-rounded human being."

work that I've done in film kind of attests to that—is what I did forty years ago still resonates with people, younger people, today. So, the ability to hold on to that artistic creativity is vital.

JV: What is the importance of a good cinema on a university campus?

MS: I think it's critically important that a university has a cinema department, a theater department, a music department, an art department, a dance department. The arts are so critically important to the development of a well-rounded human being that if you don't feed that part of the student, you are turning out a slightly damaged individual, no matter how smart they are. If they don't have compassion . . . if they're not able to relate to other people and realize that we're all part of the same ecosystem, and that's what the arts do. Science does it to a degree, but the arts hit you in the heart, go beyond your intellect. And when the education system started minimizing the arts, we kind of knew that it was leading us on a road to kids, individuals, all of us, being harmed in a major way.

Right: Schultz with wife and creative partner Gloria Schultz in IU Cinema's lobby on November 10, 2018. Chaz Mottinger/ IU Studios

Facing: Actor Glenn Close sits outside IU Cinema before her April 2015 Jorgensen Guest Filmmaker event. Eric Rudd/ IU Studios

Bridging Unit Partnerships

As previously mentioned, Indiana University Bloomington actively promotes collaboration with an abundance of arts and humanities units eager to build multidisciplinary programs. There are several bridging units that initiate programs and have funding to support interesting and mutually beneficial collaborations. The College Arts and Humanities Institute (CAHI) within the College of Arts and Sciences as well as the IU Arts and Humanities Council (A&H Council) are two such units, dedicated to advancing campus arts and humanities initiatives.

In addition to these units, there are additional resources available to support visits from high-profile guests at the University. In 2011, IU Cinema nominated filmmaker Werner Herzog for a Patten Lectureship, the University's most esteemed lectureship dating back to the 1930s. It was approved, and Herzog spent five days on the Bloomington campus in 2012 as a guest of the William T. Patten Foundation and IU Cinema, with his honorarium and expenses funded by the foundation. Similarly, IU Cinema has participated in the nominations and awards of several honorary degrees to

filmmakers, including Peter Bogdanovich, Meryl Streep, Kevin Kline, Jonathan Banks, and Viola Davis. Each of these guests engaged with students outside of their public events.

Since opening, IU Cinema has actively looked for creative ways to advance the mission of the University and these bridging units through curated programs and filmmaker invitations, which also fulfill its programming goals.

> **"I think every university campus should have an amazing film and cinema program, not just for the makers but for the audience. Cinema allows us to capture and allows us to play back our lives, our world—the things that have changed, the things that need changing."**
>
> —Deborah Riley Draper, writer/director of *Olympic Pride, American Prejudice*; *Versailles '73: American Runway Revolution*; and *Illegal Rose*

WERNER HERZOG

In 2012, Werner Herzog accepted a lectureship from the William T. Patten Foundation to share his scholarship and talent with the community during a five-day stay. IU Cinema curated a program including two public lectures, introductions and Q&A sessions for several films in a ten-film retrospective, a Jorgensen Guest Filmmaker program, master classes with film students, a WFIU *Profiles* radio interview, and several additional public and private events. The week was considered by many faculty members to be the most intellectually stimulating campus visit by anyone in decades.

Herzog's range of work across artistic disciplines is unequalled. As of his 2012 visit to IU, he had directed more than fifty films and twenty opera productions on six continents and had published numerous books, screenplays, and articles, in addition to acting in the occasional film and TV series. Established as one of the leading figures of world cinema, Herzog has developed a powerful artistic vision with a capacity for critical reflection.

His first public event was a lecture titled "The Search for Ecstatic Truth." The lecture was scheduled to be held in Indiana Memorial Union's Whittenberger Auditorium, with a seating capacity of four hundred seats, compared to IU Cinema's two hundred sixty. The enthusiasm for Herzog's visit was incredibly high, and hundreds of people were turned away the first night after the space quickly reached capacity. Herzog's next Patten Lecture was moved to the IU Auditorium with a seating capacity of thirty-two hundred. The following pages contain a condensed transcription of that lecture, printed courtesy of the filmmaker.

Jon Vickers: A storyteller, Werner Herzog began his filmmaking career in 1961 with his short film *Herakles*, which he financed working as a welder so he could shoot on 35mm film. He was nineteen years old at the time. He has been a man of celluloid; even in today's changing cinematic landscape, he chooses to film with film, unless it is prohibitive for him to get at the truth. His work in this medium has garnered major international awards, critical acclaim, scholarly consideration, and audience favor, a combination that few filmmakers achieve.

He's made a career out of creating intelligent and challenging films which have a couple of things in common: an exploration of humanity and a quest for finding the most fundamental truths in life. A Herzog film is often infused with his own philosophies, interesting characters and character studies, distinct landscapes, and a sense of wonder. Werner Herzog's range of work across the disciplines of film, opera, and literature is difficult to match.

Poster for Werner Herzog: In Search of Ecstatic Truth, September 2012. Jon Vickers

"Facts do not necessarily constitute truth; otherwise the phone directory of Manhattan would be the 'Book of Books.'"

In a 2010 writing titled *The Absolute, the Sublime and Ecstatic Truth*, Werner Herzog wrote, "Our entire sense of reality has been called into question, but I do not want to dwell on this fact any longer since what moves me has never been reality, but a question that lies behind it." There is no living filmmaker who has maneuvered between fiction and nonfiction film quite as gracefully as Werner Herzog. His quest for truth challenges these lines, if there are lines. He even called his film *Fitzcarraldo* [1982] the best documentary of his career.

On behalf of the William T. Patten Foundation, please welcome filmmaker, opera director, poet, craftsman, tamer of wild actors, traveler by foot, articulator of dreams, surveyor of landscapes, seeker of truth, and, most importantly, storyteller Werner Herzog. [*applause*]

Werner Herzog: Ladies and gentlemen, I have to thank the Patten committee, and above all Jon Vickers, who got me into this mess. And, of course, Indermohan Virk [William T. Patten Foundation], who has managed the technical side and all the spirit that brought me here. I also have to thank the president of the University [Michael A. McRobbie], who has been very, very kind to me. I have accepted this invitation with some sort of anticipation, some sort of hesitation, because I am not a man of academia. I have been so much in conflict with academia that I founded my own film school, the Rogue Film School, which has only a few things that I actually taught. At the very beginning, I teach aspiring filmmakers how to pick locks and get into places where they have to get in, and I teach them how to forge documents.

A film like *Fitzcarraldo* could not have been made without major forgery of a shooting permit, which allowed me pretty much everything after I was stopped by military moving and navigating on the Rio Marañón in the northern part of Peru, close to the Ecuadorian border. . . .

I'm here tonight to talk about ecstatic truth, the ecstasy. Of course, about fact as well, facts and truth, because they are not necessarily related. Facts do not necessarily constitute truth; otherwise the phone directory of Manhattan would be the "Book of Books." It has four million entries that are factually and verifiably correct, yet it doesn't inspire anyone. I do not wish my worst enemy to read the entire phone directory of Manhattan. I have spent some time into understanding what are the postulates for a film and where can you find a deeper truth, which lies somehow behind things which can be discovered, which can be articulated. Not in all cases. You have to really work very intensively and search with great fervor, and it's sometimes like a gift of God that has fallen into my lap. Of course, I was also searching for it.

We have to start with this fact, which, in a way, has influenced our daily lives a lot. That is a massive onslaught on our sense of reality. There is reality TV, there is Photoshop, there are digital effects in cinema, we have credible depictions of dinosaurs in cinema—which is a fantastic tool—we have virtual realities and the Internet, we have video games, and we have things that are completely new. Our sense of reality is challenged like never before in such a short span of time.

Of course, it has created confusion and insecurity. I would like to mention one incident which gave me to think, and I have not finished thinking about it. About thirty years ago in Venice—the beach of Los Angeles—I spent an evening at the house of a friend, and all of the sudden, a helicopter started to circle with its searchlight down on us. We were in the garden and had grilled some hot dogs. There was a voice from the helicopter loudspeaker: "Get into the house, take cover, go inside, go inside, move inside!" Only the next day we learned what had happened. Around the corner at a restaurant, a young kid about thirteen or fourteen years old with a skateboard was loitering outside of the restaurant. A young couple that left around 9 p.m. was confronted by him with a gun. He shot them both, and killed, I think, the man. The woman survived. Killed a man and shouted, "This is for real, this is for real," and fled on his skateboard.

What is interesting about this case is that this young kid was not out for robbing; he was not taking money. Apparently, he wanted to make a point: this is not a video game; this is for real. So, it has stuck with me, and of course I have wrestled with the question "What constitutes truth in cinema?" Cinema verité, which is very much fact oriented, has had its day. It had its great time in the 1960s, and, ultimately, it was the answer of the 1960s. But today we have a new situation, and filmmaking in particular has to find a new attitude, a new position towards the elements that constitute our reality and, deep behind that, what constitutes truth.

I was sick and tired doing battle with cinema verité people, and I wrote a manifesto which is called the *Minnesota Declaration*. I wrote this very quickly during the night. I was jet-lagged in Italy and couldn't sleep, turned on the television set and there was a lousy, really stupid documentary, and I thought, "This is what never should be shown again on television." But until today, you have the same things going on. I was up again at three in the morning, and on Italian television you can see hardcore pornos. As I switched around, all of the sudden, there is a hardcore porno, and I thought, "Finally, this is the naked truth." There is something much more direct, much more physical, much more truthful than all these phony documentaries.

So, I wrote the *Minnesota Declaration*, in fact, because I was invited to Minnesota, to the Walker Art Center in Minneapolis, and I didn't want to come with empty hands. I read to the audience the *Minnesota Declaration* and asked that it be accepted by way of acclamation. I got the acclamation for the first time in my life, getting 100 percent response in favor of what I did. *The Minnesota Declaration: Truth and Fact* in Documentary Cinema, also called *Lessons of Darkness*, which later became the title of a film:

One: *By dint of declaration, the so-called cinema verité is devoid of verité. It reaches a merely superficial truth, the truth of accountants.* That has really miffed the cinema verité people, because I do battle with them, and I call them "the accountants of truth." This has really stung them. Now, I'll just go randomly through it.

Three: *Cinema verité confounds fact and truth and thus plows only stones; and yet, facts sometimes have a strange and bizarre power that makes their inherent truth seem unbelievable.*

Four has a strange short one, a dictum.

Four: *Fact creates norms, and truth, illumination.*

> "I was sick and tired doing battle with cinema verité people, and I wrote a manifesto which is called the *Minnesota Declaration*."

Five: *There are deeper strata of truth in cinema, and there is such a thing as poetic, ecstatic truth. It is mysterious and elusive and can be reached only through fabrication, and imagination, and stylization.* This is an important point because it has really influenced what I'm doing. I will show some excerpts of films, and I will also read some texts to you that have some kind of ecstasy of truth in it.

Ten: *The moon is dull. Mother Nature doesn't call, doesn't speak to you. . . .* You hear this always from these New Age bozos, "Mother Nature speaks to you." *The moon is dull, Mother Nature doesn't call, doesn't speak to you, although a glacier eventually farts. . . .* They actually do that because they move, and it's very, very strange to hear a glacier fart. And then it continues . . . *and don't you listen to the song of life.* This is a direct quote from a famous actress, a Hollywood actress—I don't want to name her name—and at age eighty, she did a film on herself. She was asked

Herzog delivers his Pattern Lecture on September 11, 2012.
Chris Meyer/IU Studios

by an interviewer, "Miss"—(I avoid the name now)—"can you pass something on to all the young new generations and the generations to come?" She pretends to be thinking and thinking, tears well up in her eyes, and after a long, long, long pause of fake thinking, she says, "Listen to the song of life." I mean, it can't get any worse. So, now I have an answer to that.

Eleven: *We ought to be grateful that the universe out there knows no smile.* And it ends with . . .

Twelve: *Life in the oceans must be sheer hell. A vast, merciless hell of permanent and immediate danger, so much of hell that during evolution some species—including men—crawled, fled onto some small continents of solid land where the Lessons of Darkness continue.*

So, that's the *Minnesota Declaration.*

I will share a very recent discovery for me, a writer who I will quote in one or two passages, short passages. He has been quite important for me. His name is J. A. Baker, and he wrote a book, *The Peregrine* [HarperCollins], which was published in 1967. We know nothing about the man who wrote it; we don't even know the year when he died. Nothing biographical has come down to us. He observed peregrine falcons, which were, because of pesticides, at the verge of extinction. Baker has written prose of unimaginable beauty and intensity. He has a direct and immediate sense of ecstasy. His writing is intense and incantatory, and the act of birdwatching becomes one of a sacred ritual. *The Peregrine* is not a book about watching birds; it's about becoming a bird. Early on, Baker sets out his manifesto of pursuit: "Wherever he goes, this winter, I will follow him. I will share the fear, and the exaltation, and the boredom, of the hunting life. I will follow him till my predatory human shape no longer darkens in terror the shaken kaleidoscope of color that stains the deep fovea of his brilliant eye. My pagan head shall sink into the winter land, and there be purified."

It's very, very strange and beautiful, and he writes: "The body of a wood pigeon lay breast upward on a mass of soft white feathers. The head had been eaten. The bones were still dark red, the blood still wet. I found myself crouching over the kill, like a mantling hawk. My eyes turned quickly about, alert for the walking heads of men. Unconsciously I was imitating the movements of a hawk, as in some primitive ritual; the hunter becoming the thing he hunts. . . . We live, in these days in the open, the same ecstatic fearful life. We shun men."

All of the sudden he writes in plural "we," as if he had become a fellow hawk. There's some sort of a metamorphosis, an ecstatic metamorphosis, where he steps outside of his own human limitations and morphs into a peregrine falcon.

He's a very, very significant writer who has become important for me because I have the feeling that a filmmaker should, in fact, read this book. The intensity of watching the world out there and the love of being engaged with what he sees is something you have to have as a filmmaker, and I believe you have to have the same sort of intensity and ecstasy when you're a writer. He has become known to me only last year. All of the sudden, it's as if I had found a fellow in spirit. Anyway, I could read the whole book to you, but I won't. It is, of course, invention and fabrication that can lead to a deeper level of truth. In fact, what I have done in some films, I have tried to elevate the audience into a sphere of the sublime and never let them down from it.

> "I have tried to elevate the audience into a sphere of the sublime and never let them down from it."

A good example of that is a film which is called *Lessons of Darkness*. I filmed the fires in Kuwait when seven hundred fifty or so oil wells were set on fire by retreating Iraqi troops. The film is not a political film, as it was such an unseen sight, such an unbelievable thing, such a crime against—not a political crime, in my opinion—creation itself. I wanted to elevate the audience into a very, very high level before they even enter the film. I put a quote, a written caption, ahead of the film, a quote of Blaise Pascal, the French philosopher. It reads: "The collapse of the stellar universe will occur, like creation, in grandiose splendor," and I attributed it to Blaise Pascal. Fact is, these words that I attributed to Blaise Pascal are not by Pascal but by me. I invented them, and I have to say, Pascal couldn't have said it better anyway.

It's obvious. I was immediately blamed: "You are faking." I am not. I am elevating. I do certain things that are not factually true but yet of immense value for the truthfulness of the film. . . .

For example, landscapes have come across my inner eye, and I would like to show you a few images of a painter, Hercules Segers. Hercules Segers is early Rembrandt time, 1620s, only Rembrandt took him seriously. He articulated landscapes and images that only were seen three hundred or four hundred years later. You have to imagine, this is 1620, 1630. This is absolutely incredible. In fact, I made an installation at the Whitney Museum which is called *Hearsay of the Soul*, which is music and mostly these kinds of images. Now, this is four hundred years ago, and he's a father of modernity. He was a

visionary and has been of great, great importance for me. I cannot really describe this because I have not literally learned from Hercules Segers. My images and his images do not talk to each other, but I have a suspicion that they would dance with each other if they met. These images are dancing with each other. I was very proud that I did an installation for the Biennial of the Whitney Museum this spring. I am not really into contemporary art. I had some hesitation at first to do it, but now I'm proud.

I came across an ecstatic image very early on when I traveled on foot once, the entire length of the island of Crete. I was fifteen years old, and in the mountains I would walk. I came across an image where I believed, "This cannot be true." I sat down, and I knew I was insane. Either I was insane or there was some sort of a mirage out there that I witnessed. This image became the central image of my first long feature film, *Signs of Life*. [*reviewing slides on screen*]

The film was shot in 1967. At that time, there were no digital tricks; it is really ten thousand windmills. It's in the valley, about fourteen hundred meters high, the plateau of Lasithi. I didn't know that it existed; I just came, and that's why the film takes a lot of time in approaching it. You do not suspect anything. You're exhausted. All of the sudden you look down into this valley, and there are ten thousand windmills, which by the way, as I learned later, pumped water into the field. They are all dismantled now—it's all electrified with electric pumps now. It doesn't exist anymore. It was the first moment in my life which, at age fifteen, made it clear I had to be a filmmaker. I had to bring across a vision of that depth and an ecstasy of a vision that was indescribable. It can only be described in terms of cinema. This was my first encounter, so to speak.

My friends told me, "You are lying. This is all hearsay." *Hearsay* is a term that's stuck with me, that has fascinated me, because hearsay is a specific form of truth. Not in all cases, but it can actually become a form of truth. In fact, I named the installation at the Whitney Museum *Hearsay of the Soul*.

I came across this during the shooting of *Fitzcarraldo*. The native Indians, as a part of being paid for their services as extras, asked me to support them in their quest to get a title for their land. Of course, there were a couple of obstacles. Number one, there was no clear delineation of their territory; there was no map. I engaged a land surveyor who created a map, and I had some very strange discourse with him about the truth of a map. He said, "This map, although I made it as precise as it could get, is incorrect, because it does not show the curvature of the earth." It was a terrain of, let's say, ten miles

by twenty miles, and that was about it. I was puzzled. He took my glass of water in front of me, and he said, "Even the surface of this water here is not a flat surface; it has a curvature of the planet Earth on it as well." I do not forget that, because still, a surface of water, of a lake, even the surface of this water here, in a way, has minimal form, the curvature of our planet. Still, I couldn't get a land title for them. I engaged lawyers. I tried bribery. I tried everything and got lost in the labyrinthic bureaucracy of the jungle of Peru.

Ultimately, I brought two representatives of the village with me to the capital city of Lima and had an audience with the president— actually [Fernando] Belaúnde, whom I met then in person with these people—and it was a strange discourse. Belaúnde did not buy the argument that these people had lived since time immemorial in this area. He said, "Yes, I understand emotionally that these people belong there, but in legal terms, I cannot accept this quest." I said to him, "There is such a thing as hearsay. For generations and generations, the natives have passed on the knowledge that they belong here, their grandfathers have told them, they are telling their children, and it's all hearsay; it's nothing but hearsay."

In a way, it was hopeless. I said to Belaúnde, at that time the notion of hearsay has even been accepted into Anglo-Saxon common law. It goes back to a case—in English Common Law, it's basically prece-dence—and there was a precedent in 1916 in the colony of the Gold Coast, which today is Ghana. It's a famous case, *Angu v. Atta*. Two tribal chiefs were quarrelling over the use of a government mansion. A British court decided then for one of them, for Angu, because the hearsay of tribal people was so overwhelming and condensed into such an amount of evidence, that in court, all of the sudden hearsay was believed, and to be ruled admissible. I remember Belaúnde said, "*Diosito mio*, lordy lord," and I knew we had won him over.

What was also interesting—and I call this a truth of the ocean— we took representatives of that village to the Pacific. They were com-pletely mesmerized by the Pacific Ocean because they had only heard of it. They had orders from the other villagers back home to bring, as proof that there really was an ocean, a bottle full of ocean water. They wanted to have a particularly clean bottle. I bought a cheap bottle of Chilean wine, poured it into the sand, and had it cleaned

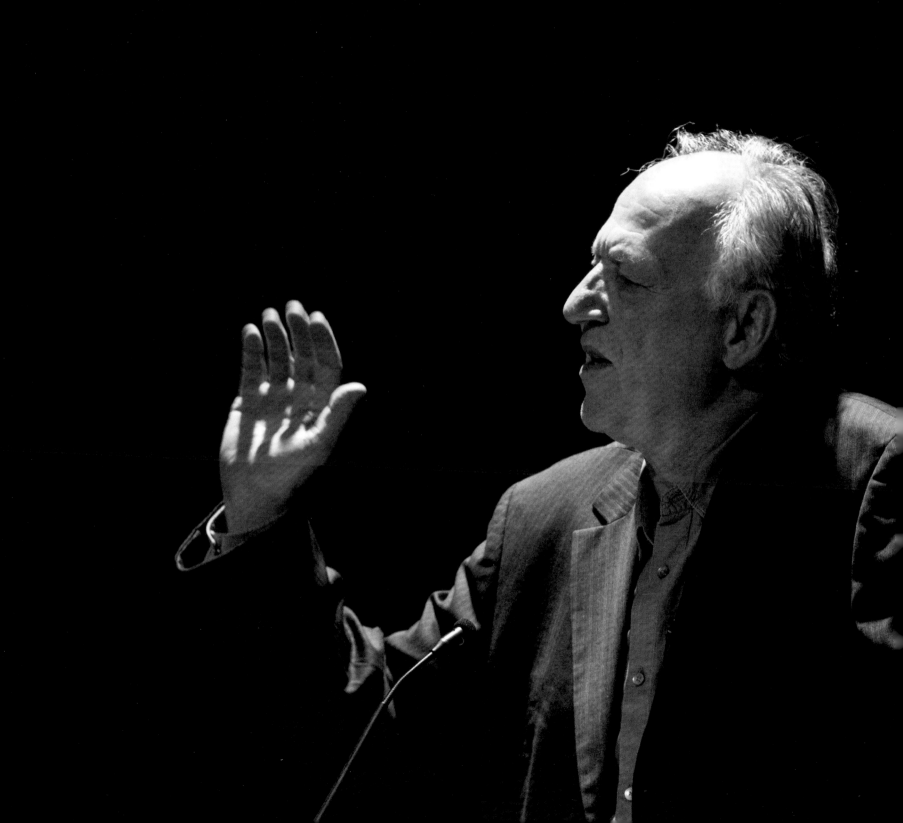

in the kitchen. It had a good cork on it. They waded out into the ocean up to their armpits, stared at the ocean, then solemnly filled the bottle with ocean water and closed it with a cork. They wanted to bring it as proof there was really an ocean. I said to them, just because I didn't know what to do and what to say, almost like a joke: "What does it mean to have just one bottle of water? Does this represent the entire ocean?" They replied, "Yes. If this bottle has the truth in it, the whole ocean is true." I do not forget that moment. I recognized certain things that are parallel with my own work.

I would like to speak about an ancient Greek writer who lived probably in the first century of our age. We do not know anything about him. He wrote about the sublime, and he wrote about ecstasy and some sort of ecstatic truth. [Cassius] Longinus wrote his essay *On the Sublime* in a way that cannot be completely verified, because the only codex that exists in Paris at the National Library, dating back to the tenth century from Byzantium, is incomplete. There are gaps in it, whole bundles of pages missing. But what is left is very, very beautiful and very significant, and I have learned a lot. I owe Longinus a lot. He writes about ecstasy, and about experiences, but always based on literature.

> "I've had moments of illumination like a thunderbolt."

What is fascinating is that at the very beginning of his text, Longinus invokes a concept of ecstasy, even if he does so in a different context than what I have identified as ecstatic truth. With reference rhetoric, Longinus says: "Whatever is sublime does not lead the listeners to persuasion but to a state of ecstasy; at every time and in every way imposing speech, with the spell it throws over us, prevails over that which aims at persuasion and gratification. Our persuasions we can usually control, but the influences of the sublime bring power and irresistible might to bear, and reign supreme over every hearer."

Here he uses the concept of *ekstasis*, a person's stepping out of himself into an elevated state—where we can raise ourselves over our own nature—which the sublime reveals "at once, like a thunderbolt." Once like a thunderbolt, he describes it. I've had moments of illumination like a thunderbolt, and I understand completely what he's saying to us. Nobody has spoken so clearly about the experience of illumination, and I am taking the liberty to apply that notion to rare and fleeting moments in film. What he does, of course, is all in literature. He quotes Homer in order to demonstrate the sublimity of images in the illuminating effect. Here's an example from *The Battle of the Gods*, and now he quotes Homer: "Aidoneus, Lord of the Shades, in fear leapt he from his throne and cried aloud, lest above him the earth be cloven by Poseidon, the Shaker of Earth, and his abode be made plain to view for mortals and immortals—the dread and dank abode, wherefore the very gods have loathing: so great was the din that arose when the gods clashed in strife."

What is interesting is that Longinus, who was very well read and quotes very, very precisely, in this case, commits a forgery: he actually combines two very different quotes from the Iliad, which he combined into one quote. I do not think it's a mistake by him. I believe there was a clear pattern of what he did. It's not really faking but rather conceiving a new, deeper truth. He asserts that, without truth in greatness of soul, the sublime cannot come into being.

He quotes a statement that researchers today ascribe either to Pythagoras or Demosthenes: "For truly beautiful is the statement of the man who, in response to the question of what we have in common with the gods, answered: the ability to do good and truth." In this case, we should not translate his, in ancient Greek, *euergesia* simply with the "charity," imprinted as that notion is by Christian culture. Nor is the Greek word for truth, *alêtheia*, simple to grasp. Etymologically speaking, it comes from the verb *lanthanein*, which means "to hide," and the related word *lêthos*, "the hidden," "the concealed." *Alêtheia* therefore is a form of a negation, a negative definition which means "the not hidden," "the revealed," "the truth."

Thinking through language, the Greeks meant, therefore, to define truth as an act of disclosure—a gesture related to cinema, where an object is set into the light, and then a latent, not-yet-visible image is conjured onto celluloid where it first must be developed and then disclosed. So, it's a process of exposing celluloid to light and then working on it with chemistry, and expose and bring to life a latent image; it's almost like cinema. What is interesting that he always points out is that it's not the language itself, it's not the poetry itself, and I add: it's not film itself that creates all this. The soul of the listener or the spectator completes this act itself. It's very important that we as an audience somehow complete this act. The soul actualizes this truth through the experience of sublimity that completes an independent act of creation. Longinus says, "For our soul is raised out of nature through the truly sublime, sways with high spirits, and is filled with proud joy, as it itself had created what it hears."

So, as if he had created the vision or the poetry in ourselves. This is, in fact, the work that filmmakers have to do. We have to work towards an audience that complements it, that creates the truth that absorbs it, that illuminates their existences individually from themselves.

It's amazing that I find this concept back two thousand years ago, and it has become very important for me. I would like to show you an example from *Bells of the Deep* [1993]. We have one excerpt, but I shortened it a little bit.

A pilgrim seeking a vision of the city of Kitezh, a sunken city which rejoices at the bottom of a bottomless lake, and pilgrims are coming. They are coming in winter as well and crawl out on very thin ice to catch a glimpse of it. [*reviewing film clip on screen*] This is one of the pilgrims, and this is the real sound, the very scary sound of thin ice. . . . Here the pilgrims are out there crawling on the ice, and we hear the bells from the deep. Now, you should know that they were not real pilgrims; they were paid extras. I picked them up in the country, and both were pretty drunk. The man in the background was so drunk that he fell asleep. I had to wake him up, and then I filmed Jesus, who was really wonderful [*translating lines from* Bells of the Deep]:

> Furthermore, I should grant my blessing onto your mature hearts, the ones that were able to perceive the magnificent Word which hath been vouchsafed unto your ears. I should give ye the strength. Be prepared to receive it, but listen attentively to your hearts. Verily, verily, I say unto you, ye shall be openly divided upon this earth into the powers of light and darkness this very year. Ye shall be divided into the wheat and the chaff. But then the harvest will begin, so hearken unto your hearts: The Lord will not leave anything undone. He maketh no mistakes. But your minds will err; listen to your hearts, for only a blind man we failed to see the gifts of the Lord. Receive the glorious blessing of the Father. Be ye blessed. May peace and happiness and love be with ye. Amen.

It's actually the end of the film. A few things I would like to note, of course. Very devout pilgrims will crawl on all fours all around the lake, but during summer nobody would ever go there on the ice and try to catch a glimpse of the sunken city, the mythological sunken city of Kitezh. It is an invention, yet the film was shown to wide audiences in Russia. The sequence they loved most were about the pilgrims on thin ice. They didn't really mind that it was an invention. The film is about faith and superstition in Russia. This Jesus who shows up in the film at various points at the end is all so organized. I asked him to stand in front of Yenisei River in Siberia. I asked him, "Would you like to give your blessing to the audiences that are out there?" He said, "Gladly, I will speak through the Father, through the Lord in heaven I will speak to you," and he blesses us. It was an

organized event, and yet very, very beautiful. Because of this, and because of the music, the images transform into something very sublime, something very strange. The people you see on the ice look like people sunk in prayer. They look like pilgrims. But they are not; they're all fishing through holes in the ice. I stage, and I fabricate; it's not like a documentary normally would be done. I do it for the sake of some sort of a deeper illumination for the audience out there.

For me, the question has always been, what are the concomitants, the natural concomitants of ecstasy, of a truth that becomes ecstatic. Sometimes, I have noticed it is pain. Pain is a natural ally, a natural concomitant of the sublime and of the ecstatic.

Sometimes ecstasy is linked to overcoming the laws of nature where we step outside of ourselves; where we can defy gravity like in dreams; where we fly; where we can do things that are not possible unless we are imagining them—unless we describe it in cinema or in poetry. I would like to read a short passage from my book *Conquest of the Useless* [Ecco, 2004]. It in a way speaks also about the sublime. "Iquitos, 12th of July, 1981. Deathly silence in the town. No one out on the street because it is census time. The birds kept still as if in exhaustion. The jungle did not stir. It was like a muggy July afternoon above fields of ripe grain shimmering in the heat. A desolate day out of which all life had been drained. In my hut, which is more and more empty, the sublime and the ghostly have taken up residence like siblings who no longer speak to one another."

> **"Pain is a natural ally, a natural concomitant of the sublime and of the ecstatic."**

The book is full of these very strange moments, and, of course, there is a moment where ecstasy and emptiness somehow go hand in hand. Also, a good comrade for ecstasy is emptiness; it's a void. I would like to read you next, although it's not completely void, the moment when I moved—after a long, long, long effort—a 320-ton ship over a mountain. It describes a moment that is very strange because I was outside of myself at that moment, and I describe it in such a way:

> Once half the ship was in the water, it keeled over so breathtakingly to the side against the current that it seemed inevitable that the boat would capsize and sink. Tossing and turning in a confused, chaotic fever dream, the ship heaved from one side to the other. I lost sight of the *Caterpillar* which had bravely jammed itself under the tipping boat, so I ran around the ship, out of range of the camera. As I did so, my bare feet came down on the razor-sharp shards of a broken beer bottle which Indians had left lying in the mud

after their nocturnal fiesta. I noticed that I was bleeding profusely, and that there were lots of other shards lying around. Rushing on, I was paying more attention to the broken glass than to the ship, which I assume was a goner. By the time I had reached the other side of the ship, the *Caterpillar* had already sunk its blade with brute strength under the ship's hull, with the result that the railing—which was almost scraping the ground—was crushed with a terrible crunching sound. But the ship, by now almost entirely in the water, righted itself. I did not feel my bleeding foot. The ship meant nothing to me, it held no more value than some broken old beer bottle in the mud, than any steel cable whipping around itself on the ground. There was no pain, no joy, no excitement, no relief, no happiness, no sound, not even a deep breath. All I grasped was a

profound uselessness, or to be more precise, I had merely penetrated deeper into its mysterious realm. I saw the ship return to its element, right itself with a weary sigh. Today, on Wednesday, the 4th of November, 1981, shortly after 12:00 noon, we got the ship from the Rio Camisia over a mountain into the Rio Urubamba. All that is to be reported it is this: I took part.

It is very strange because it's such a significant moment, and yet it is devoid of all meaning and devoid of all substance. It should be the center of everything, and the glass shard in the mud is as important as an entire ship. Later I returned to the area where we

Herzog and Provost Professor Gregory Waller onstage during a Jorgensen Guest Filmmaker event, September 14, 2012. Chris Meyer/IU Studios

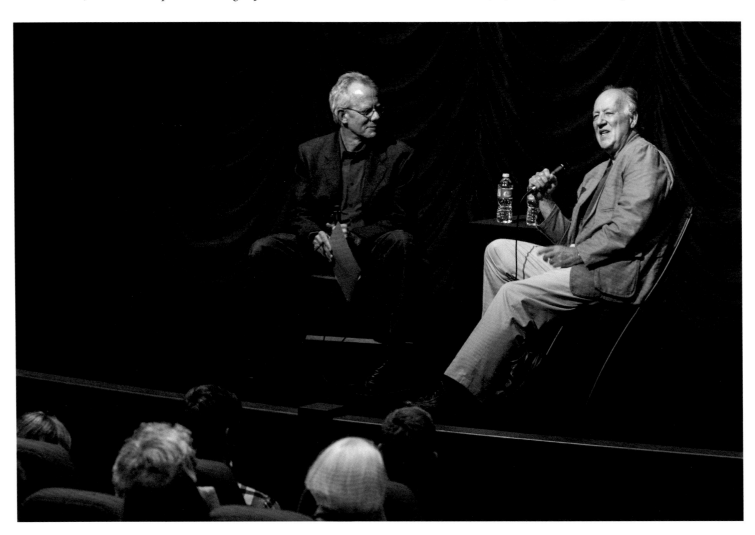

had moved the ship over the mountain and actually met some of the native men who had offered to kill [Klaus] Kinski for me, which I refused. I wrote the following, which is in *Conquest of the Useless*: "It was midday and very still. I looked around, because everything was so motionless. I recognized the jungle as something familiar, something I had inside me, and I knew that I loved it, yet against my better judgment. Then words came back to me that had been circling, swirling inside me through all those years: 'Hearken. Heifer. Hoarfrost. Denizens of the crag. Will-o'-the-wisp. Hogwash. Uncouth. Flotsam. Fiend.' Only now did it seem as though I could escape from the vortex of words."

These words were really in me, like a vortex, for many, many years. When I got rid of them, I was devoid of them, all of the sudden. I continue:

> Something struck me; a change that actually was no change at all. I had simply not noticed it when I was working here. There had been an odd tension hovering over the huts, a brooding hostility. The native families hardly had any contact with each other, as if a feud reigned among them. But I had always overlooked that somehow or denied it. Only the children had played together. Now, as I made my way past the huts and asked for directions, it was hardly possible to get one family to acknowledge another. The seething hatred was undeniable, as if something like a climate of vengeance prevailed, from hut to hut, from family to family, from clan to clan. I looked around, and there was a jungle manifesting the same seething hatred, wrathful and steaming, while the river flowed by in majestic indifference and scornful condescension, ignoring everything; the plight of Man, the burden of dreams, and the torments of time.

This shows how strange a revisiting of a place, with the solitude and motionless indifference of nature, all of the sudden elevates itself. It's very, very hard to describe. I couldn't do it in a film; I could do it only in language. By the way, language was—in all the turmoil and all the catastrophes that happened—always my last resort. Some other people would become religious, some people would go into drugs, or God knows what, but for me, it was language.

Of course, ecstasy also very often comes with solitude, and you can experience that when you travel on foot. I keep encouraging my students at the Rogue Film School: travel on foot. This is important, and

it will reveal a lot to you. Of course, [I] also encourage them to enter the world and engage yourself where there's just raw life. Work as a bouncer in the sex club, work as a guard, as a warden in a lunatic asylum, do things like that. That will make you a film-maker, not four or five years in film school. I was traveling on foot from Munich to Paris in winter, because my mentor Lotte Eisner was something like eighty years old. Nobody knew her exact age, because she started to celebrate her seventy-fifth birthday a couple of times over. She was of great importance for me for the new budding New German Cinema. I got a call, "Lotte's dying. Come quickly." I decided I wouldn't fly, I wouldn't take a train or a car, I would travel on foot, because I would not allow her to die. She was not going to die, because I would not allow it. I would travel on foot, and every single step was a pilgrimage and a protest against it. She was not going to die, because I would not allow her to.

"It had to do in a way with ecstasy and solitude, which are very good companions."

She was important for us because she was not only my mentor; she was, in a way, the consciousness of the German Cinema. Germany, in the time of barbarism, had either expelled their best filmmakers, killed them off, or they sided with the barbarism of the Nazi regime. We had no fathers; we only had grandfathers, filmmakers of the 1920s, of the silent era. Fritz Lang, [F. W.] Murnau, [G. W.] Pabst, and many others. She made the connection, put us in touch with that cinema. She sent *Signs of Life* to Fritz Lang, who was bitter and old and dwindling away somewhere in Beverly Hills. She sent him my film and said, "Fritz, finally there are films again in Germany." Fritz wrote back, "No, this is not possible." He saw the film, and it changed his mind, in a way. I'm very grateful to her. I set out traveling on foot. It had to do in a way with ecstasy and solitude, which are very good companions. It was snowing, ice, cold, and sometimes there were rainy days. It was always a very hard struggle to walk against the storm, eight hundred kilometers from Munich to Paris.

I would like to read to you the very end, when I met Lotte Eisner, and she was out of hospital. Actually, she lived eight or nine more years. She called me and said, "Come to Paris. Come quickly this time. Come by plane." So, I flew to Paris and visited her. She said to me, "Listen. I am almost blind now. I cannot read anymore. The joy of my life, to be in a movie theater, I cannot experience anymore. I can barely walk. This is now a good time for me to die, but there's still this spell upon me from you that I must not die. Can you lift it?" I said, "Lotte, hereby it is lifted." She died nine days later. I would like to read from this moment when I arrived at her place.

As afterthought just this: I went to Madame Eisner, she was still tired and marked by her illness. Someone must have told her on the phone that I had come on foot. I didn't want to mention it. I was embarrassed and placed my smarting legs up on a second armchair, which she pushed over to me. In the embarrassment a thought passed through my head, and, since the situation was strange anyway, I told it to her. Together, I said, we shall boil fire and stop fish. Then she looked at me and smiled very delicately, and since she knew that I was alone on foot and therefore unprotected, she understood me. For one splendid, fleeting moment something mellow flowed through my deadly tired body. I said to her, open the window, from these last days onward I can fly.

That is the end of this short book *Of Walking in Ice* [University of Minnesota Press, 2007], which is very dear to my heart. There is also something like solitude in flight. Something like an ecstasy that you can experience, for example, flying without real instruments, without a plane. As an adolescent, I was into ski jumping, and I wanted to become a world champion of ski flying.

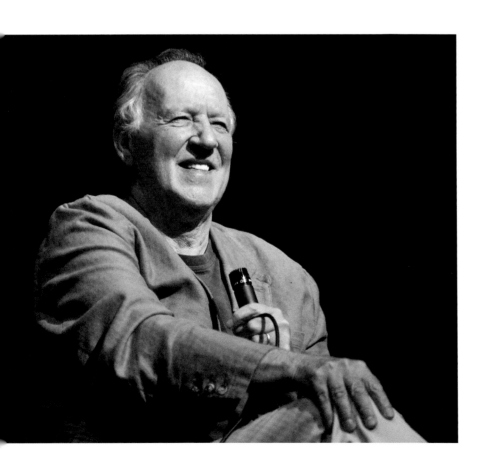

That was my dream, and before I was sixteen, my best friend had a catastrophic accident which almost killed him when I was all alone with him out at this ramp. It was so terrifying that I never did ski jumping or ski flying again. But, of course, I met a man, Walter Steiner, who was actually twice a world champion. He was a person who did what my dream was, to fly like him. I made a film before I ever thought about ecstasy and ecstatic truth, and the film is called *The Great Ecstasy of the Sculptor Steiner* [1974]. Walter Steiner, the Swiss ski flyer world champion, actually was a woodcarver. He made strange sculptures in his solitude, high up in the mountains. Nobody knew where. He would carve in the trunk and roots of a tree [shapes like] a terrified face. People who would climb and hike the mountain would discover them, but much of it is still hidden in the forest.

I would like to show you Steiner flying. There is a pure, absolute ecstasy in him. Watch his mouth, kind of ecstasy. On this ramp, he almost crashed to his death because he flew too far, almost into the plain, and that would crash you on the spot. [*reviewing film clip on screen*]

At the end of the film, you see Steiner in complete ecstasy, again too far—you see, when you are landing on these abysmally steep slopes, all the kinetic impact that you have somehow builds down slowly over a long stretch. If you jump from the Golden Gate Bridge onto concrete pavement, you would be crushed. Steiner flew too far, five times he flew too far, and had a concussion. For the whole day, he didn't know where he was, or who he was, but he continued flying. He continued competing, and he won this very competition in, at that time, Yugoslavia. He won it with a margin never seen before or after. At his last flight, a text is superimposed on-screen, which is, in a way, taken from the wonderful Swiss writer Robert Walser. I changed this text and inserted Steiner into it, and I would like to read this to you.

"I should be all alone in this world. Me, Steiner, and no other living being. No sun, no culture. I, naked on the high rock. No storm, no snow, no banks, no money, no time, and no breath. Then finally, I would not be afraid anymore."

Thank you very much for your attention.

Herzog at IU Cinema during his Jorgensen Guest Filmmaker event, September 14, 2012. Christian Doellner

KEVIN KLINE

In 2014, IU Cinema helped nominate actor and IU alumnus Kevin Kline for an honorary doctorate degree from Indiana University. On approval from the trustees and invitation by President Michael A. McRobbie, Kline scheduled a two-day visit to IU Bloomington in September 2014.

IU Cinema programmed eight public events around the visit, which included screenings of seven films, a Jorgensen Guest Filmmaker event, a master class with acting students, tours of facilities, private reception and meals, and a radio interview on WFIU's *Profiles* program. The Jorgensen event was in the form of an onstage interview, which was led by Jonathan Michaelsen, chair of IU's Department of Theatre, Drama, and Contemporary Dance, and was held immediately following the formal ceremony conferring Kline's honorary degree. The events offered several intimate opportunities for students, faculty, and community members to interact with the renowned actor.

Kline has seamlessly transitioned between the worlds of theater and film, earning equal distinction in both. He has received numerous awards, including an Academy Award for his iconic role in *A Fish Called Wanda* (1988) and two Tony Awards. He was also the first American actor to receive the Sir John Gielgud Golden Quill Award, was honored with the Lucille Lortel Award for Lifetime Achievement, and, in 2004, was inducted into the Theatre Hall of Fame.

On September 15, 2014, Kevin Kline sat for this *Profiles* interview with Founding Director Jon Vickers. *Profiles* is a production of WFIU and comes from the studios at Indiana University. James Gray produced the program, and the studio engineer was Michael Pascash.

Jon Vickers: Hello. My name is Jon Vickers, and welcome to *Profiles* from WFIU. On *Profiles*, we speak with noted writers, artists, scholars, and others to get to know the person behind the public image. Our guest today is the world-renowned actor for the stage and screen Kevin Kline. Welcome to *Profiles*.

Kevin Kline: Thank you very much. Pleasure to be here.

JV: It has also been an enormous privilege and pleasure to have you here on the campus of Indiana University, where this week, President Michael A. McRobbie bestowed upon you an honorary doctorate of humane letters for your accomplishments on the stage and screen. Congratulations!

KK: Thank you very much. I'm deeply honored.

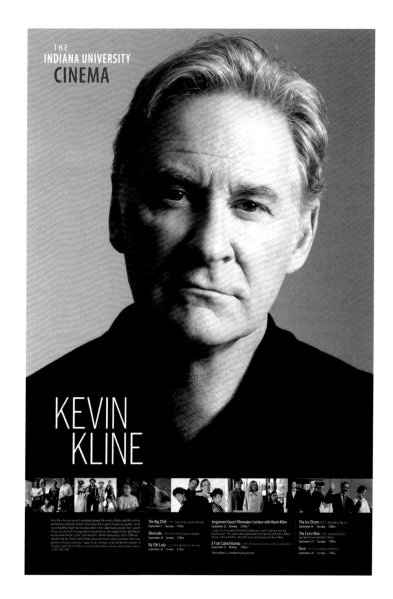

IU Cinema poster for Kevin Kline, September 2014. Jennifer Vickers

JV: This is a welcome home of sorts for you to Indiana University, where you did your undergraduate work in the late 1960s and early 1970s. So, what does it feel like to be back?

KK: It's extraordinarily nostalgic. And, as Yogi Berra said, "It's déjà vu all over again." It is unchanged in many ways, the campus—the same, only different. It's actually even prettier, one of the more beautiful campuses that I've ever visited. I toured the country in a rep company for four years and have been on a lot of college campuses. It's absolutely one of the most beautiful. I look at it now, and I think

things are landscaped even better. There are beautiful rock formations and flowers, and I don't recall Showalter Fountain having all that floral extravaganza around it. It was just a fountain. It's beautiful; in the fall, there's no place more beautiful.

JV: You grew up in St. Louis. So, as a young man from St. Louis, why did you choose Indiana University?

KK: Well, I decided at the very last minute. It was helped by the fact that I didn't get into Georgetown. The headmaster of my high school in St. Louis said, "You should go to Georgetown and study foreign diplomacy because you're good at languages and little else. And you're diplomatic." I think by that he meant, "You're the class clown, and you get away with murder somehow." However, my SAT scores were not all they should have been. I thought, "Okay, I didn't get in there; that's fine. I think I want to be a musician."

I studied music from the time I was twelve or thirteen, and luckily my parents were very close friends with Harry and Edith Farman. Harry was on the violin faculty here, and Edith was on the piano faculty. She was my first piano teacher, and he was the concertmaster and assistant conductor of the St. Louis Symphony. They helped arrange an audition for me. I came and played a couple of Bach preludes or something.

They let me in provisionally, if I would come to summer school to get some theory and a bit of practicing, because I was playing in a rock 'n' roll band at the time. I had—and still have—a very eclectic taste in music. I did not have the discipline, and it was clear to me after a semester or two that I was way, way out of my depths. I could at best aspire to be a mediocre musician.

JV: So, what did you do?

KK: I wanted to compose. I was fascinated by film music and wanted to compose film music. I also wanted to conduct orchestras. It's like at the age of thirty-five thinking, "I'll take up professional football or ballet." Music was so deeply instilled in me. From an early age, I was surrounded by great musicians, but I did not have the training or the discipline. Who did have that discipline? I also had in the back of my head that I wanted to try to take an acting class. I took Acting 101 and got hooked.

> "It is unchanged in many ways, the campus—
> the same, only different."

Kevin Kline being interviewed by Founding Director Jon Vickers
at IU Cinema on September 15, 2014. Eric Rudd/IU Studios

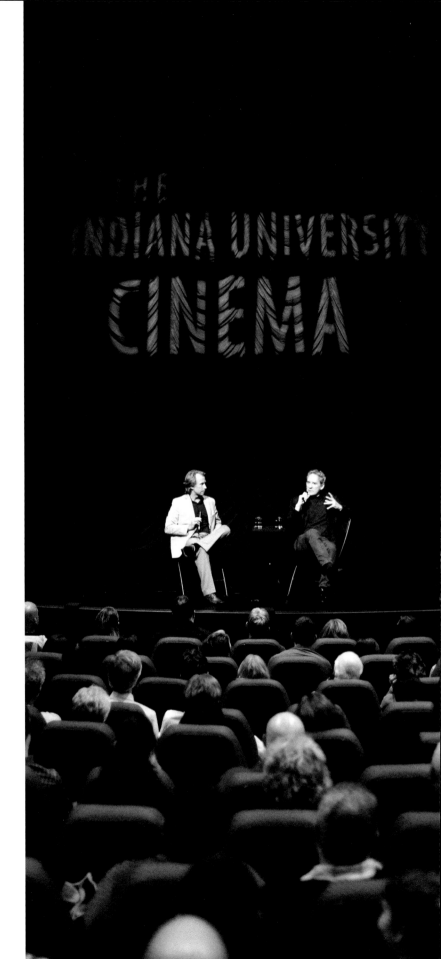

JV: After Acting 101 and the experience of rehearsing for a role and being onstage, is there a single defining moment where you thought, "Okay, it's time to change. Acting is something I think I can do, or at least for now, something I want to do"?

KK: I remember halfway through my sophomore year, I was doing plays on the main stage and in a little experimental theater while still being a music major. Whenever I'd play the piano for the guys and gals in the theater department, they said, "Oh, you play so well. I hope you're not going to give that up." When my musician friends would come and see me in plays, they would say, "You're really good at that. I think it's something you should pursue." So, the musicians were saying don't do music, and the actors were saying stick with the music. I did not have the kind of praise to think, "This is what I was born to do." I had no sense of that at all.

Finally, around junior year, I could see the future if I stayed with music. Part of my lack of discipline was the ability to sit in a room alone for hours and hours and practice music. Theater was much more of a communal experience. It's collaborative. There is nothing better than playing music with other people; making music together is the best. But making theater with people is exciting too.

I was not good when I started. I was very stiff, physically bound up, and emotionally limited. I think the turning point for me was when—after my first—after my freshman year, in those days, Indiana had *Showboat Majestic* down on the Ohio River, moored in Jeffersonville, Indiana.

JV: Was that a summer program?

KK: Yeah. It was one of the last years of the boat because it was deemed unworthy of river travel. So, we had to stay moored in Jeffersonville, just across from Louisville, Kentucky.

JV: Less romantic that way.

KK: Yeah, but you were still on this bobbing boat. When you went on land, your legs were a little shaky because you get used to living on this wavy thing. We were also swabbing the decks and stoking the furnace for the calliope concert every afternoon along with doing three plays at night and a variety show while living on the boat. It was very romantic and exciting. Most of the actors from that summer decided to stay together and form a little troupe off-campus at a coffeehouse called the Owl on Fourth Street. It was part of an

annex to a church or something. There was folk singing, and our troupe would do a weekly satirical and political review of that week's news. At the end of my sophomore year, they said we could have the coffeehouse to run and make into a coffeehouse theater.

We built a stage, lightboard, and lights out of coffee cans. On Tuesday nights, we did reader's theater. Wednesday nights were improv. Thursday nights were more sort of review-type shows, and on the weekends, we would host a playwright and perform his plays. One of the plays wasn't a musical, a play with music. I wrote the music for that play and started as sort of the pianist. I then got more and more acting parts, and my confidence and sense of authority, something every actor needs to feel confident onstage, really grew in leaps and bounds that summer.

JV: I would imagine because you were part of the process, right?

> "We were also swabbing the decks and stoking the furnace for the calliope concert every afternoon along with doing three plays at night and a variety show while living on the boat."

KK: This is my stage. I built it, yeah.

JV: You had ownership. You were creating the experiences. Did this help you feel like you could maybe take more risks or do what you wanted? It sounds like a great experience.

KK: Yeah, I just happened to fall in with this group because I was on the showboat that summer. It then became clear to me by the middle of my sophomore year that this is what I should be doing, not music. So, I segued out of the music school into the theater department.

JV: That probably gave you a better appreciation for theater companies in the future as well, that you're dealing with knowing, you know, I guess, what it takes to present shows.

KK: Yeah. It was a real ensemble collaboration. And very high-minded. I remember we would stay up all night, putting together shows for the weekend, writing manifestos of how we wanted to serve the community, what theater meant, and what we were about as the Vest Pocket Players.

JV: Speaking of manifestos, this was the late 1960s, early 1970s, and a pretty volatile time in America. As a student in the arts at Indiana University, a large state university, how did the times affect your work? Did you make political statements through the theater company?

KK: Well, yeah. While the [departmental] mainstage was devoted to giving the acting students the opportunity and experience of doing the known classics, I was doing the coffeehouse stuff, where we could be more revolutionary. The last thing I did at the Owl was after the

Vest Pocket Players had dissolved. I was one of the younger members, and everyone else had moved on to New York. We did *Viet Rock*, which is a Megan Terry play that they'd done at Caffe Cino in New York. It was very much an antiwar play with a lot of audience participation, audience confrontation. It was agitprop theater, and some members of the audience burned their draft cards at the end of the show.

JV: Wow, wow! So, you transformed people!

KK: Well, we certainly thought we were, you know? I think we did.

JV: Let's move on to New York. After graduating from IU, you enrolled in the newly formed drama division of Juilliard. Did you always know the next logical step would be New York City, or did someone encourage you to go to New York and find your way?

KK: Well, by then I had just played Prometheus and was a pretty big fish in a relatively small pond in the theater department. There were the TCG [Theatre Communications Group] auditions in Chicago, where all the regional repertory company directors would go to look for young talent. They also had them in New York, I think, San Francisco, and Los Angeles. Each school's theater department would send four or five of their top actors to audition. I went and auditioned with the opening speech from *Prometheus Bound*. Big mistake. Pretty inaccessible and very stylized. I didn't get called back. I was bummed. Whereas the other guys all got called back and sent on to the New York audition, or whatever the next step was. I was immediately defeated. But, a week later, I had my Juilliard audition.

My graduation present from my parents was a trip to New York to audition. I changed my audition piece. It's very competitive. I thought there is no way I'm going to get into this school, so I had nothing to lose and thought, oh, what the hell? I had a little more fun with the audition. Frankly, I think they just needed my type in the class because they just instituted a four-year advanced-acting program and needed to fill out the class. I actually entered the third year of the four-year program. One of the professors there said, "You know, we didn't have any leading men, so we needed your type." I must've done something right in the audition, but [I] was in the right place at the right time.

JV: Well, timing is important!

KK: Yeah.

JV: While in New York, you became a founding member of John Houseman's company, The Acting Company. With them, you did a tour of the US performing classics, is that correct? What was that experience like?

KK: Again, the right place at the right time. We were about to graduate and had done a little repertory season. The *New York Times* and Houseman invited all the press and many of his theater friends to shows. We did *The Lower Depths*, *School for Scandal*, *Measure for Measure*, and some other plays in rep. After the season, he said, "I just can't let you all graduate and go off and do television or movies or something ghastly. You are trained actors, so I'm going to form a company." I mean, it just doesn't happen like this. We were all given our equity cards, put on a bus, and sent out to tour across the United States. I did that for four years.

JV: That's amazing. What was that like as a young man? Was it romantic traveling the states as an artist?

KK: Yeah. We were bringing the classics to the hinterlands, sort of missionary work. Houseman's idealized but realizable dream was to have a permanent classical repertory company that was American, bringing the classics to major cities, faraway cities, and to universities. We even did some morning shows at high schools. We would do a little residency for a week in a town or do workshops with kids along with our shows in rep.

> "We were bringing the classics to the hinterlands, sort of missionary work."

So many kids either go to New York or L.A. when they come out of drama school. They are not given a place to now put all of what they've learned into practice in their own towns. We were like the old English repertory system, where you finish drama school, then you go and do rep. That's what they all did . . . Olivier and Gielgud and all those other great actors.

JV: I love the noble gesture you allude to, trying to bring the arts, the classics, to the people. It's a matter of access. We are going to talk about Joe Papp here in a moment, whose mission was also to provide access to the arts. Do you find, whether it's theater, music, or visual arts, that artists are in tune with wanting to share their message, wanting to share their talents with people?

KK: Yeah. Especially performing artists . . .

JV: Why performing artists?

KK: We are nothing without an audience. We are there to share. For sure.

JV: Before we move on to Joe Papp, we are going to hear a piece of music. You've chosen a few songs that you connect with. Since we are

still in the 1970s here, we're going to play "Honky Tonk Woman," by the Rolling Stones, released in 1969. What memories does this song revive for you?

KK: I remember when I was doing the *Pirates of Penzance*, jumping ahead a few years; Linda Ronstadt was the soprano. I remember us talking about the Rolling Stones and saying how I loved "Honky Tonk Woman." She said it's considered, among rock people, the quintessential rock 'n' roll song. When I saw the Stones in concert in Wembley Stadium, as soon as the cowbell ding, ding, ding, ding . . . everyone, including me, leapt to their feet. It was just—that groove was just so incredible. I had a drummer tell me, you know, that's a mistake. If you listen as it starts to the cowbell thing, Keith Richards apparently comes in on the offbeat or way off the onbeat. And it's really hard to replicate. We tried to cover it in a rock 'n' roll band I was in at one time. Whether it's apocryphal or not, I love to think that that incredible groove came out of a mistake, a felicitous mistake like just being in the moment or something happens, and you react to it. Magic can happen. [*soundbite of "Honky Tonk Woman" plays*]

JV: Before we listened to the Rolling Stones, we were starting to talk about Joe Papp. Before you met Joe Papp, had you seen performances outdoors in the Public Theatre?

KK: I graduated from IU in midyear. Because I had switched out of the music school, I lost twenty-two hours of credit, and my draft board said I could go another semester. I was stalling for as long as I could before I had to face the horrible inevitability of being drafted. When I was accepted to Juilliard, I went to New York and auditioned for the summer Shakespeare in the Park. I got a good job of basically carrying a spear and other heavy objects and understudying one or two parts.

We did *Henry VI*, Part 1, Part 2, and Part 3, as well as *Richard III*. We had a marathon one night because the Public Theatre was really just beginning, and the Shakespeare in the Park program was having financial troubles. Joe Papp decided to do a marathon and start with *Henry VI* at seven o'clock and go all through the night. At six thirty in the morning, the cast of *Hair*, a show that came out of the Public Theatre, came onstage to sing "Let the Sunshine In."

It was a magical night. It was a major event and my first exposure to Joe Papp. When he came and spoke to the cast to say, "We're going to do this thing," he launched into Henry V's St. Crispin's Day speech: "We band of brothers, for he today that sheds blood with me shall be my brother." He just segued from telling us the nuts and bolts of how we were going to structure the evening into *Henry V*. That was my introduction to him.

JV: Wow! What did you think about the Public Theatre's mission of trying to provide free Shakespeare to the people?

KK: It was—well, I thought it was great. And it was certainly a wonderful summer. I learned a lot. There was this magical thing about performing outdoors, knowing that Shakespeare, before they moved into the Inns of Court, they were performing outdoors in broad daylight. We were doing it in the evenings, of course, with artificial light. But somehow, being out in the elements was extraordinary. Especially since it was free. Joe Papp fought very hard to keep it free. The city and the mayor, they said they would build a theater, but he had to charge money. He said it must be free. It must be accessible to everyone . . . in New York.

JV: It's amazing that it's still going, right?

KK: Still going strong.

JV: There have been many great actors who started in the Public Theatre. Over the years, you have continued to go back and perform as well as acting friends like Meryl Streep. Do you know if other actors like Martin Sheen, Christopher Walken, or James Earl Jones continue to go back as well?

KK: Yeah. I saw Chris play Iago about ten years ago in the park, and we did *The Seagull* with Meryl Streep not that long ago. Mike Nichols directed it. It was Chris and me, Natalie Portman, Marcia Gay Harden, and Philip Seymour Hoffman. It was an extraordinary cast. Chris and I shared a dressing room. He's a wonderful, fascinating, sweet, sweet man. He is delightful.

Once you had a taste of the Public Theatre, we all liked to go back. We did sort of a concert-reading version of *Romeo and Juliet* two summers ago with Chris as Mercutio, Meryl Streep as Juliet, and me as Romeo. It raised $2.2 million for the Public Theatre as a fundraiser. Last summer, we did a concert version of *Pirates of Penzance* as another fundraiser.

JV: Really nice! Speaking of *Pirates of Penzance*, in that version—the one from a few years ago—did you reprise your role as the pirate king?

KK: Yeah. That was, I guess, the next thing I did in the park. After four years in the Acting Company, a Broadway musical and another Broadway show, a dramatic piece by Michael Weller called *Loose Ends*, then came *Pirates of Penzance*. It was going to be four weeks in the park, of Gilbert and Sullivan. It was the one hundredth anniversary, which I think meant we didn't have to pay for rights as it was now public domain.

Joe, who was obviously a Shakespeare lover, also happened to love Gilbert and Sullivan. He had this crazy idea of getting Linda Ronstadt and Rex Smith to do a pop rock, contemporary version of the play. And we did that. It moved to Broadway, and then we made a movie of it. I thought it was going to be a four-week romp in the park.

JV: What was the total time commitment between the play and film, by the end of the project and press tour?

KK: About two years out of my life. But great fun! Because of that, I got to know Joe Papp. He said, "You know, you've got all the right equipment for Shakespeare. Is that something you're interested in?" I was like, "Yeah. This is my last Gilbert and Sullivan as far as I can see. That's what I really want to do." So, we started talking and planning and did *Richard III*, which was the play I was originally carrying a spear in when I first got to New York.

JV: Full circle! Did Papp know you came up through the ranks of *Richard III*?

KK: No. I never said, "Hey, remember me, the third guy from left in *Henry VI* and *Richard III*?" I first met Joe when I understudied Raúl Juliá when I left the Acting Company. I had to go back to square one because we were on the road most of the time, and I thought four years was enough. I needed to get real and starve and do what all actors do—learn how to wait tables and all that. One of my first jobs was being the standby for Raúl Juliá in *Threepenny Opera*, which Joe Papp was producing when he had Lincoln Center's theater for a few years. I had just seen it, and it was this extraordinary production. I got a call saying the understudy was leaving. It had been running for about twelve weeks, and he'd had enough. I was asked to take over, and I did. It meant going to the theater every night, sitting and waiting for Raúl Juliá to get sick. He never did. He told me, "You will never go on. I go on unless I am dead."

I said, "Okay," and it was true. I never went on it. But Raúl Juliá was replaced by Philip Bosco, and Phil got sick. I did go on finally. I did that for, I don't know, about twelve weeks. I guess I also worked on a soap opera and a couple of commercials—things I swore I would never do.

JV: But you were paying the bills.

KK: Yeah. Reality had suddenly arrived.

JV: Is there a thrill in being in front of a live audience that can't be duplicated? Is there something you get out of a theater performance with an audience you do not get from film or television?

KK: I did theater for ten years before I ever did a film. The thrill—it's scary. The more I did it, the better I got, the less nervous I got. I am still nervous on the first performance or the first preview. Suddenly, there is an audience. You've been rehearsing for four or five weeks, but now, there are people there. It suddenly turns into this other creature. It's still exciting. I am less and less nervous the longer I do this.

JV: Let's move on to some film work. I'm going to start with a quote from Lawrence Kasdan, who said, "Kevin has had a really charmed actor's life. He has gone back to the theatre repeatedly. He works in the movies when he wants to." Do you enjoy making movies, and do you enjoy having feet in both worlds, going back and forth between the two?

KK: Oh, very much. It's so much fun. It's different, but it's the same. Acting is acting. When I first started, I thought, "Oh, dear, it's a whole other thing." No, it's really not. The audience is much closer, that's all, if you think of the camera as an audience. I know that's an oversimplification. It is a different animal in many ways. But, in fact, you can do more on film. It's just behind your eyes. If you're just having a thought, the camera can capture that. No one, not even in the first row, is going to see it in the theater. In theater, you instinctively make choices that are felt and heard in the back row. In film, you can do that too, but you can also do very, very subtle things.

JV: Was that hard getting used to, communicating with just your eyes or very, very small shifts in facial expression?

KK: Well, working with director Alan Pakula and Meryl Streep on *Sophie's Choice* [1982] was a great introduction. Alan said we're just going to think of the film as rehearsal. We'll do five or six takes. It'll be like we're just rehearsing that scene, that day, which is what you do in the theater, one or two scenes then put it all together after a few weeks. "Think of the takes as if we're just rehearsing. You have to trust me that I will choose the best rehearsal when it happens."

> "It had been running for about twelve weeks, and he'd had enough. I was asked to take over, and I did. It meant going to the theater every night, sitting and waiting for Raúl Juliá to get sick. He never did. He told me, 'You will never go on. I go on unless I am dead.'"

Right: Kline with a student in IU's Department of Theatre, Drama, and Contemporary Dance on September 15, 2014. Eric Rudd/IU Studios

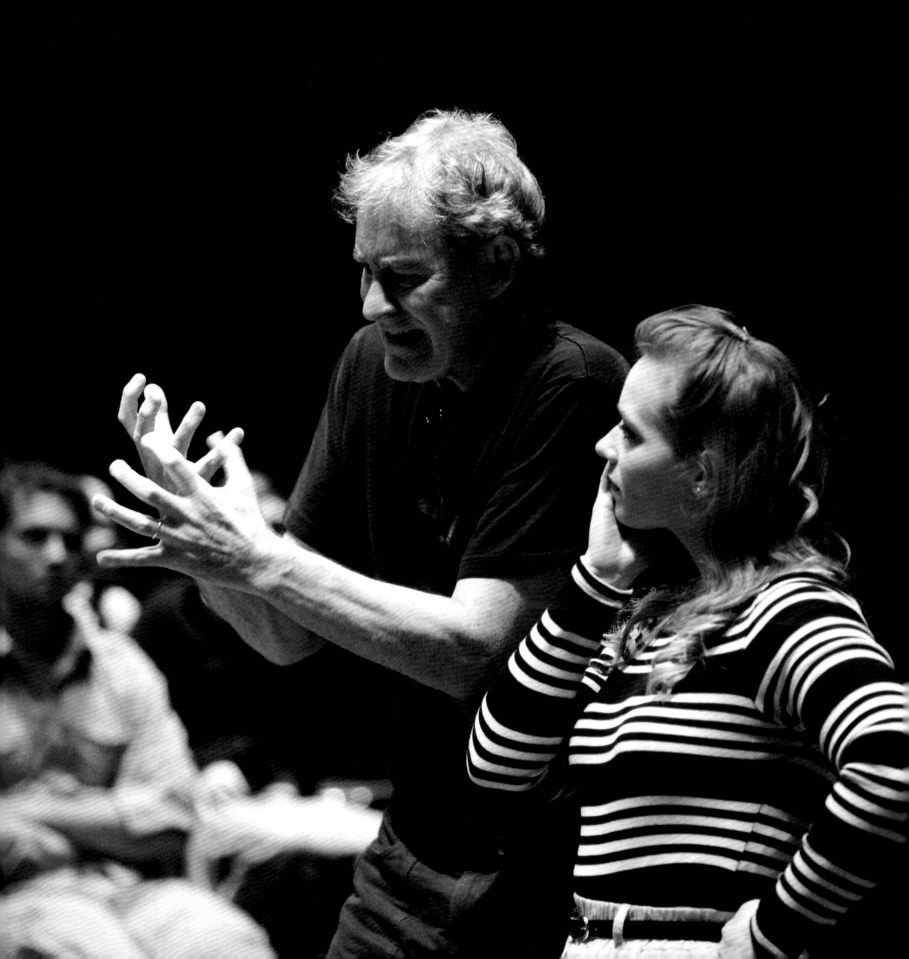

I remember he had three weeks set aside to rehearse. We rehearsed without ever rehearsing, because Meryl didn't want to rehearse. Meryl wanted it to happen on camera. I thought that was an interesting notion. How do we learn our lines? Well, you have to do that on your own as opposed to having the four or five weeks of repetition to absorb and assimilate the lines.

JV: Would you have someone to read with? Would you hire an assistant or somebody just to throw lines at you?

KK: I did for a period of time. It depends on the film. Sometimes you can look at the scene the night before, unless it's a scene with a big speech or something; you better know that cold. About halfway through *Sophie's Choice*, Meryl asked if I was saying the lines as written, because "you don't have to, you know. If it doesn't fit in your mouth, just rephrase it. This is not Shakespeare. You can."

Oh. I argued that I liked the lines, and I thought, having read the novel, this character had a very distinct way of speaking. The words he chooses, the phraseology, the locution are distinct. But I did start loosening up a little and improvising a bit.

JV: Some directors are certainly better at allowing the actors to do that than others. How was Alan Pakula?

KK: I was totally spoiled. It was my first film, and he made me feel like I was a veteran. He'd say things like, "I'm happy. I'm ready to move on. Do you want to do another take?" What? I get a choice? He also did something that very few directors do, which was to start the day with the actors, only the actors. He'd ask what we want to do, then figure out how to shoot it. This is much better than arriving on the set to see these tracks are down and the lights are all set up, "You need to start here and end here, go to the window here, sit down there." You can work that way, but it's nicer if the actors have been allowed to initiate it and sort of discover it. It was amazing, watching Meryl in that role. It was just amazing in itself.

JV: It certainly had to make it a more collaborative process, to be able to develop those characters together.

KK: Oh, it was so collaborative. And we loved each other. Peter MacNicol, Meryl, and I would, whenever we were off camera getting ready for a close-up, give each other lines and change them to make them fresher. We had already done the master and medium shots, so always doing things to help each other keep it fresh. I remember Meryl Streep saying, "I like surprises. Don't feel like you have to do the same thing from take to take with me." Also, "Don't be afraid to hurt me because you can't." So, it was like a challenge.

JV: *Sophie's Choice* went on to be a big success. Meryl Streep won an Oscar . . .

KK: She did.

JV: . . . for best leading role, and I believe there was an Oscar nomination for writing for Alan Pakula. You received a Golden Globe nomination for your role as well.

KK: Yeah, for best newcomer or something like that.

JV: How do you feel about those types of recognitions and those awards, Tony Awards, Golden Globes, Oscars? Are those validations of your career and make you feel like you chose the right path?

KK: I hate to admit it, but those awards, like good reviews, are something that I have always said are not important. Those are not the reason why I'm here. I grew up in the day when Marlon Brando refused to accept his award, when George C. Scott said, "I won't be part of that meat parade." I sort of agreed and thought, "Oh, this is so tawdry and awful." When you saw some of your favorite performances not even get nominated, and you might say, "It's not fair. It's stupid." But when you are nominated [*laughs*], and even better when you win, I started to think I am getting better at this. I think it is a validation, however unfair or stupid you think it is. With the Oscars, it's all nonsense. Better are the actors' and directors' guilds, for which peers nominate actors and the directors. So, it's your peers saying, "We thought this was really good work." So, I don't mind losing. The nomination is important because it's your peers.

JV: Not only a validation from your peers or the industry, but these awards and nominations can help get your next film made. It can add value to your career.

KK: Yes, it does. It's terrible because it's bottom-line crap, if you pardon my French. "Oh, look, he's got an Oscar," and suddenly an agent can kick up his price or an actor who won an Oscar can help greenlight a movie.

JV: Let's go to a second piece of music. This piece is the theme from François Truffaut's *Day for Night* [1973] by composer George Delerue. Why did you choose this piece of music?

KK: As mentioned, I was once an aspiring film composer. For me, film was always more like ballet than like theater, because it's movement with music and some occasional talking. I loved film

Right: Kline receiving his honorary doctorate degree from Indiana University President Michael A. McRobbie at IU Auditorium on September 15, 2014. Eric Rudd/IU Studios

composers, and I love certain scores. This is probably my favorite music cue in a film. [*Soundbite from soundtrack of* Day for Night *plays*]

JV: Your filmography spans about forty-five feature films. Of course, we don't have time to cover many of those, but there is one director who you've worked for six of his eleven features, Lawrence Kasdan. Your first film with him was *The Big Chill* in 1983. What started this relationship? How did you end up in *The Big Chill* and this long collaborative relationship?

KK: I had met Larry maybe a year and a half before when he was casting *Body Heat* [1981], his first feature film. He had written *Raiders of the Lost Ark* [1981] and a couple of the *Star Wars* things. He was a writer, but he made a stunning directorial debut directing his own script of *Body Heat* and was meeting New York actors. I went in and read with an actress for the part that Bill Hurt ultimately got. That's when we first met. I was just struck by this guy. His wife was at the auditions. Directors don't bring their wives to [*laughs*] auditions or studio meetings, in my limited experience. There was something just so real and so regular about him. He's not from the Midwest. He's from Wheeling, West Virginia, but he did go to school in Michigan.

Maybe it's that heartland thing. Anyway, I just liked him and felt very comfortable with him.

When he asked me to come read for *The Big Chill* a year later, I met with him and a bunch of actors who were reading in New York, then another reading in L.A., and he asked me to be part of that reading because he was really considering me for my role. There again, he was there with his wife, who was going to select the Motown music for the score, et cetera. We just hit it off. We made each other laugh, and I just always felt comfortable with Larry.

JV: That relationship has now spanned many years. I am always impressed with these great ensemble casts in many of his films. He's a great writer for creating and interweaving multiple characters and storylines. You see it in *Silverado* [1985]; you see it in *Grand Canyon* [1991]. Do you have a favorite Lawrence Kasdan film you worked on or a favorite experience with him?

KK: Probably the most fun was *I Love You to Death* [1990] with Tracey Ullman, Bill Hurt, River Phoenix, Keanu Reeves, Joan Plowright, James Gammon, and on and on.

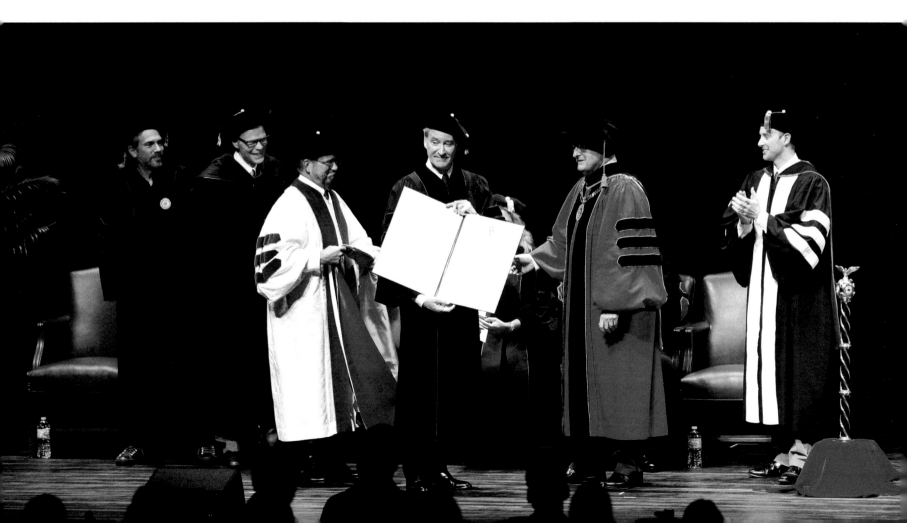

JV: What a great cast.

KK: This was the first thing I did with Larry that he had not written, written by someone else. It was a wonderful screenplay based on a true story of a philandering guy whose wife is trying to kill him, but he won't die. He's like Rasputin [*laughs*], and it's a dark comedy that was so much fun. Tracey was great, and we just laughed a lot on the set.

JV: If he came to you with another project . . .

KK: I wouldn't have to read it. I would say, "Sure." It's a fait accompli.

JV: Okay, awesome. Let's move toward *A Fish Called Wanda*. You spoke yesterday about the only characters or parts ever written for you were by John Cleese, with one of them being the bizarre and demented Otto in *A Fish Called Wanda*. Otto is such a singular character. You had some input into the development of Otto because you were friends with John Cleese at the time he was writing the film. Did that help you fully embody the character because you had input into its creation?

KK: I think so. I was actually making *Cry Freedom* [1987] with Richard Attenborough, the film about Steve Biko, a huge epic, high-minded, and important film. We were shooting in London, and John said let's have a read-through of the script. Well, my mind was elsewhere. We read it, but I couldn't really feel what was happening. It wasn't a reading with stage directions. I was just sort of confused and went back to my other movie. A few months later, John said he finished.

"You know I've been working on this first draft and polishing it up. Why don't we go away somewhere warm to read through it?" Being English, he wanted to get out of the rain and cold, so we went to Jamaica for ten days, just the two of us, to work on the character. We read through my scenes, talked about it, and improvised a little. When he was talking about an idea, I went, "Yeah, yeah," and when I got an idea, he would do the same. "Oh, that's good for the character" or "Let's give him as short an attention span as I have." I got into the movie from that. Some months later, the new script came, and there was a feeling I had some input, so it's mine. Both Jamie Lee [Curtis] and I were rather free with the dialogue and would ad-lib a lot. I remember John one day asking, "Are you going to say any of the lines I've written?" But he allowed us to embellish. There are some funny lines that ended up in the film from that improv.

JV: Do you think that you could play Otto today, discounting the age?

KK: Older and wiser or older and dumber? [*laughs*]

JV: I mean, do you think you can play it with that intensity? Do you think you could pull that off? He is a very intense character, also very demented and cruel. Is that a character Kevin Kline could play in 2014?

Kline watching the final scenes of *A Fish Called Wanda* before a Q&A at IU Cinema on September 15, 2014. Eric Rudd/IU Studios

KK: Sure. I'd like to think I would do it even better. Absolutely.

JV: In our remaining time, let's jump into a couple more films. In the film *De-Lovely* [2004], you play Cole Porter. Was that role a natural draw because of your piano and music background?

KK: Almost entirely because of my piano background. We had a reading of the script, and I thought, "I'm not sure about the structure." It just seemed kind of clunky. "Oh, he's dead? I see, he's talking to the angel Gabriel, and they're putting on a show of his life." I wasn't quite sure that would play. But I thought, you know, I just want to be in that music because he was a genius. How beautiful. I looked nothing like him. I'm at least a head taller, and he was balding, but what I did know was he was a great piano player.

However, he wasn't a great singer. I asked to sing live and not have all the songs prerecorded, because this was more about acting than singing well. And I wanted to play all the piano parts. I thought, "This is going to get me back to the practice room," and it did. I had to brush up my piano playing, and it was really thrilling to be in that music for nine weeks.

JV: So, in addition to playing Cole Porter, you've also played Douglas Fairbanks, Charlie Chaplin, and, most recently, Errol Flynn. What kind of additional preparation do you do for a film where you are playing a historical figure?

KK: Luckily, I didn't have to mimic Cole Porter because there had already been a film about him played by Cary Grant [*Night and Day*, 1946]. Even in our film, there's a scene where we're watching the Cary Grant film. It's just a joke to me because he's nothing like Cole Porter. The story is fictional too. They had him in the trenches in World War I. No, no, no. He was in Paris going to parties. So, I didn't have to mimic. It was the same with Douglas Fairbanks. He did maybe one talkie film, but very few people know how he spoke. I didn't have to mimic. I obviously watched his films. In the talkie he did do—he talked with the sort of Boston Brahmin accent. He would have gone to a Hollywood elocution school; it's that Hollywood thing.

Errol Flynn too. He was from Tasmania, an Aussie. He came via Australia to London and did some rep work in London. He would have gotten a bit of an English accent. Hollywood used to promote him as an Irish actor. He wasn't Irish. He was Tasmanian. But I had to watch all the films and listen to all the interviews and try to mimic his voice as best I could without it becoming an impersonation. The trap is to do a brilliant impersonation but not act.

Meryl can do it. When she did *The Iron Lady* [2011], she was Margaret Thatcher. There's also something else happening. She is not consumed with doing a perfect imitation; she's living it. It's real, and it's immediate, it's happening and exciting. So yes, there is much more prep work of a very technical nature doing that.

JV: We are about to wrap up here. You've been back at Indiana University this week. Have the university programs and facilities in the arts lived up to how you remember them to be forty years ago?

KK: Well, it's certainly as beautiful as I remember. I'd have to take a class here to tell you if they're really up to snuff. As I listened to people talking about my career, I sort of watched and heard my life flash before me over the last couple of days [in Bloomington] and realized that it all started here. I really know these are my roots. It's very true. I realized what formed me as an actor and a person were my four and a half years here in the music school and then the theater department. It is like coming home. It's been very nostalgic and great. It gave me a fresh realization of how important those years were. Not that I've forgotten, but it was nice to get a reminder that was more palpable than I could see and feel.

> "I sort of watched and heard my life flash before me over the last couple of days [in Bloomington] and realized that it all started here. I really know these are my roots."

JV: Last question—have you ever thought about what you want your legacy to be as an artist, as an actor? How do you want Kevin Kline to be remembered thirty, forty, fifty years from now?

KK: [*laughs*] "He was good. He was a good actor and versatile," I think because I was. The repertory theater experience from the Acting Company and playing a diversity of roles was something. I just had that experience. Listen, some of my favorite actors are actors who do the same thing every time, and I have nothing against that. I like surprising myself. If I can bring something fresh without doing the same shtick, I'm happy about that. So, I'd like to be undefinable; it's its own thing. So maybe to be remembered as doing it his own way. "He did his own thing. He was good."

JV: That's perfect. It has been a great pleasure talking with you, and thanks for your generosity of time here, coming back to Indiana University.

KK: It's been a thrill for me.

MIRA NAIR

In partnership with IU's Arts and Humanities Council and the Office of the Provost and Executive Vice President, IU Cinema curated a series of six public events and several private events to celebrate the work of filmmaker Mira Nair. The visit was part of the council's India Remixed program, a global arts and humanities festival, and included screenings of five films, an onstage lecture and conversation, private reception, and a WFIU *Profiles* radio interview for Indiana Public Media. The visit was also supported by the Media School, the Asian Culture Center, the Asian American Studies Program, and the Ove W Jorgensen Foundation, with special thanks to Professor and Associate Vice Provost for Arts and Humanities Ed Comentale and Provost and Executive Vice President Lauren Robel.

Nair is a filmmaker completely grounded in the world in which she lives. Her films often explore the conflicts inherent in families of recent immigration and ways to bridge the gap between cultures, races, and genders. They challenge stereotypes and generational assumptions while remaining steadfast in the values she holds close.

Born in India and educated at Delhi University and Harvard, Nair's debut feature film, *Salaam Bombay!* (1988), was nominated for an Academy Award for Best Foreign Language Film after winning the Camera D'Or at the Cannes Film Festival. Her next film, *Mississippi Masala* (1991), premiered at the Venice Film Festival. In 2001, *Monsoon Wedding* won the Golden Lion at the Venice Film Festival and went on to receive a Golden Globe nomination for Best Foreign Language Film. With more than twenty feature films and television projects to her credit, her work continues to push boundaries and explore the human spirit.

Ever sensitive to social issues, Nair shares her energies between filmmaking and the two nonprofit organizations she founded. In 1988, with the proceeds from the film *Salaam Bombay!*, she established the Salaam Baalak Trust, which offers a safe and welcoming environment to thousands of street children every year. In 2005, Nair founded Maisha, a center in East Africa providing film labs and workshops for aspiring screenwriters, directors, actors, technicians, and documentary filmmakers coming from Uganda, Tanzania, Kenya, and Rwanda.

Her Jorgensen Guest Filmmaker lecture and interview with Founding Director Jon Vickers were a part of the Mira Nair: Living Between Worlds series.

Nair delivering a lecture at IU Cinema. April 2018. Chaz Mottinger/ IU Studios

Mira Nair is a filmmaker completely grounded within the world she lives. Her films often explore the conflicts inherent with families of recent immigration and ways to bridge the gap between cultures, races, and genders. They challenge stereotypes and generational assumptions, while remaining grounded in the values she holds close. With 12 feature films to her credit, her work continues to push boundaries and explore the human spirit.

Mira Nair's visit is sponsored by the Indiana University Arts and Humanities Council as part of India Remixed: Global Arts and Humanities Festival, The Media School, and IU Cinema. Special thanks to Ed Comentale and Provost Lauren Robel. Events are also part of Movement: Asian/Pacific America.

MIRA NAIR
LIVING BETWEEN WORLDS

THE NAMESAKE	April 5 \| 7:00 p.m.	MONSOON WEDDING	April 13 \| 6:30 p.m.
MIRA NAIR JORGENSEN LECTURE	April 12 \| 7:00 p.m.	MISSISSIPPI MASALA	April 13 \| 9:30 p.m.
SALAAM BOMBAY!	April 13 \| 3:00 p.m.	QUEEN OF KATWE	April 15 \| 3:00 p.m.

INDIA REMIXED
ARTS & HUMANITIES COUNCIL

THE INDIANA UNIVERSITY
CINEMA
cinema.indiana.edu

IU Cinema poster for Mira Nair: Living Between Worlds, April 2018.
Kyle Calvert

Mira Nair: It is such a great pleasure to be here. Indiana was something that we always confused in India as being really India. India, nah, nah, nah—that was Indiana. And here I am in Indiana. We made a joke about Indiana in *Mississippi Masala*, and, I have to say, this is the first time I've ever stepped into the state. It is really a pleasure to bring the sunshine today and to be here. So, thank you so much for inviting me to this incredibly august festival and most progressive— I haven't actually come across something like India Remixed for a long time. The Indian right-wing government should take a tip or two.

My nickname growing up was "pugly," which means "the mad girl, the crazy girl." I still think I am much more of a crazy girl than would want to speak to august audiences as this, but in my work as a filmmaker, if we ever deserve the title of artists, then we must always welcome madness as a vital guest. People often ask me, "Is it difficult to be an Indian woman director in America?" I, first, don't quite know how to answer this, and I say it's much easier than back when I was a man. Now, I may not even be politically correct to say that, but seriously, I am very relieved to be a woman and to be from India, where I grew up paradoxically seeing women on either side of Mahatma Gandhi, fighting for freedom from the British in our country. The country was for years, as you know, led by a woman prime minister, and the thought of this unfortunately still gives the United States indigestion.

My dynamic mother—God bless her, she's eighty-seven—is the chairperson of the Salaam Balak Trust, this extraordinary foundation that we set up with the money from *Salaam Bombay!*, which is now thirty years old, and runs an enormous seventeen centers across Delhi and Bombay. She was an early inspiration. When I was eight years old, she called herself a professional beggar and raised money for the first health home, a home for healthy children born of leper parents. So, I was brought up really with the foolish confidence that absolutely anything is possible—to not believe so much in words but in action.

As a film director, my work entails the creation of a safe environment in which my actors feel protected enough to fail, even really to make fools of themselves, to work with humanity, to work with human beings, to work with emotion, to visualize the drama of what is life. I really do propel myself to feel my blood must go faster and my heartbeat go quicker, which as I get older is not often very good. In the creative world, I believe that borders by necessity need to be fluid and porous and that talent genuinely knows no borders. I always say that for actors, their fragility is their power, and they trust themselves to me the director. It is my task to make that power bloom.

Making a movie from inspiration to execution, to getting it out into the world, and to be seen is really a roller coaster without end. First, one must have something to say—a vision, an idea, a big question, something that gets under the skin and never lets me go, at least. It's an obsessive act. I have to be possessed by it. I have to be driven. I have to love not taking no for an answer and almost getting high on rejection. It persists sometimes for years until the work is brought into the world.

As an Indian filmmaker in New York in the '80s, I would ride the Greyhound bus with my documentaries under my arm, showing my films to anyone who would have me. I would have to tolerate audiences, in those days, who would ask me whether there was tap water in India and how come I spoke such good English. I would say, you know, I spoke the Queen's English before I came to America, where everything was "great, neat, I love it." In those years, I really discovered the loneliness of being an artist. I didn't want to be a cultural ambassador for my country, educating Americans about my homeland.

But I was rooted in India, and I came to the US for my education. Back home, my films were also alternatives. My family still doesn't want to admit this, but they never really saw my documentaries until I made *Salaam Bombay!* because documentaries those days were for government—boring drivel about how much coal we produced and so on. My films were alternative because they were mired in the reality of the streets. They were faithful to the idea that truth is stranger and more powerful than fiction. They were the opposite of Bollywood, the song-and-dance escapist extravaganza, and I was really an outsider.

There is a saying in India, "*Dhobi ka Kutta. Na Ghar ka. Na Ghat ka,*" which literally means "the washerman's dog, neither at home nor of the street, but at home everywhere." In the early years of making films, I felt like that washerman's dog—not really understood at home, considered a novelty abroad, but at home everywhere. I learnt many lessons in those days: to prize one's intuition, to persist in creating what makes one distinct, and to seek courage from rejection. I found that people who inhabit different worlds can see through each of them. It is such people who have a sense of modesty, who know that there are other ways of seeing, who develop appreciation for—rather than mere charitable tolerance for—other ways of life. I came to filmmaking from studying cinema verité or the cinema of truth—of making documentary films of real world and real people, of the extraordinariness of ordinary life. So often, truth is so much stranger than fiction.

The resilience of knowing street kids on the Bombay streets led me to make my first film, *Salaam Bombay!* The first image that inspired me was a kid with just a torso, no legs, holding on to my taxicab in India, the rest of him on a makeshift platform on wheels, holding himself with my taxicab through the traffic and then letting go in the momentum, pirouetting on his platform in the end, as if

acknowledging applause from an imaginary audience. I thought to myself: How can one have so little and love life so much?

And it was this with the amalgam of working in the theater—because I started as an actor—of seeking to interpret the world visually, of making a story that challenged the prevailing concepts of what is marginal in our society, to hopefully find a larger work for the work beyond audience. Documentaries received hardly any play in those times, in the early '80s. This is what led to the making of *Salaam Bombay!* As a fiction film, Indian films were often relegated to the studios, never on the streets. They were filmed in vast, opulent spaces that offered fantasy and escape to an underprivileged public. *Salaam* was the first to shoot the streets and maximize the Day-Glo phosphorescence of how ordinary Indians use color. The pea greens, the hot fuchsias, the vibrant bursts of high-kitsch flowers, the spices and colors with which we have ornamented our bodies for decades, the red *sindoor* and the parting of the hair, the henna on our nails, the Prussian blue paint on the walls in our slums. All this became the tools of the visual palette of *Salaam Bombay!,* so that critics seeing this film across the world heralded, weirdly, the coming of the phosphorescent new wave of Indian cinema.

> "I always say that for actors, their fragility is their power, and they trust themselves to me the director. It is my task to make that power bloom."

Making a strong piece of work often opens doors hitherto unimagined. *Salaam Bombay!* brought me Denzel Washington, fresh from his first Oscar for *Glory* [1989]. I wanted to make a film—my second film—about the hierarchy of color, of being brown in the midst of black and white. As a student at Harvard, as having a scholarship in the late '70s, it was interesting to be part of a Brown community that was invisible and yet accessible to both Black and White. This was what I wanted to speak about in my second film.

In the early '90s, a yet untold interracial love story, born out of a trick of history. In 1972, the Ugandan dictator Idi Amin unceremoniously expelled all Asians living in that country. Asians who were often third- or fourth-generation Africans, who had never known India, were suddenly expelled across the globe. Many came to Mississippi to own dirt-poor American motels across the south. Speak to any Indian, and they'll tell you "never rent, always buy." They could afford these incredibly poor motels and make them a thriving family business. The irony, to my eyes, was that this was the birthplace of the civil rights movement. The community of African Americans, who, like the Asian counterparts in East Africa, had also never known the continent that they came from. My premise was, what if an African

American young man would fall for an Asian African young woman and challenge the borders that separate us?

Denzel was intrigued by the originality of the story. This kind of thing had not crossed his path before. I made the film while I myself was in a stupor of love. I had just fallen in love with my husband, who was Ugandan. That kind of stupor, that kind of weak-kneed love, was not what I was getting from Denzel. He just wasn't doing it. He was consummate in every aspect of the role, but when it came to everything to do with the love, he was just playing it without expressing what I was feeling. Making films is like now or never. You cannot go back and rekindle something that isn't there unless you're Woody Allen and can reshoot, but I could never reshoot. I nervously—remember, it was the second film, no one really knew me—I nervously paced in the cotton fields of Mississippi outside his trailer. I thought about how I should approach him, and I spoke to him with marketing in my mind. I said, "You know, if you make me feel as weak-kneed as I feel in my life, I can tell you that the audiences will go for it." It really hit him, and he was the first to acknowledge that vulnerability, which is what I wanted from him, was the core of his performance in this film. Just last year, we met at the *Hollywood Reporter*'s Director's Roundtable, just after he directed *Fences* [2016], and I had directed *Queen of Katwe* [2016]. We both met as long-lost friends, and he told me this. He said, "The vulnerability that you made me have in *Mississippi Masala* is something I have never approximated ever since." It was this that led lines around the block of interracial couples and made *Mississippi Masala* an anthem to hybridity and made the film really work across the world.

One of the great advantages of living in three continents, as I do, is that one automatically begins to have an expansive worldview. What is important in one place is absolutely meaningless in the other place. The aspirations of being a filmmaker in New York City— the studio deals, the Oscar campaigns—are quickly put in place when I go home to Kampala, which did not even have movie theaters until only a few years ago. This shifting of gears from one reality to another makes me hone my own intuition, to trust the ideas that live in me and don't let me go, to not just seek what others may offer me or the second and third guessing of what the market may want. Often, the art of nonexpectation yields the greatest hit of all.

Take *Monsoon Wedding* for instance. I wanted to make an intimate family flick, something out of nothing, a love song to the city of Delhi where I come from, to return to my old habits of guerrilla filmmaking after making large-budget movies. Except this time— fired by the recent empowering of the Dogme method out of

Denmark—I wanted to make a film in just thirty days. That was the original premise, to prove to myself that I did not need the juggernaut of the millions of dollars, of men in suits, of studios, of special effects to make a good story in the most interesting visual way possible. I wanted to capture, first and foremost, the spirit of *masti*. *Masti* is a beautiful Hindi word, which means really "the intoxication of life," inherent in the full-bodied Punjabi community from where I come. We are, after all, the party animals of India! I wanted to capture this India, which lives in several centuries at the same time. The challenge was, can one juxtapose *masti*, the joy of living life large, with the deepest, darkest secret of family life, which is sexual abuse— the ultimate taboo. That was the seesaw; that was the challenge.

Such was the India that I know and live, the fluid pillars of which I wanted to put on film. With sixty-eight actors, 148 scenes, and one hot monsoon season later, using paintings and jewelries, and saris, and furniture taken from my mother, my father, my relatives, each member of my family acting in it because they were free, and they were good, shooting exactly thirty days, a film was born. It had a journey so different from any expectation or, more correctly, non-expectation that we might have had for it during its making. People from Delhi to Iceland to Hungary to Brazil to America believed it was their wedding, and their family, and themselves on-screen. If they didn't have a family, they yearned to belong to one like the people they saw on-screen. I didn't really make the film to educate anyone about my culture and my people. I believe that to be simply a cultural ambassador of one's own country is boring. Rather, if it was made for anyone beyond myself, it was for the people of Delhi to feel and laugh and cry at our own flawed Punjabi selves. *Monsoon Wedding* played for six months pretty much everywhere—at the Paris Theater in New York—breaking records, and in several streets across the world.

At the time I made the film, the success of the film brought me *Vanity Fair* [2002], which was a big studio film of my favorite novel since I was sixteen years old—the tale of Becky Sharp, the best bad-ass girl in Victorian England, whom I deeply identified with. I cast Reese Witherspoon. It was precisely because she was America's sweetheart with an exquisite sense of mischief and comic timing that convinced me that she could be Becky. That would be one way to retain the guile and the complexity of Becky's survival spirit. Of course, it was [author William Makepeace] Thackeray's astute view of how the empire had raided the colonies of the time—notably India as its crown jewel, literally—that created the upheaval within England, filled its coffers so that the lower classes could aspire to the upper echelons of the class system that had been closed to them for centuries.

Money poured in in the shape of silks, brocades, spices, ivory, tea, you name it. It crossed the oceans, making ordinary merchants wealthy in England beyond their dreams, making it possible for an orphaned girl like Becky Sharp to socially climb her way into the previously closed doors of the aristocracy.

The politics of the film were these, but what fun I had with the fusion of it with the visual sumptuousness of it, while being true to the period. The last thing I wanted to make was a frock movie. I wanted young women to want these clothes, this look. I went to Beatrix Pasztor, the great costume designer of *The Fisher King* [1991] and the supercool *Even Cowgirls Get the Blues* [1993], to work with me on creating this look. Jeweled silks from the subcontinent, feathers, rope, frayed fabrics to create an idea that the film was about sham and façade, about seeing what were underneath things.

Inspiration comes in many forms. It is a privilege and must be recognized as such. Sometimes inspiration comes from loss, from grief. My film *The Namesake* [2006] is my most personal film yet. *The Namesake*, for me, was inspired by grief. I had lost a beloved parent without warning, and, as is our custom, we had to bury her the next day in a bitterly cold field under June skies near Newark Airport. This was my mother-in-law, who had spent her entire life in the red earth of East Africa, now being laid to rest under the icy glare of snow, very far from what she and her family had known as home.

In the weeks of mourning that followed, I found myself on a plane reading Jhumpa Lahiri's *The Namesake* [Houghton Mifflin, 2003]. Now, the book became such a comfort and a source of real solace as I tried making sense of the finality of loss. Jhumpa's writing distilled the nature of grief, the loss of a parent in a country that was not home, taking readers through a world of criss-crossing which was achingly familiar to me. *The Namesake* was many of my worlds: the Calcutta that I left behind as a teenager, the Cambridge where I went to college, and the New York where I now live. Though I share this particularly personal journey with the Ganguli family, my aim was not to make a film about being Bengali or about being Indian in America. This was a film that represented the state of many of us who live between worlds and the constant comings and goings of an immigrant. I shot New York City and Calcutta as if they were one city. The textures and graffiti, the salaam to both politics and art—these were the gods of both cities. In both, you have the frayed, layered posters on the lampposts and walls, scaffoldings of steel in

one, of bamboo in the other. I began to see that the film was about movements and crossings. The bridges, the trains, the airplanes, the neutered spaces of airports would be the threads of the film, uniting its tapestry, covering thirty years in the Ganguli family life between New York and Calcutta.

As I speak about the process of taking inspiration to execution, whatever one does has to be in the service of clarity. A clear intention in any work is of prime importance. But clarity itself can be dull as dishwater. As Stephen Sondheim said recently, "Narrative art must be clear, but it also must be mysterious. If it is only clear, it's kitsch. If it's only mysterious, it's condescending and pretentious and soon monotonous. There is nothing more mysterious than a beating heart. Something should remain unsaid, something beyond our understanding, an echo, a secret that remains a secret." I feel that, in the creative realm, borders and bridges alike need to be fluid and porous. I try to tell stories in which people can see themselves, not just some

> "I try to tell stories in which people can see themselves, not just some people but all people, not just in some places but everywhere."

people but all people, not just in some places but everywhere. It takes courage really to be original, especially for those who have been told for the past few centuries that the West is the mirror in which they can see their future.

In this roller-coaster journey of an artist, I wanted to share four truths I know. One: Never treat what you do as a stepping-stone to something else. Do it fully and completely, and only at its fullest you know where it might lead you. Two: Let the heart inform the brain, to prepare, to communicate, but at the moment of working, allow inspiration from any quarter—a carpenter, a street, a child, the light of the moon. Three: Be brave and prepared to be lonely, to cultivate stamina. As the Bhagavad Gita puts it, "To beware the fruits of action, to serve your work purely and without thinking of reward," because in the film world especially, rewards can be immense and confusing. Four: There is not a single human imagination but multiple imaginations. Imaginative people amongst us are seen as crazy, but not everyone marches on the same road, and not everyone is cast in the same image. There should be no borders within art, but every artist should own all conventions. As I open this conversation with you, I would like to say that I hope you remain true to really greet the twin goddesses of beauty and truth as long as there is fire in our hearts. Thank you so much.

Jon Vickers: Thank you for that. Let me start by saying this is such an honor for me. You have been one of my filmmaking heroes since the 1990s, and I have been closely following your career, so it is a pleasure to be here with you.

MN: Thank you so much.

JV: I would like to spend the next twenty minutes trying to dig a little deeper into what makes you tick, what makes you tell such distinctive but also universal stories. I will start with a couple questions about major influences to your career as a director, that being your history in theater. How do you think your time in theater, both acting onstage in Calcutta and Delhi as a young girl and your time at Harvard, helped you as a director leading A-list actors as well as nonprofessional actors, preparing them for their roles?

MN: Thank you. You know, it's amazing in hindsight what you think about in terms of one's own journey and how that helped or did not help, like becoming an actor and really being comfortable as an actor, being happy onstage in performance. I was usually cast as the boyfriend's mother and never as the lover. Or I was cast in my all-girls Irish Catholic boarding school as the boy because I had this deep voice and not the soprano that they all wanted. Anyway, I was playing men mostly, and it made me love actors. It made me love the way and the strange alchemy it is to perform. I think in retrospect, when I went into documentary filmmaking and really lived with people like the dancers in *India Cabaret* [1985]

> "I am always casting. Today, at dinner, I was casting. I'm always casting nonactors with actors. I think it's that amalgam of how you get the best out of a person who is cast for a character I want."

or the immigrants in any of the films, I understood how truth is manifested. People are not acting. They're just living their lives, and I'm filming them.

When I became a fiction filmmaker, I am always casting. Today, at dinner, I was casting. I'm always casting nonactors with actors. I think it's that amalgam of how you get the best out of a person who is cast for a character I want, who is not an actor, but against, let's say, a Denzel [Washington] who is a consummate actor. How do you put those together and achieve a kind of great lack of artifice and truth? I think it was being an actor that made me know how to do that without really even realizing that I knew that.

JV: You've mixed nonactors with actors in your films. Do you think that your professional actors take something of value from that experience?

MN: Immensely, immensely. I can tell you, in *Queen of Katwe* we had Lupita Nyong'o and David Oyelowo, both Africans from the continent. Lupita is from just next door to Uganda, Kenya, and David's from Nigeria. But that is still different from being from Katwe.

Nair lectures at IU Cinema, April 2018. Chaz Mottinger/IU Studios

Even though they are African, and they know, but because they were in Katwe and everyone around them was from that street—all the children, all the actors who are all Ugandan stage actors or real people—the amount it gave to the so-called professional actors was priceless. Just in terms of how you sit, how you cook, how you walk, all of it is informed. Though they might have won Oscars in Los Angeles, it kind of means nothing in the streets of Katwe. They just think of it as a "gold boy" they got or something. It's lovely because the kids then tease. The first thing that we did in *Queen of Katwe* was I said to Lupita, "You cook lunch with your film family," and so Madina [Nalwanga], the girl who played Phiona, took her to the streets and started bargaining for buying food. Then, they sat there, and Lupita made this food on her haunches in the shack, and the kids were teasing her within one hour. "Mama, come on, feed us" or just like "be of use." It changes everything. It changes everything when you're not inventing something, but when you're grounding it in a reality that is not going to accept anything dishonest.

JV: There are different theories on this, but some filmmakers, verité filmmakers like Frederick Wiseman, believe that when you point a camera at someone, the only acting they are going to do is acting like themselves. Do you see a difference when you're pointing a camera at nonprofessional actors? Do you do anything to condition them to the camera, or are they acting naturally, or acting as themselves, when they are first in front of the camera?

MN: It varies, but normally I don't just put the camera on them. They have gone through a big drill of workshops, of rehearsals. Each child in *Queen of Katwe* or *Salaam Bombay!* have gone through a series of auditions, which range from both clarity of enunciation to stillness to discipline. It is a lot about stillness and focus. You can't just dart about in front of the camera. So, there's a lot that goes on before the camera is turned on them, and by the time the camera is turned on, we have really a sense of family and sense of being together. So, then they're not acting, which is the point.

JV: Speaking of a sense of family, you cultivate a creative community around yourself and a sense of family on your sets. You also have put your real family, and also folks you are working with, in front of the camera. Why [do] you do that? In an interview, you said that you do it because they're cheap, right, but there surely is something more. Are you doing it to enhance that community feeling, or are there other reasons?

MN: I'll do anything to make it work. *Monsoon Wedding* was made like a little family flick. I cast numbers of people in that film, who

did not show up, literally. An actor called me the night before saying, "I'm so sorry, Mira. I can't come. I'm hosting a dinner event." I would think, "Really? You turned down a film to be a lousy emcee?" Suddenly, I had to cast the lover in *Monsoon Wedding* the next day. I would call up various people I knew, and then I looked at my cinematographer. He looked pretty good, but he had a beard, and he was all denim-ed out. I just cleaned him up and put an Armani suit on him. [*audience laughs*] I didn't tell him how to kiss, but I've been known to do all kinds of things. He had to step in. But it is a question of necessity. I have to shoot, so I put people from the crew on the set because I have to. But the question is what you get from them. You're going to get the best from them.

JV: And they're likely then more invested in the film. Let's move on to documentary film. There are some amazing international filmmakers—and I include you on this list—who were rooted in documentary before moving to fictional films: Abbas Kiarostami, the Dardenne Brothers, Hirokazu Kore-eda, and others. What do you think having documentary filmmaking as a base brings to your fictional work? Does it give you a way of looking at the world or your subjects differently?

MN: It is the greatest teacher. The greatest teacher, because there is truly nothing more powerful and strange than what you see in life. It is completely unpredictable. I came from that true cinema verité. My teachers were Rickey Leacock and [D. A.] Pennebaker. It was not at all like the documentaries one sees now. Sometimes they are great, like *Wild Wild Country* [2018], but a lot of documentary you see now are very manipulated with a lot of music, all wrought up. That was not what I came from. I came from Jean Rouch and people who really taught you to observe life and not to interfere with it or shape it in some way. So, when you do that it teaches you about people and the struggle of how people live in their worlds. It teaches me, particularly, a real sense of humility. People are not going to let you into their world unless they trust you, unless they want you to be there. To live with strippers for four months in a tenement is not a simple matter. The first two years, I was viewed as one, and I could really understand then what they experienced in the double standards of our life, of our patriarchal society. That informed me, in a burning way, about what to make the film about, for instance. But basically, it teaches you to surrender to people and to the struggle of life. That really informs so much later.

Right: Clip of actor Irrfan Khan in *The Namesake* during Nair's lecture at IU Cinema, April 2018. Chaz Mottinger/IU Studios

Going back to *Queen of Katwe*, even though we created sets within real places and had movie stars mixed with real people, the timbre of the film—the feeling of it, the slang of it, the humor of it, the irreverence of it—comes from being a student of that life. Knowing life not just as a filmmaker but, in my case, as a citizen of Uganda, someone who lives there.

JV: *Salaam Bombay!* was really born out of the experience of making your documentary *India Cabaret.* You do some things in *Salaam Bombay!* which could be considered risk-taking for a first-time film-maker but, I think, were born out of documentary filmmaking. You shot sync [synchronized] sound, which wasn't done much in Indian commercial film. You did something else, and I want to ask whether you were trying to intentionally push buttons or just trying to tell the most authentic story. You had this passionate, on-screen kiss in the film, something which hadn't been seen on Indian screens, correct? What gave you the courage to do those things and know you could pull them off?

MN: Well, you know, I love directness. I dislike coquetry. There is a place for it in courtesans and various other things, but I just don't buy coquettishness. Indian films until the 1980s were so rooted in this kind of indirect twisted sense of sexuality. I really couldn't bear it. That's why I made *Kama Sutra* in 1995. How can a country that established the mores of how to be, between men and women—a matter-of-fact set of rules which is the Kama Sutra—come to such a twisted sense of our own selves? Of course, it has a lot to do with the English arriving, Victorian mores and double standards, and the outsiders. What it was manifesting in on our screens, which is a very powerful medium, is this kind of twisted sense of "the vamp versus the whore" or "the virgin versus the self-sacrificing mother." I really couldn't bear it.

So, when it came to *Salaam Bombay!* and showing how people live, I just didn't want to subscribe to that. I believe people are direct in their intentions, especially to do with amour, or love. That's why the kiss. It wasn't to make a big stance. Somebody leaked [to the press] that we had done this big kiss scene, and, two days after shooting it, the tabloids were all writing "first kiss on Indian screen." They ruined my life for about a week; the paparazzi chased me. I had to pay a high price for that kiss. [*audience laughs*]

JV: But in the end, it paid off. We talked about the authenticity nonactors or nonprofessional actors bring. *Salaam Bombay!*

is also so amazing for the locations and the authenticity those locations bring; they are beautiful, they're dirty, they feel real. Was there any kind of production design that had to go into it, or did you just find the right locations and start shooting?

MN: It was a mix of both. We really live with color. For instance, in one brothel there was a fuchsia wall I liked. I was shooting in another brothel for other reasons, so we painted the wall fuchsia, for instance. Children sleep on the streets where people defecate and urinate. What they do to prevent that from happening is they paint the figures of gods and goddesses. So, we painted on some street images of Christ and Buddha on the street that I picked as locations. I would use what existed to augment the production design.

We had no money, so we were always operating with a Plan A and Plan B. If we were shooting, you know, an A scene and it started raining, then we would already have a plan to shoot Chaipau the tea boy coming in the rain, shooting from a brothel above looking down at him in a sea of humanity and water. Once when it rained, we had to rush up to that vantage point to see the boy. The location was a working brothel, and three men were getting serviced at that time in the room that I wanted to shoot in. [*laughter*] We were shooting with a big 35mm Arri [camera], and a woman, Sandi Sissel, was our cinematographer. I remember we had paid the madam, but she didn't stop. She put a little piece of cloth over these six sets of legs and stepped around them. There was Sandi, all of five foot three with this huge Arri and saying, "Action," and these guys didn't stop. [*laughter*] Down below was the tea boy running through the rain. So, it was like that, in real places but with very select vantage points that sometimes worked for us and sometimes didn't.

JV: The film went to Cannes, receiving a standing ovation and the top prize. It was also nominated for an Oscar and really opened doors for you. What else did that film accomplish for you?

MN: I had the courage to make *Salaam Bombay!* after seeing Hector Babenco's *Pixote* [1980], the great Brazilian film. We had written *Salaam Bombay!*, just gotten it budgeted at $870,000. I was like actually weeping with that figure. Up until then, I had only made documentaries of $150,000. I did not know how I would raise that money and was very despondent. I went to see Hector Babenco's film in which he was present and speaking about it at New Directors/New Films at MoMA. I was so stirred and so moved by that film, and by

> "It is the greatest teacher. The greatest teacher, because there is truly nothing more powerful and strange than what you see in life. It is completely unpredictable."

his words, which gave me the courage to make my own film. I really absorbed that lesson from him.

The first day of shooting *Salaam Bombay!*, about eight months later, I read in *The Times of India* that the kid who played Pixote had just been killed. I thought, this will never happen to us; it will never happen to me. We were always interested in this, but that day I was determined we would start a trust for street kids. We would go into it open-eyed. We would not just clean up a bunch of street kids, use them in a movie, and then put them out again. We tried to find places that would work with us for street kids, but there were none at that time; this is 1987. So, we formed our own trust; that was one big thing we wanted. It is now twenty-nine years we have this trust for street kids, with five thousand kids through our centers every year.

Five years ago, the Metro gave us a five-story building in Delhi, like what you see in Times Square, where kids gather and have an unbelievable place of sunshine. These centers and what we're doing with the 180 staff of social workers across seventeen centers is just amazing. They have impacted kids, brought them to art, brought them back to their families. It has changed government policy. This is an amazing thing that doesn't happen often. I've now made so many things to try and impact the world. It is all of the staff and my mother who make this real. They have really achieved well.

JV: I'd like to talk a little bit more about *Monsoon Wedding*, which had great success. When it was released, it was in the top-ten-grossing foreign-language films in America. People talk about the universality of the film, and you have five or six great storylines going in parallel. All the characters are different but seeking love in some way, or some version of that. The film is joyous, but it's also dark. Do you think having an ensemble of great characters helps with the universality of that film?

Nair and Founding Director Jon Vickers onstage at IU Cinema, April 2018.
Chaz Mottinger/IU Studios

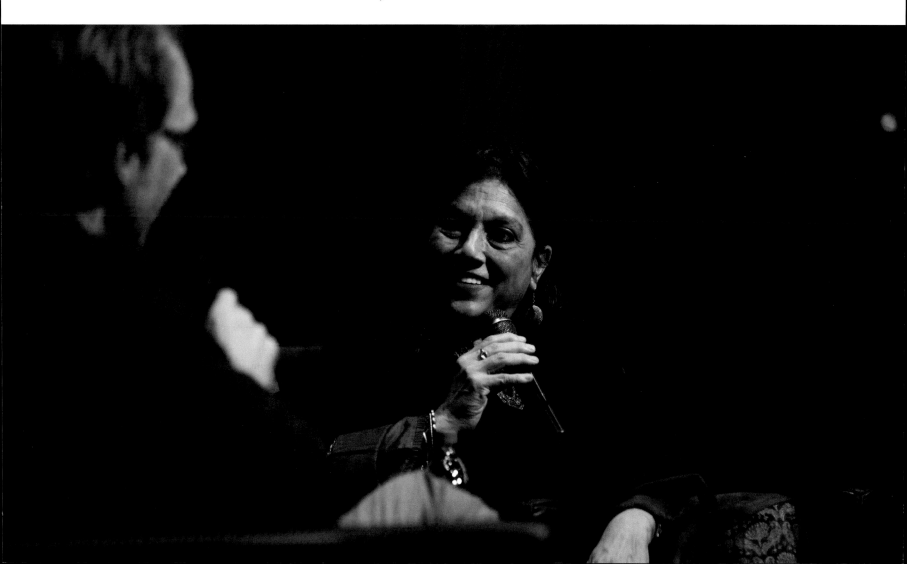

MN: Well, it's very Shakespearean in structure, but for me it was about love. It was about five kinds of love: twisted love, first love, the arranged love, all kinds of love. It worked because it was so honest about how we really are. That was because it was so inexpensive that I didn't have to answer to anyone; being the low budget gives one freedom.

For example, we do speak in three languages in one sentence. I would have had to ask the distributor who would never have allowed this to happen. But it's such a strange anomaly that we speak in in India, you know, and I just left it like that. Audiences understand when something is real, when it is truthful. It translates very easily and porously.

JV: You spoke about conveying *masti* or the intoxication of life, in *Monsoon Wedding.* Your films also try to convey authenticity and a search for truth. Is it more difficult to convey reality or find truth in a musical?

MN: Very difficult. You know, you have your inner circle of people you listen to, and I have a few great people in my life. While making *Monsoon Wedding*, I had a sea of index cards for each scene on a king-size bed. I would sleep on one side and would have these index cards on the other, so I could look at the film's whole structure. The whole idea of making a film for $1 million is to make it with great assurance, especially with five subplots and such a complicated story. I would study the structure every day, and very close friends would tell me, "Mira, you cannot marry *masti* with such darkness, like incest. It's impossible." I got concerned and remember, on that bed of index cards, I took out the abuse story to understand what the structure of the film would be without it. It just felt like a piece of fluff. I thought, when you look at the use of music in films, music is juxtaposed with silence, similarly with darkness and *masti*. The yin and yang is vital. How you achieve the balance and the artfulness, or the lack of artfulness, that's the point. So, I put it back, and I used it. It [is] a question of how to sculpt it, and how to balance it, that makes it work.

JV: I was intrigued when you were speaking earlier about being influenced by the Danish directors in the Dogme 95 movement. I didn't realize that movement inspired you. Did you use any of the other Dogme principles?

MN: Well, I can't have no music because Indians can't live without music, right? [*laughter*] And you can't have all-natural lighting because I need some lighting, but they had those kind of stringent

> "When you look at the use of music in films, music is juxtaposed with silence, similarly with darkness and *masti*. The yin and yang is vital. How you achieve the balance and the artfulness, or the lack of artfulness, that's the point."

Nordic rules. [*laughter*] We don't subscribe to those, but the principle of telling a story without frills, inventively, not just joining the dots but being visually inventive, taking that risk, and not flattering yourself with endlessness options. It entirely inspired me, entirely!

JV: We haven't really talked about your big Hollywood productions, so I'll ask a question or two about *Amelia* [2009] and *Vanity Fair*. Both films had major budgets, A-list actors, and were period pieces. These were big changes for you. Were you able to maintain your creative control and creative community in these big Hollywood pictures and still tell the stories that you wanted to tell?

MN: With *Vanity Fair*, yes, because they came to me for my sensibility. I liked Reese [Witherspoon] and knew it was Focus Features, who were highbrow, but I don't remember any of the kind of pain studio films usually inflict on us. I remember having a wonderful time, in fact, casting these great British actors whom I had loved and finally having something for them. So, *Vanity Fair* was not that kind of deep inner struggle. Because I was not of that British period drama kind of ilk, I did feel critics saw it as me poaching in a territory rather than something that I should be doing. But that is a separate notion, what critics think and what they don't think.

Amelia, for me it was pure folly. I have this criteria, when people [characters] of my films that don't originate from my heart, I ask myself, "Can anyone else do this film?" I knew with *Amelia* other people could make that film. At the time, I was actually making a big film with Johnny Depp called *Shantaram* with Warner Brothers. It is a film of a convict who escapes into a Bombay slum, and everyone in the slum thinks he's a doctor. He has to pretend to be a doctor and regains his humanity. It was kind of a wonderful thing for one and a half years, and two weeks before we started to shoot, the Writers Guild went on strike. All pencils down, and everything had to stop. We thought it would be resolved soon, and we would commence with shooting. In the middle of it, Mr. Depp signed *Pirates of the Caribbean 16* [*laughter*], so he left, which meant the whole thing crashed. It crashed at the moment of happening, literally two weeks before.

The producers of *Amelia* had been chasing me for a while. They came right in, and they said, "Look, you can't do this, so here's this." More than that, Hilary Swank knocked on my door. She is a fantastic actor and looks just like Amelia Earhart. I thought, here's a woman who

sort of literally broke the glass ceiling, and I had a point of view, but mostly it was the adrenaline of making a feature that was deprived of me which made me rebound and say, "Yes."

It was an independent film, and when I said yes, other studios signed up and said, "Think of the stars, my darling." They insisted I cast Richard Gere. Richard Gere is a darling man, but when you have Richard Gere in a movie you expect *Pretty Woman*, a romance. Suddenly, Amelia who broke the glass ceiling had to become Meryl Streep in *Out of Africa* [1985], you know? I knew that was coming once we cast Gere and almost left the film. But it's hard to leave after three months building planes with all your people, so I went into the film kind of miserable.

JV: If there are only one of those throughout a great career, that is not bad.

MN: Yes, only one. [*laughter*]

JV: When you approach a story, what is the first thing that you try to tackle, or what is the first thing that comes to mind in the process?

MN: If it starts as an idea, then we have to write the script. The script is usually born out of a lot of research. For *Mississippi Masala*, I spent six months in the motels of the South, and through the course of doing that research, you're photographing and imagining the work. But let's say you have the script; then the first thing I do is to make a look book of visual ideas, which could be anything from a Gucci advertisement to an image by Cartier-Bresson. This book will let you imagine the world I'm imagining, because I have to pitch to financiers and so on. Often the words I'm into are not words people know. You make this book to literally sell your wares.

Because music is so important to me, the other thing I do is make a kind of collection of pieces of music that have inspired me, either while writing that film or while evoking that film. For instance, it was a Bengali folk song by Nathan Sawney that I used as the kernel of *The Namesake*, or L. Subramaniam, the great classical violinist who did *Salaam Bombay!* and *Mississippi Masala*, because it was to his music we were writing the screenplays. When I am raising money, I make people listen, and I make people see.

JV: Do you approach the stories you are adapting differently than those you write?

MN: With adaptation, it is still about a point of view. If you take *The Namesake*, for instance. *The Namesake* in the novel is much more about the son, Gogol, than it is about his parents. But my inspiration to make *The Namesake* was the parents, the love story between the

two people who had lived together for fifty-nine years in a way that I knew but I had never seen on-screen—the non–Hallmark card way where they sit across the kitchen table, don't say a word, have a cup of tea, not say "I love you," and not give each other presents on Valentine's Day. My family, my culture, and my older people I know came from that place. It was an unbelievable sort of love that was inspired, as I was saying, by the loss of my mother-in-law. It was an homage to my in-laws' love for each other. So, adapting *The Namesake* was a point-of-view shift. Even while making an adaptation, I have to imbue it with personal instinct and just plain like.

JV: Last question for the night. You have told stories that only you can tell. You have created pieces of art which are going to be around for generations. You've started a film school which has inspired dozens of new storytellers and filmmakers in Africa. You have created a trust which has helped thousands. Your work has positively changed legislation. And you've inspired audiences of millions of people who have seen your films. You have created all of these wonderful legacies. Is there anything else you want to add to that? Is there anything unfinished that you still want to accomplish?

MN: Thank you so much. I should come to Bloomington when I feel low. [*laughter*] I really am touched, thank you. In many ways I feel ignorant of so much of our great culture, whether it be yoga, whether it be the sutras, whether it be the Upanishads, all the great texts that taught us so much, which I only know a smattering about. I studied the sitar when I was eleven. I was equally interested in the theater, and my sitar teacher, after two years of teaching me and seeing my books on theater, said to me, "Mira, you have to decide. You will take nine years in this tradition of sitar to create the right note. You cannot do it if you are doing something else." It was a real lesson. That is how I feel about how much I need to learn about the depth of the culture I come from. So, I have that desire, and an awareness of knowing a little about a lot, but not a lot about a little.

JV: Thank you for sharing what you do know, and thank you for being here with us. Thank you!

MN: Thank you, Jon.

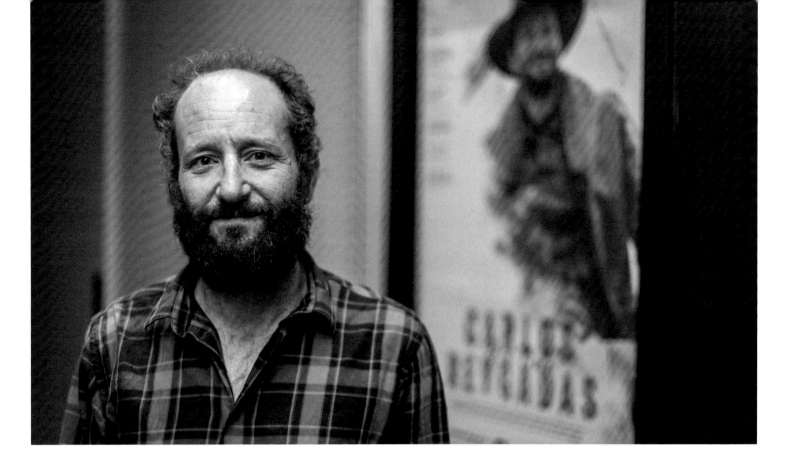

CARLOS REYGADAS

In March 2019, IU Cinema hosted acclaimed Mexican film director Carlos Reygadas. The visit and film series were presented in partnership with IU's Arts and Humanities Council and their spring cultural celebration, Mexico Remixed, along with the Office of the Provost and Executive Vice President. The curated program, Carlos Reygadas: His Time, was the first complete retrospective of Reygadas' work in the US. The series title plays off of his 2019 film *Our Time* and the use of time in Reygadas' films, which is unlike that of any other North American filmmaker.

Born and raised in Mexico City, Reygadas came to filmmaking after getting a law degree and working for years in international criminal law in Europe and for the Mexican Foreign Service in New York. Consuming films by the masters became his film school—graduating to making short films before completing his debut feature film, *Japon* (2002). *Japon* was a masterful debut, which premiered at the Cannes Film Festival, winning the Caméra d'Or and introducing Reygadas to the world.

His four feature films to follow—*Battle in Heaven* (2005), *Silent Light* (2007), *Post Tenebras Lux* (2012), and *Our Time*— have all made their mark on international cinema as singular works of art, winning Best Director and Grand Jury awards at Cannes. Awards aside, these films are each sublime works of art, exploring spiritual journeys of his main characters through themes of love, family, suffering, death, and the aesthetic quality of the natural world.

While his films do not directly reference other films or filmmakers, the ghosts are present in the texture, tone, intention, and patience of masters like Andrei Tarkovsky, Abbas Kiarostami, Ingmar Bergman, Robert Bresson, and Werner Herzog. But Reygadas' films are very much his own unique creations—imagined, written, planned, and captured under the direction of a singular vision; he has likened his work to that of a farmer, a fisherman, a poet, or a painter, collecting sounds and images from the physical world. All of his planning and creative choices leading up to turning on the camera are in the service of what he calls "bearing witness to the everyday miraculous."

Top: Reygadas stands in front of his poster at IU Cinema prior to his Jorgensen Guest Filmmaker event. Alex Kumar/ IU Studios

Facing: IU Cinema poster for Carlos Reygadas: His Time, March 2019. Kyle Calvert

> **"No film is for everybody, and almost no film is disliked by everybody."**

Reygadas believes that, when done well, a film can render or reproduce existence on-screen for an audience to observe, absorb, and even leave transformed. This is the power and artistry found in the films by Carlos Reygadas, who *Sight and Sound* magazine described in 2010 as "the one-man third wave of Mexican Cinema."

In addition to several film screenings and a Jorgensen Guest Filmmaker event, he sat for an interview with Founding Director Jon Vickers, "Carlos Reygadas: An IU Cinema Exclusive."

Jon Vickers: Why is film such a powerful artform?

Carlos Reygadas: It can capture life, presence. It can become some sort of incarnated philosophy. Film can think "life," and philosophy can only think "thoughts." So, if people from outer space come here in millennia, they will see films and be incredibly impressed by this need to know more about ourselves. Living our own lives and wanting to capture and see it shows such a deep degree of this desire to know who we are.

JV: Do you have a film experience that changed your life or direction as a filmmaker?

CR: When I started watching what I consider films, I was seventeen, and I remember—this is almost like a cliché nowadays—by a pure chance, the first film I ever saw which was not pure entertainment was *Nostalgia* [1983] by [Andrei] Tarkovsky. I do remember that it was just an incredible feeling and a completely new passage that opened in front of me. The emotion came from everything I could hear and see, from seeing time unfold, the movement of the camera, or the stains on walls, humidity, rather than the storytelling itself. This is something I appreciate very much, but mostly in literature, not necessarily in film. So, that was really like a new landscape for me.

JV: Why do you make films, and who are they for?

CR: I need to share. We can share a simple "good morning," which is a way of sharing, or say, "Look at that mountain," and we can make films. It all belongs to the same sphere, actually, it's all the same drive, the same reason. If there weren't any more humans, I wouldn't make films. Why do I make them, who do I make them for? For whomever wants to share this kind of film. Whomever feels moved by what I try to express. So, I think this idea of "a public" is just an abstraction of commerce. You cannot really ever talk about "a public" because it's only individuals in the end that watch a film on their own and experience it from deep inside. No film is for everybody, and almost no film is disliked by everybody. The numbers, in the end, are just a triviality for me. I do things with my taste, with my feeling, and just know that other humans will relate to it. The numbers are secondary.

JV: What advice would you pass on to a young or emerging filmmaker?

CR: Just be the most authentic you can be. Find your own vision, find your own ways, develop your own system. All artists, in the end, develop their own methods and ways of working, on very practical levels. And just be brave. Always be brave, always look inside, to be authentic and be brave.

JV: Who or what are some of your artistic influences?

CR: In music and painting, there are so many. In painting overall, I really love Romanticism in general terms. But I enjoy, for example, immensely now that we're here, the Hudson River Valley School of American painters from the nineteenth century. There were amazing painters all across the country. Looking to old paintings and Neoclassicism and this kind of thing has always been a source of great solace and emotion for me. In film, I mentioned Tarkovsky, of course. [Carl Theodor] Dreyer I could talk about, Abel Ferrara as well, Nuri Bilge Ceylan, the Turkish director, and so on. Someone people rarely talk about today is Carlos Saura, the Spanish director, especially all the films he made before 1976, until *Cría Cuervos* [1976] and starting from *La Caza/ The Hunt* [1966] as the beginning. Those five or six films are amazing, amazing. I saw them when I started making films, and I just wanted to see all of them. Werner Herzog and [Rainer Werner] Fassbinder were very important as influences. And how can I not mention Abbas Kiarostami, with his sense of presence that you have heard me talk about? Letting life unfold and the idea of seeing things alive and present rather than as tools for storytelling. So, all these people are very important to me. Abbas Kiarostami is a major master, and Manoel de Oliveira as well, for sure.

JV: What do you want your legacy as a filmmaker to be?

CR: This is all a vision, and everything will disappear eventually. That is important to remember, because there is too great a keenness in wanting to transcend. It is all an illusion, in a way. I just want to be authentic in whatever I do. If it remains for a while, I'll be happy. If you want me to add a concept to this idea of how to be remembered, it would be just to show my individual vision. Each one of us has our own vision, and we have to find our own voice. Each voice is always original. Rather than wanting to be something like a good illustrator of a system that already exists, I want to show that we can all find our own ways of expressing. That is the most important thing for me. Authenticity, in the end, that is how I would like to be remembered, as an authentic person who had his own vision and managed to put it together so it could be shared with others.

> "Authenticity, in the end, that is how I would like to be remembered, as an authentic person who had his own vision and managed to put it together so it could be shared with others."

JV: What is the importance of a good cinema on a university campus?

CR: It is not only important; it's a huge privilege. It's a basic thing to have a good theater to see films in any film school. To have such a good one is a huge privilege. I wish that I would see the hunger for whatever you show here. It is the time to watch films, when you're a student. You're living great times, and you have to use your time usefully. I really wish students were watching films, at least one each day, but not only the things being fed on platforms and television. This world is so vast, and there's great cinema passing unnoticed by these new platforms. So, I really think people should be here in this cinema every day, watching films as much as they can. That is really the best film school, the best teaching, and the best learning you could have. Watch films, discuss, engage. That's all you need, actually. All the rest, like technique in cinema, is so simple. It's all in a manual. You don't need to do much; you just need to watch films, talk, and develop your own taste. To be intuitive, you have to develop your own taste, and one you know well. With that, you will be able to decide, on your own grounds, what is there to be shot, shown, thought, discussed, written, et cetera.

Reygadas being interviewed by Associate Professor Jonathan Risner at IU Cinema on March 29, 2019, during a Jorgensen Guest Filmmaker event. Alex Kumar/IU Studios

MERYL STREEP

There may be no living actor who is more respected by her colleagues, critics, the film industry, and audiences than Meryl Streep. Her body of work spans over forty years and has received the highest honors, critical acclaim, scholarly consideration, and audience favor. She believes in the transformative power of art and has been quoted as saying, "The great gift of human beings is that we have the power of empathy." And movies, she states, "have the power to change you."

In late 2013, IU Cinema led a nomination for Streep to receive an honorary degree, doctorate of humane letters, from Indiana University. Along with the nomination letter from Founding Director Jon Vickers, letters supporting the degree were collected from IU faculty and outside friends, including Kristin Thompson, film scholar and author of *Film Art: An Introduction*, and Laura Emerick, arts editor for film critic Roger Ebert and the *Chicago Sun Times*.

Roger Ebert, an avid admirer of Streep, also made remarks over the years about the movies and empathy, stating that "empathy is the most essential quality of civilization," and "movies are the most powerful empathy machine in all the arts." These shared comments inspired IU Cinema to title a film series surrounding the degree Meryl Streep: Powering the Empathy Machine.

On April 16, 2014, Streep graced the stages of IU Cinema and IU Auditorium by participating in several public events, including a formal degree conferral ceremony, a master class for acting students, and a Jorgensen Guest Filmmaker program, which took the form of an onstage conversation between Streep and Provost Professor Barbara Klinger. The following are some highlights from these events.

Meryl Streep onstage at IU Cinema following a screening of *A Prairie Home Companion* (2006), April 16, 2014. Chaz Mottinger/ IU Studios

President Michael A. McRobbie opened the events, stating, "It is my great pleasure to welcome you to this truly wonderful, and I believe, by your reaction, this very special occasion. Today, we honor Meryl Streep, simply one of the greatest actors in the world today, and indeed of all time, and a great friend of Indiana University."

In conferring the degree, President McRobbie declared, "Meryl Streep, Indiana University salutes you. Throughout your lifetime, you have dedicated yourself to becoming a groundbreaking and masterful artist of unsurpassed quality, and you have shared your matchless skills with millions of fans throughout the world. Your continued commitment to philanthropy, especially your tireless efforts on behalf of women, are truly inspirational. Thus, by virtue of the authority vested in me by the trustees of Indiana University, I am proud and deeply honored to confer upon you, with honor, the degree doctor of humane letters, with all the attendant rights and responsibilities."

The formal ceremony ended, and stage crew in the IU Auditorium quickly reset the stage for the extended interview with Streep while the audience of more than thirty-two hundred patiently waited. After an introduction by Vickers, the conversation commenced between, in Vickers' words, "the incomparable Meryl Streep" and Provost Professor Barbara Klinger from Film and Media Studies within IU's Department of Communication and Culture.

Barbara Klinger: I want to say, on behalf of everybody here, how absolutely fabulous it is to have you on campus. My first question is going to be an origin question, which is about how you came to the profession. In particular, if there was an event, a text, a performer, or something that inspired you and made you go, "This is what I want to do." So, it's a question about origins. What drew you to acting?

Meryl Streep: I think I was probably like every little girl who gets up in the living room and puts on a princess dress and expects everyone to pay full and total attention. Most of us grow out of that. But I knew I was always interested in people. I didn't know what to do with that interest, which was mimetic, you know, I liked to imitate people, liked to watch people. I was nosy. I was a kid who, when I was little, I remember thinking I wanted to be an interpreter at the UN. My mother used to pull us out of school, my brothers and I, once a year, each one of us, and we'd get a special day, and we could do whatever we wanted. Sometimes we'd do what she wanted. And we'd drive—I was living in a little house in New Jersey, in a middle-class suburb, and she would drive me into New York. And one time, I remember she took me to the UN. And I thought, "Okay, this is what I want to do." Because I thought it was so mysterious. There was nothing like it. This is hard to translate to an audience that is young and has multiple platforms on which to view the world. But in those days, it was, you know, three television stations, and you weren't allowed

Facing: Streep receiving her honorary doctorate of humane letters degree from IU President Michael A. McRobbie and ceremony grand marshal Michael Tiller. Chris Meyer/IU Studios

Right: Streep being interviewed by Provost Professor Barbara Klinger as part of a Jorgensen Guest Filmmaker program at IU Auditorium. Chris Meyer/ IU Studios

to watch TV anyway. But I remember seeing this panoply of color, people wearing native dress on the floor of the UN. And arranged in a row above, in the booths, were pretty much all young women, and they had headphones on, and they were doing the translating, simultaneous translating. And I thought, "What an amazing thing to do."

I think the time I'd gone to see this—my mother had taken me to the UN—was right when we were studying in, I think it was fifth grade; I think I was ten or eleven. We were studying the melting pot that was America, and we were drawing all the different colors of faces on a mural in our classroom. You know, we didn't have many different colors of faces in our classroom. But we were in love with that dream, and we were certainly taught that it was, you know, the way to go. And so, I think that's what I wanted to do. I studied language. I studied Italian and French in college. I studied the humanities. I was always in plays, but I didn't think it was—I thought it was vain to want to be an actress, and plus, I thought I was too ugly to be an actress because, you know, glasses

> **"I have now understood that what I do is sort of a translator."**

weren't fabulous then. So, I came to it late, I guess, this is a roundabout way of saying. I have now understood that what I do is sort of a translator. I'm a translator in a way, in my work, and I get to be a princess.

BK: A translator and a princess, that's good! In the early moments, if we can call them that, was there a moment when you saw something, whether it was a play, or a movie, or whatever it might have been, where you went, "This is it for me," and it inspired you? And are there still things that inspire you? Because we always think about inspiration as something that happens at the beginning and not so much something that continues. So, was there something at the beginning, and is there something that continues?

MS: Yes, I was in love with *I Love Lucy*, which was Lucille Ball on television, and I loved the comedians, I have to say, on television, because there was only one channel that had old movies. And to you, the contemporary movies of my time, my childhood, would be very, very old, but these were even older movies. These were movies from

the '30s and '40s. I loved Carole Lombard; she was a goddess to me. I love the ones that make you laugh. But I really didn't think, "Oh, I could do that," you know, I just loved it. But my mother took me in my day to see, I remember I saw Diahann Carroll, wonderful African American actress, in *No Strings*, which was a Richard Rodgers show. I saw Barbara Cook in *The Music Man* on Broadway. I saw Georgia Brown do the very first production of *Man of La Mancha*. I mean, I saw a lot of musicals. My mother loved the theater; my grandmother loved the theater. But again, I didn't think it was for me; that came very late.

Once I had decided to sort of be an actress, I applied to drama school, because I had gotten out of college with a degree in costume design. I loved design too. That was another way of looking hard at people and deciding what signified—what told you about a human being by virtue of what they decided to put on in the morning. But once I graduated from college, I was living on a commune in rural Vermont, and we were doing absolutely dreadful plays for ski audiences. And they were like this [*lies back in her seat as if asleep*]. During the Chekhov, they checked out. [*laughter*] So, I felt I wanted to get more serious about it, and I found out about drama schools. I thought, you go to graduate school if you want to be something. So, I applied to Yale and I applied to Juilliard. And Juilliard's application was forty dollars, and Yale's was fifteen dollars, so I applied to Yale. I got a scholarship, which I'm grateful for, in the days that they were easier to get, I guess. And I went there.

But even there, my third year, I signed up for the law boards. Because I thought, "This is a silly way, who [do] I think I am, to want to be an actor?" Many, many of my friends woke up at three years of age and said, "I have to be on the stage." And I never, ever had that. I've always been an omnivore, interested in way too many things, and I actually found the one profession that fed all my appetites. I slept through the law boards, because I had a performance the night before, and the rest is history. I graduated and very quickly got work and paid off my student loans, which was really the happiest day of my life.

BK: [*laughs*] People are still happy when that happens, yeah.

MS: So, but so for performances that really struck me, I can remember certain things that I saw. I saw Irene Worth onstage with Christopher Walken in *Sweet Bird of Youth*. Am I getting that right? Yes, I think so. When I was a student at Yale, and we took the train down, they very rarely let us out of the cage, but we were able to get down there. And then another time, I saw—right at the end of my drama school education, which was three intensive years of graduate

study, there was just no daylight, really, that we ever saw—but I managed to get down and see Liza Minelli live at the Winter Garden. And that performance taught me something about acting that had been neglected in drama school. In drama school, so much of it was to achieve the truth. At the time that I was in school, a lot of it was about sort of wild imaginings of plays, nothing ever realistic. I hadn't been in a realistic play pretty much the whole time I was at school. So, I came down to the Winter Garden, and there was Liza alone onstage. It was called *The Act*. And I was seated way up where you are [*points to the back of the house*]. Yes, you! That woman made me feel the inside out of a song. And the depth of emotion, and the sheer theatricality that can be married to the truth. It was a very, very profound lesson, because my pores were open, and I was young, and I was looking for something other than what I was getting at school. This is where we learn all the time. I learn every season that films come out; I see someone do something that I think, "How did she do that?"

BK: Is there a recent example of something like that, so you've seen recently that you went, "wow"?

MS: Yes, but I don't want to single out—I'll just say one. Mmm, no, then it'll make other people mad. Many. Many many many many many. And you know who they are.

BK: All right. Fair enough.

MS: And others that you don't know. I will say Mia Wasikowska. She did a *Jane Eyre* [2011]. Astonishing. Astonishing. Not on any awards list, nowhere remarked upon. But an impeccable, impeccable performance. Thrilling. And I watched it, and I learned something. So, you know, we're never too old.

BK: I love that movie actually, and it was completely underneath the radar. Michael Fassbender wasn't bad, either.

MS: Well, he never is! [*laughter*]

BK: I've always been, and I know a lot of other people are, really fascinated with how you prepare for your roles. You were just saying you have this love of musicals, and I thought you were astonishing in *Mamma Mia!* [2008], but you've also done Margaret Thatcher and so many other different kinds of roles. So, maybe if you could just talk a little bit about how you get prepared and if you prepare differently for a musical role—I'm assuming yes—than a historical role where you're playing a real person. Are there different sorts of preparations that you go through before you actually are in the project?

MS: Yes, there's no way to sort of give a generic rule about how to prepare. Tomorrow—I'm just warning anyone who's here who's

going to be in that class—I'm teaching my very first master class. And I have no idea how to do it, so, just putting that out there. Because I've found there is no package of dreams that you can bring from one job to the next. Everything is different, everything is different. You can get ready, of course, when you're playing a historical character. You pay attention to what they actually looked and sounded like to approximate something so people aren't screaming, "That's nothing like her!" But then you also just throw all that out after the preparation because the whole movie, the whole drama, happens in a moment between you and whoever you're working with. You have no idea what they're going to bring; you have no idea. You can't get ready for that.

BK: So, you can only go so far with that before you're actually in it, and then when you're in it, you have to figure out how to make it work with the chemistry with whoever the ensemble is or whoever you're acting with.

MS: Yes. Yes, you have to throw away all your preconceived ideas, because you might find something out that you didn't know, by virtue of the insight of the other person. I mean, it's just something that happens, as they say, in the moment. And that's why plays are so much fun and why I've lamented that I haven't been able to do as many plays as I would have liked, as a mother. Because it's hard, with that schedule; it's just not as family friendly. But yeah, you get to do it

> "I've found there is no package of dreams that you can bring from one job to the next. Everything is different, everything is different."

onstage, and if you were unhappy one night, you can go up and switch it up the next night and try something new. Spring something new on that person who just ambushed you the night before with their idea: "Okay, here's my idea." It's really live, and fun, and living. But film can be that way too; it's just that the director picks which one of those wonderful ideas and the editor. You really give away the child at birth.

BK: That's the process; that's the way it works. You have described the way you get into character as "a total immersion in possibility," and I've always liked that phrase, "a total immersion in possibility," and I think you've spoken to that a little bit already, and the fact that it's different in terms of whether you're playing Karen Silkwood or Bart Simpson's girlfriend in *The Simpsons*. So, it's a very, very different kind of process. But something I've also heard mentioned here on the stage tonight, and something you've talked about, is empathy. Since empathy is kind of a baggy word still, I'd love to hear you say a little bit more about what you mean by "empathy" and if you see it as a secret to a great performance.

MS: Empathy, to me, as the mother of—how many, four?—is seeing the four-year-old crying about something, and the one-year-old will look [*gazes upward, slowly frowns, then bursts into a small sob*] and cry! Because they don't know why, but they feel what their big sister is feeling. And that's a very mysterious act; we do that in the theater.

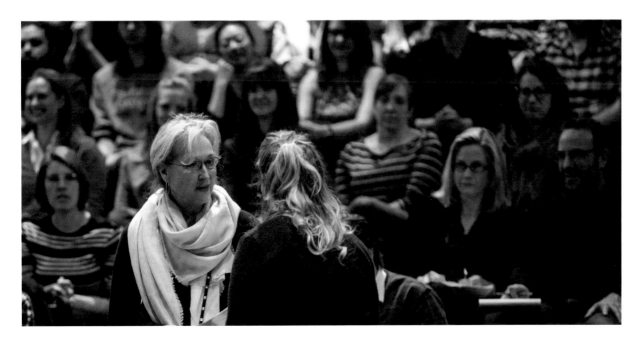

Left and next page: Streep leading her career-first master class in IU's Department of Theatre, Drama, and Contemporary Dance. Chris Meyer/ IU Studios

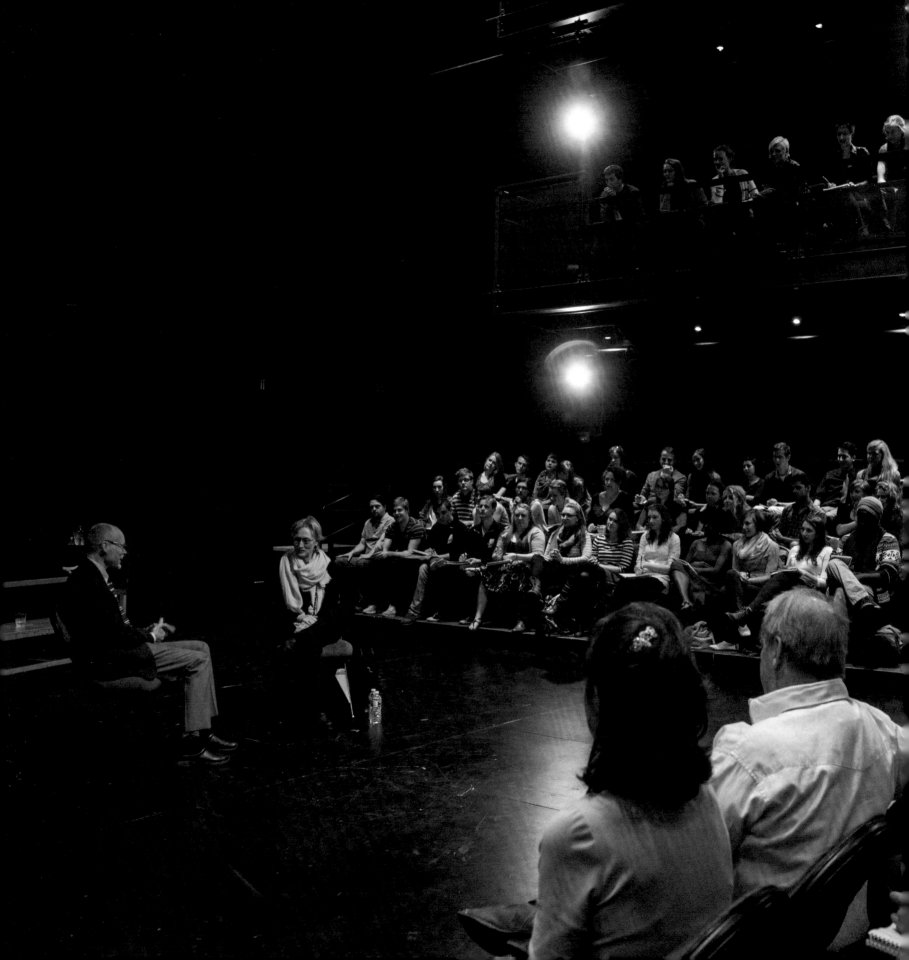

You sit, and you watch someone on-screen or onstage. And there are moments. It's not always, and it's not with every kind of entertainment that's out there, because it's not asked of you; many things, many really interesting, intellectual films, and thrilling films, don't ask the same kind of visceral connection. But it is possible for people of very diverse backgrounds to feel the feelings of someone not remotely like them, even crossing the gender line, and even the age line, and even all the things that divide us tribally, you know, in every way. You can still feel what that person feels, and that's such an interesting, underused quality human beings have. I think it's underused in diplomacy, for instance, or, you know, all the Robert's Rules of Order, and everything that we do to divide ourselves and make it all fair. I'm getting airy-fairy now. I'm just going to go back to the question. I think that empathy is a really valuable thing to teach our children, and to teach each other, and to reinforce in each other as a glue for civilizing the world.

BK: Well, we'll jump back from the airy fairy a little bit and get to some specifics. You do have this huge and admirable portfolio, and I was curious to know what jumps out at you as a particularly special scene or particularly special role that you had that you come back to often as you think about your career.

MS: Hmm. I don't do things that way. I don't think about scenes in things. I don't remember the experience that way. Because my experience making, for instance, *Out of Africa* was the total package. I think of my husband's studio in the back of the house. I think of the paintings he created there. I think of my daughter screaming in the car during the scene with Klaus Brandauer, and my makeup man in there, trying to get her to shut up. Because I made the mistake of "wouldn't it be cute to bring Mamie and put her in the movie?" And she just was mad. You know, I think about all sorts of different things. It really is the totality of life, including the scenes, and I don't really go back and look at them. Although sometimes inadvertently you're scrolling through and there's something, and then it all floods back. But I don't really do that.

BK: That makes sense. Because it is a total totalistic experience, and what we see is what's up on the screen.

MS: You see the movie.

BK: But what you're experiencing is everything around that and through that.

MS: Exactly.

BK: But I do have to ask, is there a role that you've had that is especially dear to your heart? Or maybe there are too many.

MS: Oh, there's a lot of them. There's a very small number that I am not so fond of. [*laughs*]

BK: We can't extract that information from you, can we?

MS: Well, happily you've probably never seen it. And there's a reason. There's one called *Still of the Night* [1982], which was a wonderful director, Robert Benton, and we had just made *Kramer vs. Kramer* [1979] together. I really wanted to work with him again, and he wanted to make a noir film. And anything where the style is more important than the people is not going to make the people in it as happy as it is going to make the cinematographer, because the cinematographer is the star of that. I played a character that was sort of a cypher. I just remember that her hair went like this [*swings her hand rhythmically back and forth*]. And that was my main character. I barely moved, you know. If I ever added any kind of animation, it was too much. Because a noir woman is an idea; it's not so much a woman, with all the bumps and troubles.

BK: Not so much a character. An archetype.

MS: Yeah, an archetype, exactly. So, that wasn't so much fun to play. But as far as the ones that I love, I mean, every time I think, "Oh, that's my favorite," then comes, you know, *Julie and Julia* [2009], and I love that. I love *The Iron Lady*, I do, I love the old battle-ax. I found something in her that I found really interesting. So, I don't really have favorites. Although. The one . . . *August: Osage County* [2013]. [*applause*] Thank you, but none of you liked her! [*laughter*]

BK: That's part of the point.

MS: Yeah. So, I feel really fortunate that I've had so many chances. I feel very, very guilty when the litany of my awards is trotted out, because I really feel like there are many women my age in our industry who are way capable of the work I've been doing, would have had a different spin on it, interesting. But for some reason, I've gotten all the chances, and I've felt unhappy about that. And I have expressed it numerous times. But it doesn't make anything really change. The only thing that changes is if the market speaks, and the only reason I have a career at sixty, whatever, -four, that I am now is because I had some hits late in life. I had *The Devil Wears Prada* [2006]. I had *Mamma Mia!* But before that, it was hard to get older women's interest.

> "I think that empathy is a really valuable thing to teach our children, and to teach each other, and to reinforce in each other as a glue for civilizing the world."

But now, the business is changing. I just decided to make a movie next fall, and it was vied for by three studios, and all three studios are headed by women: Sony, Universal, and Fox. That's a really, really big difference from when I started. Believe me, it was really a different thing. There was an almost impenetrable line of suits. And it's not anybody's fault; I'm not saying that. Many, many great movies came out of the '70s, absolutely fantastic movies, not a great lot for women. And the great ones for women were by really special men, like Alan Pakula, who made *Klute* [1971] with Jane Fonda and then *Sophie's Choice* with me. He had to mortgage his home to make *Sophie's Choice*; no one wanted to bankroll it. Finally, a guy who had a big car dealership in Southern California came in and saved us, but yes, it was very, very hard to get those films made.

BK: That was going to be another one of my questions for you, because I was watching the Women in Film tribute from 2012 where you were talking about the underemployment of women in the industry, the underrepresentation of women in roles on the screen, and the lack of appreciation, or underestimation, of the power of female audiences. And so, you're saying it's changing?

MS: That was a long time ago; that wasn't 2012.

BK: That was 2009 maybe?

MS: It was a loooong time ago.

BK: So, things have changed over the last ten years.

MS: Yes, ten years, I would say.

BK: And it's because the coordinates have changed because women are in executive positions?

MS: Follow the money, yes.

BK: And I noticed you've worked with quite a few female directors. Is that a conscious choice on your part, or is that something that's all part of this movement?

MS: It's all or part of the fact that they're interested in the stories about, maybe, a woman over fifty. And I've found, once certain movies were out, people realized that audiences were not so age-phobic, you know; they were willing, they were happy, and they were glad to be there. I think a lot of underestimating of, sometimes polling and all that stuff really misses the truth, you know; the truth is a different thing that's out there. You have to go on instinct more than, "Well, it's backed up by our figures, who's going to the theater." Well, yeah, but who's going to that is, because that's what you're giving them. Uh oh, I'm not talking English anymore. But sometimes the tail wags the dog.

BK: Yeah, definitely seems so. There are no doubt aspiring performers in the audience today, and I know that you have two daughters who are actresses. They've probably talked to you quite a bit for any advice you can give them, I would imagine. Do you have a kind of advice for, especially young women, but young performers in general, as they're trying to break into the business in film, television, stage?

MS: Well, for young women, I would say don't worry so much about your weight. Because girls spend way too much time thinking about that, and there's so many other things to think about. And for young men, and I would say what makes you different, what's weird about you—and for girls—is what's your strength, that's your strength. Everybody tries so hard to look a cookie-cutter kind of way. Certainly, in Hollywood, there's a lot of pressure to do that. And actually, the people who get picked up and noticed—look at Adam Driver in *Girls*.

BK: Absolutely, great example, yeah.

MS: Fantastic. But you know, he could have gone in and had everything fixed, and why? He's so generous, he's himself, and those are his strengths. What he looks like, what he brings, his weirdness, his own particular imagination. So, you know, it's your fingerprint, whatever's weird about you. I used to hate my nose. Now I think, "Well, it's okay, it's okay." You know, I was thinking [*gestures to the plants onstage*], we're between two palms.

BK: [*laughs*] Yes, indeed, yeah. That's so true.

MS: I'm gonna take on a whole other attitude.

BK: Well, that's good, because we're going to transition to questions from the audience. And I will say there were quite a few questions about the kind of pizza you ate at the Oscars. I like to start with hard-hitting questions, so maybe we could talk a little bit about that.

MS: That's a question for Don Gummer, who ate my piece. And his own. Why should anything be different? It was margherita. Boring.

BK: But safe!

MS: But we were *starving*.

BK: Moving right along. The pizza question, by the way, was from Sarah, and she was only one of the many pizza enthusiasts out there, so thank you, Sarah. This question is from [the] Meryl Streep Site: "What do you think of your fans, the Streepers?"

MS: I'm a little alarmed. But as long as you all know it's all just make-believe. I'm grateful that I've had a sort of Renaissance of interest in my career, and it's wonderful, it really is. But celebrity has become a very odd thing in our culture. I don't have a Twitter account, although

apparently, I have five. But they're not me. I'm not on Facebook, but yes, apparently, I am! And I don't know who those people are. And they're a little scary to me, but everybody needs a hobby. [*laughter*]

BK: This question is from Kelsey. And she asks, or he asks, "How do you balance being a mother and a professional?"

MS: I'm done. [*laughs*]

BK: How did you balance being a mother and a professional?

MS: Well, that's one of the things that my husband and I made decisions based on, what they all wanted, the kids. So, for a while, in the beginning of my career, I had a lot of international movies. And then my son said—he was seven, and he had been to, I think, eight different schools by the time he was a second-grader. I think he went to preschool in Texas for *Silkwood* [1983]. The American School in London—oh, no. First grade in Africa, and then the second half of first grade in London, and then back to Connecticut, and then to Australia. And he looked at me in second grade and said, "I don't want to be new anymore." So, we settled down in Los Angeles for about five years, and then I couldn't stand it anymore. So, we moved back to Connecticut, and New York, and really tried to make decisions based on things that weren't very far away. Locations of films that weren't far, and also that I was never away for more than two or three, at the absolute most, three weeks, and everything else had to be shot in Los Angeles or in New York. And pretty much it worked out okay.

When they're little, you can drag them around in the camper and stuff. And in that way, show business, film, is friendly to parenting. But of course, I would be home way, way more than they liked. Because I would be working for four months and then sort of unemployed for four or five or six months, or pregnant and home all the time. So, it was a varied existence. But one thing I really couldn't do was plays, because when you're in a play you're at the theater when they're home from school, and when you're home, they're at school. So, you never see them, and it was really hard to do that. So, I only did them in the summer in Central Park for short runs. They really don't credit the sacrifice that I made on their behalf. Could not care less. [*laughs*]

BK: This one is from Grayson. "You're constantly reinventing yourself as an actress. Does it feel like a new experience each time, or is acting incredibly commonplace now?"

MS: No. If anything, my husband can tell you I approach every new thing with even more dread and fear than I did. When I was twenty-three, I knew everything. Could not tell me anything; I knew it inside out. And you get older and you know how complicated life is, and how much you don't know, and how much there is to know. I love working, I really do love the process. What I have not grown to love as it's exponentially grown is the marketing of things and how much you have to sell. Go on this, be on that, do sixty interviews in a day, and get the product out there because there's so much competition for eyeballs, and all this kind of talk that they do. That's a different part of life; it isn't the job, but it is kind of the job now. You have to be out there in the general clamor. So, yes, I love working. I'm about to do—I've gotten two of the best scripts I've ever gotten this year, so I can't wait to do them.

BK: Before we close the shop today, is there anything you'd like to say about the very last thing you started? We were talking a little bit about it backstage—*Suffragette* [2015].

MS: Oh yes! We were talking just before the curtain went up about performance, and you were speaking about teaching, and how teaching is—you're not quite yourself; there is an element of performance in it. And you're a little bit aware, self-aware, of how it all looks and everything. And it made me think, I just finished a film in London.

Streep onstage at IU Cinema being interviewed by Founding Director Jon Vickers following a screening of *A Prairie Home Companion* (2006), April 16, 2014. Chaz Mottinger/ IU Studios

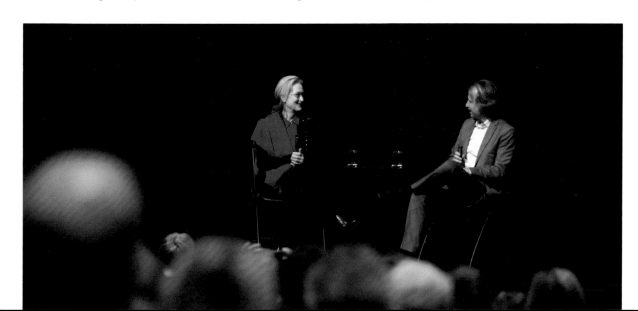

I was only on it for two days. It was called *Suffragette*, and Carey Mulligan is playing a laundress in London in 1912, and she is someone in one of these big, terrible, industrial laundries where people were exploited, women were exploited. And how hard life was. And at that time, in 1912, in London, the marriage age was twelve. A woman who married lost the rights to whatever money she had coming into the marriage. If she had children and the father was a drunk, and she wanted to get out of the marriage, she could leave, but she had to leave her children with him. Women had no rights, none.

Suffragette is about the earliest parts of the British movement to get the vote. I play Emmeline Pankhurst. The British suffragist movement was different from the American one in that it was violent. And a chief instigator of this violence was a woman named Emmeline Pankhurst, and she was extremely bright and accomplished, she'd been educated in Paris, good family. But she spoke on behalf of the women of another class from her, and she encouraged them to do violence against property only, not against people. So, these gals would roll around London with baby carriages and have bricks and throw them through the window. Because they tried for fifty years to give a nice petition to Parliament, and they'd say, "Yes, yes, of course," and for fifty years they did nothing, so, boom, they ignited it.

Anyway, I'm telling you all this because Emmeline Pankhurst was one of the first people I've ever seen—there is one piece of film of her that exists, and it's about twelve seconds long. And it's so interesting because she's a woman that has a demeanor you'll never be able to achieve, because you've all been photographed, and you know what you seem like, and you're used to your outer performance. But this was a piece of film of a person that had never been filmed, so she didn't know how to—you know, she sort of walked in an ungainly way. It was so interesting because nothing was designed. Nothing. Just her passion came forward, just her speech. And she was a charismatic speaker. This didn't have any sound obviously, but you could just see the difference between people now, who are so used to seeing themselves as an object, and people who were holistically within the gestalt of their own bodies; do you know what I mean? It was sort of thrilling to see that, and that taught me something too. About how to strive for unselfconsciousness.

BK: Really interesting. I think that's an interesting note to close on, and we look forward to the new ones coming down the pipeline. Thank you so much for this conversation.

MS: Thank you, Barbara.

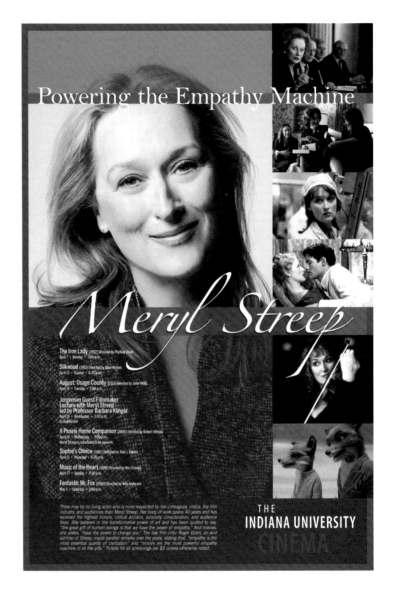

IU Cinema poster for Meryl Streep: Powering the Empathy Machine, April 2014. Jennifer Vickers

JOHN WATERS

In October 2015, author, film director, and legendary auteur of trash and charm visited IU Cinema to discuss his films and present a Jorgensen Guest Filmmaker program titled This Filthy World: Filthier and Dirtier. The sold-out lecture was presented in partnership with the College Arts and Humanities Institute (CAHI) and surrounded by a series of films curated by founding Associate Director Brittany D. Friesner titled the Inimitable and Incomparable John Waters.

Waters was born in Baltimore in 1946 and was drawn to movies at an early age—particularly exploitation films that enticed audiences with lurid ad campaigns highlighting sex, drugs, and violence. As a Baltimore teenager, he began making 8mm underground movies influenced by the likes of Jean-Luc Godard, Walt Disney, Andy Warhol, Russ Meyer, and Ingmar Bergman, and, in 1972, Waters created what would become the most notorious film of 1970s American independent cinema—*Pink Flamingos*—making him a cult celebrity.

With the success of the big-budget *Hairspray* in 1988, Waters went from "hon" to Hollywood, but he has never lost his fondness for pushing boundaries and skirting the edges of acceptable behavior. Maintaining his independent cinema ethos, he continues to charm, challenge, and dare audiences with his audacious vision. Commenting on the long-lasting popularity of *Pink Flamingos* after its twenty-fifth anniversary rerelease, Waters proudly boasted, "It's hard to offend three generations, but it looks like I've succeeded."

In addition to writing and directing feature films, Waters is the author of several books—including *Role Models* (Farrar, Straus and Giroux, 2010) and *Carsick* (Farrar, Straus and Giroux, 2014), both of which landed on the *New York Times* and the *Los Angeles Times* best-seller lists—as well as a photographer, whose work has been shown in galleries all over the world, including the New Museum of Contemporary Art, the Fotomuseum Winterthur, and the Andy Warhol Museum.

In addition to the film screenings and the presentation of his one-man show, John Waters sat for this "John Waters: An IU Cinema Exclusive" interview with founding Associate Director Brittany D. Friesner.

John Waters at
IU Cinema before
his Jorgensen Guest
Filmmaker Lecture,
October 2, 2015.
Eric Rudd/IU Studios

> "I always rooted for the villain. I thought Cinderella's stepsisters were way more fun. I like the queen in *Snow White*. I like Captain Hook. I never like the heroes."

Brittany D. Friesner: Why is film such a powerful artform?

John Waters: The most powerful aspect of film is voyeurism. You can go into everybody's world. You can feel their excitement. You can feel misery. Their murderous rage. Their sexual lunacy. Everything, without having to leave one place that you chose to go to.

BF: Do you have a film experience that changed your life or direction as a filmmaker?

JW: Very much when I was a kid, the thing that changed my life, really, I was about ten years old. I went to see *House on Haunted Hill* [1959] with William Castle, and they had "Emergo," which is where a skeleton went on a wire next to the booth, across the top of the theater projection booth, and it was the big gimmick. And the entire sold-out audience of children went insane. It was anarchy. And I am always trying to duplicate that image. The end of *Pink Flamingos* got close, but never as good as William Castle.

BF: What are some of your artistic influences?

JW: Walt Disney, because I always rooted for the villain. I thought Cinderella's stepsisters were way more fun. I like the queen in *Snow White* [1937]. I like Captain Hook. I never like the heroes. Then later in life, certainly Jean Genet was a huge influence. Usually villains, usually people that I was taught not to like, people who broke the rules. Tennessee Williams certainly saved my life, really, because everything I read about in *Life* magazine, or Jackson Pollock, beatniks. I thought, "Oh, I want to be a beatnik!" That was the first thing. I still want to be a beatnik!

BF: When did you know that you wanted to become a filmmaker?

JW: What age did I want to be a filmmaker? Well, I was a bossy child, and I was a puppeteer. Most film directors had puppets. And most actors later will say to their directors, "I'm not your puppet, you know!" But they are.

BF: Why do you make films, and who are they for?

JW: I make films because I like to tell stories. I'm Uncle Remus. [*laughs*] I think that basically, who are the people that I tell stories to? I made exploitation films for art theaters and people that have a

Facing: Waters onstage at IU Cinema during his performance titled "This Filthy World: Filthier and Dirtier." Eric Rudd/IU Studios

Top: IU Cinema poster for the Inimitable and Incomparable John Waters series, October 2015. Kyle Calvert

> "The most powerful aspect of film is voyeurism. You can go into everybody's world. You can feel their excitement. You can feel misery. Their murderous rage. Their sexual lunacy. Everything, without having to leave one place that you chose to go to."

sense of humor and don't fit in their own minority. That's my core audience. Prisoners and minorities that don't get along with their fellow minorities. And then it branched out from there.

BF: What advice would you give to a young filmmaker?

JW: Young filmmakers, I always give the same advice. A no is free. Don't hesitate to ask. You can ask a hundred people, they say no, and then all you need is the 101st one to say, "Yes, I'll back your movie," or "I'll give you your first break," or "I'll cast you," or "I'll do that." Don't fear rejection; show business is rejection.

BF: What drives you to take on the subjects you do in your films?

JW: Basically, I'm interested in things I can never understand. If I understood it easily, it wouldn't be of much interest to me. I always am perturbed about how I feel about certain subjects, and that's what always interests me, what I make movies [about], and what I write about.

BF: If you could go back and change anything on your career path, what would that be?

JW: If I could change anything? Well, I probably wasted a couple years trying to make the sequel to *Pink Flamingos*. I learned that, really, if something doesn't get made right away, it usually doesn't get made; it's dead in the water. So, don't spend too much time. If something doesn't work and you've spent two years on it, move on to the next idea. Although, it did eventually come out as a book, so it wasn't a total, total loss.

> "What age did I want to be a filmmaker? Well, I was a bossy child, and I was a puppeteer. Most film directors had puppets. And most actors later will say to their directors, 'I'm not your puppet, you know!' But they are."

BF: Do you have an artistic project of which you are most proud?

JW: I'm most proud of my body of works as a filmmaker, because I've been doing it for fifty years, and without really having to change what I wanted to do. I mean, my last movie was about lunatic sex addicts that take over a neighborhood [*A Dirty Shame*, 2004]; that's not so different from *Hag in a Black Leather Jacket* [1964] or anything. So, I basically got to make the movies I wanted to make, so I'm proud of that. That it's a body of work, and they're still playing. My audience gets younger, I get older. So that's what I'm the most proud about.

BF: Do you think it is important to have a good cinema program on a university campus?

JW: I think it's very important to have a good film program on campus, but if you never went to school, or never went for college, and you want to be a filmmaker, even if you do go to college: go to the movies on your own. See everything, see failures, see movies without the sound; that's how you see how they're made. Go to the movies all the time. Participate in that world. Once you make film, get *Variety*, get *Hollywood Reporter*, learn the trade, because you can have the best [film] in the world, what do you do with it? You've got to figure out what to do with it, to learn the business of it. So, yes, school is where you go to figure out what you want to do if you're not sure what you want to do. When I was young, I knew, and they wouldn't let me. Now, they would let you. You could probably make a snuff film here and get an A.

Visiting Filmmakers

IU Cinema prides itself on consistently providing unparalleled access to remarkable filmmakers and film scholars through thoughtful and intentional curation of depth and diversity. There are surely programs in New York or Los Angeles able to attract a steady flow of luminary guests; it would be impossible to compete with benchmark venues and programs such as Film at Lincoln Center, UCLA, or New York University, seated in filmmaking hubs where the industry thrives. However, the intimacy of IU Cinema and its audience engagement with filmmakers stands up to the best. These filmmaker visits have become a trademark of IU Cinema's program, offering cinephiles the opportunity to meet some of their filmmaking heroes and create memorable and transformative experiences.

> "A place like this doesn't exist just anywhere; I travel a lot, and I haven't encountered anything quite like it."
>
> —Guy Maddin, director of *My Winnipeg* and *The Saddest Music in the World*

In addition to introducing and discussing their work, many present public lectures, lead master classes, and dine with students. IU Cinema also documents many of their visits with professionally produced ten-question taped interviews. In the first decade, IU Cinema and Toth Media, LLC—Joseph Toth and Kirstin Wade, both IU students when the Cinema opened—produced nearly sixty of these interviews.

Among other programs, one signature filmmaker series has proven to be a staple for hosting incredible filmmaking talent: the Jorgensen Guest Filmmaker Series, which has provided IU Cinema the opportunity to welcome to campus more than two hundred visionary filmmakers and scholars. In addition to those covered in this or other sections, they have included John Boorman, Glenn Close, Kenneth Anger, Claire Denis, Albert Maysles, Xie Fei, Ana Lily Amirpour, Tony Buba, Beth B, Kelly Reichart, Paul Schrader, Josephine Decker, Nathaniel Dorsky, Sara Driver, Ari Folman, Bette Gordon, Steve James, Eliza Hittman, Guy Maddin, Avi Nesher, Megan Griffiths, Alex Ross Perry, Walter Salles, Nicolas Winding Refn, Amy Seimetz, John Sayles, Hannah Fidell, Joe Swanberg, Whit Stillman, Todd Solondz, Christine Vachon, and Peter Weir.

In addition to the Jorgensen series, filmmaker programs have also taken the form of a Filmmaker to Filmmaker program, pairing two filmmakers onstage together. The series is endowed by S. James and Roberta T. Sherman. Though a young program, it also hosted prominent filmmakers in its first decade, including Frederick Wiseman, Alejandra Márquez Abella, Hal Hartley, Robert Greene, and Paul Shoulberg.

HAIFAA AL-MANSOUR

Haifaa al-Mansour is the first filmmaker to make a feature-length film entirely in Saudi Arabia—not just the first woman filmmaker, but the first filmmaker—and is regarded as the country's most significant cinematic figure. The success of her work has earned her an appointment to the Academy of Motion Pictures Arts and Sciences as well as Saudi Arabia's new General Authority for Culture, a government body devoted to developing new arts-and-entertainment sectors.

Al-Mansour grew up in a family of artists, and the desire to tell stories came at an early age. She studied comparative literature at the American University in Cairo and completed a graduate degree in directing and film studies from the University of Sydney, where she developed the script for *Wadjda* (2012).

It was *Wadjda* that truly brought international attention to al-Mansour as a filmmaker. The film premiered at the Venice Film Festival, where it won the award for Best Film, and screened at more than forty film festivals around the world while also enjoying a successful US release with Sony Pictures Classics. The film received wide critical acclaim and was selected as the first-ever Saudi Arabian entry for Best Foreign Language Film to the Academy Awards.

The success of *Wadjda* provided opportunities to make two films in the West, with *Mary Shelley* (2016) filmed in Ireland, Luxembourg, and France and *Nappily Ever After* (2017) in the US. Like all of her films, these two stories deal with female agency, self-discovery, and empowerment, issues she continues to champion in her work. *The Perfect Candidate* (2019) took al-Mansour back to Saudi Arabia to tackle the subject of women's rights in the male-dominated culture where she grew up. The film follows an ambitious young doctor working in a small-town clinic in Saudi Arabia and was Saudi Arabia's Oscar entry for 2020.

She continues to be recognized for her groundbreaking, thoughtful, and inspiring work. Al-Mansour has served on juries of major film festivals and organizations including Cannes and the Gotham Awards. In 2019, she received a Crystal Award at the World Economic Forum for her leadership in cultural transformation in the Arab world.

While in Indiana, al-Mansour worked with students in an informal master class, discussed her films, met with First Lady Laurie Burns McRobbie and President Michael A. McRobbie, and participated in an onstage Jorgensen Guest Filmmaker event and an interview entitled "Haifaa al-Mansour: An IU Cinema Exclusive," both led by Founding Director Jon Vickers.

Jon Vickers: Why is film such a powerful artform?

Haifaa al-Mansour: I grew up in a small town in Saudi Arabia, and the way I connected with the world was through films. Exhibition in public was illegal, and making films in Saudi wasn't allowed. We had video stores, and I watched a lot of cinema on video. It made me understand what it means to enjoy a movie and to be part of a bigger world than my small town.

JV: Do you have a film experience that changed your life or direction as a filmmaker?

HAM: We were at the Berlin Film Festival, and I was writing *Wadjda* at the time, my first feature film. The way I wrote the film is very much ideological. The first draft is about this young girl who is being oppressed by the system and society, and she's innocent and beautiful. And then I went and watched a film with a similar protagonist, who was only a victim. She was so beautiful, so cute, but the film was not fulfilling at all. I was like, "That is my film!" It was eye-opening. You need to make a protagonist have life, be sassy and a fighter. That is what I missed. I went back and changed everything in the script, and hence, the character of Wadjda. So, I think that was one movie experience that really changed how I look at my leading characters, how to position them and how to create their destiny and journeys. Watching great films is amazing and very fulfilling, but you also learn from watching films that are not good.

JV: Who or what are some of your artistic influences?

HAM: A lot of my influences come from the place I lived. When I make movies, it's always about growing up in that small town, which is very absurd with all those religious ideologies; all women are dressed the same, and men are dressed all the same. It is very segregated. It is such a surreal place, almost like science fiction and

Facing: Al-Mansour with IU First Lady Laurie Burns McRobbie at Bryan House during her December 2019 visit to Indiana. McRobbie was an early champion of al-Mansour's work. Chris Meyer/IU Studios

Top: IU Cinema poster for Haifaa al-Mansour: Paving the Way, December 2019. Kyle Calvert

"I have a voice, I have an opinion, and I can share it with the world."

almost a utopian kind of movie. So, a lot of my inspiration came from that environment and that world. While growing up, being exposed to art is not easy in Saudi Arabia. Art wasn't allowed in the public spaces, so there weren't any galleries, movie theaters, or theaters for performers, something that you can go see and understand. So, influences on that level, I lacked. But I enjoyed a lot of Indian, Bollywood, American, and Chinese cinema. And that made me understand what it means to entertain. I was so bored, and watching a movie was just uplifting, as if you went somewhere totally different. After the movie is over, you have this feeling of happiness.

I think a lot of my influences, when it comes to how I relate to film, come from mainstream impact, and later on in life, I started watching more of arthouse and independent [films]. I love the Dardenne Brothers; they're from Belgium. *Rosetta* [1999] is another film that really stuck with me because of the way they built their character and how she was so resilient and so full of life. I just fell in love with Rosetta. Every time I write, I remember her eyes, the passion coming from them. So, I love the Dardenne Brothers a lot. The Coen Brothers too—they're very smart. Brothers, every [team of] brothers. [*laughs*] But their dialogue is very smart. I wish I could learn how to be witty.

JV: Why do you make films, and who are they for?

HAM: I'm a filmmaker full-time, my source of income, but mainly I make movies because it gave me a sense of who I am, gave me an existence, gave me a voice. When you grow up in the place where I grew up, you always feel as a woman you are invisible and voiceless. It is such a difficult place to be as a human being that you feel you don't matter, or you don't exist and you're just nothing. Film gave me that contribution. I have a voice, I have an opinion, and I can share it with the world. So, that's how I stuck with film, even when I was making short films and documentaries and there was no way to make any money out of it. It just became my thing, and I stuck with it until I was able to work and enjoy what I'm doing. I'm very grateful for that, very grateful to be at this stage.

JV: What drives you to take on the subjects that you do in your films?

HAM: I want to fall in love with the characters and sympathize with them. But also, be entertained and go to a place—if it's a film from Saudi Arabia, go to a place and understand the people there. My films are very much about people who don't matter. Like those coming from small towns, not rich, but they have dreams and they have passions. For me, it is just creating a connection with people who are totally different from us, but they are also very similar. There is

universality in our journeys; we are all human beings. I think it is very important to emphasize that. Hopefully, we create sympathy and empathy for each other, and through art, maybe we can be friends, not fight or have wars, because we understand each other more.

JV: What advice would you pass on to a young or emerging filmmaker?

HAM: To be true to yourself and your story and stick with it. It is hard. There will be a lot of rejection. It is not easy to break into an industry, especially as a newcomer. But it's so rewarding when you keep working at it. Also, keep learning. A lot of young people are so passionate about their stories, and they're very militant, like, "That is my story, and that is the way I want to tell it." But filmmaking is very collaborative—taking someone else's input and incorporating it and building off it is the key to being successful as a filmmaker. A filmmaker is the master of bringing everybody's vision and melting it together into your own. So, stick with it. Work hard. Don't take no for an answer.

JV: What is the importance of a good cinema on a university campus?

HAM: I think it is very important to show films at universities for younger audiences, especially arthouse films. We always blame young people that they don't see enough beyond Marvel and superhero films. Universities are a great place to shape their taste, and it gives them the means to make a film, and also bringing in a lot of filmmakers who may have a very similar journey to those students. It gives them hope to see someone like me. Like, if a Saudi girl could make it in the [film] world, that means every one of them who has a better education and more access to things can also make films. I think it is very important.

"A filmmaker is the master of bringing everybody's vision and melting it together into your own. So, stick with it. Work hard. Don't take no for an answer."

Right: Al-Mansour and Founding Director Jon Vickers onstage at IU Cinema on December 13, 2019, during a Jorgensen Guest Filmmaker event. *Chaz Mottinger/IU Studios*

JONATHAN BANKS

Jonathan Banks has a body of motion-picture and television work spanning more than forty years, earning him a reputation as perhaps the hardest-working character actor in the industry. His multiple Emmy and Screen Actors Guild Award nominations have validated him as one of the foremost supporting actors in television. The life he has brought to the character of Mike Ehrmantraut in *Breaking Bad* (2008–13) and *Better Call Saul* (2015–) has earned Banks the highest accolades from peers and critics since 2011. The 2010 decade was a pinnacle of Banks' career.

Charlie Colyer, head of AMC Television, stated, "Simply put, Jonathan is as good as they come in our business and so far beyond. Just as he adds soul and depth to everything in which he acts, Banks does the same off-screen as well." Though his characters are often rough around the edges—and sometimes pretty rough to the core—he is sincere, honest, generous, and one of the warmest human beings you will meet.

Banks attended Indiana University as an undergraduate in the late 1960s, acting on what is now the IU Cinema stage. His time in theater and drama at IU overlapped briefly with another distinguished alumnus, Kevin Kline. Indiana University has stayed dear to Banks, who has two children who are also IU alumni. He has revisited several times to participate in speaking events at IU Cinema, work informally with students, serve as a bicentennial visiting professor, and support IU in myriad ways. In 2016, an honorary degree of doctorate of humane letters was bestowed on Banks by Indiana University. During his very first visit to IU Cinema in 2014, he sat for this "Jonathan Banks: An IU Cinema Exclusive" interview with Founding Director Jon Vickers.

Jon Vickers: Why is film such a powerful artform?

Jonathan Banks: The impact of film is so overwhelming. It changed my life. It can change the direction of a life, change the ignorance of a life, change a life.

JV: Do you have a film experience that changed your life or direction as an actor?

JB: I grew up in a pretty humble place that could be a little dangerous at times, maybe. Dangerous in the sense that not many people were motivated to get up and see the world or go to a university. I went to see this film with Anthony Quinn, *Zorba the Greek* [1964], who was full of life, leaning over the old prostitute as she dies, stroking her face and telling her how beautiful she was, and telling Alan Bates to live life and enjoy it. I thought, "Oh man, that's the guy I want to be. I want to be that guy." Eventually, I traveled on ferries all over the Greek islands, slept on rooftops, caught ferries in the middle of the night with gypsies who were screaming at their wives, the yelling, the goats. Anthony Quinn's performances, for me, were life-giving, for lack of a better term. I probably still want to be Anthony Quinn. It always bothered me— although I certainly have done oh-so-many things to pay the rent— when he did something that was less than who he was, I didn't like it. But I love *Viva Zapata* [1952]. I love *Zorba.*

JV: Do you recall any specific actors or performances that changed your life or direction as an actor?

JB: I think Donald O'Connor's performance in *Singin' in the Rain* [1952]. When I was small, after seeing it in the theater with the dummy over the couch, through the wall, and up and down, and I probably threw myself over everything in our living room trying to be Donald O'Connor. I thought there was such joy in it that I thought, "Oh man, do I ever want to do that." And Jimmy Durante. Jimmy Durante with the soulfulness of "Good night, Mrs. Calabash, wherever you are," and walking out through the spotlights. Love Jimmy Durante.

JV: Of the roles you have taken on, do you have a particular favorite?

JB: No. Right now, as we do this interview, I'm doing Mike [Ehrmantraut on *Better Call Saul*]. I think the world of Mike, because Mike is so flawed, but Mike is aware of how he's lost his soul. He still has a code of honor that he lives by, and what a joy that is to play.

JV: What is your relationship to Indiana University?

JB: This place saved my life. For whatever reasons, I did come from the street, for lack of a better term. My sophistication was certainly limited and certainly still is. I'm a journeyman character actor,

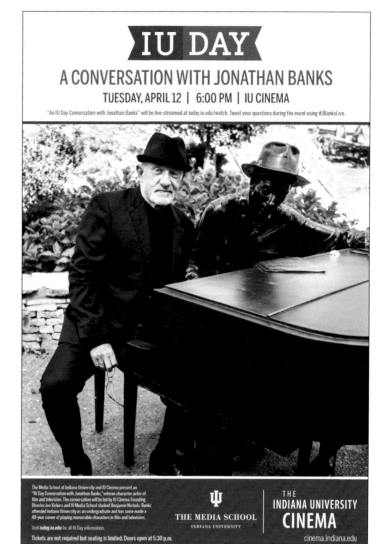

Facing: Jonathan Banks standing inside IU Cinema prior to an onstage conversation for IU Day, April 12, 2016. James Brosher/IU Studios

Top: IU Cinema poster for an IU Day event featuring Jonathan Banks, April 2016. Kyle Calvert

"The impact of film is so overwhelming. It changed my life."

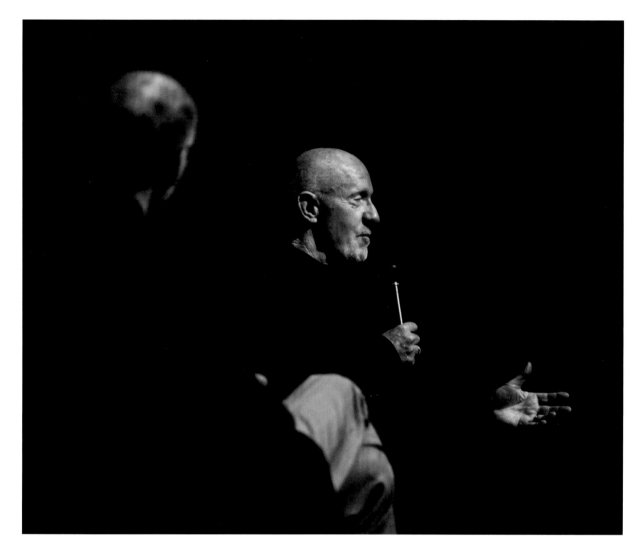

but I'm an actor, and I am so proud to be an actor. This is the place that gave a rambunctious young man—that drew in the reins, in many ways. One of the directors at Brown County [Playhouse], I think she was a graduate student, gave me the note, "Do less." I pretty much have taken that to heart and tried to do less as an actor my entire life. I mean, this gave me my life.

JV: What advice would you give to a young artist?

JB: I'm going to look right into the lens. You're choosing a life in the arts. It doesn't mean it'll work out. There have been times when I thought I'd have to sell my house. At twenty-seven, I had eight dollars to my name, child support payment due. I couldn't get home on the bus from New York to DC. I thought, "What have you done with your life?" So, with that going on, you have to believe in yourself till the day you die. And you may be the only one. You must never, ever, lose that. Because in the end, if you leave with that, you win. You win. The fame, the fortune, that is the smoke and mirrors. You can only be a better artist. For me, in this case, a better actor. That's the only thing I have control over. However maudlin it may sound, you have to be kind to yourself. You must, you must be kind to yourself and believe to the very, very end. There are going to be people who never get the chance to really show how good they are, and there is heartbreak in that, but you can't judge yourself by that, and it's certainly not who you are. I could go on; I won't. I think you got the idea.

> "You must, you must be kind to yourself and believe to the very, very end."

ROGER CORMAN

Roger Corman's sixty-year career has built a legacy that is unparalleled. Throughout the 1950s and 1960s, he set the pace to become Hollywood's most prolific filmmaker. He was the youngest director ever honored with retrospectives at the Cinémathèque Française, the British Film Institute, and the Museum of Modern Art. Along with directing more than fifty feature films, producing over four hundred films, running two production and distribution companies, and earning a Lifetime Achievement Oscar, he helped launch the careers of many of the New Hollywood filmmakers of the 1970s. Among many others, Martin Scorsese, Francis Ford Coppola, Peter Bogdanovich, Joe Dante, James Cameron, Ron Howard, and Jonathan Demme all ascended from the "Corman School" of filmmaking.

His IU Cinema visit was supported by the Academy of Motion Picture Arts and Sciences Visiting Artists Program and included a curated program of thirteen films, a master class with film students, and a Jorgensen Guest Filmmaker program in the form of an onstage interview, all under the title Hollywood Rebels: The Art and Legacy of Roger Corman.

Born in Detroit, 1926, Corman received a bachelor's degree in engineering from Stanford University and completed postgraduate work in modern English literature at Oxford's Balliol College. In 1954, he directed *The Monster from the Ocean Floor*, thus beginning his slate of low-budget films for American International Pictures. Throughout the '60s, Corman's lavish and surrealist cycle of Vincent Price–Edgar Allan Poe horror films for American International Pictures earned him international acclaim. Corman pioneered the first biker movie, *Wild Angels*, in 1966, starring Peter Fonda and Nancy Sinatra, which heavily influenced *Easy Rider*. Corman also began the '60s psychedelic film craze with his Cannes premiere of *The Trip* (1967), written by Jack Nicholson. Almost singlehandedly creating the low-budget and genre film, Corman is known as the "Godfather of Independent Film" and the "Father of Drive-In Cinema," inspiring generations of filmmakers.

Corman's taste for international cinema drove him to become one of the first American directors to bring foreign-language films to the United States, distributing the films of Akira Kurosawa, François Truffaut, Federico Fellini, Ingmar Bergman, and Werner Herzog through his company New World Pictures.

While in Bloomington, he sat for an interview called "Ten Questions for Roger Corman" with Founding Director Jon Vickers.

Facing: Corman onstage at IU Cinema during a Jorgensen Guest Filmmaker event in April 2014. Maggie Richards/IU Studios

Top: IU Cinema poster for Hollywood Rebels: The Art and Legacy of Roger Corman, April 2014. Jennifer Vickers

Next page: Corman and PhD student David Church onstage at IU Cinema during a Jorgensen Guest Filmmaker event in April 2014. Maggie Richards/IU Studios

> "I make movies because I love the creative experience. . . . I'm most alive when I'm on the set and working on a film."

Jon Vickers: Why is film such a powerful artform?

Roger Corman: Motion pictures opened up the world to movement, and I consider that to be the most important individual aspect of filmmaking.

JV: Do you have a film experience that changed your life or direction as a filmmaker?

RC: There probably wasn't any one experience that changed my work as a director. It was really seeing the work of other directors and seeing films with audiences. I would possibly go back to *Battleship Potemkin* [1925], [Sergei] Eisenstein's great film. I was really impressed by the composition and the editing style and the way in which the story was told visually.

JV: Who or what are your artistic influences?

RC: Probably the artistic experiences that influenced me circumnavigate the world. I would go back to hieroglyphics on cave walls, the three orders of Greek architecture—I still remember Doric, Ionic, and Corinthian. But, probably most specifically, modern artforms in painting, starting with Impressionism, going to Cubism, which impressed me greatly, to Abstract Expressionism, jazz music, the writing of the early twentieth century, writers such as Proust and Joyce.

JV: Why do you make films, and who are they for?

RC: I make movies because I love the creative experience. To me, I'm most alive when I'm on the set and working on a film. The movies I make are for me and for the public. I want them to have some meaning for me, and I would hope that they would have some meaning, and hopefully some entertainment value, for the public.

JV: What advice would you give a young filmmaker?

RC: The advice I would give to a young filmmaker would be to go to a film school if you have a chance. My contemporaries and I pretty much learned on the set as we went along, but I think what you get from a film school, both theoretically and practically and technically, is invaluable. If you can't go to a film school, I would say try to get a job on the set of a picture, though for a major picture that's pretty much impossible. But there's so much independent work being done all around the country that it's not that difficult to get some minor job. Having it being a minor job is not that terrible, because for me, the experience is to be on the set, doing your job as well as you can, but looking around, seeing what other people are doing, so it's an educational learning experience as well.

JV: Looking back, would you change anything about your career?

RC: I don't know exactly what I might change, looking back. One thing might be that I made a picture called *The Intruder* [1962], which was about racial prejudice in the South, and it was a great critical success and a commercial failure. The results discouraged me and moved me away from that type of film. Maybe I should've leapt in and said, "Okay, this one didn't work from a commercial standpoint." Maybe I should've stayed more with that type of film. But I did what I thought was best at the time.

JV: What are your thoughts on your legacy as an artist?

RC: I'm not certain about my legacy as an artist because I've always considered myself to be a craftsman. I feel I work in film. I try to do a good job; I do the best job I can on each film. And I really do think of it as working as a craftsman. If occasionally the work comes to the level of art, that's great, but that's an added bonus.

JV: What is the importance of having a place like the Indiana University Cinema?

RC: I think it is important to have a cinema and a program dedicated to motion pictures for two reasons, primarily: one, for students of film, it's part of their learning experiences, but for the student body in general, I think it exposes them to a different artform, an artform that I personally consider to be the most important artform of our day. So, I think it's essential—it's a grand word—but I think it is essential that a good university have such a cinema and such a program.

CHERYL DUNYE

In January 2018, IU Cinema hosted pioneering film and video maker Cheryl Dunye in a series titled Cheryl Dunye: Blurring Distinctions. The program was curated by founding Associate Director Brittany D. Friesner and Dunye in collaboration with the BFC/A, the Kinsey Institute, and Bloomington PRIDE.

Dunye emerged as part of the New Queer Cinema movement of young filmmakers and video makers in the 1990s. Her work is defined by her distinctive narrative voice. Often set within a personal or domestic context, Dunye's stories foreground issues of race, sexuality, and identity. Her narratives are peppered with deconstructive elements with characters directly addressing the camera and making ironic references to the production itself.

The effect of these devices, and of Dunye's appearance in her films, portraying a version of herself, is to blur the distinctions between fiction and real life. Dunye has made more than fifteen films, including *Mommy Is Coming* (2012), *The Owls* (2010), *My Baby's Daddy* (2004), and HBO's *Stranger Inside* (2001), which garnered her an Independent Spirit Award nomination for best director. Her debut feature film, *The Watermelon Woman* (1996), was awarded the Teddy at the Berlinale in 1996 and was recently restored by Outfest's UCLA Legacy Project for the film's twentieth anniversary. *The Watermelon Woman* is a landmark of New Queer Cinema, credited with being the first feature film directed by a Black lesbian.

Dunye has received numerous awards and honors for her work, including a 2016 Guggenheim Fellowship. She is also a member of the Academy of Motion Picture Arts and Sciences. At the time of her IU Cinema visit, Dunye was a professor in the School of Cinema at San Francisco State University. Her most recent directorial work includes episodes of *Queen Sugar* (2017–19), *Claws* (2018), *David Makes Man* (2019), and *Lovecraft Country* (2020). She is at work on her next film, *Black Is Blue*, a feature-length adaptation of her 2014 short film.

While at IU Bloomington, Dunye introduced and discussed her films, hosted students for an informal master class, and participated in a Jorgensen Guest Filmmaker program in the form of a public interview led by IU Media School associate professor and director of the BFC/A Terri Francis. The interview was later published in the renowned magazine *Film Quarterly*. In addition, Dunye sat for the interview "Cheryl Dunye: An IU Cinema Exclusive" with founding Associate Director Brittany D. Friesner.

Brittany D. Friesner: Why is film such a powerful artform?

Cheryl Dunye: Its ability to create images and imagery about culture and on culture and to share culture. Cultural differences, representations, icons, trends, cultural life. That's really where I click on and remain.

BF: Why do you make films, and who do you make them for?

CD: Immediately, I make films for women, queers, and people of color. But also, for all the allies and everybody who wants to have access to that dialogue, and have a part of that conversation, is who I'm making movies for. I must say that the first person is me, or somebody who looks like me, and all those sorts of intersections of self that I experience on a daily basis. It is shifting, you know. For fans of opera, to people worried and concerned about people with abilities and disabilities, to the invisible people, to people who are too visible. I make films to make a comment, to let people see themselves in a light where they generally cannot see themselves.

BF: Do you have a film experience that changed your life or direction as a filmmaker?

CD: There are so many, but I'll use one that really kicked me into the world of what I do and how to put it all together. I think it was during the tour of *She's Gotta Have It* [1986] with Spike Lee. He came to Philadelphia to talk about his film after a screening at the Philadelphia Film Society, or Film House, or whatever it was called at that time. So many people in the African American community there were [either] up in arms or in support of Spike's film. And Spike knew what was gonna happen; he knew that his representation of African American women in the film was problematic. I think there was some reference to even lesbian, gay culture that wasn't quite right, and questionable. More important was the relationship to African American women.

So, me and my little baby dykes, as we were called then, went to this reception and event, and we're sitting in the audience. There was a line of African American women standing at the microphone ready to put their nails into Spike's identity and ask him questions about what happened. So, somebody asked the question, "Spike, what are you trying to say about women with your film *She's Gotta Have It*? Why is Nola so problematic? Why is she sexualized in such a way; why is she represented this way?" His only answer was, "Well, it's my film, and that's the way I wanted her to be represented. If you want to make a different representation of African American women, go make your own film." Everybody was like, "Ooh, no he didn't, uh oh." I just got

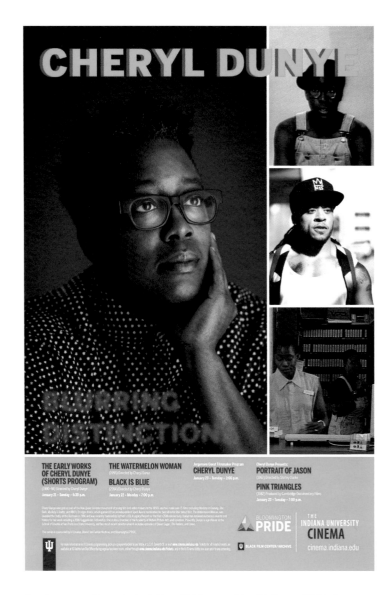

Previous page: Dunye in the lobby of IU Cinema. Chaz Mottinger/IU Studios

Top: IU Cinema poster for Cheryl Dunye: Blurring Distinctions, January 2018. Kyle Calvert

Facing: Dunye and Janae Cummings, Bloomington PRIDE board chair and director of marketing, onstage at IU Cinema during a Q&A for the film *The Watermelon Woman*. Chaz Mottinger/IU Studios

> "I make films for women, queers, and people of color. But also, for all the allies and everybody who wants to have access to that dialogue."

the big light bulb moment—you're right, if I want to make my own representations [of] Black women, I'm going to have to make my own film.

BF: What advice would you pass on to a young or emerging filmmaker?

CD: My advice to anybody, young or old, in filmmaking and in the arts, is you only live once, and you have to do it now. Nobody else is going to do it for you. You're in it; you're the only one who can do it. Don't get in the way of yourself. I think a lot of artists, a lot of creatives, a lot of people with humongous possibilities who just don't cross those lines to do them, are carrying some sort of baggage. Carrying the baggage of an ancestor, or somebody who has abused them, or somebody who told them no one too many times. You gotta turn that off and move through the door of your life. Then you're going to realize that there's another door, and you have to walk through the next door. You just keep on walking. That's how life moves, and that's how the planet moves. So, I would definitely tell anybody, somebody who's into finance, or social justice, or somebody into any other kind of cultural practice: just let yourself go. Stop stopping yourself; stop being a naysayer and say yes to yourself. Stay up a little bit late and be tired in the morning. Say yes to

"Stop stopping yourself; stop being a naysayer and say yes to yourself."

"I'll finish this off now. I'm not going to wait and do it in parcels. I'll just binge on it." Be excessive, be extravagant, go into a little debt, make mistakes. They always can be corrected.

You have to experience life to have a life. This is why I tell everyone, in particular people who haven't attended a university or haven't attended any institution, who wants to be a filmmaker: go to grad school. Go. It's the two to three years you spend pining away and poorly shaping your project and hoping and being stuck. You could just melt away and figure out a new path if you went and got your MFA. Who knows what it's going to lead you to—colleagues, knowledge of equipment, knowledge of films that you've never seen, questions that you've had all your life now answered. It will catapult you into a new space.

So, I really tell people that these are our few bastions, these few spaces that are having schools of cinema and schools of film that are separate from the sciences, from technology, that are really focusing on the craft, to attend, to visit, to see what's going on, to use their archives, to use their libraries. Everything is not on Google. Everything's not online. Some people know a little bit more than you, and some people are in different places and have the knowledge and the skills that you want. And they happen to be in a university setting,

and they happen to be making cinema. In any cultural practice, I think that it's really great to stop for a couple minutes, re-up, and then go forward. And that takes what, a couple of years of your life? You could be really stuck for that long, so why be stuck? Why not grow? That's what cinema does for students, young and old.

BF: When did you know that you wanted to become a filmmaker?

CD: That's a good question. The age of understanding that I can use film to step outside of myself because a lot of filmmaking is stepping inside of yourself, looking at your past, and realizing that it's a way to kind of organize who you are. I think for me—it's even beyond *The Watermelon Woman*, which was the first film I did in 1996, and I really put everything together about who I was and what I was, what I wasn't seeing about myself in cinema, out there.

I would say it's the project after that, called *Stranger Inside*. The second project I wanted to do in my life was to give birth to a young individual, so I gave birth to my—they—Simone; she was born a she, but she's a they now. So, I was able to move on to looking at the relationship of motherhood and mothering and the world in cinema and was able to make this relationship between women, incarceration, prison, mothers, and parents. That was the moment I realized that I could put everything together in a film way, even a way as an artist, and still reach not just my audience of lesbians, gays, and people of color but a broader and wider audience and still have an impact. That film came out in 2001, and the work that I put

into it—which was go research inside women's prisons; go work with Angela Davis on women and incarceration and the lecture that she was giving; take the script to HBO to get backing to cast right; shoot the film at a closed women's correctional facility; have a cast and crew of women and queers and folks of color, and then at the end of the day, to be nominated for an Independent Spirit Award. Yolanda [Ross], who played Treasure in the film, got a Gotham Award, and I knew this is where I need to be. This is what the power of cinema is, this is what the power of storytelling is, this is how I could make my impact. And I can't get away from it, I can't, I'm infected.

BF: What is the importance of a good cinema on a university campus?

CD: There are so many ways that cinema is being used in the arts, in economics, in math, and everybody, especially in smaller universities, everyone is using the same equipment, everybody wants to use the same cameras, all the students want to take those classes. But again, cinema is about visions of light, visions of culture, where you use a certain set of tools to project a certain message to the world. The study and the practice of that in a container, in an environment with guidance, and using a certain level of tools to find stories, using equipment in a certain way and being influenced by books, scholars, scholarship, archives, films that you never heard of, films that haven't even been made, scripts that you never heard of, screenwriting—you can't get that out there. And that's what cinema does for students, young and old.

Left: Dunye and Janae Cummings, Bloomington PRIDE board chair and director of marketing, onstage at IU Cinema during a Q&A for the film *The Watermelon Woman*. Chaz Mottinger/ IU Studios

Facing: Jim Jarmusch being filmed during his "An IU Cinema Exclusive" interview. Toth Media, LLC

JIM JARMUSCH

New York City's East Village of the late 1970s gave enigmatic artist—writer, director, poet, composer, musician—Jim Jarmusch the freedom to try anything. Originally set on being a poet, he was tempted by the Downtown scene into dabbling in multiple artforms, including music and eventually film. After receiving a bachelor of arts from Columbia University and spending a year in Paris soaking up films and culture, he enrolled in New York University's Tisch School of the Arts graduate film program, where he met many future collaborators and launched his debut feature, *Permanent Vacation* (1980).

Jarmusch's fifteen feature films create a body of film work distinct from any other. His visual style, pacing, and overall cinematic language is informed by his love of cinema and the work of great filmmakers like Nicholas Ray, Samuel Fuller, Buster Keaton, Howard Hawks, Billy Wilder, Robert Bresson, Jacques Rivette, Jean Renoir, and Yasujirō Ozu, among many others. His films are filled with ordinary and extraordinary characters, drifters, and loners, some of them sage-like, some of them lost and often on some sort of journey—whether it be physical, emotional, or existential—and guided by chance. And, of course, we can't forget the humor.

Jarmusch is also a musician, having composed music for his own films and released albums and EPs with Dutch composer Jozef van Wissem and the band SQÜRL, featuring Carter Logan. Music, Jarmusch says, offers him an "immediate form of communicating and interacting." His love for music flows directly into his film work, with musician friends in prominent roles and in the rhythm and tempo of his films, bathed in arresting soundtracks.

IU Cinema's series included nine feature films presented at the Cinema and in community venues in partnership with Cicada Cinema. The visit included a musical performance by SQÜRL set to films by Man Ray and Ed Feil, for which Logan and Jarmusch presented world premieres of two new scores. The visit also encompassed a Jorgensen Guest Filmmaker event and this "Jim Jarmusch: An IU Cinema Exclusive" interview with Founding Director Jon Vickers.

Jon Vickers: What makes film such a powerful artform?

Jim Jarmusch: Well, I like that David Lynch said that films are the closest thing that we make to dreams. I love that dreamlike quality. I love the idea of going in a dark room and entering a new world. But what I really love most about cinema, about films, are that they incorporate almost every other form of expression; they can be about storytelling, about images, about movement, about music, style, composition, writing, acting, motion, or stillness. They have so many other elements in them, which make it such a beautiful form for me.

JV: Do you have a filmgoing experience that changed your life or direction as a filmmaker?

JJ: Well, I have a lot that have changed my direction as a filmmaker. As far as my life in general, one big thing for me was when I was very young, I was on vacation with my parents in Florida, and my mother, sister, and I went to a drive-in theater and saw *Thunder Road* [1958], the Robert Mitchum film. That was the first non-Disney type of film I'd ever seen. And it was a wild movie about hopped-up cars, bootlegging, and criminality. It blew my mind. So, that was a big thing for me.

I still love that film. Robert Mitchum even sings the theme song. I don't know how old I was, probably too young for my mother to have taken me there, but I vividly remember that.

The other major thing, which is broader, is when I studied at Columbia University. In my last year, I was able to go to Paris to study. I came back with incompletes in my studies because I discovered the Cinémathèque Française in Paris, where I spent most of my days. I saw films from Japan, and India, and classic Hollywood things that I just hadn't really seen before. Being from Akron, Ohio, though I lived in New York already, this was a huge thing for me.

JV: Who or what are your artistic influences?

JJ: Yeah, I was sitting down earlier today, and I looked at this question. I'm a self-proclaimed dilettante, which means I appreciate so many different forms and things, so to mention some people who inspired me, I made this list a half an hour ago, which would change tomorrow and be endless, really. So, I'll give you a few: Howlin' Wolf, William Blake, Greta Thunberg, Sam Fuller, Lucretius, Abbas Kiarostami, Missy Elliott, Hildegard von Bingen,

> "I think you learn by doing things. My motto has always been it's hard to get lost if you don't know where you're going. So obviously, films require a lot of planning, but I think you have to hold on to your intuition at all times."

Facing: Jarmusch being interviewed by Founding Director Jon Vickers at IU Cinema on January 30, 2020, during a Jorgensen Guest Filmmaker event. Chaz Mottinger/IU Studios

Top: IU Cinema poster for Jim Jarmusch: Cinema's Enigmatic Deadpan Poet, January 2020. Kyle Calvert

"I love the idea of going in a dark room and entering a new world."

Frank O'Hara, Francis Picabia, June Leaf, Claire Denis, Gustave Mahler, Anton Webern, Pythagoras, James Brown, Andy Warhol, Patti Smith, Nico, Sister Rosetta Tharpe, Hou Hsiao-hsien, Joe Strummer, Joyce Carol Oates, Naomi Klein, Joan of Arc, Don Carlo Gesualdo, Crazy Horse, Pierre Riverdy, Maya Deren, Billie Eilish, Jean-Luc Godard, et cetera. I'm not trying to be a smart ass, it's just too difficult for me. So many incredible things have come from humans, human expression, so it's sort of limitless for me.

JV: What advice would you share with a young or emerging filmmaker?

JJ: Well, I would say I'm not a big teacher. I think you learn by doing things. My motto has always been it's hard to get lost if you don't know where you're going. So obviously, films require a lot of planning, but I think you have to hold on to your intuition at all times. And I think the two most important things I could tell younger or less experienced filmmakers is that your mistakes are invaluable. You should never be afraid of the mistakes because that's where you learn what didn't work. And, when you do things that do work, it's often quite mysterious. For me, especially, because I'm not analytical, I trust my intuition, and I don't trust my own analysis. That's just how my brain works.

JV: What compels you to take on the subjects you do in your films?

JJ: Wow. I don't know; it's not so easy to pinpoint. I always collect things for quite a while before I write a script. I usually start with actors I would like to collaborate with. So, I think up characters I imagine them embodying; that is often my starting point. But I've also had the starting point for several films, *Down by Law* [1986] and *Mystery Train* [1989] in particular, be the musical cultures of cities—New Orleans and Memphis for those two films. That drew me to want to make something there. I wrote the scripts for both of those films before having ever visited the cities. But overall, it's kind of hard to say. I gather a lot of little things that affect me. I like to overhear dialogue of other people, observe images, paintings, or even just the weather, you know. I don't know where they come from exactly.

JV: What part of the filmmaking process do you enjoy the most?

JJ: Well, I love very much all of the three basic things for me, which is writing, which is solitary. I always write alone. Then the production and filming is really amazing because you are collaborating with all these people, and everything you had in your head is now elevated by your collaborators. So, even if it's very hard and frustrating, there's a real joy in it, even in the hardest films. So, that's really joyful. And then editing is where you really make the film. Shooting is just gathering the materials. I'm not a storyboard guy. I'm pretty open

while we're shooting. I really think that I'm gathering the elements to make into the film, so I kind of love them all equally. Although the most joyful is usually the shooting of the film.

I used to say thinking of the story and writing was like a kind of seduction of an idea. Then filming with all these other people was like making love. And editing was like, you're pregnant, and you're waiting, and the thing is developing, and you're nurturing it. It's not really such a great analogy anymore because you really are making the film in the editing. But that's my old analogy for it. But I love all those things.

When you make a film, you are robbed of the experience. Another very beautiful thing about films is you enter a world, and the first time you see a film and you don't know what's going to happen, you don't know where it's carrying you. That's its incredible dreamlike strength. But if you wrote the thing, and then you shot the thing, and you were there the whole time, and you were in the editing room for months and months as I am, you can never see the film for what it is anymore. . . . You are not able to have that beauty of discovery.

JV: What do you want your legacy to be as an artist?

JJ: Oh boy, you know, I try to avoid thinking about a legacy. Somehow it seems too daunting. I really don't know how to answer that, except my snarky answer would be, at my funeral, I think they should play the Sid Vicious version of "My Way." [*laughs*] I'm very stubborn, and I've had to fight to do things my own way. I've had wonderful people helping me and collaborating, but it's still a fight. I fight to do it, and really it's not "my way," it's "our way." I would like to think we were true to our instincts and have created something somebody was affected by, or it gave them some new insight, joy, or moment of amusement.

JV: What is the importance of a good cinema on a university campus?

JJ: Well, my initial snarky answer is a quote from Mark Twain, who said, "Don't let school get in the way of your education." But I don't feel that way, given I went to Columbia, then to Paris, and I would not have had the world of cinema open to me without that university. As I travel, I've been at certain universities talking with students. Having the resource to absorb these things is incredibly invaluable. So, I actually have very positive feeling about universities being able to open people's minds and their ability to express themselves. I think it's extremely valuable, along with other types of institutions. Like for me in New York, the Anthology Film Archives that Jonas Mekas started, Film Forum, and certainly Lincoln Center with their film programs, are equally invaluable.

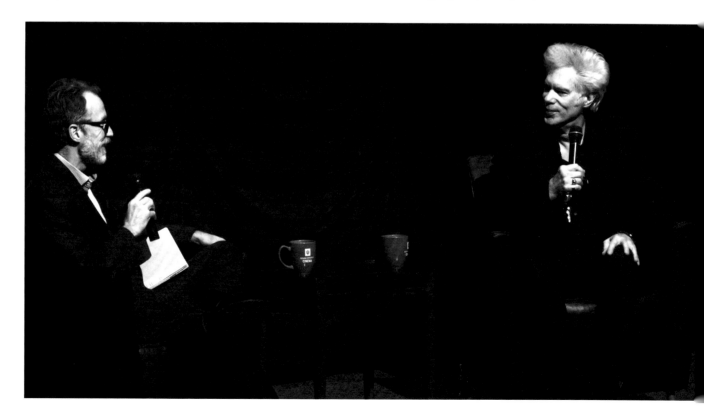

Jarmusch being interviewed by Founding Director Jon Vickers at IU Cinema on January 30, 2020, during a Jorgensen Guest Filmmaker event. Chaz Mottinger/ IU Studios

ABBAS KIAROSTAMI

In 2014, IU Cinema hosted world-renowned filmmaker Abbas Kiarostami in partnership with Syracuse University. His visit included a retrospective accompanied by an extended onstage interview led by Richard Peña, former director of the New York Film Festival and Film Society at Lincoln Center. This interview was a Jorgensen Guest Filmmaker program and was recorded by Cohen Media to be included as a bonus feature on their Blu-ray release of Kiarostami's film *The Wind Will Carry Us* (1999).

Abbas Kiarostami was born in Tehran in 1940 and had an interest in images from an early age. He studied fine arts at the University of Tehran and became a graphic designer. While working for the Institute for the Intellectual Development of Children and Young Adults (better known as Kanoon), he created a film section of the organization. This is where he made his first film, *The Bread and Alley* (1990), a neorealist documentary. Although Kiarostami made several award-winning films early in his career, it was after the Iranian revolution that he earned a highly esteemed reputation in world cinema. More than twenty years after his first full-length feature, *The Traveler* (1974), he was awarded the prestigious Palme d'Or at the Cannes Film Festival for his film *Taste of Cherry* in 1997.

His films break from conventional narrative and documentary filmmaking, inviting the viewer to reflect, confront stereotypes, and actively question their assumptions. He plays with audience expectations and provokes their creative imagination. What distinguishes Kiarostami's style is his unique but unpretentious poetic and philosophic vision. A poet—and lover of poetry—himself, he has made many comments like "Life cannot go on without a poem."

Kiarostami's visit was supported by generous gifts from Jane and Jay Jorgensen, S. James and Roberta T. Sherman, and Rita Grunwald. Additional thanks to Richard Peña (a longtime friend of Kiarostami's), Adel Yaraghi for translating the interview, Owen Shapiro from Syracuse University, and Tim Lanza from Cohen Media.

Richard Peña: Abbas, if I may, let me begin at the beginning. What was cinema like for you when you were growing up, when was the first time you began to notice films, and what were early filmgoing experiences like for you?

Abbas Kiarostami: It's a long story. Should I tell you the whole thing? [*laughs*] In fact, cinema of course was born before I was, but my first experience going to the theater was at the age of eleven when I went to the theater with my sister. Before this, we had seen single

IU Cinema poster for Abbas Kiarostami in Indiana, April 2014. Jon Vickers

frames of film stock that were exposed to see the images on them, but when I went to the theater, I realized that these were supposed to be sequential in order to create motion. I was amazed at what I was watching. The first thing I remember seeing was the big lion of Metro-Goldwyn-Mayer's logo. When the lion was roaring, I was afraid and held my sister's hand because I had never seen a moving image. There were no TVs around at the time, either.

I remember the main character in the film we were watching had a very long nose and was playing the piano using his nose.

Many years later, I was at the New York Film Festival, and I asked someone who explained to me it was Danny Kaye in the film who was playing the piano with his nose. This was the first encounter I had with the cinema per se, but I would have never thought that I would join cinema as a filmmaker. I was in awe and amazed by the image, but again, I didn't think I would be part of this world.

There were Indian films that were coming to Tehran to be screened, as well as American films. There were westerns that would be screened at the cinematheque in Tehran, including some of the films made by John Ford. Gradually they gave way to the neorealist movement of Italian cinema, and it was through the neorealism of Italian films that I became interested in cinema; it affected me.

RP: By the time that you started working in art as a graphic designer and doing your own work as an artist, it was also the beginning of what we now call the Iranian New Wave. This included the work of [Darius] Mehrjui, [Masoud] Kimiai, and all those other filmmakers. When did you become aware of their work, and how did it affect you?

> **"It was through the neorealism of Italian films that I became interested in cinema; it affected me."**

AK: As you mentioned, I started my career as a painter, but I didn't think I was a good painter, so I tried to become a graphic designer. I started making posters for films, then making the beginning and end titles for films. That is how I started getting to know these filmmakers. It was at the same time that I started to work at Kanoon [Institute for the Intellectual Development of Children and Young Adults], and we started the film department there. I was illustrating children's books, and then I started making commercial, advertising films, ads. I brought those experiences into the film department at Kanoon and started to make short movies for children. It was about the same time that we entered the era of what you called Iranian New Wave Cinema. We started to meet these people and see their films as they started their careers. I worked at Kanoon for about twenty years.

RP: What kind of relationship or bridge would there be, in your mind, between your work prior to 1979, prior to the Islamic revolution, and your work afterwards? Do you see it as continuous, or do you see any kind of break in that trajectory?

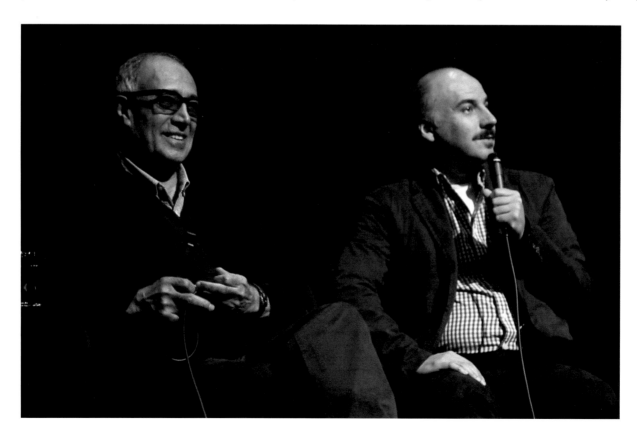

Abbas Kiarostami and translator Adel Yaraghi at IU Cinema on April 7, 2014, during a Jorgensen Guest Filmmaker event. Maggie Richards/ IU Studios

AK: I might not be the appropriate person to know this. You, as a scholar of cinema, and others as the viewers of my films, would probably have a better idea as to whether the revolution had any great effect on my pre- and post-revolution films. At the time, maybe, because I was a revolutionary myself, I did not use much sexual content or politics in any of my films. To go back to what you were saying, my journey has been continuous.

RP: Can you talk a little bit at this point about the real influence that neorealism had? You were drawing from your memory your experience of neorealist films and trying to create the sort of films you did in the 1980s, like *Where Is the Friend's House?* [1987]?

AK: I do not know more than two kind of films. There is one kind that is out of reach for us. An example would be Western films, films with a lot of attraction to them, like fictional films based on characters like smugglers, prostitutes, people who deal drugs or weapons, or killers. Those kind of films, those were the films that I used to watch.

The first film that I remember which influenced me greatly was an Italian film. The main character was played by Toto. I realized that this is different. This is based on a real character that might be a neighbor of ours. In fact, we did have a neighbor called Ali Afshar who was our Toto. At that point, I realized there were films made based on real characters, and I started to think about those ways of making films. *Through the Olive Trees* [1994] and *Where Is the Friend's House?* all probably came out of that initial experience.

I think neorealism did a great service to cinema, and it proved to us that we could make films in other ways. How could I make westerns or John Ford films in Iran, or the other films that they mentioned with those strange characters? This type of cinema showed us that there is another type of cinema that we could all make our films about. It would show that we can make films about people around us as well as hold a mirror to ourselves and see other lives in it, then make films about them.

RP: In terms of this desire to hold up a mirror, how does this impact, for example, the aspect of your writing? Can you talk about the aspect of writing? Because it's something I want to bring up later when we talk about *The Wind Will Carry Us*. How do you write, and how does writing affect what you try to portray in terms of "holding up a mirror" to those around you?

AK: Once I have an idea, or if I get an idea from somebody, the first thing I do is look for the character. I look around to find somebody similar to the character I imagine should be in my film, in terms of the physicality of the character, how he looks, how he moves, and all the characteristics he has. When I find him, I then start writing based on their real character I have in front of me now.

I then start interacting with him. I would go out and spend time with him, without him knowing he would be a character in my film. I want to learn things about him so I can get to know him better and get to know this character of my film better. After that, I basically tailor my idea to the character that is in front of me. I do not alter the character. I alter my idea based on the character I now have in front of me. I do not change his appearance. I try to get my ideas to the viewer through the character I have.

> "The most important part of my directing or direction is choosing the character, choosing the person who's going to be playing the character. Once I have done that, I do not need to do much more direction."

RP: Considering that so often in your films, especially the Coker trilogy and even beyond, you're working with those normally called nonactors, how do you work with them as performers? How do you direct them?

AK: The most important part of my directing or direction is choosing the character, choosing the person who's going to be playing the character. Once I have done that, I do not need to do much more direction. I do not change the way they talk, they move, or the way they are supposed to perform. Once I have chosen them, I follow them. There is a poem by Rumi which I think relates to this way of directing actors which I will try to recite.

> You are my little ball that I play with,
>
> I will hit you with my polo bat to get you started rolling,
>
> And I will follow you.

These two ways of relating are good ways to direct nonactors to arrive at a good performance. Directors are only in total command and can claim full control when they are making proper films or perhaps in animation. When you are working with a live being, you have to give, and you have to get. Making films this way, you might not have the bitter experience as directors who choose their characters thinking that there are things about them they can change but know that it is impossible to do.

RP: Going from what you just said, I'm wondering then what is your relationship to your cinematographer? How much planning must you do with your cinematographer beforehand? Do you allow

the cinematographer to follow the action, or how much do you plan shots in advance?

AK: They probably have not had very good experiences with me, though I have had very good experiences with them. The cinematographers would like to work with more professional actors because of their stature; they like the credit of working with them. What they especially like is to have the blocking marked on the floor to know where the action starts, where he or she is supposed to move to and from, the spot he or she are supposed to stop or turn, so the lighting is set. This is something that I do not accept and that ends up being a problem. At the end of the film, we each walk our own way, maybe not say hello anymore to each other.

They think I spoil those nonactors because I give them so much attention. They wonder why this person is getting so much attention and being filmed. What is the reason for us to give so much time for somebody that is so unknown? I understand them, although I believe that we as craftsman, or anybody who works in cinema, their work, their profession, what they do for the film has to go unnoticed. The work of the editor, the work of the cinematographer, should go unnoticed. But I understand them because they want their work to be noticed, and they want to have that ray of light on an actor's face at a certain moment, but with my films that doesn't happen. I understand the frustration.

RP: One thing about your films especially in this period is that I think more than most directors the films really are in conversation with each other. With the Coker trilogy, one builds on the other. But even *Close-Up* [1990], *Taste of Cherry*, and finally *The Wind Will Carry Us*, each one seems to be answering questions that started off in the one before that. Do you as a filmmaker, as an artist, think about that as you are making films? Do you start a new project based on what you had done before? Obviously, with the Coker trilogy, those films were based on each other in a way, but even when you were making *Taste of Cherry* or *The Wind Will Carry Us*, were there issues or ideas from the other films that you now wanted to address again?

AK: Obviously, this requires a long time to answer this question, but to make it short, I would tell you that I would never use literature or poems or other films to start my ideas. I draw my ideas from my surroundings and characters I am surrounded by. When I am working on a film, it is natural that I get close to the people I am working with, both the crew and the characters I am working with.

It becomes very natural for me to draw my ideas for the next film from them. It is also natural that once you make a film, you cannot say everything that you have to say in one film. So, the next film may be a continuation of what you wanted to say.

RP: Before you wrote the screenplay for *The Wind Will Carry Us*, had you found that village, or did you already have an idea of what you wanted to write? It seems to me it's a film that is as much about a place as it is about an event.

AK: I should add to the answer I had to the question, once I choose my character, or the person who will be in the film, I take him to the location where we will be filming. Now I can observe him in the location, including the changes he might go through in the location. Writing the screenplay, choosing the character, choosing the location and the idea, for me, all the stars have to align at the same time simultaneously. They do not come one after the other. When I start the idea, basically I've started production of the film. Once I have my character in the location, I find the people who will be fulfilling the supporting roles.

RP: What was it like finding the supporting cast in *The Wind Will Carry Us*? The people who are in the film, the women who put up the crew members in their homes? Was it difficult finding, for example, the woman who runs the tea restaurant? Did you have a difficult time convincing them to be in the film?

AK: It seems like he's been with us, and he knows all the answers. [*laughs, pointing at Richard Peña*] Every question he asked brings up a lot of memories. Many of the stories that are behind the film and things that happened during the making of the film really are more attractive than the film itself. No woman in the village would be convinced to play the role of the lady that serves tea or runs the tearoom, or the coffee shop as he would say these days, so we had to travel to the capital city of that region, Kermanshah, and pay her an amount of money more than usual to play the role of that woman. After two days of filming, she said, "Okay, thank you very much, but I cannot come anymore. My daughter will be playing the character from now on. She is younger and more beautiful than I."

I said I cannot do that, but she said her daughter was very upset that she was doing this. It would be a better thing for her daughter to do. She put me in a very difficult position, and I didn't know what to do. I was ruining a relationship between a mother and daughter, but I have the film to make. I didn't know what to do. This was just an

> "I would never use literature or poems or other films to start my ideas. I draw my ideas from my surroundings."

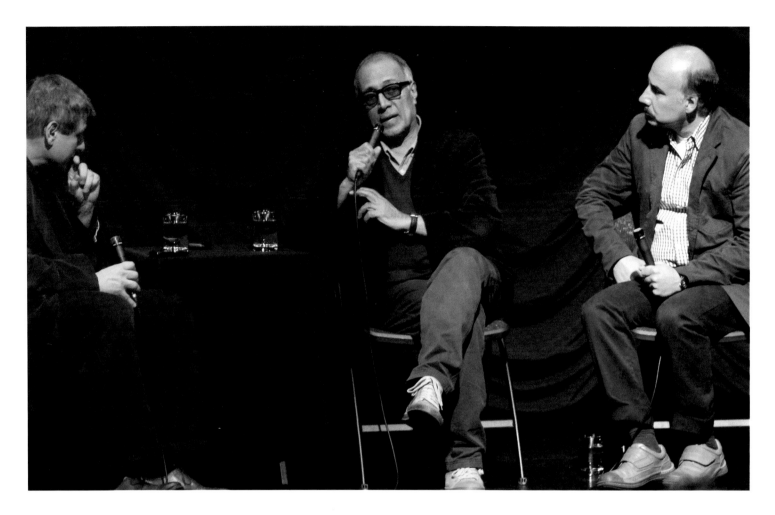

example, but with each and every one of these people in the film, we had similar problems. So, nonactors are very good, but they have these problems to deal with.

When the film is said and done and you walk away from it, you see there has been so much effect these people have had on you. In this particular scene, we were almost convinced to bring in the daughter of the lady and start over by reshooting the two days. But if you allow yourself to know these characters and to work with these nonactors, you find dimensions that you would not have experienced otherwise if working with regular actors. They bring these new experiences to your life that are interesting if you are willing to deal with them.

RP: Can you talk, especially with regards to this film, about your use of editing, of montage? I am wondering especially about rhythm. One of the things that I find very interesting in this film is the rhythm that it has, the passage from scene to scene. Was that a concern of yours in terms of the way that you set up the action?

AK: I wish I had seen the film recently so I could answer that question. I only watched this film once in the Venice Film Festival, fifteen years ago. I was hoping that I would watch the film here so that I could answer your questions. I don't even know what scene follows what other scene right now, so I cannot really answer your question.

I do remember something that might be of interest to you. It was about the day we were watching the film that day in the festival with producer Marin Karmitz Mantz in Venice. The film is 117 minutes long. I think it is a little too long for a film like this. I think the best timing for a film would be ninety minutes, but I could not make this particular film any shorter. I told Marin, my producer, that I know the film is long and gave him carte blanche to take out whatever scene or part of the film he wanted. I did not know what part to take out, so I gave him full permission to shorten it.

The film was supposed to screen at a late hour. It was a black-tie event full of cultured people, cinephiles, and scholars. As we watched the

film, there was a part when everyone clapped. When the film ended, the reactions were good, and people seemed to like it. We went to dinner, and there I told my producer, "Marin, now I know where we can shorten the film." He asked where, and I said, "The place where everybody clapped; we can take that out." [*audience laughs*]

I'm not kidding you; he was shocked a little for me to say that. I really believe that when you create some general excitement among your viewers, there is something wrong with the film. I think if I were to watch it again, that part of the film is like a little slogan which does not have much to do with the rest of the film.

RP: One thing that's often remarked about in the film is the fact that there are so many sequences in which there are off-screen voices. You are talking to people who we don't see—the camera crew or many people like the man in the pit. Could you talk about that idea? When did that idea come to you? Was it something that was there from the beginning, or did it occur during the shooting?

AK: This idea, this type of use of off-screen sound, has been with me for a long time. Every time the situation in the film permits, I use that technique. I think it has to do with the architecture and dimensions of a space. If we say there are six ways—up, down, back, forth, right, and left—then there are six dimensions. When we are watching a film, we are just looking at one of these dimensions, and using off-screen sound is a witness to remind us that we are only looking at one of the dimensions. We can bring in a reminder of the presence of other dimensions by using off-screen sound.

Off-screen sounds always remind us of the logic of the image. Because we can only use this dimension and the images we are able to create on-screen, off-screen sound helps us to create, in the minds of the viewers, additional images we are not able to bring up on-screen. There is a deeper meaning to it which is not mine, somebody told me about it. They said, "If you close your eyes, do you think the world does not go on?" Off-screen sounds are witness to that. You know that even when we close our eyes, there are still things going on; there are images and the world goes on.

RP: If I am correct, I think this is your last major film that used 35mm [film stock]. After *The Wind Will Carry Us*, you switched to digital. Do you miss filming in 35mm?

AK: No, I would never miss 35mm. If there were no digital cameras, I would probably have left the cinema. The problems we had after

the revolution acquiring film stock, all of the old out-of-service equipment, the scratching of the negatives in the labs, all of the problems with getting the films developed and everything else that we had to deal with, it was very tiring, and I would have left cinema if it were not for digital cameras.

I was one of the first directors to embrace digital cinema. I used a Hi-8 camera, very low quality, new Handy-Cam camera on my film *Ten* [2002]. I think it was appropriate for *Ten*. If it were not for that technology, I probably could not have made the film because of the situation and the location, which is inside of a car, filming conversations. It was very friendly, the camera. It would smile at me. It was a very good companion for me to make this kind of film, whereas 35mm camera is very bitter and very tough to work with as a companion, especially in close quarters. Before I knew it, *Ten* was made easily and was screened at Cannes. It was a film made with a very little camera.

> "More than creativity, I think you need to have a good antenna, a good receiver, so you can receive what is around you, what you are interested in."

So, when the film was completed, we had printed on 35mm in order to screen it. I was a member of a festival jury with Jean Rouch. Mr. Peña knows him. I asked him to watch my film, and he was very angry. He said, "I would never want to watch a film made with such a little stupid camera, and I don't even want to go to a theater," which was the Balzac Theatre on the Champs-Élysées [in Paris], "that is screening a film made with such a camera." It's a pity that Jean Rouch is no longer with us to see that such a high percentage of films, even Hollywood films, are made digitally. It is amazing. You cannot deny the fact that a new technology has come around and is of use to us, of course.

Audience Question: I have a question about the shot in *Close-Up* of the can that is rolling down the hill. I'm wondering first off if that was planned, but I am also wondering more broadly how it is that you practice filmmaking in a way that allows for chance to come into the frame?

AK: Many of the shots that might not seem of much value in my films had much more time spent on them compared to the scenes that you might think are the major parts of the film. These include the tin can scene in *Close-Up* and the journey of the apple in *The Wind Will Carry Us*. The way the apple falls off the balcony was not accidental. We probably spent a day to mold that little path where the apple was traveling. I spend a lot of time on those seemingly unimportant shots, but I think they have their say in the film when you watch. Again, they

might seem unimportant, but they have their importance in the film, and I personally like those unimportant shots much more than the seemingly more important shots.

AQ: When making your film *Like Someone in Love* [2012], which was shot in Japan, a very foreign culture to you and much different than Iranian society which you capture so well, how did you find your character and story?

AK: There was a lady at dinner last night who is a psychologist who told me that through my films, we can understand how close we are as people, whereas the media is telling us otherwise. Obviously, if I did not believe this, I would not dare to go into other places to make films. I do also believe that we are very similar and very close to each other as people. None of you sitting next to each other really look alike. The three of us sitting up here are all different; we do not look alike. I do not mean we are the same on the surface, but if we

took X-rays of everyone here, it would be very difficult to differentiate who is American and who is from another culture. I mean to say that, in a deeper sense, we have much more similarities than differences.

Our reaction to the phenomenon of pain or happiness are all the same. When we have pain, we have a certain expression, and when we are happy, we often laugh. This is very similar in all of us and would give me the audacity to go to Japan and follow a man who is older and probably in the range of my age. This allowed me to follow him and try to get close to him in order to understand, and perhaps understand myself better. Maybe that also helps you understand him better.

AQ: Could you speak about the way that you work with poetry and still photography and film as a creative artist, and are there areas for which you explore different kinds of creativity in the different media, or do they blend together?

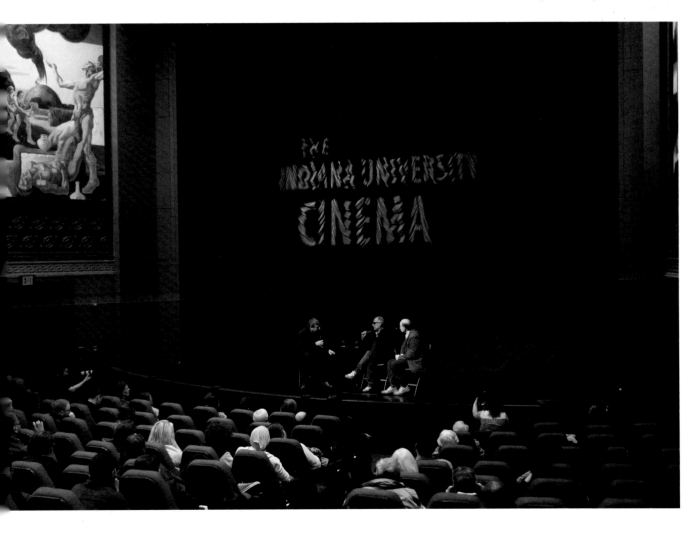

Previous page and left:
Kiarostami being interviewed by Richard Peña and translated by Adel Yaraghi at IU Cinema on April 7, 2014, during a Jorgensen Guest Filmmaker event. Maggie Richards/ IU Studios

AK: I don't think there is a difference. You should look into the kinds of poetry you like and images you like. Once you find that, you will see there is not much difference in your tastes you might have. I would use the analogy of musical notes. If you know how to read musical notes, then changing your instrument is not very difficult. Things come to you. I don't even know if creativity per se has much to do with it. It depends on how you look at things and what you look for. Then they start to come to you. More than creativity, I think you need to have a good antenna, a good receiver, so you can receive what is around you, what you are interested in.

AQ: What would you like your legacy to be as an artist?

AK: It is difficult to say what I'd like to leave behind. Undoubtedly those things that I have not destroyed, ripped apart, or thrown away, things that have my signature on them—definitely I would like to have a confirmation of those works and leave them behind.

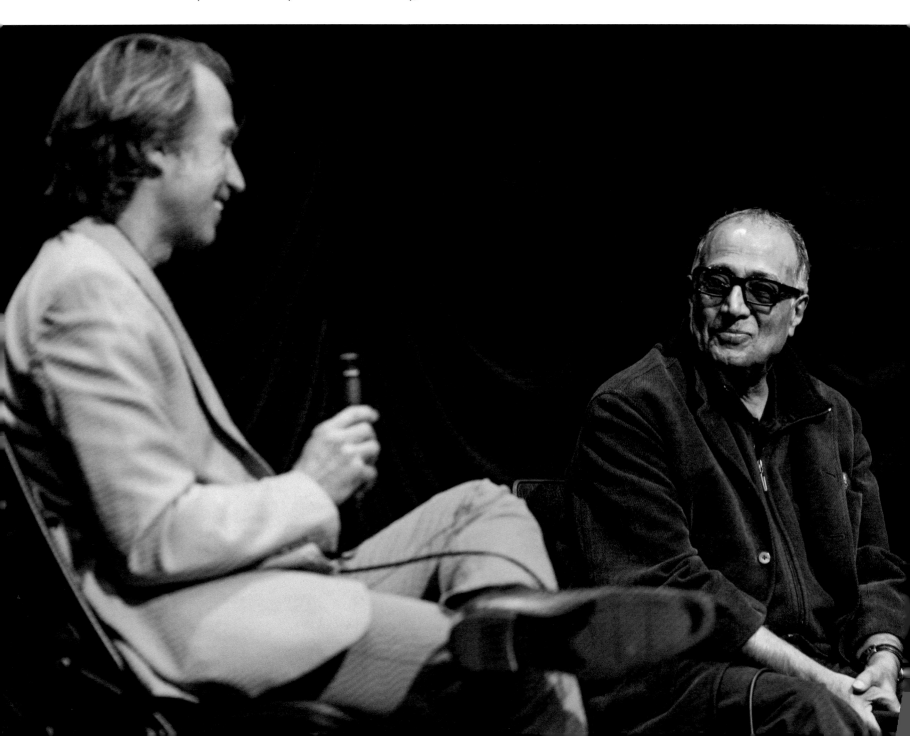

However, to think that one day I would not exist but my works would remain, I have not thought about that since my pleasure is in my own existence, not in those works that would remain of me. If that should be in opposition to the fact that something would remain of me, but I would not exist, then I prefer that I would remain and my work would not.

AQ: *Shirin* [2008] is one of my favorites of your films, and you talked about off-screen sound, and this film, of course, brings that concept to an epitome. I wonder how you filmed *Shirin*. Did you simply have conversations with all of these various people and then edit in their responses as actors? Or did they in fact sit through the entire epic that is playing off-screen, with you filming their reactions and responses as it was being watched?

AK: *Shirin* is a film in which many women are sitting in a theater watching a film which happens to be based on a poem from a very famous old poet from Iran. It is about the first love triangle in Iranian literature, between a woman and two men. One of the men in the poem was an ancient king of Iran, and the other man was an architect. The poet lived about eight hundred years ago. The viewers of the film are almost all women, with a few men sitting in the back. The film has to do with trauma. The women watching the film start out by having smiles on their faces; thereby we literally see an excitement under their skin. Little by little, the film turns melancholy, and the women's emotions change with most of them crying by the end.

I do not know how to best explain the film to you, but if I had to tell you my favorite film, it would be *Shirin*. It is because of the role of all the people who took part and the minimal role I had as the director. Usually films should not affect the filmmaker. They are made to affect the audience, not the director. But there are two films of mine which have affected me. One is *Close-Up* and the other is *Shirin*, which I have watched more than fifty times. Every time I watch this film, I really get emotional. My tears well up because I claim that I did not make this film. It is a film that was made by itself.

Now, here is how the film came about. From the time I was very young, I would go to the theater. I always had an eye on the screen and the other eye on the people watching this screen. It was always very interesting for me to see how the action on the screen would affect the people watching. I always thought that I should somehow show that. I invited all the Iranian actresses from the age of eighteen to over eighty, which was a hundred twenty of them.

> "To me, a film that reveals something new about life is a fitting one."

I have them sit on three theater seats in my basement, and I have a camera in front of them with a clean sheet of paper. I would tell them to look at the white sheet of paper, and I would set an alarm to go off in six minutes. They would look at this white sheet of paper and try to experience their feelings while I tried to capture their expression on their faces with the camera. I was not planning to make a film out of this. It was really a way of me being nosy or curious about what goes on in their mind, and I just wanted to record that. I would say that all of them would get very sad and emotional after the fourth minute, and they would all end up crying, in such a way after the alarm rang, they would get up from their chair and walk away to another chair and continue to cry.

We finished filming, and after principal photography was done, I had about seven hundred minutes of footage that I didn't know what to do with. I thought this would make a good gallery installation with each of these in a space where people could come look at them. That did not seem like a very good idea, so eventually I decided to make a film out of the footage.

I did not know what soundtrack I should use. At first, I thought I would use a foreign soundtrack, starting with *Romeo and Juliet* [1968] by Franco Zeffirelli. Unfortunately, we could not afford the rights, so I started writing a script based on the poem from Nizami [Ganjavi] that I mentioned earlier. With the script, we recorded narration and added a score and sound effects for a complete soundtrack. From there, we worked backwards, editing the images to best fit the sound.

It's unfortunate that I made this film later in my career. It would have been more help for me if I had made it when I was around fifty, because then I would have gotten to know women better. It would have been of use to me. It is a very deep film, emotionally. If you look at it deeply and pay attention, it also shows that we are not all alike in terms of emotion. There are so many differences and layers of emotion that you can experience. To me, a film that reveals something new about life is a fitting one.

RP: After that beautiful answer, I'm afraid we're going to have to call it an afternoon. Abbas, thank you so much for coming to Indiana. Adel, thank you so much for your wonderful translation. Thank you all very much for coming.

Left: Kiarostami being interviewed by Founding Director Jon Vickers at IU Cinema on April 6, 2014, during a Q&A following a screening of *Like Someone in Love*. Maggie Richards/IU Studios

Academic Symposia and Conferences

As a campus venue, IU Cinema has supported academic research by hosting symposia connected to film and media studies. For ten years—even before it opened—IU Cinema supported the international symposium New Trends in Modern and Contemporary Italian Cinema. In partnership with IU's Department of French and Italian, each year, the festival hosted Italian filmmakers—including Wilma Labate, Vincenzo Marra, and Roberto Andò— as well as international scholars in Italian cinema. Another recurring conference with visiting filmmakers is the Latinx Film Festival and Conference. Over the years, it has welcomed to campus filmmakers such as Edward James Olmos, Cristina Ibarra, Rashaad Ernesto Green, Sonia Fritz, John Valadez, Edmundo Desnoes, Andrea Meller, Alex Rivera, and Miguel Coyula.

In addition to supporting many academic symposia in its first decade, IU Cinema also played a significant role in the planning and programming of several conferences with campus and community partners, including The (William S.) Burroughs Century; Orphans Midwest: Materiality and the Moving Image; Orson Welles: A Centennial Celebration and Symposium; Wounded Galaxies 1968: Paris, Prague, and Chicago; and Visible Evidence XXV. Through these symposia, IU Cinema helped bring to campus a vast array of talented filmmakers, artists, and cultural critics, including Bill Morrison, Deborah Stratman, Jennifer Reeves, Greil Marcus, Lydia Lunch, Chuck Workman, J. Hoberman, Maya Beiser, Annea Lockwood, and Sergei Loznitsa.

"You are giving people a platform to be able to explore a wide spectrum. . . . That's really refreshing to see."

—Paul D. Miller aka DJ Spooky, composer, multimedia artist, and director of *Rebirth of a Nation* and *The Book of Ice*

Bottom: Actor and activist Edward James Olmos at IU Cinema for a Jorgensen Guest Filmmaker event during the Latino Film Festival and Conference, April 4, 2014. Maggie Richards/IU Studios

Facing: Loznitsa during an "An IU Cinema Exclusive" interview at IU Cinema, August 2018. Toth Media, LLC

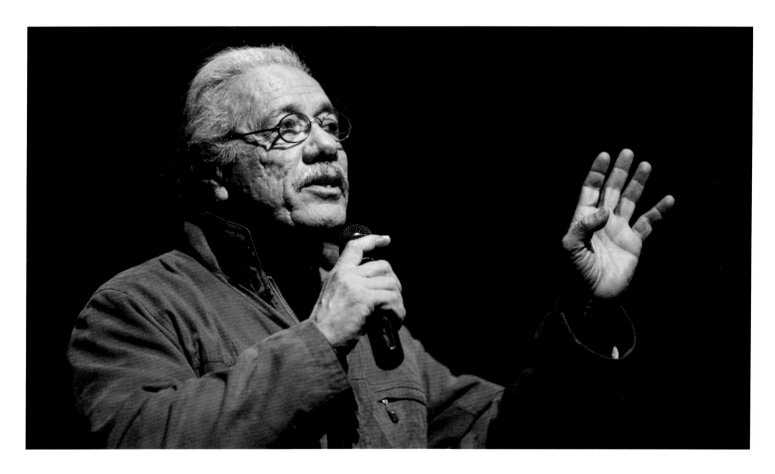

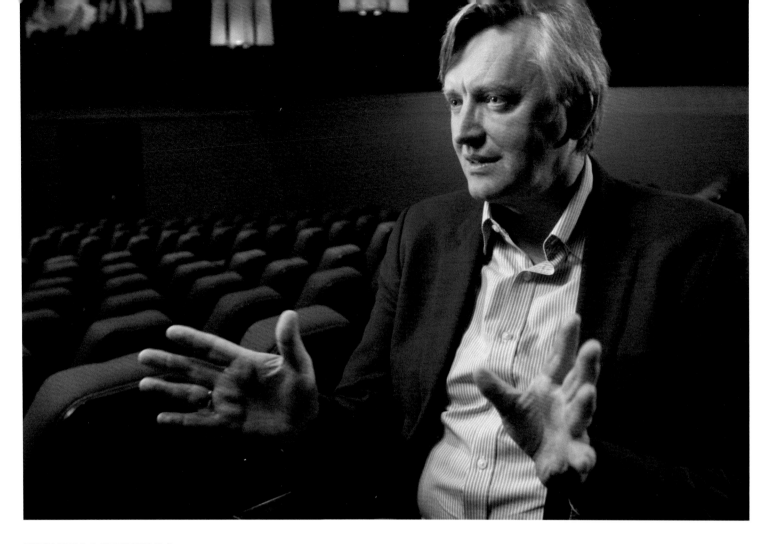

SERGEI LOZNITSA

In August 2018, IU Cinema was a programming partner and cohost of Visible Evidence XXV. The conference was produced by the Center for Documentary Research and Practice, the Media School, IU Libraries Moving Image Archive, and IU Cinema. Visible Evidence is a collection of scholars and practitioners engaged in research and debates on historical and contemporary documentary practice and nonfiction media culture.

The three keynote filmmakers at the conference were Bill Morrison, Deborah Stratman, and Sergei Loznitsa. Each of the filmmakers presented their work and sat for extended interviews to be transcribed for an anthology publication titled *The Documentary Moment* (IU Press, 2021).

Born in Belarus, Loznitsa studied engineering and mathematics as a young man. From 1987 through 1991, he was employed as a scientist at the Institute of Cybernetics. During that time, Loznitsa developed a strong interest in cinematography, and in 1997, he graduated from the Russian State Institute of Cinematography in Moscow with a major in movie production and direction. In 2001, he immigrated with his family to Germany. His documentary and fiction films have been awarded dozens of prizes at festivals around the world, including Cannes, Karlovy Vary, Leipzig, Oberhausen, Paris, Madrid, Toronto, Jerusalem, and Saint Petersburg, as well as the Russian National Film awards "Nika" and "Laurel." Loznitsa won Best Director in Un Certain Regard at Cannes Film Festival for *Donbass* (2017).

In addition to the film screenings and Visible Evidence XXV speaking events, Loznitsa also sat with Founding Director Jon Vickers for this interview, "Sergei Loznitsa: An IU Cinema Exclusive."

Jon Vickers: Why is film such a powerful artform?

Sergei Loznitsa: From the first shot when a film starts, the good director rebuilds a world, and our possibility to understand that world, from zero. Every good director starts from zero with every film.

JV: Who or what are your artistic influences?

SL: My feelings I have when I'm thinking about the destiny of my family and many families in the Soviet Union. These are very tragic stories, and I have such a strong passion, because I would like to say things which these people cannot say, not allowed to do that. After that, we can speak about art. The passion came from that.

In cinema, I don't want to mention names, but there is a great tradition of Russian cinema. There are [several] directors who worked in the world cinema—not only [Sergei] Eisenstein, but many, many names, like [Aleksandr] Dovzhenko, like [Vasiliy] Shukshin, [Andrei] Tarkovsky, and [Sergei] Parajanov and many others. Some of them still work. That's from one side, and from the other side, I like the formalists like [Alfred] Hitchcock. By formalist, I mean the directors who are very familiar with the form [*laughs*], very strong with the form. I like [Luis] Buñuel. I like [Rainer Werner] Fassbinder, for example. He has a very big heart, and you feel it, how deeply he felt all of this suffering, all the pain of his nation.

I watched a lot of film when I studied. I watch a lot of film now when I have time. I sometimes watch five films a day. I can't do it when I am making a film because I have to be clean, absolutely without any influences. I see that cinema is just in the beginning of development because this visual language is what we will need to develop for our life because conversation through the image, it's faster and deeper with information than, for example, the alphabet. It will have to develop somehow, and cinema does it. We have not opened everything. This is what I believe.

JV: What drives you to take on the subjects you do in your films?

SL: In beginning of cinema, it was a moment when they create, like the Lumières [Auguste and Louis], all genre in one moment. Cinema was very lucky that these kind of creative people were there in the beginning. I don't know how many films they made, like around a thousand; you can see the potential for different kinds of development, almost in each film. You can see different genres and different development inside the genre in these short films, like twenty seconds each, or even less. Cinema very quickly developed, and in twenty or thirty years there was sound. But cinema language stopped developing until the 1950s, when they began layering sound. They started re-creating cinema language. Today, with all the new possibilities, I can make whatever I want, make it sound very deep and touchable, serious, and so strong, much stronger than image. This opened for me plenty of possibilities on how to work with it. The same with a camera, which now can shoot long takes, giving possibilities to work with time. There are now many, many ways to develop your topic. Unfortunately, life is so short. [*laughs*] Cinema is such heavy stuff. In one year, how many [films] can I do? I have more ideas than time.

 INDIANA UNIVERSITY BICENTENNIAL 1820–2020

THE ANDREW W. MELLON FOUNDATION

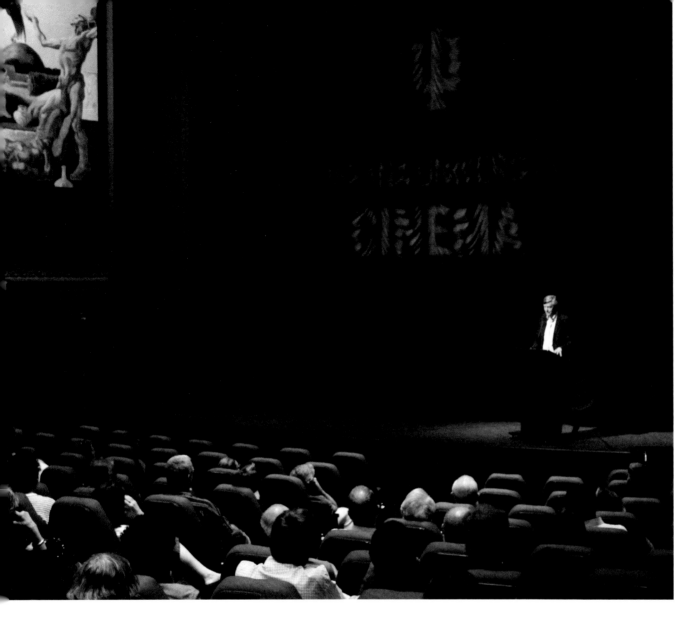

Facing: Banner for Visible Evidence XXV, an August 2018 documentary conference partially hosted by IU Cinema. Arturo Contreras/ The Media School

Left: Filmmaker Sergei Loznitsa introducing his film *Austerlitz* (2016) during Visible Evidence XXV at IU Cinema, August 2018. Ava Vickers

JV: What advice would you give to a young or emerging filmmaker?

SL: Read a lot. Watch a lot. Know very well the history of art, and the history of cinema, theater, literature, and fine art. It is very important. Start as a mathematician. [*laughs*] Have this education because mathematics help you understand that all what we're doing in cinema is abstraction. Not a lot of people understand that. All of what we are doing is a model; it is not life. Many directors make a film and try to prove that "this is like it is in life." They swim against the stream. They don't understand this.

JV: What is the importance of a good cinema on a university campus?

SL: It's very important. It is one of the elements of human cultural a ctivity. For me, the same question is "Is it important to have a culture?" Yes, it's very important. Because only these thin, thin lines divide us as a culture. Very thin line divides us from war, from wildness, from the animals which live inside us, which still live inside. It's not so easy to remove from ourselves the five hundred million years we developed from the microbe. I always think about culture because it's already known that a territory without culture, they jump immediately, without invitation, to war. This is our only protection, only culture, and everything that culture means.

> "I see that cinema is just in the beginning of development because this visual language is what we will need to develop for our life."

John William Griffith II

THE STRONG MAN

(2019)

Film Score

Written and Directed by Oscar Micheaux

BODY AND SOUL

(1925)

Original Music by

EUN-CHUL OH

(2016)

CREATIVE WORKS

The arts and humanities help us make sense of the world around us. They probe us to ask questions and challenge our biases and beliefs, and they offer pathways to personal discovery and universal truths. Indiana University is a Research One university and a "multi-campus, multifaceted research institution with world-class academic programs, and the nation's largest medical school, the IU School of Medicine," as stated by the Indiana University Office of Research Administration.

IU Cinema takes seriously its role in serving this part of the University's mission and is proud to be a catalyst for the creation and public presentation of new scholarly and artistic work in the arts and humanities. In its first decade, IU Cinema has been the cause or inspiration for the publication of new scholarly works ranging from articles in accredited journals to complete manuscripts, the creation of solo and orchestral music, and even new works on film, which received premieres at IU Cinema.

This section presents a selection of creative outputs resulting from thoughtfully curated and planned programs by IU Cinema programmers and program collaborators. There are now many creative and scholarly works which would not exist in this world if IU Cinema were not there to inspire, encourage, fund, or produce.

Academic Symposia and Conferences

On opening, IU Cinema quickly became interwoven into the academic fabric of the Bloomington campus. Even before the Cinema existed as a venue, it had already been a partner in two academic film events. The first was DEFA (Deutsche Film-Aktiengesellschaft) Dialogues, led by scholar, filmmaker, and critic Brigitta Wagner, in partnership with the DEFA Foundation in Berlin, the Consul General of the Federal Republic of Germany, and various IU departments. This took place in April 2010, a month after Founding Director Jon Vickers was hired. With rental equipment, he turned a classroom in the Fine Arts building into a 35mm screening room to present the rare film prints imported from Germany. That same month, Vickers represented IU Cinema by managing the screenings for the first New Trends in Modern and Contemporary Italian Cinema symposium,

which would be held at the Cinema for the next nine years and bring Italian filmmakers and scholars to IU from all over the world.

In addition to supporting conferences like these and many others, IU Cinema has been involved in initiating, programming, and planning several academic symposia in its first decade. In 2012, IU Cinema and IU Libraries began planning for Orphans Midwest: Materiality and the Moving Image, a three-day conference and festival in September 2013, examining "orphaned films" and hosting more than one hundred scholars, collectors, artists, and filmmakers from across the globe. An orphaned film is typically defined as a cinematic work abandoned or neglected by its creator or copyright holder. The event was an offshoot of the ongoing Orphans Film Symposium, an initiative of Professor Dan Streible of New York University's Tisch School of the Arts, which is held annually in various international locations.

Facing: Orchestral film scores written by students for IU Cinema's presentations of the Jon Vickers Film Scoring Award. IU Cinema

Right: Filmmaker Bill Morrison presenting a Jorgensen Guest Filmmaker lecture at IU Cinema in September 2014 after first visiting in 2013 for a presentation and premiere of his new film *All Vows* at Orphans Midwest. Chaz Mottinger/ IU Studios

Along with keynote addresses and special events like the world premiere of a new Bill Morrison film, which will be detailed in the next section, each of these symposia include social events connecting the international film community to Indiana University.

In 2015, IU Cinema, IU Libraries, and the Media School planned Orson Welles: A Centennial Celebration, Symposium, and Exhibition, which hosted scholars and filmmakers from seven countries. The programs included a major exhibition of Welles' papers and ephemera at Lilly Library, curated by manuscript archivist Craig Simpson, as well as twelve film programs. Keynote addresses and paper presentations were streamed live online, including a panel discussion on Welles' unfinished film *The Other Side of the Wind*, presented by the film's producer and several Welles scholars who contributed to the 2018 completion of the film by Netflix. The success of the symposium and celebration led to a similar program being presented at the Rio International Film Festival later that year, carrying Indiana University's name. Several of the conference scholars, including Indiana University Professor Emerita of Spanish and Portuguese Darlene J. Sadlier and Chancellor's Professor Emeritus James O. Naremore, along with Vickers, were invited to attend as festival guests.

> **"This was in many ways the best Welles conference I've ever attended. I am very grateful."**
> —Jonathan Rosenbaum, film critic

Chancellor's Professor Emeritus James O. Naremore presenting one of three keynote addresses at Orson Welles: A Centennial Celebration, Symposium, and Exhibition in May 2015. James Brosher/IU Studios

Additional examples of symposia with IU Cinema in a leadership role include Ray Bradbury: From Science to the Supernatural, produced in partnership with the Center for Ray Bradbury Studies at Indiana University–Purdue University Indianapolis; The Burroughs Century, examining the work and influence of writer William S. Burroughs; and Wounded Galaxies 1968: Prague, Paris, and Chicago, reflecting on the tumultuous year of 1968 and its cultural and political impact. Each of these symposia featured special guests, and the latter two were developed in partnership with a community nonprofit organization called the Burroughs Century, Ltd., comprised of artists, musicians, writers, filmmakers, and public intellectuals. Both symposia also featured live-music components at venues throughout the community.

Wounded Galaxies 1968 hosted New Zealand composer Annea Lockwood, inviting her to re-create her 1968 performance work *Piano Burning,* giving a defunct piano its final voice by setting it on fire. The event was streamed live online and kicked off the three-day

"Of particular importance to the Black Film Center/ Archive, the success— past and future—of its programming activities in the cinematic depend in no small measure on our partnership with Indiana University Cinema."

—Michael T. Martin, professor, the Media School

Facing: Publications resulting from scholarly work presented at IU Cinema during conferences and symposia between 2014 and 2015. IU Press

Right, top: Film critic and author J. Hoberman speaks to symposium organizer and Professor Joan Hawkins in IU Cinema's lobby prior to Hoberman's keynote address for the symposium Wounded Galaxies 1968: Prague, Paris, and Chicago in February 2018. Chaz Mottinger/IU Studios

Right, center: A defunct 1916 Henderson piano ablaze in Dunn Meadow, a re-creation of New Zealand composer Annea Lockwood's performance work *Piano Burning*, staged with Lockwood for the symposium Wounded Galaxies 1968: Prague, Paris, and Chicago in February 2018. Robert Mitchell

Right, bottom: Authors and scholars Joseph McBride, Jonathan Rosenbaum, and Josh Karp (not pictured) discussing the unfinished film *The Other Side of the Wind* with producer Filip Jan Rymsza at Orson Welles: A Centennial Celebration, Symposium, and Exhibition in May 2015. All three authors were special consultants for the completion of the film by Netflix. James Brosher/IU Studios

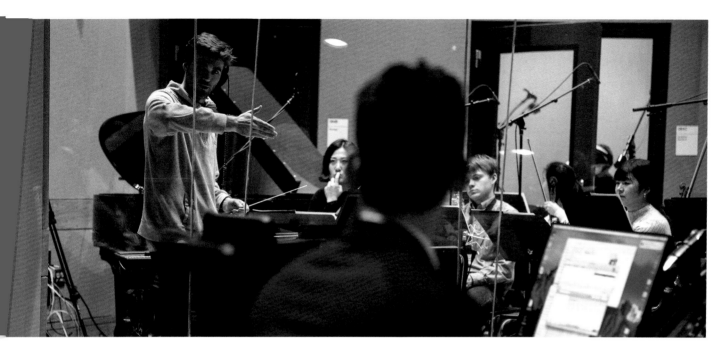

symposium, which also featured a film series curated by former *Village Voice* film critic J. Hoberman and keynote addresses from Hoberman and cultural critics Greil Marcus and McKenzie Wark.

Many of these symposia and conferences have led to publications. Presented papers have been developed into countless journal publications, and several book projects have resulted from these initiatives. In addition to books developed from the Welles and Burroughs symposia, *The Documentary Moment* was born from the 2018 Visible Evidence XXV conference, which was a partnership between the Media School, Center for Documentary Research and Practice, IULMIA, and IU Cinema. It is fair to say many of these publications would not exist without a university cinema dedicated to contributing in such impactful ways to the academic and research missions of the University.

Live-Music Events

From the beginning, IU Cinema was uniquely positioned to develop new programs marrying moving images and live music. Indiana University is home to the Jacobs School of Music (JSoM), one of the largest and most esteemed music schools in the country. Long before the Cinema curated its first film series, Founding Director Jon Vickers met with Dean Gwyn Richards and composition faculty to discuss collaborative opportunities. In its first semester, IU Cinema

presented five programs with live music, including the US premiere of the newly orchestrated score for the complete version of *Metropolis*, previously mentioned in this book.

This set the stage for a vibrant and ever-evolving relationship between JSoM and IU Cinema, which has led to innovative and unparalleled film-music events as well as new academic programs. The first of these was Double Exposure, inspired by IU Cinema and led by faculty of the Media School, JSoM, and the Student Composers Association. Each year, approximately a dozen new short films and new film scores are collaboratively created by students specifically for Double Exposure, then premiered at IU Cinema with live ensembles. Beyond the live premieres, the scores are also recorded and mixed in JSoM's Georgina Joshi Recording Arts Studio with the aid of student producers and engineers. All students walk away from these experiences with new creative works for their portfolios and festival submissions.

Another ambitious and original program IU Cinema piloted in 2012 was a competition and commissioning award for JSoM student composers to write new orchestral music for silent films. Three years after the premiere of Ari Barack Fisher's score for *David Copperfield* (1922), former IU trustee the Honorable P. A. Mack Jr. endowed this commission as the annual Jon Vickers Film Scoring Award. Each year, students receiving the award create hundreds of pages of new orchestral music to accompany silent films curated by IU Cinema.

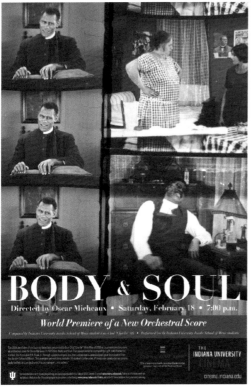

"I don't believe there is any other place for a student to get the chance to conduct a newly composed feature-length score for an existing professional film live-to-picture and in professional recording sessions. This opportunity is second to none."

—Tyler Readinger, student, Jacobs School of Music

In addition to transformative experiences for the student composers who dedicate months to these projects, many other students are impacted, with student engineers and conductors claiming these experiences as highlights of their college careers.

Like with Double Exposure, these scores also offer the opportunity of studio recordings in JSoM's world-class facilities. This has allowed IU Cinema to partner with film distributors and archives to plan opportunities for these new scores to be synchronized with new film restorations for theatrical and home-video release. Student compositions for *The Strong Man* (1926) and *Grass: A Nation's Battle for Life* (1925) secured Blu-ray releases with Cohen Media and Milestone Films, respectively, giving these students recorded and published work.

In addition to commissioning student work, IU Cinema has commissioned film projects and music from renowned filmmakers and composers. Its first nonstudent commission was for filmmaker Bill Morrison's 2013 work *All Vows*, which premiered at the Orphans Midwest: Materiality and the Moving Image symposium. Like most of Morrison's films, it repurposes footage from earlier films that have undergone some form of material deterioration. The film was commissioned by IU Cinema and the Dorit and Gerald Paul Program in Jewish Culture and the Arts as part of the Robert A. and Sandra S. Borns Program in Jewish Studies at Indiana University. The world premiere at IU Cinema featured touring artist Maya Beiser performing Michael Gordon's score on cello.

Facing: Posters promoting world premieres in IU Cinema of new orchestral film scores written by students for the Jon Vickers Film Scoring Award and Double Exposure. Kyle Calvert

Bottom: Jacobs School of Music student musicians and conductor preparing for the 2011 world premiere of Gottfried Huppertz's score for the 1927 silent film *Metropolis*. Peter Stevenson/IU Studios

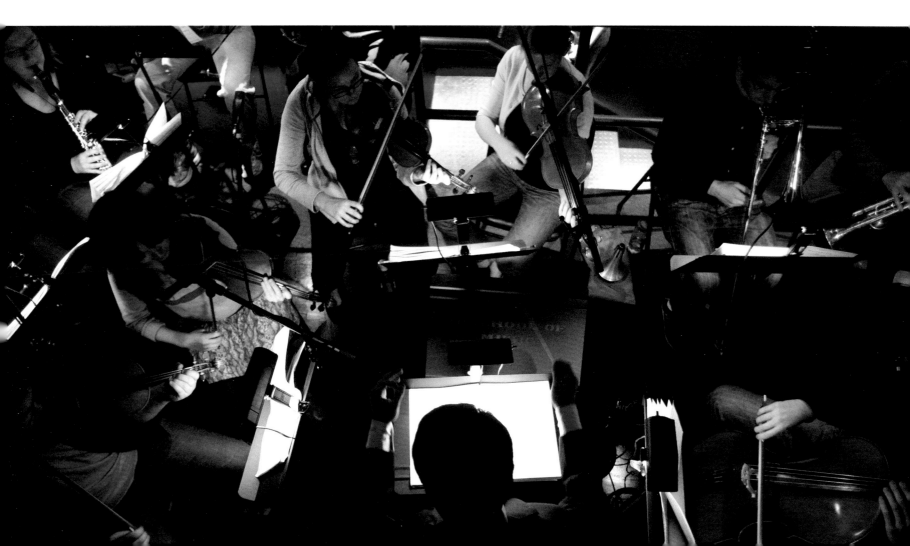

Beiser later mounted a worldwide tour using the title *All Vows*, which included this and additional films by Morrison as well as music by other artists. Indiana University's name was credited on the tour. Morrison returned to IU Cinema in 2018 with the premiere of another commission, *Buried and Breaking Away*, referencing the 1979 film shot in Bloomington and inspired by Morrison's swim in one of the local limestone quarries with Vickers. The film premiered at the conference Visible Evidence XXV at IU Cinema with Bloomington guitarist and songwriter Jason Fickel providing its score.

Another notable co-commission was *The Scar of Shame/Renée Baker Project*, in partnership with the BFC/A. In 2017, Chicago composer Renée Baker was conducting research on a collection in the BFC/A of the largely forgotten jazz pianist, orchestral arranger, band leader, and recording artist Phil Moore. A piece of music in the collection inspired Baker to begin sketches on a score to *The Scar of Shame*, a 1927 race film about a gifted pianist who falls in love with a woman and saves her from a life of poverty. The film remains a relevant and fascinating examination of prejudices of class within African American society of the 1920s, and Baker's score brought the film to life once again. After premiering at IU Cinema, Baker conducted her score with the film in Chicago and Europe.

During Indiana University's bicentennial year, IU Cinema created two high-profile commissions to premiere in Bloomington, which were made possible by the Office of the Bicentennial and donors Ed Myerson and Kaili Peng. Alloy Orchestra began writing and performing music for silent films in 1991, and film critic Roger Ebert declared them to be "the best in the world" at doing so. For several decades, the three-piece orchestra annually premiered a new film score at the adored Telluride Film Festival. IU Cinema's commission for their score to the 1924 film *La galerie des monstres* (*Gallery of Monsters*) was the first ever for Alloy Orchestra, and they subsequently toured the US extensively with the University's name credited. Lobster Films, which restored the film, later released it on Blu-ray with Alloy's commissioned score and all the credits for Indiana University.

National touring artist Maya Beiser performing Michael Gordon's score to the world premiere of Bill Morrison's film *All Vows*, which was commissioned by IU Cinema and the Dorit and Gerald Paul Program in Jewish Culture and the Arts. Chaz Mottinger/IU Studios

The second score commissioned for the University's bicentennial celebration was from the band SQÜRL, featuring Carter Logan and independent film icon Jim Jarmusch. In partnership with IULMIA, IU Cinema commissioned Logan and Jarmusch to score two experimental films from Ohio filmmaker Ed Feil, which are a part of IULMIA's collection and had recently been restored. The screening and performance at IU Cinema included the world premiere of both the restoration and new scores for the two Feil films. SQÜRL had previously written music for five feature films, but this was their first commission.

IU Cinema has consistently presented live film-music events since its inaugural semester in 2011, and live music events are considered an integral part of its program. These continue to include a mix of events with traditional scores on piano from some of the nation's leading accompanists—Philip Carli, Rodney Sauer, Dave Drazin, Larry Schanker—to small orchestras premiering work from composers like Neil Brand and Andrew Simpson, to more modern silent-film music by national and local acts including Coupler, Garden Gates, M, and solo electric guitarist Jason Fickel. IU Cinema even hosted a Benshi performance by Ichiro Kataoka for the Yasujirō Ozu film *An Inn in Tokyo* (1935) and a live Foley artist for Hildegard Keller's film *Der Ozean im Fingerhut* (*The Ocean in a Thimble*) (2012).

Facing: Promotional image of the band SQÜRL, featuring Carter Logan and Jim Jarmusch, used in promotion of their live-music event at IU Cinema in January 2020. SQÜRL/Sara Driver

Left, top: Frame from Bill Morrison's film *Buried and Breaking Away*, which premiered at IU Cinema as part of Visible Evidence XXV in August 2018. Bill Morrison

Right, top: Jacobs School of Music student musician Christian Johnson prepares to perform the US premiere of Neil Brand's score to the 1927 film *The Lodger: A Story of the London Fog* as part of Le Giornate del Cinema Muto at IU Cinema in November 2019. Alex Kumar/IU Studios

Right: The musical group Coupler accompany the 1925 silent film *Our Heavenly Bodies* as part of a February 2018 Science on Screen and Underground Film Series program at IU Cinema. Chaz Mottinger/IU Studios

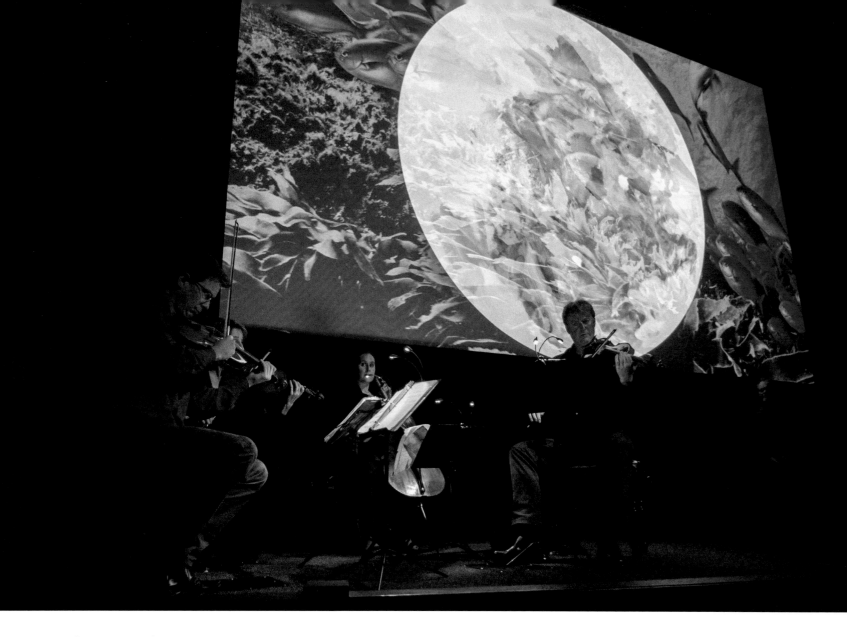

Producing a silent-film screening with archival elements and orchestral accompaniment is no small feat. Over the years, IU Cinema produced several silent-film events, which were massive undertakings. For a presentation of John Ford's silent masterpiece *The Iron Horse* (1924), IU Cinema rented an enormous Allen thirty-two-rank theater organ for renowned organist and IU alumnus Dennis James to provide the accompaniment. In 2013, IU Cinema hosted Slapsticon, four days of silent films on 35mm and 16mm, each with piano accompaniment. The festival brought together archivists, collectors, researchers, and film fans to celebrate the extraordinary richness of silent-film comedies.

In a 2019 partnership between IU Cinema, IULMIA, and JSoM, Indiana University hosted the very first US satellite version of the renowned silent-film festival Le Giornate del Cinema Muto, held each year in Pordenone, Italy. The Indiana program brought seven highlights from the festival, including several US premieres, visiting scholars, composers, and the festival's director, Jay Weissberg. In addition to the film screenings, scholars and experts presented multiple panels and workshops focused on music for silent films, curating from archives, and the representation of women in early cinema. The festival was part of Indiana University's bicentennial celebration and was supported by the Office of the Bicentennial and donors Ed Myerson and Kaili Peng.

The Fry Street Quartet performs onstage at IU Cinema as part of Rising Tide: The Crossroads Project, a two-day celebration of the catalyzing change arts and humanities leverage in support of environmental sustainability, which took place on the Bloomington campus in October 2018. Chaz Mottinger/ IU Studios

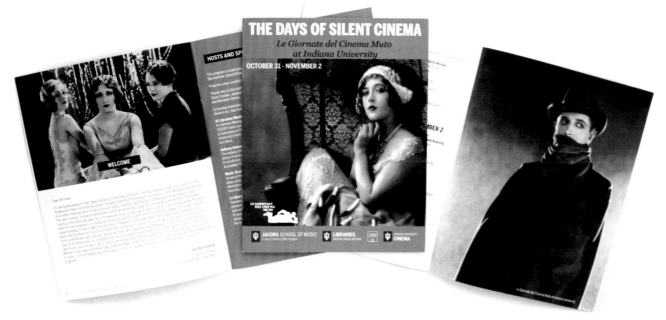

Top: Posters promoting special live-music events at IU Cinema, including US and Midwest premieres. Kyle Calvert/Jennifer Vickers

Bottom: Program book for Le Giornate del Cinema Muto at Indiana University, a three-day silent-film event that presented US and Midwest premieres of film restorations and orchestra scores. Jennifer Vickers

Signature Series and Programs

Most public-arts presenters curate unique programs and develop repeating or signature series in which artistic offerings are cultivated and grouped by theme, genre, and intended audience experience. This section provides examples of IU Cinema's ongoing signature series, a variety of Cinema events hosted in its first decade, and additional programs curated by its founding director, Jon Vickers, and founding associate director, Brittany D. Friesner.

There are several series IU Cinema is committed to curating every semester, including the 5X series highlighting a small retrospective of five films of a nonliving filmmaker; CINEkids, an international children's film series; President's Choice, for which President Michael A. McRobbie chooses films that made a significant impact on him; Sunday Matinee Classics, celebrating and providing a brief introduction to classic cinema; and Staff Selects, films curated by IU Cinema's noncuratorial staff. Several of these series are now supported by donor endowments with annual disbursements to cover film screening fees and associated presentation costs.

Many of the programs within these series become festive events unto themselves, with live or interactive components. These include an annual quote-along event with *The Sound of Music* (1965) and *The Creatures of Yes*, a puppetry and film performance and workshop with creator, puppeteer, musician, and filmmaker Jacob Graham.

Several additional series have also become staples of each semester's program, including Art and a Movie, presented in partnership with the Eskenazi Museum of Art; Not-Quite Midnights, reimagining midnight-movie programming at a reasonable time for those who value a good night's sleep; Underground Film Series, an

Left: Audience members young and old filing into IU Cinema for its first annual CatVideoFest event in June 2019. Eric Rudd/IU Studios

Facing, left: Live performance by puppeteer, musician, and filmmaker Jacob Graham and Tad, one of the Creatures of Yes, part of a CINEkids International Children's Film Series event at IU Cinema in November 2018. Chaz Mottinger/ IU Studios

Facing, right: Audience members enjoy the first annual *The Sound of Music* quote-along at IU Cinema in December 2015. James Brosher/ IU Studios

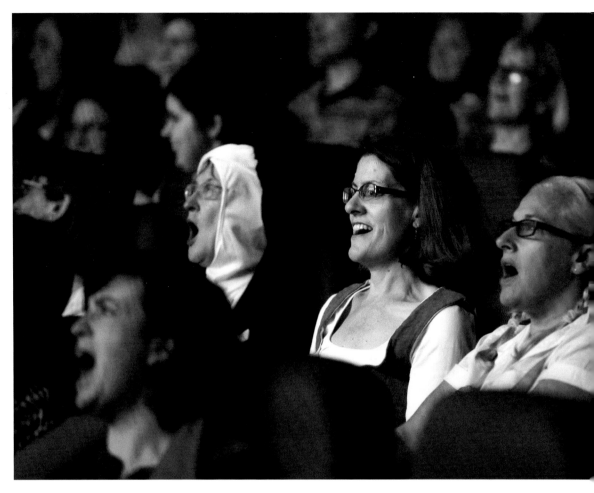

experimental series curated by Indiana University graduate students; and City Lights Film Series, a classic-film series highlighting titles within the David S. Bradley Collection in the Lilly Library, also programmed by IU graduate students. These series ensure IU Cinema's program each semester includes breadth and depth in genre and era, with offerings for everyone.

Film screenings often become much more than just that at IU Cinema. Creative event ideas can be sparked by the start of the semester; the new restoration of a great, fun film; an anniversary of a beloved cult film; or any number of inspirations. These types of events build excitement and community—and let's face it, they're fun!

Screening a Hayao Miyazaki film any time of the year is a treat, but there is no better way to kick off a new school year than with a classic from Studio Ghibli as IU Cinema did in 2016 and 2019 with *Spirited Away* (2001) and *Howl's Moving Castle* (2004), respectively. The screening of *Spirited Away* was IU Cinema's first

outdoor film presentation, which attracted more than six hundred attendees to the lawn of the newly opened Hamilton Lugar School of Global and International Studies, just up the hill from the Cinema. In previous years, IU Cinema partnered with the City of Bloomington and the Starlite Drive-In on outdoor screenings, including *E.T. The Extra-Terrestrial* (1982), *Night of the Living Dead* (1968), and *Time Bandits* (1981).

Though event cinema was not new to IU Cinema, these types of events became much more frequent and another recognized staple of the Cinema's programming when founding Associate Director Brittany D. Friesner began curating more of the program during the 2015–16 academic year while Founding Director Jon Vickers was on sabbatical. In addition to building excitement around campus and the Bloomington community, this programming engages a broader community on social media. IU Cinema program ideas have even been borrowed and adapted by other programmers around the country.

"That was an amazing day. The sound, especially for *Return of the Jedi*, was incredible. Let's do it again tomorrow!"

—John Keith, IU Cinema patron and donor

Following is a selection of such series and events:

- A twenty-four-hour film marathon celebrating the work of actor Philip Seymour Hoffman, two weeks after he unexpectedly passed away

- Jurassically Yours, a series of dinosaur-related films leading up to a twenty-fifth anniversary screening of *Jurassic Park* (1993), replete with a special "dinosaur" guest and a re-created *Jurassic Park*–themed vehicle

- Back to Back to *Back to the Future*, a marathon that included screenings of the entire film trilogy in one day—from the first movie to the third and then in reverse—complete with a DeLorean parked near the Cinema's entrance

- A marathon of digital screenings of the special-edition versions of the original *Star Wars* trilogy with cosplay guests from local organization Bloodfin Garrison—501st Legion and Rebel Legion Mos Espa Base

- A twentieth-anniversary screening marathon of the *Matrix* film trilogy

- Raiders-versary! a weekend celebration of *Raiders of the Lost Ark*, including a thirty-fifth-anniversary presentation of the film; a screening of *The Adaptation* (1989), the adventurous fan-film remake by two childhood friends, Chris Strompolos and Eric Zala; and a screening of the new documentary about the fan film, *Raiders!: The Story of the Greatest Fan Film Ever Made* (2016)—all presented with filmmaker Zala present

- The 1993 film *Groundhog Day* running nonstop on—you guessed it—Groundhog Day, starting at 6:00 a.m. with "I Got You Babe" on repeat as house music throughout the all-day marathon

Many other one-of-a-kind events are sprinkled throughout the Cinema's program each year. It is sometimes hard to categorize these events, and while most are intentionally curated and planned, other opportunities arise organically. In 2018, IU Cinema screened the restoration of the 1954 Indiana State Basketball Championship title game, in which Milan High School—with an enrollment of only 161 students—won the Indiana High School Boys Basketball Tournament against the much larger Muncie Central High School.

The underdog story of this team's journey, referred to as the Milan Miracle, inspired Indiana's beloved basketball film *Hoosiers* (1986), written, directed, and produced by IU alumni David Anspaugh and Angelo Pizzo. The screening was attended by many who were present at the 1954 game.

Other events include screenings of early silent films by pioneering women directors with a DJ spinning music selected to accompany the films. The program was part of the monthlong Running the Screen: Directed by Women series, as well as the A&H Council's First Thursdays Program, supported by Women's Philanthropy at IU. Other special-event programs have included Victoria Price presenting a lecture on her father, "Vincent Price: Master of Menace, Lover of Life," followed by a screening of Roger Corman's *The Masque of the Red Death* (1964), and a conversation with funk musician Bootsy Collins, preceded by a performance from the IU Soul Revue. The latter program was initiated by IU's Archives of African American Music and Culture and launched a multiyear relationship with Collins, which includes recordings and performances.

Curation is a creative act and intellectual pursuit. The process requires a knowledge of film history and production, research, scholarship, emotional connection to the work, good instincts, and a willingness to share and defend personal taste and aesthetics as well as to take creative risks. Curatorial inspiration thrives in film-festival environments with dozens of US and international films screened over several days. Vickers and Friesner have represented IU Cinema at several prestigious film festivals—including the Sundance Film Festival; Cannes; Berlinale; and the Toronto, Palm Springs, Beijing, Seattle, and Rio international film festivals—bringing back to IU the films and stories that most affected them.

> "I was pretty broken up about [Philip Seymour Hoffman's] death, so when I heard the Cinema was putting on a retrospective, all I said to myself was 'I am going to all of it.' Turned out it was one of the most cathartic and surreal experiences of my life. I feel like I went through all the stages of grief in one day for a person I didn't even know. . . . IU Cinema came through with some celluloid therapy for the heavy-hearted. I wouldn't trade that memory for the world."
>
> —David Carter, cohost and producer of *A Place for Film: The IU Cinema Podcast* and contributor to *A Place for Film* blog

Facing, top: IU Cinema patrons having fun being entertained by a special "dinosaur" guest, Rawry, prior to the twenty-fifth anniversary screening of *Jurassic Park* in December 2018 as part of the series Jurassically Yours: Extinct But Not Forgotten. Chaz Mottinger/IU Studios

Facing, bottom: An outdoor screening of Hayao Miyazaki's *Spirited Away* presented by IU Cinema on the lawn of the Hamilton Lugar School of Global and International Studies during Welcome Week in August 2016. Ava Vickers

Right: Posters for a sampling of IU Cinema's collaborative and signature series. Kyle Calvert

Inspiration can also be found in networking with programmers from other institutions, a process made easier with the founding of the Art House Convergence (AHC)—in partnership with the Sundance Institute—in 2006. Vickers and Friesner have both presented on IU Cinema's curation and programming at the annual AHC conference. Additionally, Jessica Davis Tagg, events and operations director, has presented on IU Cinema's volunteer program. At the tenth annual AHC conference, the Cinema was featured in a special anniversary publication highlighting ten arthouse cinemas from around the world, including Film Forum in New York City, the Belcourt Theatre in Nashville, and Film Streams in Iowa City, Iowa.

The creative output of a well-curated series are the programs themselves, the promotional materials created to begin a conversation with your audience, and, finally, the curation of the experience of attending the events—house music, preshow content, introductions, and any other accoutrements.

As a testament to the promotional materials, this chapter is brimming with fantastic artwork by IU Cinema's Design and Marketing Manager Kyle P. Calvert, as well as volunteer designers over the years. These materials communicate for the curators, evoking the ethos of the series while embracing IU Cinema's brand.

The same holds true for the curation of invited guests and the programs surrounding their visits. A good curator knows what types of guests will connect with audiences and which filmmakers complement the program. IU Cinema had the good fortune in its first decade to host several master filmmakers and many more on the cusp of major successes. Like all curated series, visiting artists and their series also receive creative

Facing: Musician, activist, and filmmaker Boots Riley in IU Cinema's lobby following a screening of his film *Sorry to Bother You* (2018) in October 2018. Benedict Jones

Right, top: Alumna and donor Jane Jorgensen standing with IU Cinema technical lead Manny Knowles prior to a screening as part of the series Back to Back to *Back to the Future* in October 2015. Brittany D. Friesner

Right, bottom: Victoria Price signs books for a patron after her lecture, "Vincent Price: Master of Menace, Lover of Life," at IU Cinema in March 2018. Chaz Mottinger/IU Studios

Left: Posters for series curated by IU Cinema's Founding Director Jon Vickers and Associate Director Brittany D. Friesner, in addition to posters for visiting guests. Kyle Calvert

Facing, top: Filmmaker Penelope Spheeris being interviewed by Associate Director Brittany D. Friesner for "An IU Cinema Exclusive" interview at IU Cinema as part of her September 2015 visit. Toth Media, LLC

Facing, bottom: Funk musician Bootsy Collins being interviewed by UCLA scholar Dr. Scot Brown at IU Cinema in March 2018, an event presented in partnership with IU's Archives of African American Music and Culture. African American Arts Institute

treatment with well-designed promotional materials. These materials receive the highest praise from visiting guests, and many have an extended life—after being signed by filmmakers—on display in IU Cinema's lower lobby. Guests often take copies for their own collections and, occasionally, poster designs will be used by filmmakers or other curators with the Cinema's permission. In 2019, IU Cinema presented a Barbara Hammer retrospective, which included a virtual conversation with Hammer two months before she passed away; the program and poster were presented later that year at the National Gallery of Art.

A final creative output of note is the production of highly produced filmmaker interviews with IU Cinema guests. As noted previously, these interviews are produced by IU alumni Joseph Toth and Kirstin Wade of Toth Media, LLC. These documents capture a moment in the careers of these filmmakers while visiting Indiana University and have also proven to be engaging reflections of their own histories. When film director Martin Scorsese was preparing to host Polish filmmaker Krzysztof Zanussi in New York for an event, his office contacted IU Cinema to request a copy of its exclusive interview with Zanussi to help Scorsese prepare.

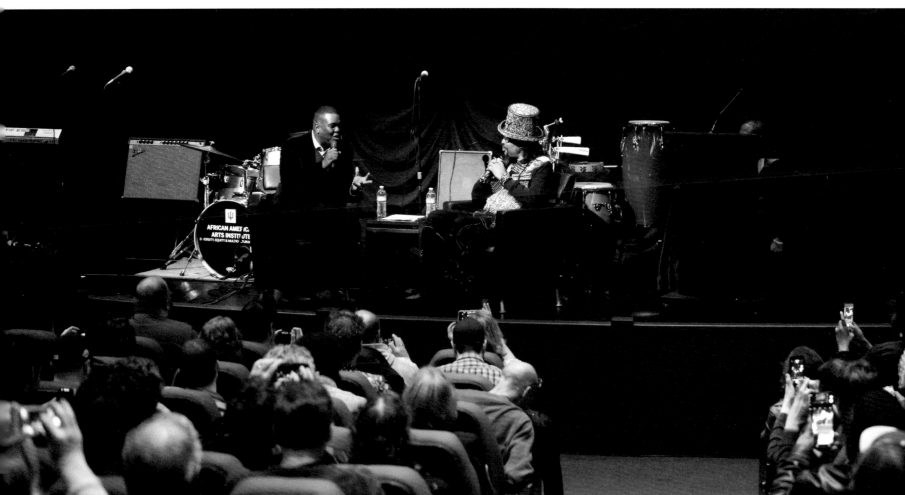

In its first decade, the Cinema has amassed a video library of nearly sixty recorded conversations, which are hosted on its YouTube channel. Many have been transcribed for publication in this book as well as in international film journals like *Post Script* and *Chiricú Journal: Latina/o Literatures, Arts, and Cultures*, extending their scholarly life beyond video form.

While other public-facing arts programs and university cinematheques support their institutions and academic missions, IU Cinema sees its collaborative role with Indiana University as being paramount to its own success. IU Cinema understands its unique value not only by offering support and collaboration but also as a catalyst for new ideas, research topics, and ways to elevate the University's profile surrounding the study, production, preservation, and research of the moving image.

Facing: DJ MADDØG spins music for silent films from pioneering women directors at IU Cinema during an IU Arts and Humanities Council First Thursdays event in September 2019, kicking off the monthlong series Running the Screen: Directed by Women. Brittany D. Friesner

Right: Screenshots of the opening credits of three "An IU Cinema Exclusive" interviews, produced for many of IU Cinema's visiting filmmakers. Toth Media, LLC

04
CONTINUING A LEGACY

Advances made at great institutions like Indiana University build on traditions firmly grounded in their mission and ethos, then soar to new heights through research, vision, innovation, and drive. Everything IU Cinema has accomplished in its first decade was preceded by the good work of others who formed this base, creating programs in the arts and humanities that are the envy of other institutions.

Herman B Wells commonly receives the credit, as he modeled and created a culture on the IU Bloomington campus that placed the highest value on arts and humanities programs as the backbone to a liberal arts education. He also recognized their contributions to the sciences and professional schools. The foundation Wells began laying in the early 1940s has been renewed and expanded on by generation after generation of IU faculty, staff, alumni, and donors, building nationally recognized programs throughout the arts and humanities. These include a world-class museum and collections, one of the top-rated music schools in the world, and outstanding facilities and programs in opera, ballet, theater, contemporary dance, and the visual arts.

As captured in previous chapters, film and media are not new to Indiana University. With films being presented by students since the early 1900s; campus film production and distribution taking place since the 1940s; film studies being taught since the 1960s; and the opening of WTIU, IU Bloomington's public television station, in 1969, the University had a very strong

base in film and media. The timing was indeed right for Indiana University's eighteenth president, Michael A. McRobbie, to declare the need for a campus cinema.

Did President McRobbie have the foresight to know how a university cinema might act as a catalyst for programs linked to film and media, leading to continued growth and innovation? As IU Cinema was preparing to open, a zeitgeist was forming around the possibilities the seventh art's new campus venue would bring. During IU Cinema's first decade, several new film and media initiatives launched, while existing programs expanded. In an October 2018 article in the *Chronicle of Higher Education* titled "Low Profile, Big Changes," President McRobbie's passion for cinema also became a significant example of how he "sought to revitalize the university—not just by eagerly eyeing big splashes, but by retooling and repurposing

buildings and programs." It also stated, "The refurbished cinema has now become the anchor of the film-studies program, serving as both a classroom and a place to showcase the university's archive of movies and related memorabilia."

These initiatives during IU Cinema's first decade included a Media Digitization Preservation Initiative, committed to digitizing, preserving, and making accessible IU's time-based media collections; the formation and opening of the Media School, which combined the School of Journalism, Department of Telecommunications, and Department of Communication and Culture; the development of a Black Cinema minor, the first of its kind in the US; the formation of the Center for Documentary Research and Practice; new facilities and International Federation of Film Archives membership for IU Libraries Moving Image Archive (IULMIA); the development

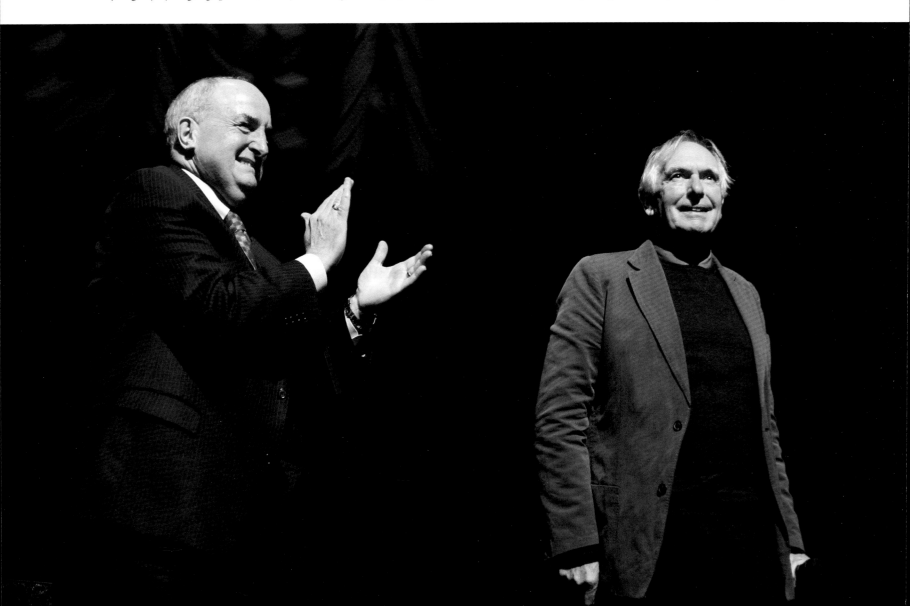

of the music scoring for visual media degree programs in the Jacobs School of Music (JSoM); and growth of the filmmaker collections in both the Lilly Library and Black Film Center/Archive (BFC/A).

IU Cinema does not claim credit for any of these major achievements, but it has served as a hub for collaborative activity alongside each of these initiatives and has expanded IU's reputation for film and media collections, studies, and production through its innovative programs, strong networks, and branding.

In addition to advancing Indiana University's reputation and its film and media programs, in 2017, IU Cinema adopted a new vision statement: transformative cinematic experiences accessible for all. The Cinema broadly interprets this statement to go beyond the exterior walls of the venue and to carry into the community, even beyond Bloomington. Indiana University's Bicentennial Strategic Plan included "Priority Seven: Building a Prosperous and Innovative Indiana." In the latter half of the first decade, IU Cinema has worked on several initiatives to fulfill both of these charges.

Starting in 2015, IU Cinema staff led an initiative to reintroduce tax incentives for film and media production into Indiana state legislation. Jon Vickers guided a small committee of faculty, graduate students, filmmakers, and a former film commissioner, which researched

> "Every time I come over to the Cinema, I feel what a special place it is and what a great fit with the MAC [Musical Arts Center], the Lilly, the Auditorium, and the IU Art Museum. [Herman B] Wells' vision continues to inspire students, community, and our visitors."
>
> —James Canary, conservator, Lilly Library

Facing: President Michael A. McRobbie with filmmaker Peter Weir onstage at IU Cinema following a screening of *Gallipoli* (1981) on March 4, 2015. Eric Rudd/IU Studios

Top: Tim Wagner, a film archivist and projectionist from the IU Libraries Moving Image Archive, examines film during a workshop at the Biennial Audio-Visual Archival Summer School 2019. Eric Rudd/IU Studios

thirty-five states with existing production incentives and drafted its first bill. The committee introduced the bill in budget year 2017 and again in 2019. Along with leading this initiative, Cinema staff have continued to lobby for an incentive program each legislative session. In 2020, the Senate Bill 262 passed the Senate forty-seven to two but did not make it through the House. IU Cinema will champion a bill in 2021 and every year needed until it passes, making the state of Indiana competitive for film and media production, which will have a ripple effect for Indiana University students and alumni.

As referenced in Chapter 2, in 2018, IU launched a new grant-funded initiative called the Center for Rural Engagement (CRE), designed to have a positive impact on Indiana's rural communities across the state. One of the focuses of this new center is Quality of Place, for which the center partners with IU units to build arts and humanities opportunities in the communities it serves. IU Cinema proposed a series of pop-up film screenings and filmmaking workshops across these communities. The program began with monthly arthouse film screenings in three rural towns, held in nontraditional venues like art galleries, town halls, libraries, bars, and Veterans of Foreign Wars halls. IU Cinema developed relationships with local organizations, secured screening licenses for contemporary films with themes relevant and interesting to each community, and then, in partnership with the CRE and local film cooperative Cicada Cinema, traveled into the communities, set up screening rooms, and presented films to local residents. By 2019, this expanded to include filmmaking workshops in partnership with local filmmakers.

Also in 2018, Indiana University began rehabilitation of a major landmark in Indianapolis, the Walker Theatre—part of the Madam C. J. Walker building, named after the Black entrepreneur, philanthropist, and activist who is recorded in the Guinness Book of World Records as the first self-made woman millionaire in America. IU Cinema leadership consulted on the venue's rehabilitation until its near completion in 2020. Due to budget priorities and constraints at the point of completion, the venue, now formally named the Madam Walker Legacy Center, lacked cinema capabilities; however, infrastructure was designed and developed to enable adding technology for future film presentations.

IU Cinema has also provided mentorship to several new Indiana film initiatives, from pop-up cinema collectives in Bloomington, Indianapolis, and Evansville to film festivals to purpose-built art cinemas. Staff have provided many hours of consultation to help others present transformative cinematic experiences in their own communities.

Top: Waiting for a pop-up film screening of *Eva: A-7063* (2018) as part of an IU Cinema and Center for Rural Engagement Quality of Place initiative. Jon Vickers

Facing, left: Screen capture of a Zoom Q&A with Founding Director Jon Vickers and hosts of IU Cinema's podcast *A Place for Film* Elizabeth Roell and David Carter. IU Cinema

Facing, right: IU Cinema's poster case showing event changes due to the COVID-19 pandemic. Kyle Calvert.

"As a film lover, few places could have attracted me away from my job as the curator of the Washington University Film and Media Archive. But the appeal of living near IU Cinema is just that strong. I can't say enough about how magnificent the facilities are and about the quality and thoughtfulness of the programming. It's truly world class and designed to be so inclusive of so many parts of the IU and Bloomington communities. The Cinema really is a local and national film treasure."

—Brian J. Woodman, associate director of University collections

Finally, IU Cinema grew from a new, ambitious film program into a maturing public-facing arts presenter with a devoted base of stakeholders in its first decade. It created a model for broad, multi-disciplinary collaboration as an independent unit, reaching across the entire academy while also developing and codifying sustainable staffing, systems, documentation, funding, and networks. The base is set for the next scene in IU Cinema's story.

INDIANA UNIVERSITY'S BICENTENNIAL YEAR

Academic year 2020 was not only the University's long-awaited bicentennial year but also a year of transition and grand challenges. Vickers' tenure was scheduled to end at Indiana University in June 2020, and IU Cinema staff prepared well for the transition. Bicentennial programs were robust and included high-profile events. Outside of the Cinema, the University community celebrated one achievement after another, including a successful fundraising campaign for which generous donors exceeded every expectation set by the University.

The celebratory bicentennial year was also the year of COVID-19, the virus that led to a global pandemic and turned the world upside-down. Indiana University canceled all in-person public events from March 13 onward, and completed its bicentennial academic year remotely, with students finishing the spring semester and summer sessions online. In April 2020, the University put the search for the Cinema's new director on hold. Vickers offered to stay on for an additional three months, and Friesner agreed to serve as interim director.

Several programs from IU Cinema's spring program were rescheduled for the 2020–21 academic year. On March 27, the Cinema launched its first virtual screening room program with an online streaming engagement of the 2019 Brazilian film *Bacurau*. The film was originally scheduled to be a part of IU Cinema's spring International Arthouse Series before in-person events were canceled. This would become the first of many weekly programs engaging IU Cinema audiences and stakeholders during the time of isolation caused by the pandemic. IU Cinema vowed to continue to interact with its audience through programs and conversations with film-makers and scholars, including IU alumni Jonathan Banks

and Eliza Hittman, as well as retiring professor Glenn Gass, best known for creating the first history of rock 'n' roll courses for a major university. Virtual programming also included a student-film showcase, presented in collaboration with the Media School, as well as a screening of *The Return of Draw Egan* with orchestral score by IU alumnus Ari Barack Fisher, the same film and score mentioned in the opening of this book. These types of events became a new model for reaching segments of IU Cinema's audience in a post-COVID-19 future with virtual programs planned for the 2020–21 academic year.

Vickers' final public event was held on September 29, 2020. IU Cinema produced an outdoor screening of *Cinema Paradiso* (1988) in IU's Memorial Stadium, limiting the attendance to 150 guests in the fifty-thousand-seat venue. The celebratory program was introduced by President McRobbie, who presented Vickers with the President's Medal for Excellence to honor his service and the accomplishments of IU Cinema.

On October 1, 2020, Friesner became interim director, positioned to lead IU Cinema and its team into 2021 and through the COVID-19 pandemic in an indelibly changed cinematic exhibition landscape.

> **"I applaud you providing access to movies virtually, particularly those offerings that are free, as they keep spirits up, entertain, and serve as 'empathy machines' for us all."**
> —T. Michael Ford, IU administrator

At the time of the completion of this manuscript, we—a collective "we" extending beyond the Cinema, beyond the University, beyond the state, and beyond the US—are still dealing with the health crisis and the impact on our families, communities, businesses, economy, and institutions.

Our world changed in 2020, and so have our educational and cultural institutions. IU Cinema vowed to return stronger and more inspired than ever as the campus and community's accessible place to engage, rebuild, inspire, entertain, and even transform. The Cinema will continue to provide transformative cinematic experiences accessible for all.

Left: IU Cinema full-time staff during Indiana University's bicentennial year. *Top row*: Founding Director Jon Vickers, Associate Director Brittany D. Friesner. *Middle row*: Design and Marketing Manager Kyle Calvert, Business Manager Carla Cowden, Technical Director Elena Grassia. *Bottom row*: Technical Coordinator Seth Mutchler, Events and Operations Director Jessica Davis Tagg.

Facing: Musician, activist, and filmmaker Boots Riley with IU student Donovan Harden outside of IULMIA prior to a Jorgensen Guest Filmmaker event in October 2018. Sohile Ali

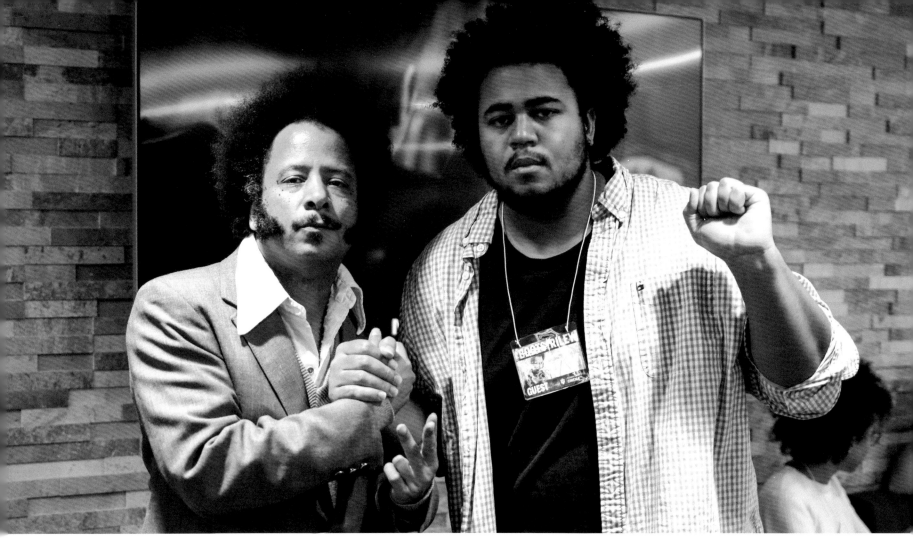

THE NEXT CHAPTER

IU Cinema's 2025 strategic plan was outlined in 2018, designed to focus on five main areas:

- sustainability and infrastructure
- programming and reputation
- student engagement
- diversity, equity, and inclusion
- audience experience

Strategies and actions were developed to enhance each of these focus areas. In the area of programming and reputation, IU Cinema will continue to focus on ensuring its program is highly collaborative, inclusive, and representative as well as launching an exploration on the feasibility of expanding its educational opportunities into a formal education program. Beyond the current array of filmmaker master classes, lectures, Q&As, and other interactions, the Cinema plans to further research best practices for developing teaching aids, community and K–12 screenings, and workshops.

IU Cinema also sees more opportunities in developing partnerships with film and media institutions outside of Indiana University similar to what it piloted with Le Giornate del Cinema Muto and Slapsticon. It will continue to seek the best opportunities for these types of partnerships.

Many of these opportunities are contingent on securing additional funding sources. Similarly, IU Cinema hopes to expand its ability to commission new work that travels with Indiana University's name attached as well as host filmmakers for extended stays as artists-in-residence or visiting faculty in the Media School. There are new programs in IU's Arts and Humanities Council and the Media School supporting such opportunities.

IU Cinema was founded on the principles of collaboration and representation. Since its inception, the Cinema has been committed to

> "Transformative cinematic experiences accessible for all."
> —IU Cinema vision statement

engaging and representing a diversity of voices and stories in its program. In June 2020, following the murder of George Floyd and global groundswell of demand for greater accountability in dismantling the cruel systems and ideologies that have oppressed Black lives for more than four hundred years, the Cinema accelerated its 2025 strategic goals on diversity, equity, inclusion, and social justice. Through the leadership of founding Associate Director Brittany D. Friesner and with the support of all staff, IU Cinema launched a set of equity and inclusion initiatives to bring the organization into even greater alignment with one of its founding principles.

Along with IU Cinema's strategic plans for the future, many of its partners are also thriving with recent growth and expansion. Both the Media School and JSoM's Music Scoring for Visual Media program now have satellite programs in Los Angeles. IULMIA has a screening room that is flourishing, and their collections are growing. The BFC/A is offering annual fellowships to scholars, filmmakers, and archivists. Enrollment in the media production track of the Media School is growing at rapid rates, and in 2020, the Trustees of Indiana University approved a Bachelor of Fine Arts

Facing: Graduate student filmmaker Nzingha Kendall in IU Cinema speaking to a friend before the premiere of her short film *Summer Memorial*, part of the Cinema's annual Double Exposure program in March 2016. James Brosher/IU Studios

Top: Filmmaker MM Serra with PhD student Noelle Griffis in the lobby of IU Cinema prior to a Jorgensen Guest Filmmaker event, which Griffis curated in February 2015. James Brosher/IU Studios

Bottom: Junior Alyssa Woolard feigns a punch to the face of actor Jonathan Banks as he sits for a moving portrait for The Media School's Production as Criticism's class project, "The People of IU: Moving Image Portraits and the Public Screen." Ty Vinson/IU Media School

in cinematic arts with the goal of eventually offering a master's degree program. The Lilly Library's filmmaker collections continue to grow with the accession of Ousmane Sembène's papers in 2019. The decade preceding the University's bicentennial celebration was a defining period of extraordinary growth and advancement for film and media at Indiana University.

As this volume in IU Cinema's journey comes to a close, there is a quote from filmmaker Beth B that is appropriate to reflect on: "Wow, what a wonderful whirlwind adventure I had at IU. Really amazing. I'm still reeling from the incredible people I met, the wonderful response and engagement with the audiences, and the special welcome you all gave me. I was so honored to be part of your screening series. It's so damned impressive! What an inspiring community!"

The next decade and beyond are bright for IU Cinema, its film and media stakeholders, and its audiences. It is truly remarkable to reflect on the maturity and reputation achieved by this young institution within its first decade. While introducing a Peter Weir film in 2016, President McRobbie stated, "The Cinema has very quickly become one of the jewels of the Bloomington campus."

IU Cinema has indeed become a benchmark for other educational institutions seeking more from arts and humanities venues and programs—a new model for university cinemas.

> "The Cinema has very quickly become one of the jewels of the Bloomington campus."
> —Indiana University President Michael A. McRobbie

Patrons departing an IU Cinema event in March 2011. Halkin Mason Photography

AFTERWORD

The power of cinema! Personally, I was hopelessly hooked when Donald O'Connor sang "Make 'Em Laugh" when running up the wall in *Singin' in the Rain*. A few years later, Anthony Quinn convinced me of a way to approach life in *Zorba the Greek*. Albert Finney and Diane Cilento exposed me to the art of fine dining with *Tom Jones*. James Stewart assured me it is important to travel with a pooka thanks to *Harvey*.

Cinema, undoubtedly, has brought all of us moments of joy, fear, sadness, and empathy—empathy that helps us be a little better than the day before. Sidney Poitier had a gifted, gracefully strong impact on almost everyone; I was fortunate to have been directed by him.

Why is a place like IU Cinema important to the campus and community? How could it be otherwise? What better place for the community to exchange thoughts and opinions, to learn and enjoy? There are students who will come to IU Cinema because they want film in some form to be their life's work. Indeed, it is a big dream, and big dreams need to be supported and nurtured. I have said many times that I will never be able to repay the gifts Indiana University has given me. They took a kid—that would be charitable to say, as I had a lot of rough edges—and introduced him to art and learning. For all his bravado, he didn't have much confidence.

During the spring of 2019, I lectured in a directing class. A young man approached me after the class. He was a freshman who was feeling very out of place. I imagine it was a case of rough edges recognizing each other. He was nervous and afraid. The beauty of the IU campus was new, and most of the people looked different from him. I emphatically told him not to give up. I also told him, as a director, he might want to take an acting class. Jon Vickers called Professor Jonathan Michaelson of the theater department, and he reached out to the young man to make the connection. Break a leg, Alejandro! Become a great director!

I have been admonished not to mention Jon and his numerous contributions to the IU Cinema. Yup, so I won't say nothin' about nothin'. How fortunate we have been to have had him pass our way. Nope, I won't say nothin'.

And a director doesn't make the magic alone. To everyone at IU Cinema, thank you for building this together. To everybody at IU, thank you for helping them. To all of you reading, as Jerry the Mouse said to Gene Kelly, "I'm dancin'!"

Jonathan Banks

Brittany D. Friesner is the founding associate director for Indiana University Cinema. She began her career at the Arts Council of Indianapolis and has held leadership roles in several arts and educational non-profit organizations, including Sundance Film Festival, Pacific Science Center, and Jacobs School of Music. Friesner holds a bachelor's degree in journalism and a master's degree in arts administration, both from Indiana University.

Jon Vickers is the founding director of Indiana University Cinema. Armed with a civil engineering degree, a love of cinema, and entrepreneurial spirit, he has led the successful launch of three venues and programs over twenty-five years—Vickers Theatre (Three Oaks, Michigan), Browning Cinema (University of Notre Dame), and Indiana University Cinema. Each of these programs have screened thousands of films, engaged filmmakers, and enhanced the cultural and social fabric of their surrounding communities.